Slime Mould in Arts and Architecture

RIVER PUBLISHERS SERIES IN BIOMEDICAL ENGINEERING

Series Editor:

DINESH KANT KUMAR
RMIT University
Australia

Indexing: All books published in this series are submitted to the Web of Science Book Citation Index (BkCI), to SCOPUS, to CrossRef and to Google Scholar for evaluation and indexing.

The "River Publishers Series in Biomedical Engineering" is a series of comprehensive academic and professional books which focus on the engineering and mathematics in medicine and biology. The series presents innovative experimental science and technological development in the biomedical field as well as clinical application of new developments.

Books published in the series include research monographs, edited volumes, handbooks and textbooks. The books provide professionals, researchers, educators, and advanced students in the field with an invaluable insight into the latest research and developments.

Topics covered in the series include, but are by no means restricted to the following:

- Biomedical engineering
- Biomedical physics and applied biophysics
- Bio-informatics
- Bio-metrics
- Bio-signals
- Medical Imaging

For a list of other books in this series, visit www.riverpublishers.com

Slime Mould in Arts and Architecture

Editor

Andrew Adamatzky

University of the West of England
Bristol, UK

River Publishers

Published, sold and distributed by:
River Publishers
Alsbjergvej 10
9260 Gistrup
Denmark

River Publishers
Lange Geer 44
2611 PW Delft
The Netherlands

Tel.: +45369953197
www.riverpublishers.com

ISBN: 978-87-7022-072-9 (Hardback)
 978-87-7022-071-2 (Ebook)

©2019 River Publishers

The cover design uses a photograph of slime mould Physarum *Polycephalum* growing in template imitating Bristol city centre made by Elliott Ballam.

Contents

*Teresa Dillon, Elliott Ballam, Richard Mayne, Neil Phillips
and Andrew Adamatzky*

Preface

Acellular slime mould *Physarum polycephalum* has a rich life cycle that includes fruit bodies, spores, single-cell amoebas, and syncytium. At one phase of its cycle, the slime mould becomes a plasmodium. The plasmodium is a coenocyte: nuclear divisions occur without cytokinesis. The plasmodium is a single cell with thousands of nuclei. The plasmodium is a large cell. It can expand up to several meters when conditions are good. The plasmodium consumes microscopic particles and bacteria. During its foraging behaviour, the plasmodium spans scattered sources of nutrients with a network of protoplasmic tubes. The plasmodium optimises its protoplasmic network to span all sources of nutrients, stay away from repellents and minimise transportation of metabolites inside its body. The plasmodium's ability to optimise its shape attracted the attention of biologists, then computer scientists and engineers. Thus, the field of slime mould computing was born.

In the last 15 years, over 50 sensing and computing devices have been invented with the slime mould. The field of *Physarum* computing flourished and got widely publicised in papers and monographs. While getting fame in science and engineering, *P. polycephalum* lived a second life. The slime mould's adaptability, polymorphism and aestheticism inspired artists and architects. The slime mould has been seen as a self-conscious fluid form continuously changing its shape in response to external stimulation and due to interactions of thousands of micro-oscillators in its body. Elusiveness is a magic feature of the slime mould. One moment the slime mould gives you a solution to a mathematical problem by a shape of its body, next moment it changes its shape and the solution disappears. The authors of this book employ this momentariness of structure of an "unstructured" creature.

The book presents a set of unique chapters by leading artists, architects and scientists resulted from creative translations of the slime mould behaviour into forms and sounds, unconventional investigations and sensorial experiences and the slime mould ability to remove boundaries between living and artificial, solid and fluid, science and arts. The book gives readers unique tools for designing architectural forms and creative works using the slime

mould, understanding how proto-cognitive living substrates can be used in every day life, it sparks new ideas and initiates further progress in many fields or arts, architecture, science and engineering.

Vibrant concepts of biology, arts, non-linear sciences and architecture interact in the book towards the formation of an unorthodox vision of the future and emergent concepts of a socium, where science and art are becoming a single unity. The striking polymorphism of contributions reflects the vibrant development of the field of bio-inspired and bio-integrated arts and architecture. This makes the book stand out from the standard art, science and architectural book. The book provides in-depth insight and first-hand working experiences into current production of art works at the edge of art, science and technology. The book is a unique compendium of works made by a new type of artists and architects who are not only concerned with the visual level of their work but also with scientific conceptualization and theoretical reflection on contextualization of their studies and work in the interdisciplinary field of art and science. All contributors of the book are world-leading artists, architects or scientists, with an impressive track record of exhibitions, installations and scientific and engineering discoveries. They provide in-depth insights and first-hand working experiences into current developments of artistic and architectural works at the edge of art, science and technology.

<div align="right">

Andrew Adamatzky,
Bristol, UK
February 2019

</div>

List of Contributors

Alessio Erioli,*Co-de-iT, Via Agostino da Montefeltro 2, 10134 Torino, Italy; E-mail: alessio.erioli@unibo.it*

Amy Halliday, *Hampshire College, 893 West St, Amherst, MA, USA; E-mail: ahalliday@hampshire.edu*

Andrea Graziano, *Co-de-iT, Via Agostino da Montefeltro 2, 10134 Torino, Italy; E-mail: arch.a.graziano@gmail.com*

Andrew Adamatzky, *University of the West of England, Bristol, UK; E-mail: andrew.adamatzky@uwe.ac.uk*

Angelo Vermeulen, *Systems Engineering and Simulation, Faculty of Technology, The Netherlands; E-mail: a.c.j.vermeulen@tudelft.nl*

Axel Cuevas Santamaría, *Department of Plant Pathology, The Ohio State University, Columbus, Ohio, USA; E-mail: cuevassantamaria.1@osu.edu*

Barbara Imhof, *LIQUIFER Systems Group and University of Applied Arts, Vienna, Austria; E-mail: barbara.imhof@liquifer.com*

Catalina Puello, *Institute for Advanced Architecture of Catalonia (IAAC), Carrer de Pujades 102, Barcelona, Spain; E-mail: catalina.puello.acosta@iaact.net*

Ceren Yönetim, *Vienna, Austria; E-mail: cerenyonetim@gmail.com*

Claudia Pasquero, *1. The Bartlett School of Architecture, University College London, UK; 2. The Faculty of Architecture, Innsbruck University, Austria; E-mail: c.pasquero@ucl.ac.uk*

Eduardo Reck Miranda, *Interdisciplinary Centre for Computer Music Research (ICCMR), Plymouth University, Plymouth, UK; E-mail: eduardo.miranda@plymouth.ac.uk*

Edward Braund, *Interdisciplinary Centre for Computer Music Research (ICCMR), Plymouth University, Plymouth, UK; E-mail: edward.braund@plymouth.ac.uk*

Elliott Ballam, *University of the West of England, Bristol, UK;*
E-mail: elliottballam@hotmail.co.uk

Elvia Wilk, *The New School For Social Research, 235 Bowery, New York,*
NY 10002, USA; E-mail: elviapw@gmail.com

Fabio Rivera, *Institute for Advanced Architecture of Catalonia (IAAC),*
Carrer de Pujades 102, Barcelona, Spain; E-mail: fabio.rivera@iaac.net

Gonzalo Moiguer, *Buenos Aires, Argentina;*
E-mail: gonzamoiguer@gmail.com

Grace Chung, *Architectural Association School of Architecture, 36 Bedford*
Square, Bloomsbury, London, UK;
E-mail: gracechung@heatherwick.com

Heather Barnett, *University of Arts, London, UK;*
E-mail: h.barnett@csm.arts.ac.uk

Jason C. Slot, *Department of Plant Pathology, The Ohio State University,*
Columbus, Ohio, USA

Jenna Sutela, *E-mail: jenna.sutela@gmail.com*

Johana Monroy, *Institute for Advanced Architecture of Catalonia (IAAC),*
Carrer de Pujades 102, Barcelona, Spain; E-mail: johana.monroy@iaac.net

Jonathon Keats, *Hampshire College, 893 West St, Amherst, MA, USA;*
E-mail: jonathonkeats@gmail.com

Liss C. Werner, *Technical University of Berlin, Germany;*
E-mail: liss.c.werner@tu-berlin.de

Marco Poletto, *ecoLogicStudio, London, UK;*
E-mail: marco@ecoLogicStudio.com

Massimo Moretti, *WASP, Viale Zaganelli, 26, 48024 Massa Lombarda RA,*
Italy; E-mail: info@3dwasp.com

Maurizio Montalti, *Officina Corpuscoli, Witte de Withstraat 108 hs,*
1057 ZG Amsterdam, The Netherlands, E-mail: info@corpuscoli.com

Megan Dobro, *Hampshire College, 893 West St, Amherst, MA, USA;*
E-mail: mjdNS@hampshire.edu

Michael Sedbon, *Studio Michael Sedbon, Paris, France;*
E-mail: michaelsedbon.com; michaelsed7@gmail.com

Mirko Daneluzzo, *Co-de-iT, Via Agostino da Montefeltro 2, 10134 Torino, Italy; E-mail: mirko@nyxostudio.com*

Neil Phillips, *University of the West of England, Bristol, UK; E-mail: neil.phillips@uwe.ac.uk*

Nenad Popov, *Independent Scholar, Berlin, Germany; E-mail: nesa@morphogenesis.eu*

Petra Gruber, *Biomimicry Research and Innovation Center BRIC, The University of Akron, Akron, USA; E-mail: pgruber@uakron.edu*

Pieter van Boheemen, *WAAG, Sint Antoniesbreestraat 69, 1011 HB Amsterdam, The Netherlands; E-mail: p.vanboheemen@rathenau.nl*

Preety Anand, *Architectural Association School of Architecture, 36 Bedford Square, Bloomsbury, London, UK; E-mail: preety_83@hotmail.com*

Richard Mayne, *University of the West of England, Bristol, UK; E-mail: richard.mayne@uwe.ac.uk*

Sarah Choukah, *University of Montreal, Montreal, Canada; E-mail: schoukah@gmail.com*

Satvik Venkatesh, *Interdisciplinary Centre for Computer Music Research (ICCMR), Plymouth University, Plymouth, UK; E-mail: satvik.venkatesh@students.plymouth.ac.uk*

Sonja Bäumel, *Studio Sonja Bäumel, Witte de Withstraat 108-H, 1057 ZG Amsterdam, The Netherlands; E-mail: info@sonjabaeumel.at*

Steven L. Stephenson, *Department of Biological Sciences, University of Arkansas, Fayetteville, Arkansas, USA; E-mail: slsteph@uark.edu*

Teresa Dillon, *University of the West of England, Bristol, UK; E-mail: teresa.dillon@uwe.ac.uk; teresa.dillon@polarproduce.org*

Tommaso Casucci, *Co-de-iT, Via Agostino da Montefeltro 2, 10134 Torino, Italy; E-mail: tommaso.casucci@gmail.com*

Tristan Matheson, *Concordia University, Montreal, Canada; E-mail: trifektion@gmail.com*

WhiteFeather Hunter, *The University of Western Australia, Perth, Australia; E-mail: whitefeather@whitefeatherhunter.com*

List of Figures

List of Tables

1

Myxomycetes and Art

Steven L. Stephenson

Department of Biological Sciences, University of Arkansas,
Fayetteville, Arkansas, USA
E-mail: slsteph@uark.edu

Myxomycetes, commonly referred to as slime moulds, do not have a particularly attractive name, but many species produce fruiting bodies that are miniature objects of considerable beauty. Because of their small size and the conditions in which they occur, these organisms tend to be overlooked in nature. However, anyone who takes the time and effort to search for them cannot fail to be impressed by the incredible diversity, intricate structures and vibrant colours displayed by many members of the group.

The earliest known reference to a myxomycete in the scientific literature appears to be that of the German botanist Thomas Panckow, whose *Herbarium Portatile* (published in 1654) contained a brief description and a woodcut depicting the common species *Lycogala epidendrum* (Figure 1.1). Although the existence of the printing press had allowed for the dissemination of images of nature for almost two centuries, this woodcut was the first time a myxomycete had been depicted in print.

Additional drawings by other scientists followed, but the first truly outstanding art work depicting examples of these organisms was produced by the Ernst Haeckel (1834–1919), a gifted German scientist and artist who discovered, described and named thousands of new species during his lifetime. Haeckel was primarily a marine biologist, but he illustrated a number of myxomycetes (Figure 1.2), as can be seen in his rather appropriately named *Kunstformen der Natur (Artforms in Nature)*, published in 1904.

The world's leading authority on the myxomycetes during the late nineteenth and very early twentieth century was the Englishman Arthur Lister

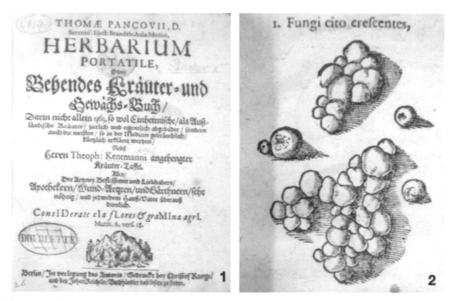

Figure 1.1 Woodcut showing the myxomycete *Lycogala epidendrum* from Thomas Panckow's *Herbarium Portatile*, published in 1654.

(1830–1908), whose work culminated in the appearance in 1894 of *A Monograph of the Mycetozoa*, published by the British Museum. Lister was assisted in his work by his daughter Gulielma Lister (1860–1949), who continued her father's work after his death. She prepared the second edition of *A Monograph of the Mycetozoa* (1911) and included beautiful watercolors. The third edition (1925) was much enlarged through her own work. A truly skilled artist, she produced some of the finest artwork ever done for myxomycetes (Figure 1.3).

The Lister monograph remained the definitive treatment of the myxomycetes until 1969, when a collaboration between the Americans George W. Martin (1886–1971) and Constantine J. Alexopoulos (1907–1986) resulted in their comprehensive world monograph, entitled *The Myxomycetes*, published by the University of Iowa Press. This work is now long out of print. However, it still remains the single most definitive treatment on the myxomycetes, literally representing a "bible" for those individuals engaged in studies of these organisms. The illustrations used in the monograph, which were done by Ruth McVaugh Allen (1913–1984), a gifted and extremely talented artist, are an almost indispensable resource (Figure 1.4).

Japan has a long-standing tradition for studies of myxomycetes, and these studies have been supported at the highest level. Hirohito (1901–1989), the emperor of the country during a major portion of the twentieth century, was a

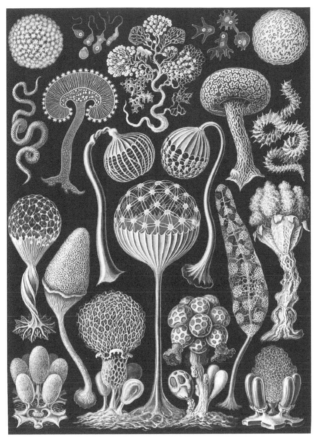

Figure 1.2 Plate depicting a number of species of myxomycetes from *Kunstformen der Natur*, published in 1904.

keen naturalist. In fact, he was so interested in natural history that on the palace grounds in Tokyo, there was a laboratory devoted to the study of myxomycetes, with Yoshikadzu Emoto as the director. Emoto published a series of paintings of Japanese myxomycetes in *The Myxomycetes of Japan*, which appeared in 1977 (Figure 1.5). Unfortunately, the book is currently almost impossible to obtain, but the illustrations represent some of the most extraordinary artwork ever produced on myxomycetes.

The small size of the fruiting body of most species of myxomycetes makes it a difficult structure to photograph. However, with the improvement of photography, most published works on the myxomycetes that have appeared since the publication of *The Myxomycetes of Japan* have used

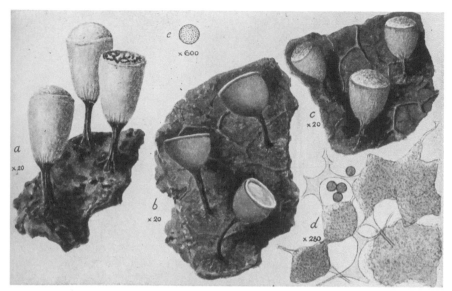

Figure 1.3 Example of the artwork produced by Gulielma Lister for *A Monograph of the Mycetozoa*.

287 *Physarum roseum* Berk. & Br.
 a Six sporangia, × 5
 b Two sporangia, × 20
 c Detail of capillitium, and spores, × 250
 d Spore, × 1000

Reprinted from
The Myxomycetes
published by the
University of Iowa
Press in 1969.

Figure 1.4 One of Ruth McVaugh Allen's illustrations from *The Myxomycetes*.

Figure 1.5 An illustration from Emoto's *The Myxomycetes of Japan*.

photographs instead of paintings or drawings to illustrate the species being considered. The artwork used in the exceptions to this general rule (e.g., Ing, 1999, Stephenson, 2003) has tended to be rather "functional" (i.e., consisting of line drawings that emphasize certain structural features) and lack the attention to detail of earlier works. However, individual artists have still been attracted the myxomycetes, and the work they produce is comparable to what was done by earlier artists such as Gulielma Lister and Ruth McVaugh Allen. A recent example produced by the young American artist Angela Mele is shown in Figure 1.6.

Some of the scientists who study myxomycetes produce the artwork used in their own publications. Few people outside of the scientific community ever have the opportunity to view this artwork, since the journals in which it appears have a limited distribution, but some of the artwork is of very high

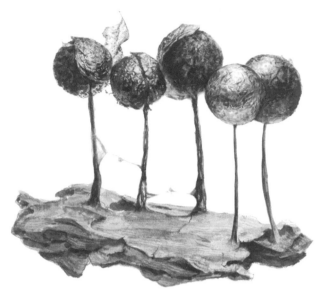

Figure 1.6 The myxomycete *Collaria arcyrionema*, as depicted by Angela Mele.

quality, as is the case for the example produced by the Ukrainian myxomycete specialist Dmitry Leontyev (Figure 1.7).

Every three years, an international congress on the systematics and ecology of myxomycetes is held somewhere in the world. The most recent congress (2017) was held in Japan, with the next one scheduled for Costa Rica (2020). Each congress attracts people with an interest in myxomycetes, ranging from amateurs to specialists in the group. The congress also attracts artists, who are provided with an opportunity to display their work. There is certainly no better place to view the range of artwork currently being generated on the myxomycetes.

Although most displays of art relating to the myxomycetes are relatively simple, this is not always the case. More extraordinary exhibits have been part of the congresses mentioned above or as stand-alone efforts such as the one shown in Figure 1.8. These exhibits not only reveal the beauty of myxomycetes but also serve to introduce the biology and ecology of these organisms to the general public. They are especially useful for the role they can play in introducing myxomycetes to students.

The fruiting bodies of myxomycetes, if collected and stored properly, can retain their general appearance for years if not decades. This means that they do not have to be sketched or painted immediately after being collected, which allows an artist to work with a particular specimen for as

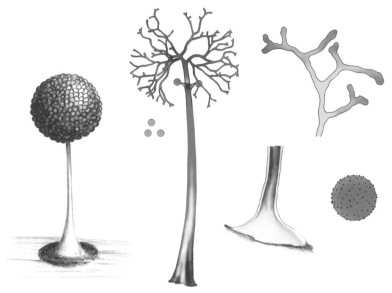

Figure 1.7 An illustration of *Macbrideola cornea* produced by the Ukrainian scientist Dmitry Leontyev.

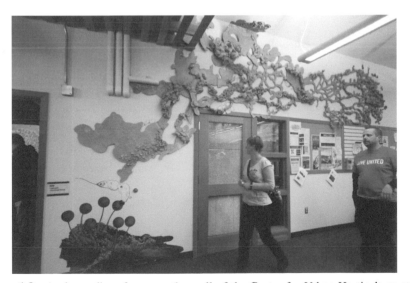

Figure 1.8 A plasmodium forms on the wall of the Center for Urban Horticulture at the University of Washington in 2015. This was part of an exhibition (entitled "Now You See It! The Slime Mold Revelation") designed by Angela Mele. Also displayed is an enlarged print from Emoto's *The Myxomycetes of Japan*.

long as necessary. This is not the case for such things as flowering plants and fungi, which are two other groups of organisms that artists find attractive. Moreover, as shown in Figures 1.3–1.5 and 1.7, it is possible to include details of the morphological structures found within the myxomycete fruiting body in addition to the entire fruiting body. This can be of considerable value when the ultimate purpose of the image is to facilitate identification of the species in question.

Acknowledgements

Sincere appreciation is extended to Angela Mele, who reviewed the final version of this manuscript, provided valuable input when it was being written and graciously supplied two of the images used herein.

References

Emoto, Y. (1977). Myxomycetes of Japan. Sangyo Tosho Publishing Company, Tokyo, Japan.

Haeckel, E. (1904). Kunstformen der Natur. Bibliographic Institute, Leipzig, Germany.

Ing, B. (1999). The Myxomycetes of Britain and Ireland: An Identification Handbook. The Richmond Publishing Company, Ltd, Slough.

Lister, A. (1894). A Monograph of the Mycetozoa. British Museum of Natural History, London.

Lister, A. (1911). A Monograph of the Mycetozoa, 2nd ed. British Museum of Natural History, London (revised by G. Lister).

Lister, A. (1925). A Monograph of the Mycetozoa, 3rd ed. British Museum of Natural History, London (revised by G. Lister).

Martin, G. W., and Alexopoulos, C. J. (1969). The Myxomycetes. University of Iowa Press, Iowa City.

Panckow, T. (1654). Herbarium Portabile. Berlin, Germany.

Stephenson, S. L. (2003). Myxomycetes of New Zealand. (Volume III in the Series "Fungi of New Zealand"). Fungal Diversity Press, Hong Kong.

2

Introduction to the Myxomycetes

Steven L. Stephenson

Department of Biological Sciences, University of Arkansas,
Fayetteville, Arkansas, USA
E-mail: slsteph@uark.edu

Myxomycetes (also known as plasmodial slime moulds or myxogastrids) have been known from their fruiting bodies since at least the middle of the seventeenth century, when the first recognizable description of a member of the group (the very common species now known as *Lycogala epidendrum*) was provided by the German mycologist Thomas Panckow (Alexopoulos et al., 1996). However, since the fruiting bodies produced by some species of myxomycetes can achieve considerable size (those of *Fuligo septica* commonly exceed 10 cm or more in total extent), there is little doubt that myxomycetes have been observed in nature as long as mankind has existed.

Since their discovery, myxomycetes have been variously classified as plants, animals or fungi (Martin, 1960). Because they produce aerial spore-bearing structures (fruiting bodies) that resemble those of certain fungi and also typically occur in some of the same ecological situations as fungi, myxomycetes traditionally have been studied by mycologists (Martin and Alexopoulos, 1969). Indeed, the name most closely associated with the group, first used by Link (1833) more than 175 years ago, is derived from the words "*myxa*" (meaning slime) and "*mycetes*" (referring to fungi). However, myxomycetes are profoundly different from the "true" fungi and actually belong to the assemblage of amoeboid protists that make up the supergroup Amoebozoa and not to the kingdom Fungi.

Approximately 900 species of myxomycetes have been described to date (Lado, 2005–2017), and some of these have been recorded from every terrestrial habitat investigated to date. Myxomycetes are associated with a wide variety of different microhabitats, the most important of which are coarse woody debris, ground litter, aerial litter (dead but still attached plant parts above the ground) and the bark surface of living trees. Specimens can be obtained as fruiting bodies that have developed in the field under natural conditions or cultured in the laboratory.

The life cycle of a myxomycete encompasses two very different trophic (or feeding) stages, one consisting of uninucleate amoebae, with or without flagella (the term "amoeboflagellate" is used to refer to both types), and the other consisting of a distinctive multinucleate structure, the plasmodium (plural: plasmodia). Plasmodia are motile, and those of some species can reach a size of a meter or more in total extent. A large example contains several thousands of synchronously dividing nuclei. Under favorable conditions, a plasmodium gives rise to one or more fruiting bodies containing spores. Presumably, the spores are largely wind-dispersed and complete the life cycle by germinating to produce the uninucleate amoeboflagellate cells (Stephenson et al., 2008). These feed and divide by binary fission to build up large populations in the various microhabitats in which these organisms occur. Ultimately, this stage in the life cycle gives rises to the plasmodium.

Fruiting bodies (also called sporocarps) are usually classified into one of four different types or forms based on their overall morphology. The most common type of fruiting body is the sporangium (plural: sporangia), which may be sessile or stalked and can be found in a wide variety of different shapes and colors. The actual spore-containing portion of the sporangium, as opposed to the entire structure, is referred to as the sporotheca (Lado and Pando, 1997). Sporangia usually occur in groups, since they are derived from separate portions of the same plasmodium, but this is not the case for the very smallest examples, in which a microscopic plasmodium gives rise to a single minute sporangium. The second type of fruiting body, an aethalium (plural: aethalia), is a more-or-less cushion-shaped structure that is presumed to be, at least in many instances, masses of completely fused sporangia. Aethalia can be quite large, with those of some species commonly exceeding several centimeters or more in total extent. The third type of fruiting body is the pseudoaethalium (literally a "false" aethalium), which consists of a mass of sporangia closely crowded together but not fused to form a single structural unit. Pseudoaethalia are comparatively uncommon. Most examples are sessile, but a very few are stalked (although the "stalk" involved has a

different origin than for a sporangium). The fourth type of fruiting body is a plasmodiocarp, which is almost always sessile. Plasmodiocarps take the form of the main veins of the plasmodium from which they were derived. Most examples are relatively simple and somewhat elongated to sparsely branched structures, but a few examples form an elaborate network on the substrate upon which they occur.

The traditional classification used for myxomycetes places these organisms in six different taxonomic orders—Ceratiomyxales, Echinosteliales, Liceales, Physarales, Stemonitales, and Trichiales. However, the order Ceratiomyxales (which consists of the single genus *Ceratiomyxa* with four species) is distinctly different from the other orders and has been assigned to a different taxonomic class. Other than the Ceratiomyxales, all of the organisms assigned to the myxomycetes constitute a well-defined and homogenous group. However, results from recent molecular studies indicate that the orders as traditionally recognized do not hold together, and a new more modern system of classification needs to be developed.

References

Alexopoulos, C. J., Mims C. W., and Blackwell, M. (1996). Introductory Mycology, 4th ed. John Wiley & Sons, Inc, New York.

Lado, C. (2005–2017). An on line nomenclatural information system of Eumycetozoa. http://www.nomen.eumycetozoa.com (4 September 2017).

Lado, C., and Pando, F. (1997). Flora Mycologica Iberica. Vol. 2: Myxomycetes, I. Ceratiomyxales, Echinosteliales, Liceales, Trichiales. Real Jardín Botánico, J. Cramer, Madrid.

Link, J. H. F. (1833). Handbuch zur erkennung der nutzbarsten und am häufigsten vorkommenden gewächse 3. Ordo Fungi, Subordo 6. Myxomycetes 405–422, 432–433. Berlin.

Martin, G. W. (1960). The systematic position of the Myxomycetes. *Mycologia*, 52(1), 119–129.

Martin, G. W., and Alexopoulos, C. J., (1969). The Myxomycetes. University of Iowa Press, Iowa City.

Stephenson, S. L., Schnittler, M., and Novozhilov, Y. (2008). Myxomycete diversity and distribution from the fossil record to the present. *Biodiversity and Conservation*, 17(2), 285–301.

3

Many-Headed: Co-creating with the Collective

Heather Barnett

University of Arts, London, UK
E-mail: h.barnett@csm.arts.ac.uk

In this essay, I critically reflect on my artistic encounters with the slime mould, *Physarum polycephalum*. Since 2008, this non-neuronally intelligent organism has provided stimulus for diverse creative enquiries and speculative actions, including time-lapse studies (testing and revealing behaviours), objects and installations (for public exhibition), and embodied encounters (inviting groups of people to enact slime mould rules). Focussing discussion on selected projects and processes developed over the past decade, connecting public audiences with slime mould behaviours, I will address the organism as a working material to be manipulated, coerced, or encouraged to 'perform' and as a conceptual model, to explore notions of embodied intelligence between human and nonhuman entities.

Whilst looking directly at the collective behaviour of the organism, the narrative also addresses wider processes of human enquiry, the slime mould as a vehicle for curiosity and discovery. The concept of *polycephalism* – many-headedness – here relates not only to the internal cellular mechanisms of the slime mould, but to the methods developed to connect diverse ways of thinking and working in a process of co-enquiry. My artistic practice is a literal and symbolic investigation of information distribution mechanisms, diverse knowledge systems, and collective intelligence – an invitation for interdisciplinary and interspecies encounters. This essay is as much about the emergent properties of the creative process and the interactions between disciplinary approaches, as it is a study of the properties of slime mould itself.

3.1 Introduction

As an artist I have long enjoyed working with biological materials, having previously cultured my own skin bacteria, built growing installations employing the tropisms of seeds, and experimented with the camouflage capabilities of cuttlefish[1]. Working with living matter is a balance between artistic intent (my ideal impositions) and biological behaviour (the characteristics inherent in the organism). To a great extent, this logic can be applied to any process of making, a negotiation between artistic aspiration and material property – form cannot be imposed upon a piece of marble but must be carved out with consideration to its inherent structures and imperfections. This need to understand material properties is, however, more prevalent when working with a living system, where the material in question possesses agency and exists within its own 'ümwelt'[2]; and where motivations, perceptions, and intentions relate to vastly different needs. Here, the subjective reality of the organism operates through unfamiliar sensory and communication mechanisms and notions of artistic control and authorship are called into question.

My first encounter with slime mould took place in July 2008 when I was gifted a live culture after a visit to the laboratory of Dr Simon Park at the University of Surrey[3]. It was a speculative meeting to share common interests in microorganisms and exchange creative activity across art and science. As I prepared to leave, aware that I had worked with living organisms before, he handed me a petri dish containing a small yellow blob. The only care instructions given were that it liked to be kept dark and damp and its favourite food was porridge oats. Simon had a hunch I would be intrigued by the structure and behaviour of slime mould. He wasn't wrong.

The organism in the petri dish was *Physarum polycephalum* – literally meaning the 'many headed' slime mould – one of over 700 known species of slime mould, a single-celled organism that lives a relatively quiet existence digesting rotting vegetation in temperate woodland. A slime mould cell may contain thousands, often millions, of individual nuclei, fused together and operating as one collective entity. Within the organism, a channel of protoplasmic streaming[4] distributes nutrients across the cell mass,

[1] A portfolio of previous works can be found on my website at: www.heatherbarnett.co.uk

[2] Literally translates as 'surrounding world' – a term coined by German biologist Jakob von Uexküll relating to how an organism perceives its environment uniquely and subjectively.

[3] Simon Park has worked for many years at the intersection of microbiology and art. Many of his experimental practices can be viewed on his blog *Exploring the Invisible*.

[4] A regular rhythmic oscillation within a vein-like structure. It is within this pulsing mechanism that many of slime mould's achievements are believed to lie.

Figure 3.1 Protoplasmic streaming within *Physarum polycephalum.*

as well as communicating valuable chemical information about environmental conditions (Figure 3.1). It has built-in mechanisms enabling it to compute a range of cost/benefit trade efficiencies and allowing it to make variable decisions without a brain. The slime mould has demonstrated that it can recognise pattern by anticipating events and is entirely self-organising, with no centralised control system – purely a mass of cellular cytoplasm operating at a capacity far greater than the sum of its parts.

3.2 The *Physarum* Experiments

Safely housed in a shoebox and growing on a moist substrate, I began the rather ad hoc process of empirical enquiry and discovery. My new studio pet was fed on an eclectic diet of foodstuffs, including decaying plant matter and desiccated insects (Figure 3.2). Its material environment contained a range of materials with different 'moisture holding' properties and its housing ranged in size and material form, from laboratory glassware to Tupperware. My initial thoughts were that I could get the organism to draw for me, that I would lay down a trail of food and that the slime mould would dutifully follow, creating intricate growth patterns along the way. It soon transpired, however, that this was a naïve assumption.

I ground down oats and boiled them into a paste, which was then piped into shapes and lines. I placed food on pieces of felt and moved them around, following the growth trajectories through a combination of time-lapse photography and stop frame animation. This was an intuitive process of

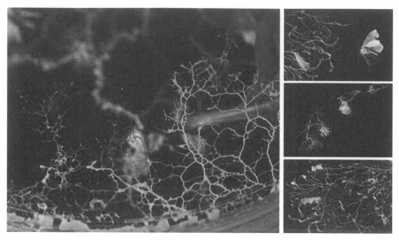

Figure 3.2 Early culinary experiments with *P. polycephalum.*

trial and error in intervention and observation, learning from the organism's response to given stimuli. Through this process, it became apparent that any ideas I had of imposing my own aesthetic sensibilities on the organism were not necessarily compatible with the organism's own desires. Rather than trying to coerce the slime mould into doing what I wanted, it was clear that I needed to work with its inherent properties instead, to understand its fundamental needs and behaviours and use them as a starting point for experimentation. If this 'collaboration' was going to go anywhere, I needed to work with the slime mould on its own terms.

Hence, a process of enquiry followed with a meandering trajectory, exploring to what extent I could affect the organism's behaviour. By understanding its motivations, intentions or reactions, I could learn how far I could control or influence its growth and pattern formation. My early time-lapse studies lacked consistency. Without an automated set up to capture the pace of growth – I simply took a photograph manually when I could – the results were haphazard, with time frames shifting at irregular intervals (Barnett, 2008). Whilst these early studies had low production values and lacked aesthetic 'flow', they provided enough visual feedback to indicate that something interesting was going on, that the organism would respond to given cues and exhibit novel behaviours (Figure 3.3).

As my time-lapse techniques improved, the organisms' behaviours began to reveal themselves more clearly through my interventions. For example, in *Study No. 011: observation of growth until resources are depleted*

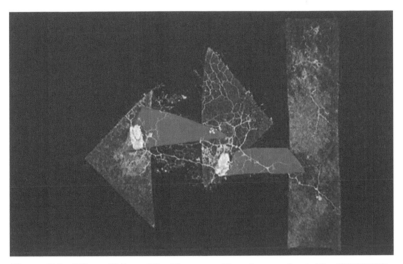

Figure 3.3 Film still from *The Physarum Experiments, Study No: 008* (2009).

(Barnett, 2009), having fed on a pile of porridge oats, the slime mould went off exploring in two directions simultaneously. At one point, the two branches grew towards one another, but before they collided, the growth slowed, paused and then reversed direction. Somehow the slime mould knew it was already there and should divert energies into exploring new territory elsewhere – a point of recognition, decision and action (Figure 3.4). I was impressed that an organism with no brain or sensory organs could map its environment in such an efficient manner and operate with seeming intention.

What then developed was a process of influence and observation; I would encourage growth with attractants, or discourage with repellents, and note the responding behaviours and structures. The artistic process became one of 'creating the conditions for something interesting to happen' and then observing the outcomes, choosing to intervene (or not) depending on what I was exploring. Over time, I have created a number of time-lapse studies exploring navigational abilities, interspecies encounters, problem-solving strategies and pattern generation (Barnett, 2018). Within these studies, my role became that of instigator rather than sole author. Whilst I could predict certain behaviours, I could not control the outcomes. What ensued became an on-going 'collaboration', a process of negotiation between an artist and a single-celled organism.

As I continued to create scenarios and environments to test the slime mould's abilities, I began reading up on other studies and a vast world of

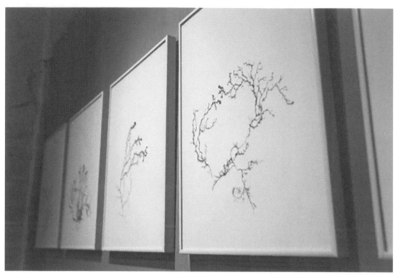

Figure 3.4 Growth Studies (digital prints) - from *The Physarum Experiments, Study No: 011* (2009).

research began to unfold. I discovered that slime moulds could find the shortest route through a maze (demonstrating a primitive form of intelligence) (Nakagaki), could form efficient networks between food sources (replicating all manner of networks whilst doing it), and that they possessed the capacity for memory (Saigusa). The transport network experiment (Tero), whereby the slime mould replicated the Japanese railway system surrounding Tokyo, spawned a whole host of further navigational enterprises for the slime mould, including mapping myriad other transport systems, migration routes, drug-trafficking routes, and evacuation pathways. These notable experiments had translated from academic journals to editorial features and online blogs. Other modes of enquiry were less widely available, residing within highly specialised academic journals. On a recent search, Google Scholar cited 59,000 published academic papers on slime mould[5], a great many heads from diverse disciplines asking different questions of this simple yet complex organism.

In addition to the many feats of computational navigation and memory cited in scientific research, slime mould has inspired those working in sectors as diverse as arts, humanities, industrial design, and philosophy. For example, its network formation has informed new structural designs for

[5]On entering the search terms "slime mold OR slime mould" to capture both American and British spellings (note that this is English language texts only).

partition walls in Airbus' planes (Rhodes); used as a speculative model for resource distribution networks within urban design speculations (ecoLogic-Studio); and employed in philosophical discussion on the nature of cognition and decision-making in nonhuman forms of life (Shaviro). It was not only *Physarum polycephalum* that featured as a model organism. Other species of slime mould also provided a rich territory for enquiry, most notably the cellular slime mould *Dictyostelium,* with research ranging from studies on aggregation, motility and altruism by renowned biologists such as John Bonner (2010) (Durston), to experimental research using the organism in the context of human healthcare (Huber and O'Day) and agricultural ecology (Amaroli, 2015).

As I developed my own image-making techniques, I also turned to the early films of Percy Smith for inspiration. A naturalist, inventor and pioneering filmmaker working in the early 20th century, Smith's vision and innovative cinematographic techniques captured the character of a broad range of natural systems, including slime mould as seen in his 1931 classic *Secrets Of Nature – Magic Myxies* (Smith). Some of my experiments also took inspiration directly from the scientific literature. As homage to Nakagaki's maze experiment, which demonstrated primitive intelligence, I built a three-dimensional model of the maze for the slime mould to explore (Barnett, 2013). In the scientific experiment researchers filled a maze with pieces of plasmodium, which spread and conjoined into a single mass cell. Food was then added at two points and the organism was observed as it contracted to form a thick tubular network connecting the two nutrient sources. The organism retreated from empty areas of the maze and adapted its morphology to form a single pathway, choosing from four possible solutions. The experiment was repeated several times, a significant number resulting in the slime mould selecting the shortest and most efficient route. Rather than replicate the scientific experiment to rationalise networks I was interested to observe the slime mould making arbitrary decisions at each turn to find its own path through the maze (Figure 3.5).

A range of exhibition outputs stemmed from these early *Physarum Experiments* including digital prints of growth studies, time-lapse films and sculptural objects (such as the maze), which could house a living sculpture – though at a top speed of 1-cm growth per hour observing living slime mould requires extreme patience. However, the amplified pace of time-lapse films in accompaniment in exhibition can help connect viewers with the mechanisms of the organism and reveal its potential, albeit imperceptible, growth trajectories.

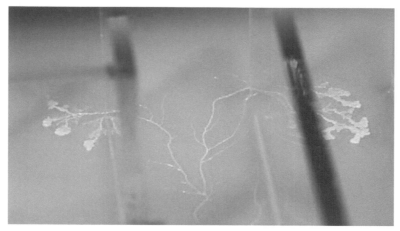

Figure 3.5 Film still from *The Physarum Experiments, Study No: 019 The Maze* (2013).

As I worked in the studio, getting to know my new 'collaborator' and discovering a world of enquiry through the research papers and articles, I posted every time-lapse study I made online, irrespective of its seeming success. I wanted the process of experimentation to be transparent and open, and I also wanted to connect with others curious about the behaviours of this organism, so one month after being given my first slime mould, I set up an online network, The Slime Mould Collective (slimoco), as a way to pool interest, share research and connect experimental practices. It was important that the network operated across disciplinary boundaries and beyond academic walls – a democratic knowledge space where professors and students, designers and scientists, enthusiasts and the simply curious, could engage on a level footing. There was also a subtext to the network, which was to see who would find it and how knowledge of it would spread through the existing online networks and search engines. After all the World Wide Web operates on similar principles of emergence as does the slime mould: namely, local interactions, pattern recognition and feedback loops, with no overriding control mechanism (Johnson, p. 22) – a self-organising platform for knowledge exchange, with all participants equal agents in the system. To date, the network has facilitated international exchanges, distributed collective knowledge and experience, helped experimental problems be solved, fostered collaborations and instigated many slime mould swaps.

Over the past ten years, through working in the studio, undertaking desk research and interacting with other slime mould researchers, practitioners and enthusiasts, I have developed a range of experimental practices, which explore slime mould behaviour and engage audiences with the questions that this organism raises. Through a range of techniques including film making, photography, print-making, sculpture, installation, interactive media, workshop design and participatory experiments I have tried to draw attention to the intriguing mechanisms of this natural phenomenon through creative and collective action.

3.3 Encounters and Interactions

The intention with *The Physarum Experiments* has never been to 'represent nature' – though that is a perfectly valid pursuit and inevitably forms a part of what I do – but to 'work with' a natural system that is little known to the general public, often overlooked and not fully understood (even by the scientists who have spent years studying it). This process of working with a living system can be incredibly time consuming (most time-lapse studies take several days to shoot and several more to edit) and involves a certain amount of uncertainty (until the hundreds, sometimes thousands, of individual still images are composited as a video I never really know if I have captured anything interesting). Similar to the latent image of an analogue photograph emerging in the developer bath, the time-lapse reveals what has been imperceptible in real time observation at the point of rendering.

A primary motivation to make artworks, or create experiences for audiences, is to encourage people to look at and to think about things I find interesting or important. This may seem a selfish pursuit, but in very simplistic terms it is at the core of any artist's agenda, to draw attention to things that others may not notice. In presenting works from *The Physarum Experiments* in public exhibition, wherever possible I aim to translate some aspects of the essence of slime mould, a gradual reveal of the organism's behaviour, and bring an element of individual discovery. Every exhibition aims to present an opportunity for interspecies encounters.

One example of bringing different strategies together is the exhibition *BioDesign* (2013), curated by William Myers and held at the Neu Museum in Rotterdam. For this presentation a trio of works was developed to engage viewers with the slime mould through observation, simulation and enactment.

Exhibited under the name of slimoco, as a collaborative endeavour[6], I brought together various elements intended to encourage close observation and interaction.

The first element comprised a selection of time-lapse studies from *The Physarum Experiments*. This showreel presented a range of slime mould behaviours including moments of open exploration, rationalisation, decision-making, retreat and self-recognition. Behaviour was not made explicit, but could be deciphered by the viewer. The second element encouraged viewers to interact directly with a computational simulation of slime mould networking behaviour[7]. As people entered the gallery, a motion sensor located their presence and mapped them onto a screen – each visitor becoming a virtual food node for the digital slime mould to 'consume'. As it explored its screen domain, the simulated slime mould located the food nodes, joined the dots and formed a network between the visitors in the gallery. As viewers moved, their positions were tracked in real time on screen. Albeit slowly, viewers became connected by the virtual organism and could test the dynamic network formed between human and digital agents (Figure 3.6).

Whilst the simulation went some way to engage viewers with the underlying mechanisms of slime mould behaviour, the computational simulation took reference away from its biological source. I wanted to find a way to directly address the biological effects of the behavioural rules. A third element was therefore developed to push the viewer further in trying to understand slime mould existence through a process of 'enactment', a way to directly experience something of 'slimemouldness' and explore how an organism can self-organise and cooperate from very simple elements. Devised initially in collaboration with Daniel Grushkin[8], some rules of behaviour were extracted from *Physarum polycephalum* and applied to a participatory exploratory experiment. Much discussion was had about how to form a dynamic super-cell network where individuals could be held within an adaptive membrane[9],

[6]slimoco (The Slime Mould Collective) has also been used as an umbrella name for public exhibitions where several members of the network and/or external collaborators have co-produced outputs.

[7]The interactive piece was developed from a model of slime mould provided by computational scientist, Jeff Jones, and reprogrammed as an interactive installation by digital artist, Alex May.

[8]Daniel Grushkin is a science journalist and co-founder of Genspace, the first community laboratory, in Brooklyn, New York.

[9]A system of yellow ropes was used in this first iteration of Being Slime Mould, which could connect and disconnect to form an adaptive network, but never used since as they were far too distracting.

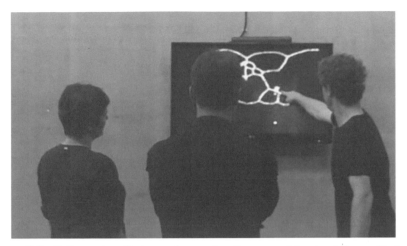

Figure 3.6 Gallery installation view of slime mould simulation, *Biodesign*, New Museum (2013).

how people would be permitted to communicate, and to establish what level of instructions should be given for them to understand the task at hand.

The experiment took place twice: once on the opening night within the museum and again the following day outside the museum in a tree-lined park. Both experiments were followed by filmmakers Jasper Sharp and Tim Grabham, who were shooting for the feature length slime mould documentary, *The Creeping Garden* (2014). The task for the group (a random collection of strangers on each occasion) was to navigate their environment as a single collective body, to locate food sources (giant oats) and form an efficient network (a competition against slime mould network optimisation). The experiment that took place within the building experienced some issues with bottlenecks forming, and enforcing the rules of behaviour proved quite challenging – perhaps exacerbated by a few drinks consumed on the opening night – but there was some attempt made by the group to collectively organise, communicate and cooperate, with partial success (Figure 3.7).

The next day passers-by were bribed with a specially commissioned slime mould T-shirt and the promise of beer[10] and, once a group was formed, the strangers were set the task of navigating a park populated with multiple obstacles (trees). The rules of *Being Slime Mould* on this occasion maintained the need for a *constant physical connection between 'cells'*, though this should

[10]We replaced oats with beer as an attractant for the effective recruitment of members of the public on a busy Saturday afternoon.

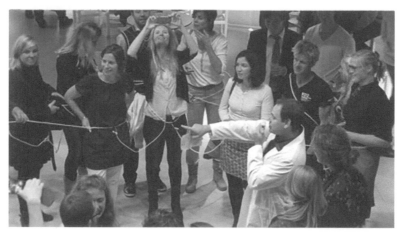

Figure 3.7 Daniel Grushkin explaining the rules of Being Slime Mould on the opening night of *Biodesign*, New Museum (2013).

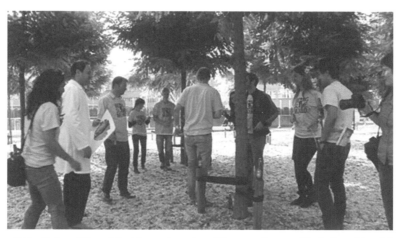

Figure 3.8 Being Slime Mould enactment, public experiment, *Biodesign*, New Museum (2013).

be dynamic and not fixed, and *no speaking*, the slime mould communicating through some form of improvised oscillation. The task here was to *locate a food source* (beer) and *distribute resources* across the network to nourish all parts of the cell (Figure 3.8). The experiment lasted around 15 minutes and there was clearly some evidence of problem-solving in navigating around obstacles and reaching attractants whilst maintaining a collective and cohesive body, and in the end, everybody got a beer.

Clearly, *Being Slime Mould* is not a scientific experiment. It is not intended to prove a hypothesis or demonstrate anything measurable. In many ways the experiment is set up to fail, in that humans cannot 'be' slime mould. It is a knowingly impossible task. The point of the exercise, therefore, is in the trying – the attempt to let go of deeply held human traits for a short period of time – by following some fundamental rules of an 'other' life form. By setting a few simple rules, directing the mode of connecting, communicating and decision-making, complex behaviours can emerge.

In many ways, the most interesting outcome of *Being Slime Mould* is the discussion that follows the experiment. On this run, as people drank the beer they had collectively located and distributed, they reflected on what they had just experienced and shared their observations. Depending on their background they tuned in to different interpretations: a biologist compared the chemical signalling of slime mould to the quorum sensing of bacteria; a psychologist observed the range of human responses to the task, that some people lead and others followed; and an urban design student enquired whether we were trying to engender social agency in the group by thinking about how we relate to our environment as a collective entity.

Since this first attempt at *Being Slime Mould,* the exploratory experiment has evolved, adapting to different groups and situations. The slime mould has proved to be a malleable metaphor for exploring ideas ranging from communication strategies and organisational systems, to social agency and distributed intelligence. Through each iteration the framework remains the same – applying some simple 'logic' of nonhuman collective behaviour to a group of humans – but the specifics change depending on context. Notable examples include: entreating a group of digitally orientated corporates to navigate a conference room of a Mayfair hotel[11]; testing the self-organisational capacity of a largely Swedish audience interested in biomimicry[12]; sensory explorations with a small but committed group in the Arizona desert[13]; challenging a group of collective behaviour scientists to embody the same mechanisms that they observe and measure in their own research[14]; and looking at slime mould through an educational lens (learning being a biological and phenomenological endeavour)[15] (Figure 3.9).

[11] After lunch slot on Day 1 of the Financial Times Innovate Conference 2014.

[12] At The Conference in Malmö with approximately 300 people, the largest group yet, 2015.

[13] Programmed off site on the first evening of the Open Embodiments Conference, Tuscon, 2015.

[14] At the Collective Motion Conference 2016 in Uppsala, Sweden.

[15] ELIA conference keynote presentation, University of the Arts London, 2017.

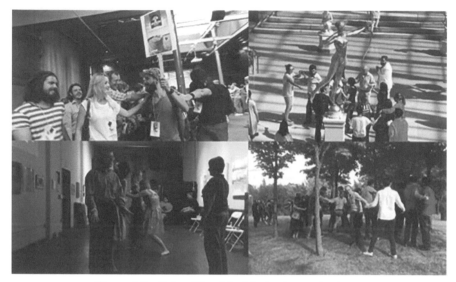

Figure 3.9 Being Slime Mould experiments (various).

By embodying some fundamental rules of slime mould the experiment invites people to act first and think second, to enact and then reflect on the experience of attempting to shift ontological perspective. In many ways, this organism is utterly alien to us, yet by possessing traits that we can relate to (such as learning, memory, and problem-solving), it somehow resonates. Beyond observation or measurable analysis, to embody an experiment is to learn through direct experience. Much of my participatory work encourages tacit, rather than purely explicit, learning to recognise diverse forms of knowledge. Including material thinking and embodied cognition, I aim to create opportunities for people to explore through doing, whether in the studio, the gallery or the park.

3.4 Playful Pedagogies

My own material experiments in the studio are very much 'with' the organism, learning from direct experience, and sharing the process of intervention and observation with others. My practice as an artist has co-evolved over the years with my practice as a teacher[16], each informing the other. Hence,

[16]I have been involved in community arts and formal education since 1992. I am currently Pathway Leader on the MA Art and Science at Central Saint Martins (University of the Arts

workshops and educational activities have always played an important role in what I do as an artist. From science museums to floating cinemas, and from arts festivals to community laboratories, I have facilitated numerous workshops and participatory experiments bringing different groups of people into creative contact with the slime mould[17]. The aim of these activities is threefold: for people to engage with the organism as a living subject to observe (an interesting specimen of non-neuronal intelligence – 'isn't it fascinating?'), an object of enquiry (a system of knowledge for research – 'what questions are being asked of it?') and, thirdly, a model for examining larger questions of communication and cooperation (a comparative model – 'how do we relate to it?').

In workshops, the intention is not to present a prescribed view of the organism or to 'instruct' a lesson, but to use the slime mould as a vehicle for creative and critical exploration. Whilst people need to have a certain amount of information at their disposal in order to be able to engage meaningfully with the organism conceptually or experimentally, I am not in the business of science communication. The workshops aim to be associative rather than didactic.

An introductory preamble should equip a group with some fundamental knowledge about the organisms' behaviour – for example, its morphology, function, communication mechanism and motivation – so that they can then design their own practical experiment. Questions embedded within the experimental design may relate to navigational abilities, foraging behaviour, pattern formation, or problem-solving; or people may simply wish to provide an interesting habitat for it to explore. The format of one workshop invites participants to create an experimental environment for the slime mould to explore within a small petri dish. They build into the circular arena with coloured felt, pipe cleaners, filter papers and other absorbent materials (to create ideal levels of humidity within which the slime mould can flourish). Water is added and a selection of attractants and/or repellents[18], and then finally slime mould is introduced, transferred from a parent culture via a miniature cookie cutter. The tools people are given are purposely simple and require tactile manipulation, an invitation to explore haptically and, most importantly, playfully. As anyone who makes anything knows, the physical activity of

London), a Higher Education Academy National Teaching Fellow, and led the Broad Vision art/science research and learning project at University of Westminster from 2010–2015.

[17]I estimate that, in the past ten years, over 3000 people have participated in some form of slime mould related workshop, encounter or participatory experiment that I have facilitated.

[18]Attractants include oats, pasta, rice and flour; repellents include salt, chilli and lemon.

manipulating materials engages just enough of the brain to free up associative cognition[19]. It is important for creative thinking that participants don't overly predetermine the outcomes, but allow ideas to coalesce and emerge. From the same base materials diverse experimental environments are designed, from elaborately intricate networks to functionally experimental platforms, some intended for open exploration, others attempting to test a particular hypothesis about how the slime mould will respond to the conditions set. At the end of a workshop participants are invited to take their new pet home, given care instructions[20] and encouraged to share any results on slimoco (The Slime Mould Collective).

The social aspect is also important in any workshop situation, the bringing together of people from different disciplines, ages, and backgrounds and providing a context in which they can exchange ideas, converse as they make, and share moments of individual discovery (Figure 3.10). This combination of knowledge exchange and interdisciplinary interaction has gone on to form

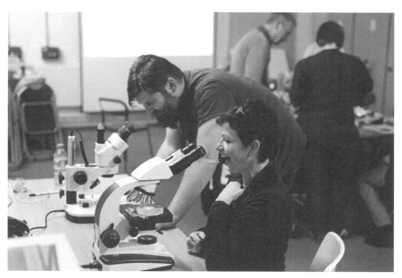

Figure 3.10 Observing protoplasmic streaming, BLAST workshop (2015).

[19]Think about how many writers are regular walkers or how many ideas you've had in the shower.

[20]Care instructions include acknowledging the nomadic nature of slime mould and its need to move house regularly, its preference for dark and damp conditions, and ideal diet of porridge oats; as well as instructions on safe disposal of slime mould if it is neglected and doesn't survive.

the basis for extended workshops and situated collective experiments, which cross borders of knowledge, discipline, and practice.

3.5 Collective Experiments

In recent years I have been developing a series of expanded workshops which use the slime mould as a starting point to explore other networked systems across species and scales – a form of bio/social collective experiment. Each situation responds to a specific set of conditions: a conference, an urban environment, a specific context, and/or a core question. Here, I reference a few examples which demonstrate the iterative and adaptive process of co-enquiry and share some of the methods and practices developed.

3.5.1 Nodes and Networks

In 2015 I was invited to contribute to a scientific conference, a three-day workshop on *Physarum* Transport Networks to be held at Columbia University in New York City. The invitation came from Professor Hans-Günther Döbereiner[21], a biophysicist working with slime mould, based at the University of Bremen. Whilst the scientific field of slime mould research already operates across the domains of biology, physics, mathematics and computer science, the event organisers were also keen to include educational and art practices in the proceedings. I was more than happy to contribute to the conference and engage with the scientific research, but also wanted to connect the academic delegation with the city's art and science community[22]. Thinking about slime mould transport networks in the context of New York City, a framework was established for exploring the city as a superorganism, a collective interconnected body of networks and information channels. Organisms such as slime mould offer intriguing models to test how ideas spread, how group decisions are made and how communities evolve.

Taking the behaviours of *Physarum polycephalum* as stimulus, a multi-disciplinary team was recruited, comprised of artists, writers, architects and designers working with biological systems, and scientists from the fields of biophysics, ecology, genetics, and neuroscience. Together we devised a

[21]The Döbereiner group are interested in the biological physics of cellular systems and soft matter. In vivo studies of animal cells and slime molds are combined with in vitro investigations of model membrane systems.

[22]Having previously delivered talks and workshops at Genspace community laboratory and contributed to exhibitions such as Cut/Paste/Grow at The Observatory in Brooklyn.

series of experiments to explore the interconnections between biological, cultural, and social collective systems and invited public participation for a marathon day of activities which took place at the BioArt Lab (School of Visual Art), in Central Park, and in The Metropolitan Museum of Art (in collaboration with MET Media Lab). The nature of the experiments varied. Material exploration in the laboratory used attractants and repellents as a means to create social maps of the New York boroughs, exploring subjects of pollution, crime or gentrification (Figure 3.11). Modelling experiments played out in Central Park, adapting the rules of *Being Slime Mould* to affect motivation, communication, and collective coordination. Finally, The Metropolitan Museum of Art provided a human petri dish for us to conduct a series of cultural foraging experiments tracking human behaviour in the galleries (whilst back in the lab the slime mould was exploring a scaled down 3D model of the same territory).

Nodes and Networks (Barnett et al., 2016) provided an opportunity to combine different methods of research with participatory art practices, situated in a specific location and context. Through a partially self–organising process, everyone involved could explore different ways of thinking about

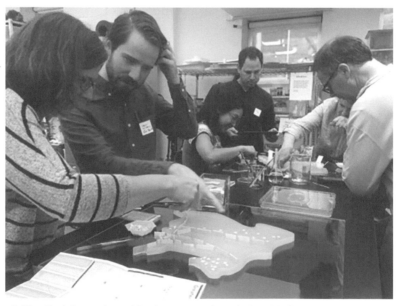

Figure 3.11 Social mapping with *Physarum polycephalum*, *Nodes and Networks*, New York City (2015).

networked intelligences and collectively contribute knowledge and experience. The project brought many heads together to create novel ideas through a creative emergent process.

3.5.2 Swarm/Cell/City

Other collective experiments have addressed specific traits and mechanisms of the slime mould. In September 2017, working in collaboration with performance art duo *plan b*[23], I ran an extended workshop at Art Laboratory Berlin (ALB) as complement to the exhibition *Nonhuman Networks*[24]. A participatory collective experiment in art, performance and biology, *Swarm | Cell | City* invited participants to view the local urban area through the nonhuman perspective of *Physarum polycephalum*. Using the local topography around ALB as inspiration, we ran a series of experiments exploring mapping mechanisms, spatial awareness and stigmergic[25] marking of territory. In practice this involved creating maps for the slime mould to navigate, mapping our own trails using GPS trackers (Figure 3.12), devising cooperative nonverbal navigation techniques, and developing a biosemiotic system of communicative chalk markings. All activities were documented and the subsequent film formed part of the exhibition (Barnett and plan b).

Within the group I recall a biochemist, an anthropologist, a choreographer, several artists, and a writer – typical of most slime mould workshops, where disparate disciplinary backgrounds centre around the organism from individual points of interest. Questions raised during the two days were plentiful and cannot be fully recorded here, but to give a flavour discussion ranged from curiosity about pigmentation and colour indicators, through questions of epigenetics and learned behaviours passing through generations of cell lines, to philosophical musings on a duty of care towards nonhuman organisms and recognition of the slime mould's performance (sacrifice)

[23]plan b are Sophia New & Daniel Belasco Rogers. See more of their work at: http://planbperformance.net/

[24]Nonhuman Networks featured work by Saša Spačal, Mirjan Švagelj & Anil Podgornik, and various works from *The Physarum Experiments*. The exhibition, the last in the Nonhuman Subjectivities series spanning two years, ended with a three day international conference exploring themes of *Nonhuman Agents in Art, Culture and Theory*, November 2017.

[25]Stigmergy is a process by which an organism leaves a trace in its environment which affects the behaviour of other organisms, such as ant pheromone, termite mudballs or slime mould membrane.

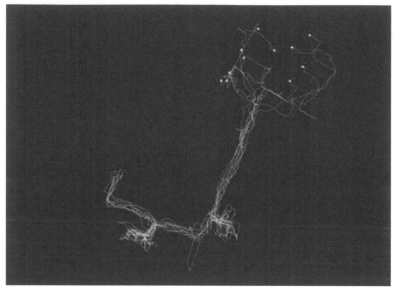

Figure 3.12 Trail making in *Swarm | Cell | City* workshop (2017).

for our intellectual curiosity[26]. Throughout the workshop, the slime mould operated as a springboard for sympoetic working[27] – collectively exploring, experiencing and discovering.

This model of co-enquiry has been developed and applied to a number of different situated experiments, many relating to urban contexts. For example, *Crowd Control* (Barnett et al., 2017), a month-long interdisciplinary residency with Arebyte Gallery in Hackney Wick, an area of East London which has undergone a great environmental and economic change in recent years. Connecting visual, digital and performance art practices with contemporary scientific research, law and urban design, the project explored the mechanisms of collective behaviour across biological, urban and social scales. Other examples include *Spatial Negotiations,* an on-going collaboration with choreographer Emma Ribbing[28], using the slime mould

[26] At the end of the workshop one participant dedicated a poem by Emily Dickenson to the slime mould in recognition of its contribution to our enquiry.

[27] 'Sympoesis' meaning creating together, coined by scholar and community activist Beth Dempster in relation to self-organising human systems.

[28] Emma and I met at the Collective Motion conference in Uppsala, Sweden, whilst facilitating embodied experiments with a group of collective behaviour scientists. She was the most dynamic cell in the Being Slime Mould experiment and inspired the idea of working with dancers.

as a stimulus for movement research. And at the time of writing, a number of bio/urban exploratory experiments are planned to take place in Munich[29] and Amsterdam[30], each a platform for shifting perspective from a human-centric position to embrace the multitude of interspecies interconnections.

3.6 Polycephalism

Like the slime mould I move with seeming intention, yet very little of what has been described here has been in any way predefined. Most of the practices – the time-lapse studies, the workshops, the gallery installations, the absurd experiments (Bates) – stem from a creative process which has unfolded over time... each encounter or experience leading to new learning, novel insights and hybrid forms of enquiry. Not to exhaust the metaphor (too much), but my own creative process has operated much in the same way as slime mould behaves. I forage until I find a resource (a piece of research which acts as a stimulus or tells me something new; a collaborator who shares a common interest but who brings a different perspective; or an observation of a novel behaviour in the organism itself), and then form connections between these nodes. New projects and ideas coalesce and the exploration continues, finding other bodies of knowledge or points of connection along the way. In the ten years I have been 'working with' slime mould, my practice has evolved in new directions and with unpredictable results – the creative process operating as its own many-headed emergent system.

The notion that we 'can learn from semi-intelligent slime' (Barnett, 2014) should not be taken too literally, but there is much to be gained from taking note of its capabilities. As an artist, the slime mould offers me a set of aesthetic properties to work with (it is beautiful), a fascinating subject (it is biologically and behaviourally peculiar) and a muse (it raises many interesting ontological and epistemological questions). The slime mould is, for me, a story telling device – a vehicle through which we can appreciate the complexity of natural systems. As a model organism, it offers myriad curiosities to investigate questions of decision-making, distributed intelligence, and computation. In pragmatic terms, it provides an amenable body for experimentation, without the need for ethical approval or high-level

[29]Part of {un][split}Micro Performance and Macro Matters Science & Art Festival in Munich, September 2018.

[30]Part of Open Set's Summer School and Labs Programme, Fluid Rhythms: Urban Networks and Living Patterns, August 2018–February 2019.

laboratory controls. Yet the achievements of this single-celled organism do raise some important philosophical questions about how we recognise and engage with other forms of intelligent life. As for assessing a duty of care to my living co-worker, I have come to realise that the relationship here, between artist and organism, is far from 'collaborative', but more akin to a form of benevolent slavery (though consensus on who is a slave to who is yet to be reached).

In his manifesto, intended for artists working with living systems, Mark Dion (2000) sets out a series of guiding principles addressing questions of responsibility, anthropomorphism, nostalgia, representation, and language. He proposes that "The objective of the best art and science is not to strip nature of wonder but to embrace it. Knowledge and poetry are not in conflict." (ibid, p. 240). Like Dion, my work seeks to explore how we understand and interrelate with nature through different forms of knowledge. My creative explorations with slime mould are less directly 'about' the organism, but far more about 'ideas of' the organism: how we view and interpret and make sense of its way of being in the world we share with it. The intention is to hold up this organism as a subject, a model and a metaphor, to capture curiosity and to offer up discussion around different ways of knowing and different ways of being, "as humanity cannot be separated from nature, so our conception of nature cannot be said to stand outside of culture and society. We construct and are constructed by nature" (ibid, p. 239).

The argument for 'polycephalism' is, therefore, not that we should become more like slime mould, but that we should become more acutely aware of other living systems around us (and within us for that matter)– a reminder that 'we are always inside an environment with a group of other interdependent living organisms' (Manacorda, p. 15). It is an encouragement to be open to different ontological perspectives, be they from diverse humans speaking different disciplinary languages or from diverse populations of nonhuman cohabitants.

Whilst methods and intentions vary and have evolved as my understanding of the organism has grown, what lies at the core of all my practices and processes is a fundamental curiosity about what drives the behaviour of this fascinating organism; a desire to share that curiosity and discovery with others; and a will to bring others into the process of enquiry, not as passive participants, but as active agents. I may amplify inherent behaviours which reveal traits and abilities; I may set the frame through which I invite people to ponder, and I may create the stimulus by which I ask people to engage. However, creating the conditions is far from controlling the results.

I have spent considerable time, energy and effort over the years getting to know this curious organism, to understand how it works, and to develop methods for working with its inherent mechanisms. I have fostered collaborative relationships with scientists, designers, choreographers, programmers, and musicians, travelled the world talking about what a wondrous organism it is and persuaded groups of unsuspecting individuals to let go of their humanness and attempt to 'be' slime mould for a short while. And in all this time, I realise all too well that the subject of my close attention remains utterly ambivalent to the human curiosity it has unknowingly inspired.

References

Amaroli, A. (2015). 'The Effects of Temperature Variation on the Sensitivity to Pesticides: a Study on the Slime Mould Dictyostelium discoideum (Protozoa)'. *Microbial Ecology*, 70(1), 244–254. doi: https://doi.org/10.1007/s00248-014-0541-z

Barnett, H. (2008). *The Physarum Experiments, Studies No: 001–006.* Available at: https://youtu.be/oWvAFZsdCg8 (Accessed: 29 June 2018).

Barnett, H. (2009). *Study No. 011: observation of growth until resources are depleted.* Available at: https://youtu.be/Lc9Y4M5vvtE?t=2m10s (Accessed: 29 June 2018).

Barnett, H. (2013). *The Physarum Experiments, Study No:019 The Maze.* Available at: https://youtu.be/SdvJ20g4Cbs (Accessed: 29 June 2018).

Barnett, H. (2014). *What humans can learn from semi-intelligent slime.* TEDSalon Berlin 2014. Available at: https://www.ted.com/talks/heather_barnett_what_humans_can_learn_from_semi_intelligent_slime_1 (Accessed 05 April 2018).

Barnett, H. (2018). *The Physarum Experiments.* Available at: http://www.heatherbarnett.co.uk/physarum.htm (Accessed: 29 June 2018).

Barnett, H. and plan b. (2017). *Swarm | Cell | City.* Available at: https://youtu.be/BZTpxQmRsCI (Accessed: 29 June 2018).

Barnett, H, et al. (2016). 'Nodes and Networks — New York City', *SciArt magazine*, pp. 5–10.

Barnett, H, et al. (2017). 'Crowd Control. In The Subjective Lives of Others', *Interalia magazine*, Issue 36 September 2017. Available at: https://www.interaliamag.org/issue/subjective-lives-others/ (Accessed 17 May 2018).

Bates, T. (2015). 'Cutting Together-Apart the Mould'. *Antennae*, 32, 44–66.

Biodesign: On the Cross-Pollination of Nature, Science and Creativity. (2013). [Exhibition]. Neu Museum, Rotterdam 27/09/2013–05/01/2014.

Bonner, J. (2010). *John Bonner's Slime Mould Movies,* Princeton University. Available at: https://youtu.be/bkVhLJLG7ug (Accessed 12 April 2018).

Dion, M., and Marbury, R. (2000). *Some notes towards a manifesto for artists working with or about the living world*, quoted in *Radical Nature: Art and Architecture for a Changing Planet 1969–2009*, published in conjunction with the exhibition of the same name, shown at the Barbican Art Gallery, edited by Francesco Manacorda, London: Barbican Art Gallery, 2009. Koenig Books.

Durston, A. (2013). 'Dictyostelium: The Mathematician's Organism'. *Current Genomics*, 14(6), 355–360. doi: 10.2174/13892029113149990010

ecoLogicStudio (2016). *B.I/O. power* [Installation] In *Menagerie of Microbes, Bio and Beyond* [Exhibition]. Edinburgh International Science Festival 2016, Summerhall, Edinburgh.

Huber, R., and O'Day, D. (2017). *'Extracellular matrix dynamics and functions in the social amoeba Dictyostelium: A critical review'*. *Biochimica et Biophysica Acta (BBA)*, 1861(1), 2971–2980. doi: https://doi.org/10.1016/j.bbagen.2016.09.026

Johnson, S. (2001). *Emergence,* Penguin Books: London.

Manacorda, Francesco. (2009), chapter in *Radical Nature: Art and Architecture for a Changing Planet 1969–2009*, Koenig Books.

Nakagaki, T, et al. (2001). 'Path finding by tube morphogenesis in an amoeboid', *Biophysical Chemistry*, 92(1–2), pp. 47–52.

Rhodes, M. (2015) 'Airbus' newest design is based on bones and slime mold', *Wired* 12/01/2015. Available at: https://www.wired.com/2015/12/airbuss-newest-design-is-based-on-slime-mold-and-bones/ (Accessed 28 June 2018).

Saigusa, T., et al. (2008). Amoebae anticipate periodic events. *Physical review letters*, 100(1), 018101.

Shaviro, S. (ed.) (2011). *Cognition and Decision in Non-Human Biological Organisms.* Open Humanities Press.

Slimoco: The Slime Mould Collective (online network) Available at: http://slimoco.ning.com and https://www.facebook.com/groups/slimoco/ (Accessed 29 June 2018).

Smith, P. (1931). *Secrets Of Nature – Magic Myxies.* Wardour Films Ltd. Available at: https://www.youtube.com/watch?v=04kdhZQTnIU (Accessed 15 June 2018).

Tero, A. et al. (2010). 'Rules for biologically-inspired adaptive network design', *Science,* 327(5964), 439–442. DOI: 10.1126/science.1177894

The Creeping Garden (2014). Directed by Jasper Sharp and Tim Grabham. Iloobia Cinema.

4

A Nonlinear Approach to Generate Creative Data Using *Physarum polycephalum*-based Memristors

Satvik Venkatesh, Edward Braund and Eduardo Reck Miranda

Interdisciplinary Centre for Computer Music Research (ICCMR),
Plymouth University, Plymouth, UK
E-mail: satvik.venkatesh@students.plymouth.ac.uk,
edward.braund@plymouth.ac.uk; eduardo.miranda@plymouth.ac.uk

This chapter presents a generic biocomputing system developed to generate data for creative pieces such as music and art. It harnesses the nonlinear behaviour of *Physarum polycephalum*-based memristors, which is in contrast to stochastic processes that are often explored in creative systems. Within this chapter, we explain the advantages of using biomemristors for such applications and discuss a compact and portable biocomputer called *PhyBox*. It harnesses biomemristors as processing units and highlights the need for non-digital ways of representing, processing and storing data. The system generates new creative pieces that are inspired by seed data that is input by the user. It allows the user to determine the *degree of similarity* between the output and the pre-existing creative data by controlling the *nonlinearity* of *Physarum polycephalum*-based memristors. The mapping procedure considers the resistor's behaviour to be ideal and reproduces the pre-existing data if a resistor is connected instead of a memristor. Our system is generic because it does not depend on the type of creative piece that is being processed. The chapter presents results from testing the system under different scenarios and provides ways for creative practitioners to adopt Unconventional Computing technologies in their works.

39

4.1 Introduction

Stochastic models are common in systems that generate creative works like music, digital art and text (Cope, 2005; Roads, 1996; Xenakis, 1992; Simonton, 2003; Conroy and O'leary, 2001). A stochastic process aims to induce randomness, that is the output of the system cannot be predicted (Ross, 1996). One of the earliest stochastic models is the Bernoulli process, which was implemented by flipping a coin with *heads* and *tails* opposing to two different values. Hedges (1978) describes music that was composed by the rolling of dice, in which each number represented a musical note. The use of Markov chains is a well-established methodology adopted by many creative systems (Pinkerton, 1956; Brooks, 1957). A Markov chain presents a conditional probability distribution of future states based on the present state of the system (Ross, 1996). The probability distributions in Markov chains are generally calculated based on certain rules or pre-existing data. This allows the system to generate creative pieces that are *inspired* by some content. Cope (1996) built a system to generate music in the style of composers like Bach and Mozart. Programmes have used artificial neural networks to develop several subroutines for music composition (Miranda, 2001). Evolutionary computation and genetic algorithms also use stochastic processes to create generations of creative pieces. This chapter proposes the use of *nonlinear* behaviour of biomemristors as opposed to stochastic processes for creative applications.

Unconventional Computing (UC) aims to develop new computer architectures for data processing and storage by adopting physical, biological and chemical systems (Adamatzky, 2010). Conventional creative applications are primarily based on discrete data. The fundamental unit of information is the binary digit, that is either 0 or 1. This chapter presents a hardware-wetware architecture that uses two different fundamental units for information. The pre-existing aspect of the system is implemented by using a conventional computer, but the *nonlinearity* is realised by a *Physarum polycephalum*-based biomemristor, which replaces the stochastic element. Alongside the advancement of UC technologies, new approaches towards data representations are bound to be realised. The relationship between pre-existing creative data and the generated creative product needs to visualised in non-digital ways. The chapter establishes a link between the pre-existing data and output by using metrics that allow the user to control the *nonlinearity* of *Physarum polycephalum*-based memristors.

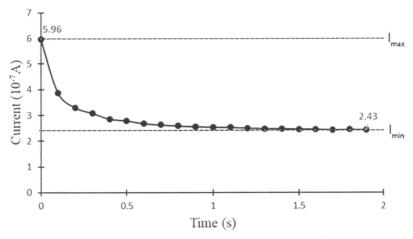

Figure 4.1 Spiking response of *Physarum polycephalum* for a positive change in voltage. The relevance of I_{max} and I_{min} is explained later in the chapter.

In this context, the term nonlinear behaviour is derived from memristors being nonlinear electronic components. As shown in Figure 4.1, when a voltage change is applied across a memristor, there is a spike in current. *Memristance* is formulated by the following Equation (4.1).

$$M = \frac{d\phi}{dq} \tag{4.1}$$

where M is the memristance, ϕ is the magnetic flux and q is the charge. The current flowing through the memristor is not constant. For a positive change in voltage, the magnitude of current declines over time because of an increase in memristance. Memristance depends on the physical history of the memristor, that is the amount of charge that has flowed through it (Johnsen, 2012). Chua (1971) hypothesised the memristor as a fundamental circuit element because its behaviour cannot be replicated by a combination of the other three circuit elements – resistor, capacitor and inductor. Memristance shares the same unit as resistance and if M is constant, it is identical to resistance (Tour and He, 2008). Just how probability distributions are used to effect the future states in Markov chains, this chapter uses memristors as processing units. It aims to harness the spiking property of *Physarum polycephalum*-based memristors to create a bridge between the pre-existing creative data and generated output.

Physarum polycephalum is plasmodial slime mould which is easy and inexpensive to obtain. Its ability to act as a biomemristor was demonstrated in Gale et al. (2015). Initially, it was grown in small Petri dishes with electrodes retrofitted inside them. Braund (2017) conducted several experiments to harness it as a memristive component. Compact receptacles to contain the organism were designed and fabricated by using a 3-D printer (Braund and Miranda, 2017b). They conveniently incorporated the organism into electronic circuits. In this chapter, each biomemristor is implemented as a processing unit and it realises input in the form of voltages. The current flowing in the circuit is a function of the *Physarum polycephalum*'s memristance. Therefore, the magnitude of current is considered to be the organism's output. Each creative system handles data by breaking it down into attributes. For instance, an image can be described by red, green and blue (RGB) values for each pixel. Therefore, digital art can be generated by assigning 3 memristors to each of the respective colours.

The approach of employing nonlinearity to generate creative data can be evaluated by comparing the behaviours of linear and nonlinear electronic components. Figure 4.2 illustrates an overview of the system. The processing unit is connected serially between the input and output. Hence, this chapter addresses the comparison between a memristor and resistor. Creative data needs to be translated into voltages to serve as input for the memristor;

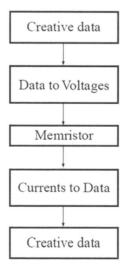

Figure 4.2 Overview of functions carried out by the system.

current needs to be translated back to creative data to generate the final output. A mapping procedure to perform these translations is demonstrated in this chapter. The resistor, being a linear component is considered to be *ideal*. Therefore, when the memristor is replaced by a resistor the system should produce the pre-existing creative data itself. This demonstrates that the generation of creative data is purely because of the nonlinearity of the biomemristor and no other factor.

The system encompasses two user-adjustable parameters – Dwell time and measurement offset (Braund and Miranda, 2017a). Dwell time specifies how long the voltage is applied across the memristor. Measurement offset determines the time at which the current is sensed. The objective of these parameters is to control the *degree of similarity* of the output with regard to the pre-existing creative data. A detailed discussion of how these parameters effect the output is presented in this chapter. As mentioned earlier, it drifts away from conventional methods of data representation and proposes non-digital ways to control creative pieces generated by the system.

4.2 Why Biomemristors?

UC technologies have a history of being accessible only through well-resourced laboratories that use sophisticated instruments. Creative applications that adopt biocomputing will be useful to artists who are non-experts in the engineering of the system. Music composers, digital artists and poets to name but three can incorporate UC technologies in their creative processes, only if the framework is feasible to use. *PhyBox* (as shown in Figure 4.3) is a stand-alone and portable system for *Physarum polycephalum*-based memristors to be incorporated as processing units. It was developed at Interdisciplinary Centre for Computer Music Research (ICCMR), Plymouth University, UK.

PhyBox uses a Raspberry Pi as its main processing unit. At present, it provides a framework to allow four biomemristors to process data. It uses breakout boards to apply voltages and read currents. MCP4725 is used as the digital to analogue converter (DAC) and ADS1115 is used as the analogue to digital converter (ADC). Both these breakout boards are manufactured by Adafruit. The Raspberry Pi and these boards are inexpensive and widely available. MCP4725 is used to source voltages across the biomemristor. Current is sensed in the circuit with the help of a shunt resistor placed in series with each memristor. ADS1115 measures the voltage across the shunt. Figure 4.1 shows a spike recorded using the PhyBox. This system

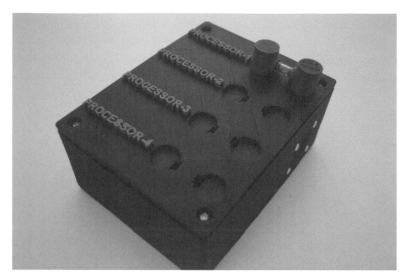

Figure 4.3 PhyBox. A micro-kernel to use *Physarum polycephalum*-based memristors as processing units.

runs a multi-threaded Python programme. It simultaneously processes data for four biomemristors. All threads carry the same function – source voltage across the memristor and measure the current flowing through it. An additional thread or programme runs in the background to implement the mapping procedure, that is to translate creative data into voltages and current readings into the creative data. The number of processing units are easily changeable by adding or deleting threads. Hence, PhyBox can be visualised as a microkernel that handles different types of data through biomemristors. The microkernel is encapsulated into a box that is fabricated by using a 3-D printer. The dimensions of PhyBox is $135 \times 105 \times 60\ cm$ and thus, making it a portable module. Pre-existing creative data can be fed into the system by either using a memory stick or the means of any real-time transport protocol. Receptacles that contain *Physarum polycephalum* are detachable from the PhyBox. They are clamped onto the system as shown in Figure 4.3. This gives the user flexibility to easily replace them. The number of processing units depends on the type of creative data that is generated by the system. As mentioned earlier, digital art can be defined by three parameters – red, green and blue. Music can be defined by four parameters – pitch, velocity, time between note-ons (rhythm) and duration. The time taken by PhyBox to generate a creative piece depends on the dwell time specified by the user. For example, if there are 80 elements of creative data that needs to be

processed and a dwell of 1.5 s is specified, then the system would take 120 s to generate the output. Since the biomemristors are easily detachable, linear electronic components like resistors can be used for certain attributes. For instance in music, you could have the rhythmic structure resembling the pre-existing creative data and allow the biomemristors to alter only the pitch. PhyBox harnesses the nonlinear behaviour of *Physarum polycephalum*. Hence, the accuracy while sourcing voltages and measuring currents is crucial. Several tests were conducted and readings were verified with a Keithley programmable electrometer. It proved to be an efficient framework for *Physarum polycephalum*-based memristors and Figure 4.1 shows a spike recorded by it. The breakout boards can source a maximum voltage of 5 V and *Physarum polycephalum* produces negative currents in some cases. Considering these factors, the operating range for *Physarum polycephalum* was decided on 0−3 V.

Braund and Miranda (2017a) conducted experiments to verify the memristive behaviour of *Physarum polycephalum*. It produces pinched hysteresis curves that look similar to that of an ideal memristor, but not the same. The current–voltage (I–V) profile of an ideal memristor for an alternating current is a pinched hysteresis loop which passes through the origin (Leon, 2015). However, each biomemristor produces a unique I–V profile and would generate different deviations from the pre-existing creative data. Furthermore, the I–V profile of a biomemristor does not remain constant throughout its life cycle. It depends on its age and external factors such as light, temperature and humidity. Braund and Miranda (2017a) have also studied methods of altering a *Physarum polycephalum*-based memristor's hysteresis profile. Here, the cell was treated with solutions such as calcium chloride ($CaCl_2$), which produced hysteresis curves that were considerably different from the original ones Braund (2017). This opens up opportunities to effect the output by using external parameters. Hence, the creative piece that is generated with the help of PhyBox cannot be predicted, but can definitely be controlled. This proves its potential to substitute stochastic processes in creative applications. Incorporating *Physarum polycephalum* as the processing unit for an attribute of data uses only one information bit. Each attribute of creative data can be generated solely by the nonlinear property of the organism. Implementing the same with a conventional computer would require many more information bits.

Snider (2008) studied the spiking behaviour of chemical memristors that are composed of metal oxides. The spikes are much shorter in duration. They attain a more stable memristance after 40 ms as opposed to 1000 ms in

Physarum polycephalum-based memristors. Chemical memristors are generally not affordable out of laboratories and a hardware framework to record their spikes would be expensive to acquire. On the contrary, Stephenson and Stempen (1994) discuss simple ways to obtain *Physarum polycephalum* and explain that it is also naturally available (Adamatzky, 2010). Chemical memristors produce ideal curves and do not change their behaviour with time. This would lead to higher possibilities of repetition in the generated output. These facts explain the advantages of using biomemristors over chemically manufactured memristors for creative applications.

4.3 Mapping Procedure

This section discusses the mapping procedure of the system and considers the resistor's behaviour to be ideal. It assumes the operating range of the biomemristors to be $0-3$ V.

4.3.1 Events to Voltages

The system aims to generate a creative piece which is inspired by pre-existing creative data. Therefore, the data needs to be sorted based on a specific criterion. In this chapter, we have used *popularity* as the criterion to sort data. If a specific event in the data occurs more number of times than another, then it is assigned greater priority. If two events have occurred equal number of times, then the more recent event is assigned greater priority. Table 4.1 sorts different types of creative data based on *popularity*.

In order to develop a relation between sorted data and the spiking behaviour memristors, we observe the rate at which the memristor is changing its memristance. Figure 4.1 depicts that the memristor attains a more stable memristance after a certain period of time. Greater changes in voltage cause greater magnitudes of spikes. Hence, we devise a relationship between the stability of memristance and the popularity of events. Events that have higher number of occurrences are assigned lower voltages and events that have lower number of occurrences are assigned higher voltages. All the events that are detected by the system need to be *quantised* into definite voltage ranges between 0 and 3 V. The translation of events into voltages follows the *midrise quantisation*, a technique followed by many communication systems. It is a type of uniform quantisation that divides a particular range into equal intervals. Further information on midrise quantisation can be found in Bosi and Goldberg (2003). Figure 4.4 illustrates the mapping of events into

Table 4.1 Sorting of events in different types of creative data

Pitch	No. of Occurrences	Priority	Assigned Voltage (V)
C4	9	1	0.375
A4	6	2	1.125
G5	4	3	1.875
C5	2	4	2.625

(a) Sorting of events in musical data of the attribute *pitch*

Colour Value	No. of Occurrences	Priority	Assigned Voltage (V)
150	15	1	0.3
250	10	2	0.9
0	8	3	1.5
60	6	4	2.1
120	1	5	2.7

(b) Sorting of events in a 24-bit image of the different shades of *red*. It considers the value of red in the range 0 255

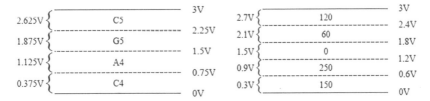

(a) Mapping of 4 pitch events in musical data to voltages.

(b) Mapping of different shades of red in a 24-bit image to voltages.

Figure 4.4 Mapping of events to voltages.

voltages. It allocates a voltage range for each event. The mean of each range is the voltage that is assigned to the respective event.

In this system, voltages are assigned dynamically. Each time an event occurs in the creative data, the table of assigned voltages is updated. Let us consider the first 7 pitches occurring in the musical composition *Fur Elise* by Beethoven. The sequence of pitches are $E5 \rightarrow D^\#5 \rightarrow E5 \rightarrow D^\#5 \rightarrow E5 \rightarrow B4 \rightarrow D5$. Table 4.2 shows how voltages are updated. Note that the more recent event is give higher priority if the events have occurred equal number of times.

The equation to calculate the assigned voltage is given below.

$$v_a = \frac{3}{N} \left(p - \frac{1}{2} \right) Volts \tag{4.2}$$

Table 4.2 Assigned voltages updated dynamically

Pitch	No. of Occurrences	Priority	Assigned Voltage (V)
E5	1	1	1.5

(a) Assigned voltages after first event

Pitch	No. of Occurrences	Priority	Assigned Voltage (V)
D#5	1	1	0.75
E5	1	2	2.25

(b) Assigned voltages after second event

Pitch	No. of Occurrences	Priority	Assigned Voltage (V)
E5	2	1	0.75
D#5	1	2	2.25

(c) Assigned voltages after second event

Pitch	No. of Occurrences	Priority	Assigned Voltage (V)
D#5	2	1	0.75
E5	2	2	2.25

(d) Assigned voltages after fourth event

Pitch	No. of Occurrences	Priority	Assigned Voltage (V)
E5	3	1	0.75
D#5	2	2	2.25

(e) Assigned voltages after fifth event

Pitch	No. of Occurrences	Priority	Assigned Voltage (V)
E5	3	1	0.5
D#5	2	2	1.5
B4	1	3	2.5

(f) Assigned voltages after sixth event

Pitch	No. of Occurrences	Priority	Assigned Voltage (V)
E5	3	1	0.375
D#5	2	2	1.125
D5	1	3	1.875
B4	1	4	2.625

(g) Assigned voltages after seventh event

where v_a is the assigned voltage, N is the number of events and p is the priority of the event. Every *pitch* occurring in a musical piece can be considered to be an individual event. However, events like *colour value* need to be rounded. This is done to handle redundancy of creative data. A pixel with RGB values {200, 50, 20} is not very different from one with values {199, 50, 20}. Similarly, musical events have high redundancy in velocity and time-related events. Therefore, for testing Phybox with musical data, we rounded velocity to the nearest 5 and time-related events to the nearest 30 ms.

4.3.2 Currents to Events

A similar procedure is followed to translate current readings into creative data. While mapping creative events to voltages, the voltage range is already known, that is 0−3 V. This is not the case while mapping current to events. Hence, we need to obtain a current range to implement the mapping. For each spike, the system records the maximum and minimum current value, I_{max} and I_{min} respectively. The current flowing through the circuit is recorded every 100 ms. Obtaining current readings at a faster rate leads to poor performance of the *system clock* of the Raspberry Pi. The system was tested with different sampling rates and 10 Hz was chosen empirically. However, experiments need to be conducted to find an optimal sampling rate. A positive change in voltage produces a positive spike as shown in Figure 4.1 and a negative change in voltage produces a negative spike as shown in Figure 4.5.

After obtaining current readings, we record the minimum and maximum memristance that can be exhibited by the memristor. The minimum and maximum memristance are calculated by the following equations.

$$M_{min} = \frac{v_a}{I_{max}} \tag{4.3}$$

$$M_{max} = \frac{v_a}{I_{min}} \tag{4.4}$$

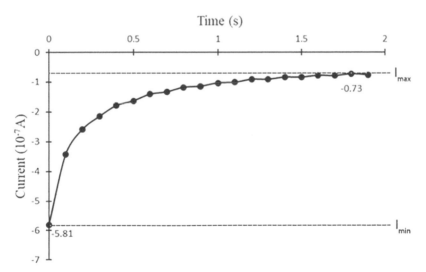

Figure 4.5 Calculation of I_{max} and I_{min} for a negative spike.

Figure 4.6 Translation of current readings into pitches.

where M_{min} is the minimum memristance, M_{max} is the maximum memristance and v_a is the assigned voltage. The current range $[I_1, I_2]$ is obtained by the following equations. It takes the table of assigned voltages into account.

$$I_1 = \frac{min(V_a)}{M_{max}} \tag{4.5}$$

$$I_2 = \frac{max(V_a)}{M_{min}} \tag{4.6}$$

where V_a is the set of all assigned voltages. Current is translated to creative data by using a similar procedure. Figure 4.6 shows the translation of current readings into pitches. It considers the table of assigned voltages in Figure 4.4(a). Lower values of current are mapped to more popular events and higher values of current are mapped to less popular events. Note that the direction of current is taken into consideration. For instance, $-5 \ mA$ is considered to be lower than $2 \ mA$.

4.3.3 Resistor as Ideal Behaviour

This section discusses the output of the Phybox for connecting a resistor instead of a biomemristor. The current flowing through a given resistor is constant for a given voltage. Hence, the current flowing in the circuit can be calculated by using Ohm's law. Let us consider the example of a circuit that carries a resistance of $500 \ k\Omega$. The resistor's output for pitches in Fur Elise is illustrated in Figure 4.7. The output is the same as the original song. It is due to the fact that M_{min} and M_{min} are equal for a resistor. Dwell time and offset percentage do not effect the output. Furthermore, the resistance does not effect the output. Hence, for any given resistance and combination of user-adjustable parameters, the output is always the original creative piece. This proves that a creative piece generated by using *Physarum polycephalum*-based memristors is solely based on nonlinear behaviour. Several tests were

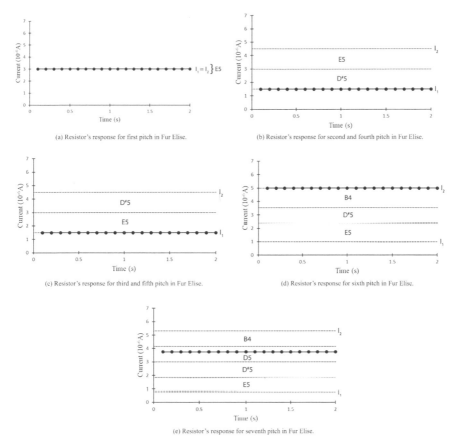

Figure 4.7 Resistor's response for pitches in Fur Elise. Solid line is the resistor reading calculated by using Ohm's law. The output generated is $E5 \rightarrow D^{\#}5 \rightarrow E5 \rightarrow D^{\#}5 \rightarrow E5 \rightarrow B4 \rightarrow D5$.

conducted with PhyBox to verify the ideal behaviour of resistors. $200\ k\Omega$, $500\ k\Omega$ or $700\ k\Omega$ resistors were connected to test the circuit with varying resistances. The output produced by the system consistently matched the input. Tests to confirm this statement are described in Section 4.4.

The linear behaviour of resistors can be creatively incorporated into such systems. In digital art, one could retain the shades of red, green, or blue as in the original picture. In music, the rhythmic structure of the original song could be retained. Such features give the user more control over the output generated by the system. Fur Elise was fed into the Phybox and $500\ k\Omega$ resistors were connected for time between note-ons and duration. The output

produced by the system retained the rhythmic structure of the song and produced variations only in pitch and velocity.

4.3.4 User-adjustable Parameters

As mentioned earlier, the behaviour of *Physarum polycephalum* is controlled by 2 parameters – dwell time and measurement offset. A longer dwell time gives the memristor time to attain a more stable memristance and *vice-versa*. For example, if the dwell time is 2 s and measurement offset is 25%, then current is sensed 0.5 s after the voltage has been applied across the memristor. This section explains how these parameters effect the output produced by the memristors. Measurement offset provides a way controlling the *degree of similarity* with the original creative piece. When current readings are closer the mean of I_1 and I_2, the memristor exhibits behaviour that is more linear. Therefore, current readings that are closer to the mean produce outputs that are more similar to the input. Readings that are farther from the mean produce outputs that are less similar to the input. Figure 4.8 shows how the output of biomemristors vary for different values measurement offset. 5% is expected to produce outputs that are more similar to the input when compared to 50% and 95%. Tests to confirm these statements are described in Section 4.4.

This chapter predicts that the nonlinearity realised by measurement offsets of 0% and 95% are slightly different. Both have similar degree of dissimilarity with the input, but they deviate from the input differently. On one hand, when the input creative piece induces a positive spike, 0% offset

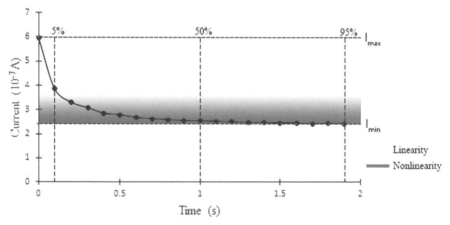

Figure 4.8 An illustration of how the output of biomemristors vary for different values of measurement offset.

tends to produce an event that is less popular. 95% offset tends to produce an event that is more popular. On the other hand, when the input piece induces a negative spike, 0% offset tends produce an event of higher popularity. 95% offset tends to produce an event of lower popularity. These statements need to be analysed with the help of data mining techniques and a clearer distinction between 0% and 95% offsets needs to be devised.

As mentioned earlier, a longer dwell time gives the memristor more time to attain a more stable memristance. In other words, it has longer time to recover from the spike. On one hand, for a dwell time of 0.5 s, two consecutively occurring positive spikes are more likely to produce currents of higher values when compared to a dwell time of 2 s. On the other hand, for a dwell time of 0.5 s, two consecutively occurring negative spikes are more likely to produce currents of lower values. However, a clear relation of dwell time on the output is still not deduced. This due to the fact that the mapping procedure calculates I_{max} and I_{min} for each event. Hence, the effect of dwell time is likely to be cancelled out.

4.3.5 Hardware Limitations

The operating range for *Physarum polycephalum* is $0-3$ V. PhyBox uses a 16-bit ADC and a shunt resistance of 100 $k\Omega$. By using Ohm's law, the current resolution of the system was calculated to be 1.25 nA. Greater values of memristance would require the ADC to make more accurate measurements because currents will be of a smaller magnitude. While performing experiments, *Physarum polycephalum*-based memristors consistently had a memristance of lower than 7 $M\Omega$. Let N be the number of discrete events that are fed into the PhyBox. There exists a value N_{max} such that for $N > N_{max}$, the resistor would no longer produce the input musical piece and lose its ideal behaviour. While conducting experiments with Phybox, N_{max} was never reached. Creative data with greater values of N needs to be fed into the system in order to obtain a practical value of N_{max}. N_{max} can be increased by improving the resolution of the ADC or increasing the shunt resistance.

4.4 Creative Systems

The examples of creative systems discussed so far were based on discrete events. This section explores the use of transitions, which is analogous to Markov chains presenting probability distribution of future states based on the current state. A transition is defined as the occurrence of two consecutive events. If a creative piece contains N events, then it will contain

N-1 transitions. In these systems, the mapping procedure is implemented for transitions instead of individual events. Therefore, if a resistor is used as the processing unit, the output would be identical to the input, excluding the first event. This is because there is no transition that exists after feeding in the first event.

The system maintains an independent translation table for each event. Table 4.3 shows the assignment of voltages for Fur Elise. On occurrence of each event, only relevant transitions are considered for assignment of voltages. For instance in Fur Elise, after the occurrence of the sixth event, the relevant transitions are $\{E5 \rightarrow D^{\#}5\}$ and $\{E5 \rightarrow B4\}$. The transition $\{D^{\#}5 \rightarrow E5\}$ will not be considered because the sixth event is *E5* and not $D^{\#}5$. Equation 4.2 can be used to calculate the table of assigned voltages, but N would stand for the number of relevant transitions and not the number of events.

While mapping currents to events, I_1 and I_2 can be similarly obtained by using Equations 4.3–4.6. The range $[I_1, I_2]$ is divided into only transitions that are relevant to the input. For example in Fur Elise, on the occurrence of the sixth event, the current range is divided into two regions and not three.

Table 4.3 Translation tables updated after the occurrence of the second event

Transition	No. of Occurrences	Priority	Assigned Voltage (V)
$E5 \rightarrow D^{\#}5$	1	1	1.5

(a) Assigned voltages after second event. Translation table for pitch E5

Transition	No. of Occurrences	Priority	Assigned Voltage (V)
$D^{\#}5 \rightarrow E5$	1	1	1.5

(b) Assigned voltages after third event. Translation table for pitch $D^{\#}5$

Transition	No. of Occurrences	Priority	Assigned Voltage (V)
$E5 \rightarrow D^{\#}5$	2	1	1.5

(c) Assigned voltages after fourth event. Translation table for pitch E5

Transition	No. of Occurrences	Priority	Assigned Voltage (V)
$D^{\#}5 \rightarrow E5$	2	1	1.5

(d) Assigned voltages after fifth event. Translation table for pitch $D^{\#}5$

Transition	No. of Occurrences	Priority	Assigned Voltage (V)
$E5 \rightarrow D^{\#}5$	2	1	0.75
$E5 \rightarrow B4$	1	2	2.25

(e) Assigned voltages after sixth event. Translation table for pitch E5

Transition	No. of Occurrences	Priority	Assigned Voltage (V)
$B4 \rightarrow D5$	1	1	1.5

(f) Assigned voltages after seventh event. Translation table for pitch B4

Creative systems that are based on transitions require more number of events to populate the translation tables. If the musical sequence *C4* → *D4* → *E4* → *F4* → *G4* → *A4* → *B4* → *C5* is fed into the system, then it would generate a replica of the input. This is because each event has only one transition that is relevant to it. It allows us to feed in huge amount of data and allow the system to generate new creative pieces. It also requires many more events to reach N_{max}.

Tests were conducted to evaluate the effect of user-adjustable parameters on the musical outputs produced by the biomemristors. Two samples *A* and *B* of four biomemristors each were taken. They were tested with two musical compositions – *Fur Elise*, by Beethoven and *Gavotte en rondeau* by Bach. Dwell time was kept constant at 2 s and measurement offset was varied between 5%, 50% and 95%. Output produced by the PhyBox was evaluated by calculating its deviation *dev* from the input melody. If the input transition has a priority *i* and the output transition has a priority *k*, *dev* is defined as | *i* − *k* |. The *degree of similarity* was quantified as Avg_{dev} and was calculated by the following equation.

$$Avg_{dev} = \frac{|i - k|}{N - 1} \tag{4.7}$$

where N is the number of notes in the song.

The tests confirmed that 5% had maximum similarity with the input melody and 50% and 95% showed much higher deviation. This allows the user to specify adjustable parameters as per the requirements. It also confirms the behaviour predicted in Figure 4.8. The output produced by a specific combination of user-adjustable parameters was always different. For instance, tests no. 1 and 4 had the same input parameters, but their outputs are different and showed similar degree of similarity with the input melody.

Tests were also conducted with two samples C and D of only resistors. Sample C contained 100 $k\Omega$, 500 $k\Omega$, 200 $k\Omega$ and 100 $k\Omega$. Sample D contained 700 $k\Omega$, 500 $k\Omega$, 200 $k\Omega$ and 100 $k\Omega$. The results are tabulated in Table 4.5.

Avg_{dev} for all attributes was consistently 0 and thus, proves that creative pieces were purely created by the memristor's nonlinearity. Tests were also conducted by connecting memristors for pitch and velocity and 200 $k\Omega$ resistors for time between note-ons and duration. Results are shown in Table 4.6.

The output produced by PhyBox in Table 4.6 maintained the rhythmic structure of the original input melody. This gives the user flexibility to allow

Table 4.4 N, DT and MO stand for number of events, dwell time and measurement offset respectively. Avg_{dev1}, Avg_{dev2}, Avg_{dev3} and Avg_{dev4} stand for the Avg_{dev} of pitch, velocity, time between note-ons and duration respectively

Test	Sample	Input	N	DT	MO	Avg_{dev1}	Avg_{dev2}	Avg_{dev3}	Avg_{dev4}
1	A	Fur Elise	296	2	5	0.39	0.88	0.35	0.77
2	A	Fur Elise	296	2	50	1.33	2.40	0.65	2.27
3	A	Fur Elise	296	2	95	1.49	2.52	0.65	2.32
4	B	Fur Elise	296	2	5	0.43	0.96	0.34	0.78
5	B	Fur Elise	296	2	50	1.44	2.52	0.59	2.23
6	B	Fur Elise	296	2	95	1.41	2.55	0.6	2.25
7	A	Gavotte en rondeau	45	2	5	0.3	0.43	0.43	0.36
8	A	Gavotte en rondeau	45	2	50	0.98	1.27	0.56	0.56
9	A	Gavotte en rondeau	45	2	95	1.07	1.38	0.61	0.59
10	B	Gavotte en rondeau	45	2	5	0.31	0.56	0.31	0.38
11	B	Gavotte en rondeau	45	2	50	1.05	1.56	0.31	0.36
12	B	Gavotte en rondeau	45	2	95	0.98	1.27	0.56	0.5

Table 4.5 Output of PhyBox with resistors used for all four attributes

Test	Sample	Input	N	DT	MO	Avg_{dev1}	Avg_{dev2}	Avg_{dev3}	Avg_{dev4}
1	C	Fur Elise	296	2	50	0	0	0	0
2	C	Fur Elise	296	2	50	0	0	0	0
3	D	Govette en rondeau	45	2	50	0	0	0	0
4	D	Govette en rondeau	45	2	50	0	0	0	0

Table 4.6 Output of PhyBox with memristors for pitch and velocity and resistors for time between note-ons and duration

Test	Sample	Input	N	DT	MO	Avg_{dev1}	Avg_{dev2}	Avg_{dev3}	Avg_{dev4}
1	B	Fur Elise	296	2	50	1.38	2.61	0	0
2	B	Govette en rondeau	45	2	50	0.97	1.43	0	0

the output to have some attributes that are identical to the input. The mapping procedure is solely based on popularity and does not depend on the type of creative data. Therefore, these tests confirmed the potential of PhyBox to act as a generic framework for creative applications.

4.5 Concluding Discussions

This chapter presented a generic biocomputing system for creative applications. It harnesses the spiking property of memristors to develop such applications. The advantages of using nonlinearity over random or pseudo-random processes have been discussed. It stressed on the importance of using non-digital ways to represent data. It defined the relationship between pre-existing creative data and the generated output with the help of *nonlinear* parameters that control the behaviour of *Physarum polycephalum*.

The appropriateness of using biomemristors as opposed to chemical memristors was discussed. Biomemristors acted as inexpensive and accessible processing units for the system. Furthermore, the memristance of *Physarum polycephalum* depends on environmental conditions like light, temperature and humidity. The hysteresis curve produced by *Physarum polycephalum* varies over time. Hence, it generated interesting variations that can be useful for creative applications. The chapter gave a brief introduction to PhyBox, a micro-kernel to harness *Physarum polycephalum*-based memristors as processing units. It allowed four biomemristors to simultaneously process data. PhyBox is a convenient and portable system that can be easily accessed by creative practitioners. It belongs to the field of UC and hence, several approaches are still at an elementary stage. In terms of information bits, Phybox only uses one memristor to process each attribute of data. This is much lower than conventional computers that implement stochastic processes. The processing time depended on the dwell time specified by the user. Based on the experiments conducted in this chapter, it took 2 s to process each event in the creative data.

The mapping procedure took linear electronic components into consideration. It assumed the resistor's output to be ideal. The procedure was developed such that the system produced a replica of the input if resistors were connected instead of memristors. The value of resistance did effect the output. This proved that the creative pieces generated by PhyBox were purely because of the nonlinear behaviour of *Physarum polycephalum*. The idea to translate events to voltages was derived from midread quantisation, a technique adopted by many communication systems. Current readings were translated back to events by a similar procedure.

The chapter discussed the use of transitions as opposed to individual events. This concept was analogous to n-order Markov chains that is widely adopted by creative systems. It demonstrated that sequences of different lengths can be incorporated by PhyBox and the mapping procedure had to be

implemented accordingly. The effect of measurement on the output generated by PhyBox was discussed in detail. The system was tested with two musical compositions, *Fur Elise* and *Gavotte en rondeau*. 5% offset produced outputs that were most similar to the input. 95% offset generated creative pieces that had greater dissimilarity with the input. The output generated by a particular combination of user-adjustable parameters did not repeat itself, but showed similar degree of similarity with the original piece in successive tests. It was also demonstrated that the behaviour of each biomemristor is unique. Tests were conducted with combinations of resistors and memristors. Resistors were connected for two attributes and memristors were connected for the other two attributes. Attributes processed by the resistors exactly reproduced the input and memristors produced variations for their respective attributes. This enabled the user to alter only specific attributes of data.

This chapter were based on musical systems. However, it demonstrated the mapping procedure to be independent of the type of creative data. It can be incorporated into systems that generate digital art or even text. It was flexible to increase or decrease the number of biomemristors that were processing data. This allowed the developer to alter the system according to the specifications of the type of creative data. It proved to be a generic mapping procedure that accepted creative events and generated data by employing the nonlinear behaviour of biomemristors.

4.6 Future Work

This chapter explored the use of nonlinear behaviour of biomemristors as opposed to random or pseudo-random processes implemented in conventional creative systems. Biocomputation for such systems is relatively new and has wide scope of further development. The chapter demonstrated a reliable and portable biocomputing framework, but several challenges might have to be addressed for the large scale deployment for general creative practitioners. The advantages of using nonlinearity need to be further understood by adopting it in different types of systems. All experiments in this chapter were demonstrated through music. However, practical implementations and tests of PhyBox with other types of creative data need to conducted. The role of nonlinear parameters needs to be clearly explained to the user. A stronger and clearer relation between the input and the output needs to be derived.

This chapter conducted experiments for measurement offsets of only 5%, 50% and 95%. Tests with other values of measurement offset need to be conducted to understand the effect of this parameter in greater depth.

The region between 0 s and 0.1 s in the spiking response of biomemristors needs to researched. Braund and Miranda (2017a) suggested that 2 s is an optimal dwell time for the operation of memristors. But the mapping procedure proposed in this chapter might require a much shorter dwell time. This chapter predicts that the system could operate with a dwell time of 1 s. This is due to the fact that 50% and 95% offsets produced creative pieces of almost same degree of dissimilarity. Furthermore, their positions in Figure 4.8 attribute to similar current values. This would increase the processing time by at least two times. This chapter did not find a notable impact of dwell time on the output generated by the PhyBox. Hence, this parameter could be kept constant by finding an optimal dwell time. On the whole, the prospects of biocomputing in creative computing seem bright with a wide spectrum of unexplored approaches which might change ways of data representation, storage, processing and generation.

References

Adamatzky, A. (2010). *Physarum Machines: Computers from Slime Mould*, Vol. 74 of *A*, World Scientific.

Bosi, M. and Goldberg, R. E. (2003). *Introduction to Digital Audio Coding and Standards*, Kluwer Academic Publishers.

Braund, E. (2017). Unconventional Computing and Music: An Investigation into Harnessing Physarum polycephalum, PhD thesis, University of Plymouth.

Braund, E. and Miranda, E. R. (2017a). An approach to building musical bioprocessors with physarum polycephalum memristors, in E. Miranda, ed., Guide to Unconventional Computing for Music, Springer, pp. 219–244.

Braund, E. and Miranda, E. R. (2017b). On building practical biocomputers for real-world applications: Receptacles for culturing slime mould memristors and component standardisation, *Journal of Bionic Engineering*, 14 (1), 151–162.

Brooks, F. P., Hopkins, A. L., Neumann, P. G. and Wright, W. V. (1957). An experiment in musical composition, *IRE Transactions on Electronic Computers*, EC-6(3), 175–182.

Chua, L. (1971). Memristor – the missing circuit element, *IEEE Transactions on Circuit Theory*, 18(5), 507–519.

Conroy, J. M. and O'leary, D. P. (2001). Text summarization via hidden markov models. In *Proceedings of the 24th Annual International ACM SIGIR Conference on Research and Development in Information Retrieval*, ACM, pp. 406–407.

Cope, D. (1996). *Experiments in Musical Intelligence*, A-R Editions, Inc.

Cope, D. (2005). *Computer Models of Musical Creativity*, MIT Press Cambridge.

Gale, E., Adamatzky, A. and de Lacy Costello, B. (2015). Slime mould memristors, *BioNanoScience,* 5(1), 1–8.

Hedges, S. A. (1978). Dice music in the eighteenth century, *Music and Letters,* 59(2), 180–187.

Johnsen, G. K. (2012). An introduction to the memristor – a valuable circuit element in bioelectricity and bioimpedance, *Journal of Electrical Bioimpedance,* 3(1), 20–28.

Leon, C. (2015). Everything you wish to know about memristors but are afraid to ask, *Radioengineering,* 24(2), 319.

Miranda, E. (2001). *Composing Music with Computers*, Music Technology Series, Focal Press.

Pinkerton, R. C. (1956). Information theory and melody, *Scientific American,* 194(2), 77–87.

Roads, C. (1996). *The Computer Music Tutorial*, MIT press.

Ross, S. M. (1996). *Stochastic processes*, 2 edn, JohnWiley & Sons, Inc.

Simonton, D. K. (2003). Scientific creativity as constrained stochastic behavior: The integration of product, person, and process perspectives, *Psychological Bulletin,* 129(4), 475.

Snider, G. S. (2008). Spike-timing-dependent learning in memristive nanodevices. In *Proceedings of the 2008 IEEE International Symposium on Nanoscale Architectures*, IEEE Computer Society, pp. 85–92.

Stephenson, S. L. and Stempen, H. (1994). *Myxomycetes: Handbook of Slime Molds*, Timber Press, Inc.

Tour, J. M. and He, T. (2008). Electronics: The fourth element, *Nature,* 453(7191), 42.

Xenakis, I. (1992). *Formalized Music: Thought and Mathematics in Composition*, number 6, Pendragon Press.

5

The Plasmodium Consortium: When Art, Science and Philosophy Form a Policy Think Tank

Megan Dobro*, **Amy Halliday*** and **Jonathon Keats**

Hampshire College, 893 West St, Amherst, MA, USA
*Authors contributed equally to work
E-mail: mjdNS@hampshire.edu; ahalliday@hampshire.edu; jonathonkeats@gmail.com

5.1 Introduction

In May 2017, Hampshire College announced the founding of the world's first and – thus far – only policy research institute for non-human species. The first scholars-in-residence, plasmodial slime moulds, arrived from Carolina Biological Supply, moved into a dedicated office in the College's Cole Science Center, and were soon set up with a faculty webpage and a team of student research assistants (Figure 5.1).

Slime moulds have navigated complex ecosystems such as forest floors for 500 million years, proving themselves to be some of the foremost optimizers on the planet. In order to survive in often adverse conditions, they have evolved an aptitude for assessing opportunities and risks to achieve optimal outcomes, even in the midst of complex problems. As plasmodia are super-organisms – containing many genetically distinct nuclei in a single amoeboid body – their decisions represent a collective optimum for the whole population, reached by consensus.

Humankind could likewise be seen as a super-organism. Through the agency of technology, people around the world are now densely networked, and technology amplifies the impact of human activity: The decisions of one individual can have repercussions for everybody. However, since these technological enhancements are relatively recent, humans have not yet

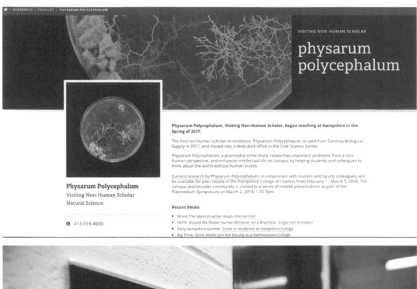

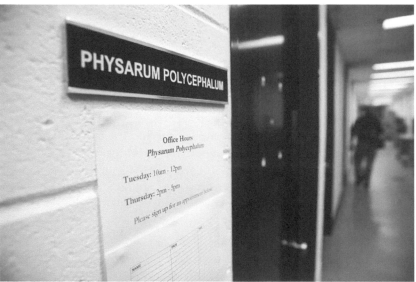

Figure 5.1 Slime mould being fully embraced by Hampshire College as visiting non-human scholars. Above: Screenshot from the School of Natural Sciences faculty page. Below: *Physarum polycephalum*'s office in the basement of the Cole Science Center.

Photograph by Andrew Hart.

evolved the aptitude to live as a super-organism, and we are seldom able to see outside of ourselves or break the political gridlock informed by our own biases and agendas. Human Policy is therefore often deficient, and may even imperil future survival. As such, the Plasmodium Consortium was formed to enlist the optimization abilities of slime moulds for policy analysis,

addressing global problems ranging from food security and climate change to income inequality.

As an interdisciplinary cohort including a Scientific Attaché (Megan Dobro, biologist), Secretary (Jonathon Keats, experimental philosopher), and Outreach Coordinator (Amy Halliday, curator), we viewed our non-human colleagues as equal contributors to knowledge production and problem-solving: moreover, their intriguing behaviour, aesthetic properties, and group decision-making capabilities drew staff, faculty, and students from every discipline on campus to think together about the problems we were sim-ulating. After an initial study of the extant literature, we first translated problems or issues (such as border policy, distribution of wealth, food deserts, or addiction) into scenarios that slime mould can confront. We created a series of models with slime mould as agent: simultaneously the modeling medium and the subject with an active role in shaping outcomes. Repellents to slime mould, such as salt or light, might represent environmental pollution or border walls; protein and sugar ratios could be optimized for slime mould to represent varying levels of wealth and reward.

The idea was to remove some of the human bias in policymaking and to turn over a selection of our most polarizing issues to non-partisan entities. Our preliminary findings were disseminated in the form of a Gallery exhibition, public symposium, a policy circular, and letters of policy advice to politicians and administrators. Our hope was to find ways forward, prompted by slime mould's efficient, decentralized decision-making. We recognize that models can never perfectly replicate the real world, nor can they account for all variables: rather, in reducing the complexity of problems, focusing on certain aspects through a process of simplification and abstraction, we are often able to gain greater clarity and perspective, allowing us to see the problems in new ways. Taking our cues from a species that does not separate collective interests from individual ones and that operates from a place of environmental entanglement, was, we felt, a good place from which to start a posthumanist policy think tank: The Plasmodium Consortium.

5.2 Conceptual Beginnings: Jonathon Keats

I first became invested in slime mould several years ago when reading about their ability to solve complex optimization problems, in the context of a book I was writing about inventor, visionary and systems theorist Buckminster Fuller (*You Belong to the Universe: Buckminster Fuller and the Future, 2016*). Fuller founded the field of comprehensive anticipatory design science, a practice he described as an effort "to make the world work

for 100% of humanity, in the shortest possible time, through spontaneous cooperation, without ecological offense or the disadvantage of anyone." Although the field was interdisciplinary and open-ended – sometimes to the point of incoherence – one of the key strategies was biomimicry, in which materials and structures are designed and fabricated with biological processes and organisms as a model. Importantly, Fuller's work attempted to engage biomimicry at a systems level, rather than from the "tech-fix" mentality of conventional biomimicry, which pilfers individual attributes of other species as a basis for environmentally disruptive stand-alone inventions (e.g., applying the kingfisher beak design to bullet train nose cones). Yet all too often, after starting to take this systems-oriented approach, Fuller would ultimately succumb to tech-fix biomimicry.

I simultaneously noticed that contemporary scientists working with slime mould would often make somewhat flippant comments about how *Physarum polycephalum* would make efficient and economical civil engineers and should be employed by town planning commissions. These comments rang true to me, making me wonder how far the notion might be taken. As an experimental philosopher and conceptual artist for whom the thought experiment presents a key methodology, it occurred to me that there was a deeper, systemic level at which slime mould could perhaps offer some sort of universal optimization.

I reached out to Amy Halliday, Hampshire College Art Gallery Director and curator, with whom I had previously worked. In a late 2016 talk at the college about my book *You Belong to the Universe*, I found Hampshire particularly receptive to the ideas of anticipatory design at its core. And so I wrote an email that was a part proposal, part manifesto:

> I've been thinking more about potential collaborations extending ideas I've proposed in the book and there's one concept in partic-ular that I'd like to share with you because it seems well suited to Hampshire's atmosphere of politically-charged interdisciplinary experimentation. It's an extension of my chapter on the Dymaxion Car, in which I argue that biomimicry needs to be at the level of systems rather than products. Here's what I'm thinking:

> Several years ago, one of the hardest problems in transportation was solved by a plasmodial slime mould. Working collectively as a colony, billions of the simple single-cell organisms worked out optimal highway systems for the United States and Europe – including the German Autobahn – matching or improving upon the

road network mapped out by human civil engineers. (Since slime moulds are more interested in feeding than tourism, cities were represented by dabs of oatmeal distributed on a plate topographically matching the national geography.) We shouldn't be surprised by their success. While we only started driving cars in the 19th century, and our earliest road systems are just several millennia old, *Physarum polycephalum* has navigated complex ecosystems such as forest floors for half a billion years. Self-organizing through quorum sensing, they're some of the foremost optimizers on the planet. And as is always the case in optimization – from highway systems to hedge funds – their reasoning is economic.

Having mapped out the relationship between American cities, I propose to put slime moulds in charge of the American economy. While my intention is ultimately to have them appointed to key positions in the Treasury Department, initially they'll work as independent advisors. In Petri dishes, I'll set up timely economic problems for the slime moulds to resolve. For instance, they'll be tasked with finding ways to achieve greater economic equality and also to reprioritize the US economy for environmental sustainability. (The problems will be set out in ways that make sense to slime moulds, with opportunities presented as nutrients and risks conveyed through threatening pulses of light, which slime moulds are evolved to avoid.) After they've had time to digest the problem, I'll convey their advice to political authorities by sending photographs of the colonies enjoying the economic balance.

In biological terms, plasmodial slime moulds are superorganisms, simultaneously many and one. Their self-interest is in their collective interest and vice versa. The same is true of humans – integrally linked in a global ecosystem – but our society doesn't realize it yet. If *Physarum polycephalum* can straighten out our economics, perhaps we can finally discover our inner slime mould.

If you think this might be of interest, I'd love to discuss it in greater detail. I'm envisioning it as an exhibition built on collaborations with students and faculty in biology, political science, economics, etc.

I think the project could have great traction nationally – generating media coverage and provoking discussion in political and economic

circles – especially if we could appoint the slime moulds as visiting scholars at Hampshire or somehow recognize their work as a college-based economic think tank.

Hoping all is well with you, and looking forward to your thoughts....

Best,

Jonathon

Halliday shares my interests in questions political and posthumanist, which have previously led me to work experimentally with organisms ranging from bacteria to plants. She connected with biology professor Megan Dobro, whose work in microscopy and modeling seemed a good fit for the project, and started a campaign to convince the college Communications department to present the Plasmodium Consortium as an institutional affiliate.

The Plasmodium Consortium, as we developed it, came to represent a holistic approach to biomimicry in which we learn from the systems sustaining other species in their biomes, and potentially adapt and implement their time-tested approaches at a systemic level in the global biome we occupy as humans. Moreover, beyond the potential to lift biomimicry above product development and greenwashing, the experimental nature of the Plasmodium Consortium was novel and important. We would not just observe and mimic natural systems; we would actively engage them in the problem-solving process.

5.3 Project Structure

Spring 2017.	Initial student research assistants identified, lab set up
Fall 2017.	Modeling course runs with 11 students
October 2017.	Interdisciplinary 3-part faculty/staff/student workshop
Spring 2018.	Gallery exhibition and public symposium
Fall 2018.	Modeling course runs again with 11 students

Given Hampshire College's emphasis on student-driven learning, the project was designed for students to become the Consortium's experts, with support from faculty (human and non-) and staff across disciplines. And, in order to be successfully curriculum-integrated, Megan Dobro built the project into her Natural Sciences course called 'Microscopy and Modeling', based in the College's Collaborative Modeling Center. In the first semester,

with the arrival of our first non-human scholars, five students conducted an independent study as a lab group to perform preliminary experiments, sharing notes, findings, and key papers in a collaborative digital project management tool. These five students took the modeling course in the second semester and taught their classmates about the procedures and background literature for working with slime mould. In this course students worked on one of a number of group projects, collaborating with slime mould to model a human problem. They also worked on an individual project from their field of interest, such as writing a slime mould science fiction story complete with plasmodial cosmology, or looking to slime mould to model neuron development and regeneration.

In order to identify the driving questions that would inform the group experiments in class, early in the semester we organized a three-part workshop run over three successive evenings with faculty and staff from across campus (Figure 5.2). Part one included an introduction to the project

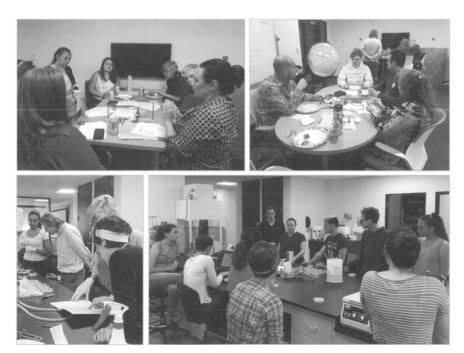

Figure 5.2 Top – Students working with staff and faculty to brainstorm human problems and possibilities for modeling them with slime mould. Bottom – Students working in the lab to set up their experiments.

Photographs by Amy Halliday.

and background information about slime mould and the Consortium's goals. In part two, we used newspapers as starting points for creating a lengthy list of contemporary issues to explore, and discussed the uses and limitations of models. Groups organized across staff, faculty, students and disciplines began working to brainstorm experiment designs for the topics they identified as most compelling, which included addiction, food deserts, and the environmental burdens of affluence. In any given group, the fields represented could have been computer programming, economics, philosophy, ecology, poetry, art and design, molecular biology, community organizing, public policy, animal behavior, or mathematics. Groups presented their ideas in part three, with all participants helping to critique and refine their designs into concrete plans for laboratory exploration. The workshops resulted in the class having well-defined experiments to conduct through the rest of the semester, and a range of campus stakeholders following their progress.

As students performed their experiments, they captured the results in images and time-lapse sequences that could be displayed in the Gallery exhibition the following semester. All notes, drawings and doodles, images, journal articles and lab protocols were also kept and later displayed as the integral ephemera of a real, messy, lived process of scientific inquiry. As students' experiments were the foundation of the Gallery exhibition, they had to consider constantly how to make their work meaningful to a broad public, and how they could design experiments with effective visual and verbal communication in mind.

5.4 Example Investigations

Drawing from the three-day workshops, student groups coalesced around five major investigations with local and global significance. One group researched public transportation in the Pioneer Valley of Western Massachusetts (where Hampshire College is located) to design bus routes that will more equitably serve economically disadvantaged populations. Following budget cuts, bus routes were being eliminated and schedules were being reduced. Perhaps slime mould's ability to connect a network of points (chosen according to identified need as well as usage statistics) in the most efficient routes could save time and money while maintaining essential services? (Figure 5.3) Another group investigated food deserts, areas where communities struggle to access healthful ingredients, by siting food wells with varying ratios of sugar to protein based on Dussutour *et al.,* (2010) in locations corresponding

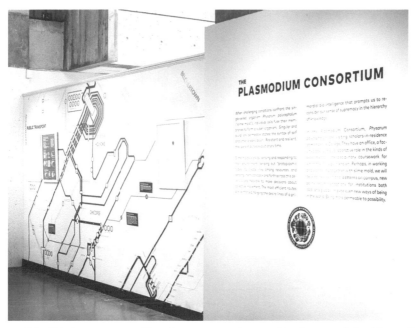

Figure 5.3 The bus route problem became a major graphic feature of the Plasmodium Consortium exhibition, which proposed a new route laid out in blue across a stylized public transport route map.

Photograph by Ray Mendel.

to varied food outlets in a local area. Maybe our slime mould scholars could calculate where new, state-subsidized farmers' markets could be optimally positioned?

Issues around addiction were another locus of investigation, particularly whether slime mould might be weaned away from a concentrated drug (valerian root) that it often prefers over food and toward healthier environments (Figure 5.4) and, conversely, whether it would be as easily lured from healthful choices towards addiction.

Another group modeled different border policies (open, closed, intermittently open/enforced) and placed two slime mould cultures on either side of the border. We placed sugar on one side of the border and protein on the other in order to simulate the differential resources (or incentives) often distributed unevenly across borders. The slime mould cultures thrived in an open border scenario, and died or sporulated with the closed border. Students interpreted preliminary plasmodial findings to suggest policy directions that

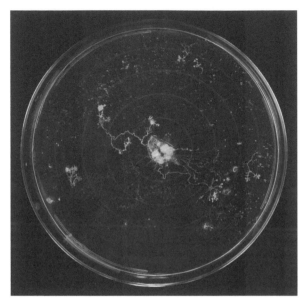

Figure 5.4 A Petri dish was set up with concentrated valerian root, a sleep aid, in the center and decreasing concentrations moving outward. The outer rings also contained protein and sugar. Adamatzky (2011) showed when *Physarum polycephalum* was given a binary choice between food or valerian root, it moved toward the valerian root. We have observed behaviors similar to addiction to valerian root, such as a decrease in metabolic activity. In this experiment, we were able to lure slime mould away from the concentrated drug by surrounding it with increasingly healthier options across a gradient. This led the slime mould to the food source before it became metabolically inactive. Jonathon Keats postulated that this weaning study might offer a correlate for policy discussions of less harmful or concentrated drugs (such as cannabis) being used to move users from serious addiction towards more healthful choices. Experiments were conducted by Matthew Hinderhofer, Rick Noble, and Hannah Davidson. Photograph by Ray Mendel.

might be pursued, while cautious about the need for replication and the limits of their studies.

For the Gallery exhibition, each major investigation was presented as four panels: a summary of the experiment, an infographic providing condensed context for the problem, an image from the experimental results, and a policy letter to a high ranking policymaker, written by Jonathon Keats as Consortium Secretary and based on plasmodial advice. Along with supplementary information, the investigations were also published in a policy circular, and presented as part of a public symposium. Examples from the border experiments are shown in Figures 5.5–5.7.

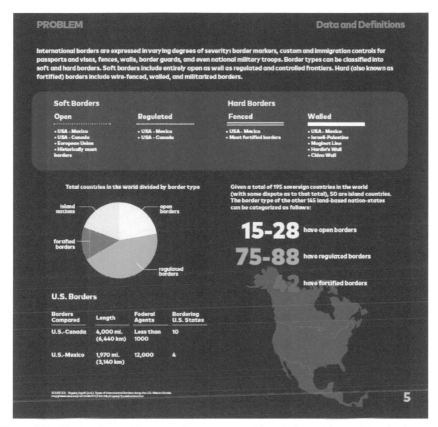

Figure 5.5 The border problem was given context with an infographic providing background information.

Infographic designed by Thom Long.
Data source: Vogeler, Ingolf. (n.d.). Types of International Borders along the U.S.-Mexico Border. http://www.siue.edu/GEOGRAPHY/*ONLINE*/*Vogeler*/*Types*Borders.htm.

For the exhibition, the summary text of the border policy experiment, written for a broad audience by curator Amy Halliday and derived from students' notes stated:

> Neither natural nor immutable, national borders can be based on geographical, cultural, or political boundaries. Borders typically involve some measure of control over the flow of people and goods: since slime mould can be understood as both a population and a system for transporting resources (nutrients), it presents a compelling model for observing the effects of diverse border conditions.

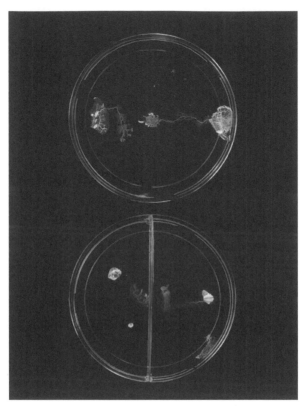

Figure 5.6 Petri dishes model two border scenarios: open border (top) and closed border (bottom). Protein and carbohydrate sources were placed on either side of the border and predictably, the slime mould grew more extensively and lasted longer in the open border setup. Border experiments were conducted by Rick Noble and the photo was taken by Ray Mendel.

According to one hypothesis, all populations will benefit most by having free flow of citizens and resources across completely open borders. A contrary hypothesis holds that border restrictions provide beneficial protections by preventing populations from unfairly taking advantage of one another. For this investigation, two countries are represented in a single petri dish, as equal populations on opposite sides. One side has exclusively protein as a nutrient, while the other has exclusively carbohydrate. Optimally, slime mould would have access to both. Light acts as a deterrent or risk factor, disincentivizing movement and representing modes of border control.

The Honorable Kirstjen Nielsen
Secretary of Homeland Security
U.S. Department of Homeland Security
245 Murray Lane SW
Washington, DC 20528-0075

February 7, 2018

Dear Ms. Secretary:
I am writing on behalf of the Plasmodium Consortium, an independent policy institute based at Hampshire College in the United States. One of our research groups studies how national border walls effect society. A primary objective of this research is to determine whether barriers improve or impair the livelihood of citizens on both sides of the divide. Every territory offers some opportunities, but not all that may be wanted by the resident population. A major dilemma for policy-makers is whether to secure exclusive access to internal resources by restricting movement of people and goods, or to allow free circulation in the interest of sharing.

Our researchers are uniquely qualified to provide policy advice because of their objectivity: As members of the species *Physarum polycephalum* – a type of plasmodial slime mold – they have none of the prejudices common to human researchers, administrators, and politicians. At Hampshire College, where they hold a collective faculty appointment as visiting non-human scholars, they are able to immerse themselves in human problems without human preconceptions. Moreover, slime molds are superorganisms. Populations are capable of fusion and cooperative behavior that can reveal how humans could cooperate to their mutual benefit without the burden of nationalism.

Preliminary results from the plasmodial research group suggest that the United States government should not build a border wall, and should replace current national barriers with parklands. These suggestions are based on the observation of slime mold populations grown in petri dishes with different nutrient types on each side, simulating the different opportunities available in different countries. One dish was prepared with an impenetrable plastic barrier down the middle. Another was free of obstructions. After a period of several days, the unconstrained slime molds were found to join together and thrive in the open border zone, suggesting that borders may be especially vital regions if allowed to develop without government interference.

Additional research will provide further details on this important topic. The Plasmodium Consortium will continue to brief interested parties with periodic circulars. We also invite dialogue with the Department of Homeland Security, the United States government, and the American public. Please do not hesitate to contact us with any questions.

Sincerely,

Jonathon Keats
Secretary

cc: President of the United States, President of Mexico, Prime Minister of Canada, Secretary General of the United Nations

Figure 5.7 Letter to the Secretary of Homeland Security from the Plasmodium Consortium making recommendations based on slime mould simulations of border scenarios.

Border conditions are modeled in the following ways: in the first scenario, the populations are completely separated by the unpassable border of a sealed plexiglass wall; in the second, a brightly illuminated central strip operates as a controlled border; in the third, the illumination is intermittent, simulating erratic border control; and in the final scenario, there is no barrier at all. After 72 hours, the populations are measured in terms of surface area covered, indicating which conditions are most beneficial for the world as a whole. Further steps to be taken might include modeling asymmetric border controls and the dynamics of multiple international trade agreements.

5.5 Curating the Plasmodium Consortium: Amy Halliday

How do we move from a set of experimental investigations in a lab to a viable exhibition in a Gallery that can engage non-specialist audiences? Interpretation – the wall text, programming, participatory elements and other means by which we communicate ideas to an audience in galleries and museums – plays an important role in making exhibitions meaningful, and underpinned my role as the Consortium's Outreach Coordinator. A major challenge was the writing of an introductory text which was simultaneously short enough to hold visitors' interest, accessible enough to provide entry points for non-specialists, and suggestive enough to capture something of the project's complexity and wide-ranging implications:

> When challenging conditions confront the single-celled organism *Physarum polycephalum* ("slime mould"), individual cells fuse their membranes to form a super-organism. Singular and plural are permeable states; the syntax of self and other breaks down. Resistant and resilient, they persist across evolutionary time.

> Slime moulds work by sensing and responding to their environment, sending out "protoplasmic tubes" to create links among resources, and sending chemicals back and forth across this decentralized network to make decisions about collective movement. The most equitable and efficient routes are reinforced, forging the desire lines of a primordial bio-intelligence that prompts us to reconsider our sense of supremacy in the hierarchy of knowledge.

In the Plasmodium Consortium, *Physarum polycephalum* are vis-
iting scholars-in-residence at Hampshire College. They have an
office, a faculty page, and a collaborative role in the kinds of
experimental, interdisciplinary coursework for which the College
is known. Perhaps, in working and wondering together with slime
mould, we will develop new relational patterns on campus, new
policy recommendations for institutions both local and global –
maybe even new ways of being in the world: Being more permeable
to possibility.

Introductory wall text for *The Plasmodium Consortium* exhibition – Hampshire
College Art Gallery, February 7 – March 16, 2018.

As a curator, I have always been drawn to the interdisciplinary and exper-
imental in my field: the in-between spaces where the theory and practice
in and of contemporary art is emergent. I have become particularly inter-
ested in posthumanism as a form of open-ended critical inquiry – an ethics,
even – which recognizes that, "given the state of the planet, human-centered
approaches to research may not be enough." (Ulmer, 2017: 2) Moreover,
our increasing entanglements with technology, science, the environment, and
other animals open up new ways of being and knowing in the world.

Jonathon Keats's initial provocation towards a plasmodial policy think
tank immediately engaged my interest. Necessarily involving multiple knowl
edge spheres and collaborations, a deep engagement with environmental
issues, as well as an ability to think outside the (anthropocentric) box,
Hampshire College – with its historic founding in the 1970s as an "experi-
menting" institution, and its leading role today in issues of sustainability –
seemed like the ideal institutional home for such a project...and perhaps
the only place we *just might* be able to get purchase on the idea of "slime
mould scholars!" Inviting *Physarum polycephalum* to be visiting scholars
at our college was, on one level, a performative gesture: one that provided
the aura of institutional legitimacy necessary for the broader interpretative
framework of a policy think tank. It was also a deeply posthumanist gesture
towards the seriousness with which we took the notion of decentering human
knowledge, instead recognizing slime mould's phenomenological and envi-
ronmental intelligence as a different way into (or out of) seemingly intractable
and divisive global issues.

The idea of interconnectedness on both a micro and macro level became
a curatorial framework for the project as a whole, taking its cue from

Physarum polycephalum itself. Just as plasmodial slime mould forms a large network of embodied knowledge that optimizes outcomes for the whole, so we worked to bring together a polycephalous – or many-headed – project. After all, posthumanism "argues that because we are always already interconnected with our environments, methodological thinking should respond in kind by fostering similar interconnections". (Ulmer, 2017: 3) Bringing together poets and mathematicians, architects and anthropologists, philosophers and computer scientists, meant that a range of methodologies and epistemologies were on the table. Yet the result tended to deepen rather than dilute rigor, as each participant's background sharpened, challenged or complemented another's approach, and the often unpredictable agency of slime mould presented entirely new models for thought:

> It begins with a polycephalous (many-headed) encounter. Students, staff, and faculty meet and mingle with visiting scholars *Physarum polycephalum* and experimental philosopher Jonathon Keats in a series of collaborative workshops to consider the pressing questions of the day from diverse disciplinary perspectives – architecture and anthropology, poetry and computer science. It marks an attempt to break from the siloed, hierarchical and linear structures of traditional knowledge-making.
>
> From these initial encounters emerge several resounding questions: What is the nature of intelligence? Why do we place humanity at its apex, despite all the evidence of our biases, our foregone conclusions? How might we think *with* slime mould, from within their frame of reference (if never fully knowable), to consider seemingly intractable global problems? Perhaps slime mould might offer new perspectives, informing policy recommendations to institutions and organizations both local and global.
>
> Process is paramount in the student investigations that follow. Rather than the neat, linear path traversed in a scientific journal, or finished artworks hung on a gallery wall, presented here are promissory notes for further elaboration. As with any model, each investigation will necessarily involve assumptions and abstractions in the absence of complete information. Some use real-world data while others model dilemmas in the abstract as a basis for developing alternative heuristics. All offer annotations and early research, initial experiments and preliminary results; they are field notes to

missteps and marveling, to both rigor and randomness, to a meeting of minds, human and non-.

Wall text for *Plasmodial Policy Recommendations* section of exhibition

5.5.1 Curating for Aesthetic Coherence and Effective Communication

Conveying the nature of an open-ended, ongoing and process-oriented project, while still providing some measure of the aesthetic and conceptual coherence necessary for a "legible" exhibition, was one of the biggest challenges of the Plasmodium Consortium. The largest unifying design element became the formation of an institutional identity for the Consortium, complete with a logo, rubber stamp, letterhead and all the other necessary graphic features of bureaucratic ephemera, which in turn informed exhibition wall text and interpretative material such as the Policy Circular (Figure 5.8). Project participant and associate professor of architecture and design, Thom Long, was a key collaborator in ideation and design, including the fabrication of a visual register for slime mould behaviour and capabilities, synthesized and derived from extant literature (Figure 5.9). This institutional aesthetic informed the exhibition, which opened with an imposing communications desk in the entryway (staffed by student workers briefed on the project and equipped with policy circulars and press releases) and a series of case studies for public review.

Long and I helped coach students in the Microscopy and Modeling class to design their petri dish scenarios with non-specialist viewers – and visual dissemination – in mind. If they planned to set up a gradient of valerian root to nutrition across the dish to explore issues of addiction, for example, could they design a visible template for the base using a color that would contrast with the agar substrate, the yellow slime mould, and the black background against which the results would be photographed? (see Figure 5.4) Throughout the course, we emphasized how effective graphic design, incisive data visualisation, and high-quality, standardized photographic documentation helps to communicate complex scientific information in a meaningful way.

Confronted with such a range of interests and approaches to the problems students were investigating, we also developed a unifying structure for speaking about process: each should include a verbal description of the problem, relevant data and context for the problem, and a representative photograph of the process (all taken by senior student Ray Mendel, who devised the best method for photographing petri dishes, with all the challenges of viscous

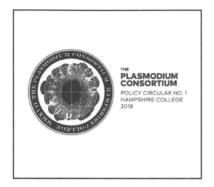
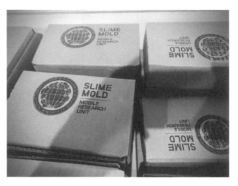

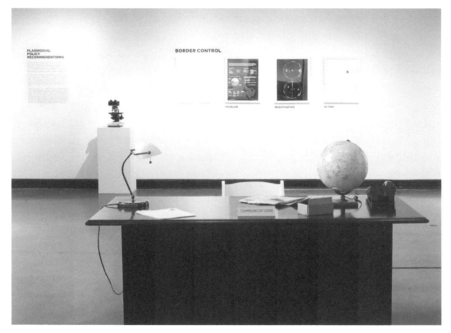

Figure 5.8 Top left and right: The Plasmodium Consortium seal on the policy circular and Mobile Research Units, that along with the communications desk (bottom) partook in an official institutional aesthetic.

Photograph by Ray Mendel.

and reflective surfaces) (Figure 5.10). Students' experimental "deliverables" were then given aesthetic unity through Long's integrated color palette, design and typography, and white contemporary frames. The final component of each case study was Jonathon's Keats' intervention as Consortium secretary in the form of a policy recommendation sent as a letter to the

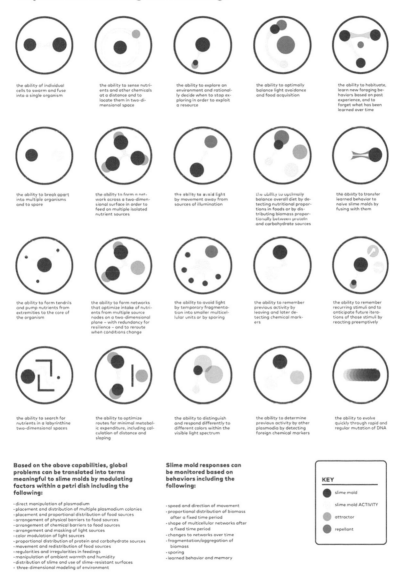

Figure 5.9 Iconography of Slime Mould Behavior and Capabilities, 2017, for the Plasmodium Consortium.

Designed by Thom Long.

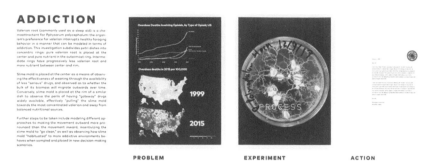

Figure 5.10 Concept layout shows the design structure developed for each project in the Gallery. Concept Project Layout for the Plasmodium Consortium, 2017.

Designed by Thom Long.

relevant government exponent of the current administration (in both the U.S. and the U.K.). Again, the letters were part performance, part serious injunction to consider the limitations and biases of human intelligence.

5.5.2 (Re)Presenting Process and Participation

In the Plasmodium Consortium, human and non-human scholars play out a complex choreography as senior students intermittently continue their investigations alongside slime mould. Here, as science is performed within the public space of the Gallery, hypotheses are challenged and experimental design refined. Unexpected results and newly pressing questions – influenced by daily news, informal discussion, or a puzzling discovery – will inform iterative changes within the space. The exhibition, much like the scientific process, becomes a dynamic, unpredictable – perhaps even living – thing.

Wall text for *Scientific Practice & Performance* section of exhibition

You are encouraged to expand the reach of the Plasmodium Consortium by conducting your own investigations. Consider questions that you find relevant or pressing: how might they be modeled within slime mould's frame of reference? While there is much we don't know or understand about our plasmodial collaborators, the exhibition's graphic icon map shows characteristics and abilities of slime moulds that can be used to translate human problems into terms that *Physarum polycephalum* can comprehend.

In this kit, you'll find the basic constituents and instructions for an investigation: mobile researchers (dried slime mould poised for reactivation), an environment (petri dish), growth medium (agar), incentives (oat flakes), and barriers (salt). Results can be submitted to the project at plasmodium@hampshire.edu or dropped in the Five College Mail box at the campus post office (attention: Plasmodium) for consideration as part of our ongoing series of circulars to the United Nations, the United States Congress, and governing bodies worldwide.

Wall text for *Mobile Research Units* section of exhibition

Alongside attempts to give unifying structure to the Consortium, we also wanted to emphasize the precarity and primacy of *process* in both art and science as forms of inquiry, and to shift expectations of where and how "science" happens. The second major section of the exhibition, after the communications desk and case studies, became a working laboratory with materials and furniture sourced from the college's science building. With all the resources necessary to consult with *Physarum polycephalum* in the space, students could continue their work in the Gallery, enabling viewers to engage with practices and habits that usually go unseen by the public, generally only disseminated in the neatly-packaged form of a peer-reviewed journal article.

Moreover, process boards (filled with photos, documentation, relevant articles, annotated napkins from late-night take-away food, and other random musings) lined the wall, and televisions played live cable news, reinforcing the real time – and context-specificity – in which scientific research takes place (Figure 5.11). Finally, a lab table filled with "mobile research units" presented viewers with the opportunity to participate in the Consortium. These elements underscored the sense of the exhibition itself as a dynamic, potentially unpredictable thing. Both spaces also functioned to interrogate received notions of the expected "apparatus" of knowledge production and legitimacy in different spheres – the policy world, the laboratory and, in its overall framing, the contemporary art gallery, in which the Consortium operated as a conceptual installation. By having all three coalesce, we hoped to formally register something of the interconnected nature of the project, and its posthumanist openness to multiple methodologies and ways of knowing.

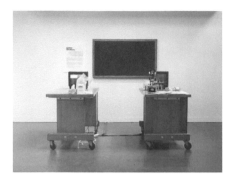 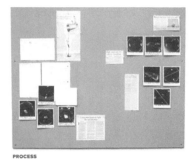

Figure 5.11 Lab benches, cable television, and process boards.

Installation views of the Plasmodium Consortium exhibition by Ray Mendel.

5.6 On Working with Slime Mould from a Biologist's Perspective: Megan Dobro

5.6.1 Recruitment to Science

The lab sciences have historically had a problem with recruiting students of diverse backgrounds and interests. The sterile buildings, intimidating lab equipment, and a seemingly "foreign" language do not help the case. Moreover, in this information era, the job of faculty is no longer to profess their knowledge in dense, potentially alienating lectures but to guide students through relevant experiences that prepare them for a range of future work contexts, and inculcate critical thinking skills that will serve them long after graduation. But first, we must get them through the door!

Physarum polycephalum is an attractive recruitment tool and an optimal species for an introductory biology course, while also offering scaffolded levels of complexity for higher-order investigations. They are safe, intuitive, hardy, inexpensive, and beautiful to watch. They do not require microscopes (though their use can deepen and expand our learning) or incubators, and they can adapt to new environments, allowing students to transport them from lab to home and back again. Students' first reactions were usually that the slime mould was "gross", a feature that was simultaneously attractive and repellent: and thus utterly captivating. Students of all levels wondered how slime mould would deal with the various obstacles they devised, and were excited to see slime mould was capable of escaping their petri dishes and challenging their assumptions. Suddenly their experiments "came to life" in a way they'd never previously experienced, and – like a meme gone viral – they wanted to show their friends and create new imaginings. Soon, we found students were

recruiting their dorm- and classmates to their projects, and finding ways of connecting slime mould to their peers' questions and projects in completely different classes.

5.6.2 Value to the Community

Slime mould was not just a valuable recruitment tool for students: it also brought staff and faculty together in new and unusual ways. With the demands of teaching, research, advising, and service, academics have little "bandwidth" for extra work, especially when it does not appear directly applicable to one's field. But many faculty and staff engaged with the project outside of their typical duties, finding enough intrinsic value in it to spend extra time in this way.

For faculty and staff, this project presented a rare opportunity to engage in serious play together across disciplines. For the same reasons that "hack-a-thons" and "makerspaces" bring people with wide-ranging talents together to work as a team, we were able to learn from each other to approach a problem in new ways, and to forge deeper connections by enjoying each other as teammates. We created a new environment, rare to academia, in which faculty could feel comfortable *not knowing*, learning from students and challenging assumptions together without feeling threatened. It was important to model this environment for students, as well as show them the process of how to tackle a problem when starting with little to no experience. Students could observe how experts in specific fields come together to find common ground, identify interesting questions, define conventions and limitations, and find joy in obtaining information to help the team move forward. They were able to watch collaboration rather than competition in practice. Significantly, students came in as the slime mould experts, so they were highly valued to the staff and faculty in the process of designing experiments. They were also more invested in the project because of this ambassadorship. All together, it was exciting brainstorming "what if" scenarios with colleagues outside of our fields.

5.7 Challenges

We have identified a set of practical challenges to consider when reproducing the project elsewhere.

As with any new project, getting started requires an investment of time. We began with reading the research literature and conducting preliminary

experiments to acquaint ourselves with our new slime mould collaborators. The administrative effort to organize logistics, raise supporting funds, and recruit participants was done by the three co-directors without additional staff help and in the absence of robust institutional infrastructure for collaboration. There were many weekends and school breaks spent working on writing, speaking to journalists, wrangling students, creating cohesive design elements, designing the course, and building the exhibition.

Slime mould was easy to work with, but there were logistical challenges that surprised us. Because slime mould grows in dark, moist environments, fungal contaminations were common and could be difficult to eliminate. Photographing petri dishes requires very specific lighting to reduce glare on the plastic – tops could be removed for better photos but at the risk of contamination. Similarly, science students were unprepared to consider the visual needs of the exhibition and were unaccustomed to documenting their experiments in ways that were clear and appealing – a lesson we have remedied the second time around with advanced training.

Significantly, the wide-ranging fields represented in this project enriched the experience but presented communication challenges. Explaining the project was difficult and capturing the essence of an idea into an experiment with slime mould was the biggest hurdle for all participants. While it is a rare gift to be able to immediately see the experiment that should be done, it was a fun brain exercise for students to work on together. This challenge presented an important teaching moment in which we could ask students who had just developed an experiment whether or not the results of that experiment would answer the question they are asking. This usually sent them back to the drawing board, which is a great habit to develop in budding scientists. The most common remark when explaining the project to outsiders was that they just could not "see" how we could model human problems with slime mould. Clear examples were important, as was attention to the nature and purpose of models.

When introducing this project to others we had to carefully communicate this purpose, which was not to perfectly replicate the real world or account for all variables, but to reduce complicated problems to simple scenarios that would be considered with all their limitations (and in addition, to collaborate with a modeling agent so wholly "other" that we were forced to reorient our notion of models and our framing of questions in new and productive ways). In this project, we were using the behavior of slime mould to foster critical discussion about how humans create policy, interact with each other, and interact with their environment. It was tempting for some to consider

every real-world variable when constructing scenarios with slime mould, and others dismissed the project at first glance because our experiments were too simplified. Striking a balance between simulations that were complex enough to be interesting but simple enough to be understood by the broadest audience was very challenging.

Lastly, for better or worse, we caught ourselves frequently anthropomorphizing the slime mould. To some extent, this was catalyzed by our intentional framework of "collaboration with non-human scholars," but it was also a reminder of how – even in our attempts to proceed from a non-human frame of reference – our tendency is to accommodate the unknown to ourselves.

5.8 Outcomes

The Plasmodium Consortium created a hub of interdisciplinary vitality on campus, prompted several ongoing collaborations, inspired the re-design of courses across campus (as faculty in philosophy, poetry, architecture and computer science integrated our non-human scholars into their curricula), and cultivated a deeper understanding and appreciation for how others approach their scholarly work. These results have enhanced our campus community and forged interdisciplinary connections that will no doubt have unexpected outcomes for years to come, branching ever outwards over new and exciting terrain.

Students have adopted slime mould as the research organisms for their senior theses, and all students who participated in the project learned how to use the scientific method, critically evaluate sources, work safely in the lab, manage a multi-faceted group project and communicate their research to wide audiences. The strong presence of artists, designers and curators as contributors to the project taught students the importance of the visual in meaningfully disseminating their research, and prompted them to consider the mutual entanglement of the arts and sciences as ways of knowing, experiencing and communicating about the world. We focused on evaluating what makes a good or interesting question, how to design experiments and choose methodologies that address the question effectively, and how to interpret the results. These were useful skills for all students, whether they wanted to pursue a career in science or not.

Instead of our normal method of inquiry in which we ask biological questions and probe model organisms to collect data, our thinking shifted. If we consider the intellectual potential of slime mould and respect their

500 million years of adapting to this planet, students begin to treat their specimens as colleagues with a higher degree of respect. They designed experiments more carefully so as not to be wasteful, they visited their petri dishes frequently to make sure the slime mould had conditions for thriving, and they hesitated before bleaching and disposing of their plates as they normally would. This perspectival shift into considering our specimens as visiting scholars also provided a rich discussion about science ethics.

5.9 Conclusion

The Plasmodium Consortium has now provided preliminary policy advice on public transportation, food deserts, border walls and drug legalization. All of these issues still require further investigation, which we hope will be stimulated by the elucidation of our motivations and methods. Many other issues – both political and economic – also need to be examined from a non-human perspective, and we believe slime moulds can provide genuine insights. Perhaps they can ultimately find their way into governmental offices, including the United States Treasury as Jonathon Keats initially envisioned.

Moreover, the idea of engaging other species in the big questions facing human civilization need not be confined to slime moulds. We believe that any species can provide insights, as can interactions between multiple species, if rigorously modeled. Other species can even be empowered more directly. For instance, Keats is currently working with collaborators at the University of Nevada – Reno to enlist bristlecone pine trees as alternative timekeepers, proposing to synchronize society with the ground conditions of life as lived on our planet.

Ideally, the Plasmodium Consortium will serve as a model for posthumanist thinking, while also inspiring greater experimentation in pedagogy. As Keats writes in the final chapter of *You Belong to the Universe* (2016), our educational structures tend towards extreme specialization and siloing, yet in the midst of our "spectacularly complex" world, "specialists cannot comprehensively study the world's problems, and cannot anticipate the impact of their solutions outside their own speciality". Open-ended inquiry and a collective, collaborative, interdisciplinary framework for anticipatory design – a global polycephalous platform, if you will – is our best path forward: the Plasmodium Consortium presents a beta test of possibility.

References

Adamatzky, A. (2011). On attraction of slime mould *Physarum poly-cephalum* to plants with sedative properties. *Nature Precedings.* http://dx.doi.org/10.1038/npre.2011.5985.1

Dussutour, A., Latty, T., Beekman M., and Simpson S. (2010). Amoe-boid organism solves complex nutritional challenges PNAS, 107(10), 4607–4611.

Keats, J. (2016). *You Belong to the Universe.* Oxford: Oxford University Press.

Ulmer, J. B. (2017). Posthumanism as research methodology: Inquiry in the Anthropocene. *International Journal of Qualitative Studies in Education.* 1–17.

6

Polycephalum Wetware: Reasoning across Architecture, Biology and Computation

Claudia Pasquero[1,2] and Marco Poletto[3]

[1]The Bartlett School of Architecture, University College London, UK
[2]The Faculty of Architecture, Innsbruck University, Austria
[3]ecoLogicStudio, London, UK
E-mail: c.pasquero@ucl.ac.uk; marco@ecoLogicStudio.com

6.1 Introduction

This chapter looks at *Physarum polycephalum* both as a future urban design system and a biological computer, which we call Polycephalum Wetware. For Adamatzky the Physarum Machine is a concept for a new kind of computing machine. He wrote:

> *By experimentally implementing the Kolmogorov/Uspensky machine in Physarum we proved that plasmodium of Physarum P. is a general purpose computer.*
>
> *Adamatzky, A. Physarum Machine. World scientist. 2010.*

It is a form of bio-artificial intelligence embedded into an unicellular organism. Through the interaction of millions of nuclei P.P. can perform quite sophisticated tasks of network optimization and resource redistribution. However, what interest us here is that computation can be embedded in matter, and more broadly it can be understood as a model of embedded intelligence at multiple scales, including architecture.

Wetware is a term which first emerged as part of cyberpunk culture and is defined by Rudy Rucker as

> *'the underlying generative code for an organism, as found in the genetic material, in the biochemistry of cells, and in the architecture of the body's tissues'*

[Rucker, "*http://www.rudyrucker.com*", 2007].

In the context of the academic research developed at the Urban Morphogenesis Lab at the Bartlett UCL the potential of P.P. as future Wetware has been explored in the last five years (Figure 6.1). The goal has been to define the protocols and apparatus that enables end user interaction. That is to make use of P.P. as a new form of computational tool for speculative architectural design.

It is from these findings that the authors draw their speculative positions later deployed by ecoLogicStudio in several projects. In this instance P.P. becomes a space for reasoning between biology, computation, and urban design. It provides room for critical reflections on the discipline of urban design, often obsessed with a search for truth from within a problem-solving framework. This research therefore discusses a new role for design to approach the most pressing socio-ecological-political issues of our time.

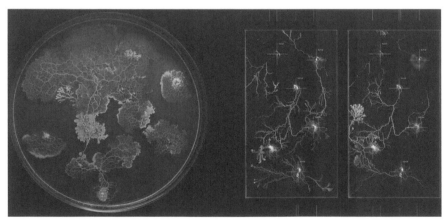

Figure 6.1 *Physarum Polycephalum* as Wetware at the Urban Morphogenesis Lab at the Bartlett UCL 2017–2018.

Tutors: Claudia Pasquero with Filippo Nassetti and Emmanouil Zaroukas; Students: Qing Qin, Jiayi Tu.

Timothy Morton in his book Ecology Without Nature: Rethinking Environmental Aesthetics has recently articulated the need for a new perspective of these issues with the paradigm of dark ecology:

> [...] while we campaign to make our world 'cleaner' and less toxic, less harmful to sentient beings, our philosophical adventure should in some way be quite the reverse. We should be finding ways to stick around with the sticky mess that we are, making things dirtier, identify with ugliness.
>
> Morton T., Ecology Without Nature: Rethinking Environmental Aesthetics, Harvard University Press, 2007.

Significantly Goethe too, in his later years, often referred to Nature as a "mystery in broad daylight". Rejecting the conceptual opposition of an inside and an outside of Nature, he wrote:

> Nothing is within, nothing without,
> what is inside is also outside.
> Seize, then, with no delay,
> The sacred Mystery in broad daylight.

Goethe W., *Epirrhema*, WA, I, 3, p. 88.

This notion applies perfectly to the peculiar nature of P.P.. We can say that it appears in broad daylight because it is open to everyone's eyes. We can easily observe its behaviour and the transformational abilities of the plasmodium phase. Yet its intelligence remains a mystery, even to the most trained scientific eye. What are the motives or the meanings of such behaviour?

How can we recognize in such phenomenological expressions what Goethe calls the Urphanomene, the original phenomena, what would we call its prototypical behaviours? And can interpreting such tiny creature unlock some more fundamental paradigm shifts for our urbanizing society as a whole?

6.2 Modern Bias: From the Modern Linear City to the Microorganism as Bio-citizen

One of the main ideas we inherited from modernity, and that has come to define the shape of our contemporary cities, is that microorganisms like bacteria, are dangerous. Modern master-planning and modern design has strong roots in the concept of sanitation.

In fairness, such tendencies have emerged in the early years of the industrial revolution as demonstrated by such projects as the Haussmann's renovation of Paris. Here large tree-lined boulevards, squares, and parks are designed to cut wide open the dirty old medieval neighbourhoods of Paris, bringing air and sunlight and reducing drastically the risk of new epidemics. Such urban design operations where often accompanied by new infrastructural works, like with the introduction of sewers.

Similarly, in London, the first public urban park opened in the East End with the specific purpose of proving access to fresher and cleaner air. Victoria Park, called the People's Park, offered to many the only access to nature they would ever see.

However, it was the modern movement that embraced this attitude and turned it into an all-encompassing vision. Perhaps the most enduring example is the ideal city named Ville Radieuse, by the French-Swiss master Le Corbusier. The project represented a utopian dream to reunite man within a well-ordered environment. Although it was never realized it became a blueprint for many later projects. Modern architecture therefore came to embody human's rational ability to frame nature and its darkest and uncontrollable aspects. Similarly, Modern master planning evolved into a system for the rational organisation and separation of all urban functions; this is known as zoning. Despite recent attempts towards mixed use and hybridisation, modernist zoning still has a profound influence on contemporary urban planning.

Central to modernist zoning was moving Zones of production and treatment of waste further out of city centres, technically preventing contamination of the residential and leisure quarters. Such removal, however, had the effect of hiding the by-products of urbanisation from our sight and, in time, from our consciousness at a fundamental level. So, of course, we are all rationally aware that our waste does not disappear once we throw it away but it certainly does disappear from our perceived reality, the world that we daily inhabit and capture with our senses.

This is the origin of the modern and metabolically linear city. Resources are introduced, in the form of energy, food, products and so on, while waste is disposed; we do not know much about where and how these fundamental flows originate and terminate, nor we can perceive their relevance on our life. So, in time, and out of sight, these flows have grown dramatically in both size and complexity to the point of becoming almost untraceable and uncontrollable. Today, for instance, nobody can tell for sure where the substances making up hamburgers we buy at food retailers actually

come from. Yet we eat them and they become part of our metabolisms. Nobody can tell for sure where all the electronic waste we dump is actually going, yet we find parts in the most remote and unlikely locations, such as isolated islands as well as in the bodies of many marine organisms.

The metabolically linear city has infiltrated virtually any living organism on earth; scientists have determined that such influence may grant our age its own name, Anthropocene. Since now more than half of the world's population lives in dense urban environments it may be the case of renaming our Biosphere as the Urbansphere.

So if today we are more than ever dependent for our prosperity on a global and shared Urbansphere, why do we fail to act and implement truly progressive measures ensuring its evolution? Among the many reasons one that is often overlooked but that is significant in our opinion involves our contemporary notion of nature. Modernity not only has sanitized our cities, as discussed before but also nature, or better, our concept of nature.

Today we came to believe that such rationally organized environment that we consider our modern living habitat applies to the Biosphere as a whole. In other words, today we have a machine like model of nature dominated by the ideals of growth, prosperity and most of all equilibrium. The Biosphere is often represented in a state of perpetual homeostasis, a perfect balance of forces that is temporarily perturbed by humans' actions, but that with some considerate help can be rebalanced. This notion forms the basis for an eco-green ideology that often influences even the most progressive administrators, architects and urban planners.

Talks about re-greening cities and re-naturalising forests abound, as if such easy fixes would be at all possible. The action of planting trees has acquired absolute symbolic value and now stands for our ability to evolve as sustainable Urbansphere. Their picturesque and sanitized image erases all that is dirty and polluted about our urban society. So for instance, trees' rather limited capacity to absorb CO_2 is often used as a measure of human's best efforts to stop climate change.

However, this is not how the Biosphere actually works. In fact, it is a non-linear system composed of near infinite interlocking feedback loops. Within each of these loops on the one side we may observe processes of growth and proliferation of life while on the other there are processes leading to destruction, decay, digestion and ultimately death. In fact we may argue that the latter are some of the most fundamental processes of nature and are critical to its circularity; these processes often take place in the dark,

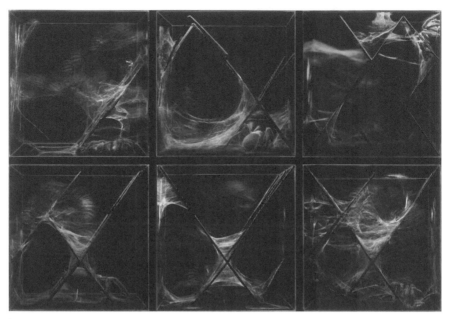

Figure 6.2 XenoDerma project investigating Asian Fawn Tarantula as bio-citizen. Behavioural model stage 4. Urban Morphogenesis Lab at the Bartlett UCL 2017–2018.

Tutors: Claudia Pasquero with Filippo Nassetti and Emmanouil Zaroukas; Students: Mengxuan Li, Xiao Liang.

occur anaerobically, and they generate strong odours. They trigger in us atavistic fears of contagion and death.

They constitute what we may call the dark side of ecology, one that we have all erased from our consciousness but that is nevertheless critical to the functioning of ecosystems in the Biosphere (Figure 6.2 and Figure 6.3).

Our eco-green fiction has had some productivity in but we have now reached its limit. We need to write a new narrative for Nature. Microorganisms will be the protagonists of this new narrative as microbiology is opening many doors in our current understanding of such peculiar forms of life.

At the microscale, things work very differently. We are discovering that, at a scale where the individual organism has no central brain or any form of nervous system, intelligence evolved different strategies and computation is often the product of emerging collective intelligence enabled and embedded in spatial substrata external to the body of the individual organism. That is how mycelia, for instance, get to coordinate and grow networks the scale of a forest.

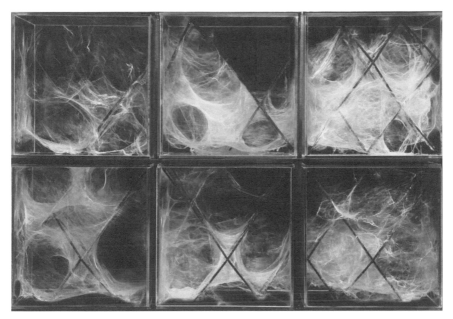

Figure 6.3 XenoDerma project investigating Asian Fawn Tarantula as bio-citizen. Behavioural model stage 4. Urban Morphogenesis Lab at the Bartlett UCL 2017–2018.

Tutors: Claudia Pasquero with Filippo Nassetti and Emmanouil Zaroukas; Students: Mengxuan Li, Xiao Liang.

Such exceptional properties, that we are discovering and in some cases we are beginning to manipulate in Labs, can be projected to the urban scale and make us reconsider what we now understand as the separate realms of pollution/waste and nutrient/raw material. Cyanobacteria for instance eat CO_2 as part of their metabolism to grow as biomass, the same CO_2 that we consider a greenhouse gas and the symbol of man-induced climate change. From this perspective, microorganisms are the missing link to a circular urban metabolism.

6.3 Bio-citizens 01: Anthropocene Island at TAB 2017

ecoLogicStudio recently promoted this vision with the project Anthropocene Island, which investigates the urban future of Tallinn, the capital of Estonia. The project is sited in a unique Peninsula at the outskirts of Tallinn, called Paljiassarre. It is a former Soviet Military Base that after Estonia became an independent country was abandoned. As it is often the case, nature slowly

re-grew and different species of plants and animals now occupy the land-scape; especially migratory birds settled on the tip of it as they found it an ideal resting and nesting site.

Since the late 90s, the main wastewater treatment plant for Tallinn has been built in the middle of the Peninsula and now receives and processes 100% of the urban wastewater and surface rainwater. Ever since the plant increased its operations and the top part of the Peninsula entered the net-work of Euronatura 2000 protected areas, a battle started among the plant management and birdwatchers/ecologists claiming the plant's emissions are contaminating the reserve and negatively affecting the resident species. It is a typical case of what we may define as green vs. dark ecology.

However, upon visiting the wastewater treatment plant, ecoLogicStudio's team was able to film a peculiar scene showing migratory birds actually inhabiting the warm and nutritious waters in the bio-digesting tanks of the wastewater treatment plant. They even appeared to be playing with its large rotating machines. ecoLogicStudio's project ended up taking the birds per-spective, or better a non-anthropocentric perspective on the site. This point of view was eventually developed it into a speculative proposal for the main curated exhibition of the Tallinn Architecture Biennale 2017, directed by Claudia Pasquero (Figure 6.4/Figure 6.5).

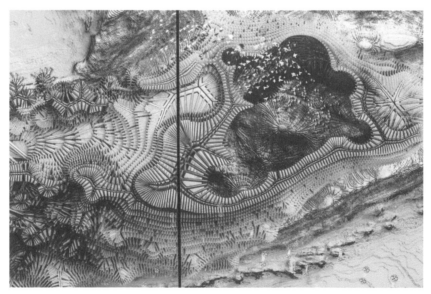

Figure 6.4 ecoLogicStudio, Anthropocene Island, detail Top view.
Photo by Tonu Tunnel.

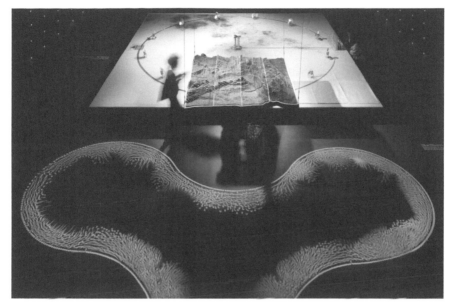

Figure 6.5 Anthropocene Island Exhibition at TAB 2017.

Photo by NAARO.

The exhibition was conceived as a real Laboratory of future city making, designed by ecoLogicStudio and developed in collaboration with 11 invited practices, including artists, architects and scientists. At the core of it is a new city model that grows from the waste of Tallinn itself. The vision integrates microorganisms into the built environment and explores the microbial re-metabolisation of Tallinn's wastewater as the founding principle for a new city. New distributed habitats emerge, able to receive Tallinn's wastewater, and process it. Surplus of heath and nutrients are produced which in turn alter the local microclimate and increase its ability to host a diversity of new species, both autoctonus and bio-engineered.

In time these microbial gardens would begin to communicate and exchange information, matter and energy, increase the overall photosynthesis and store solar energy in living biomass. Such surplus biomass will be harvested to extract biofuels and feed it back to the city of Tallinn as a source of energy. As these processes evolve so will the landscape of the peninsula, which will increase its level of complexity and acquire multilayered articulation. This will be made possible by the introduction of digital and robotic construction devices, like robotic rovers and building drones.

The most prominent portion of the peninsula is expected to evolve and reach hi-density urban status, while incorporating novel processes and generating a new microclimatic buffer zone.

Crucially in this vision birds, microorganisms, machines and all other communication devices become, alongside human beings, bio-citizens; they are residents of an ever-evolving urban landscape. This expanded form of citizenship is formulated to account for the urbanisation of such processes as microbial digestion as well as artificially enhanced photosynthesis. Within this framework organisms like microalgae for instance are not simply accounted for as biomass as they contribute to a substantially more sophisticated system of collective intelligence, the founding process of a new metabolically circular bioTallinn.

6.4 Bio-citizens 02: Cyanobacteria in Aarhus and Astana

This notion is perhaps better exemplified by one of ecoLogicStudio's longest running project, spanning a decade and called Urban Algae Farms. It is based on the idea of creating habitats for microalgae organisms as part of building envelopes. Within this framework microalgae are not only able to photosynthesize, but also to absorb emissions from the building itself. This evolves into a new active layer that takes part in both city and natural metabolic cycles. In other words green and dark ecology are reconnecting within a new expanded framework of urban ecology (Figure 6.6/Figure 6.7).

In fact, there are multiple interactions in buildings that can be activated by the intelligence of microalgae colonies. Microorganisms can grow very efficiently in ecoLogicStudio's designed bio-digital habitats because they are very closely connected with the life of the building they inhabit. Its surplus of CO_2 and heath stimulates algal biomass to grow and the biomass, a biological storage of solar energy, can be used by the inhabitants of the building itself as source of energy or food. What emerges is a new kind of symbiosis operating across scales, from the molecular to the architectural, and regimes, from the biological to the digital and all the way to the infrastructural.

From this perspective buildings, their appearance, morphology and performance, is not given or completed at the end of construction; rather we understand them as intelligent systems that keep learning and keep evolving. In 2017, ecoLogicStudio has built a permanent pilot project in Astana, Kazakhstan, designed to enable such bio-digital intelligence to flourish in the urban environment. Called Bio.Tech Hut, it is the first permanent biotechnological dwelling (Figure 6.8).

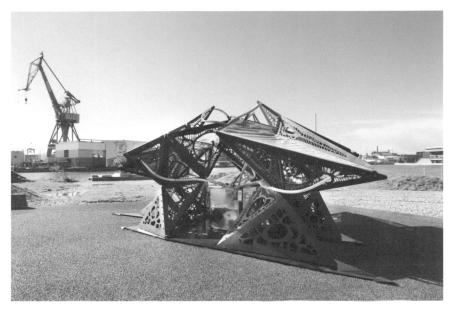

Figure 6.6 ecoLogicStudio, Aarhus Urban Algae Folly.
Photo by NAARO.

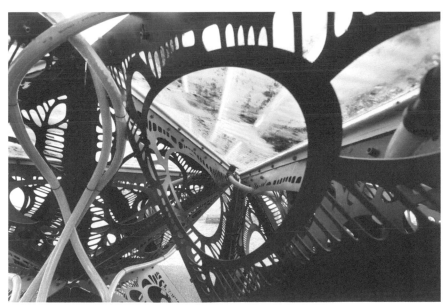

Figure 6.7 ecoLogicStudio, Aarhus Urban Algae Folly.
Photo by NAARO.

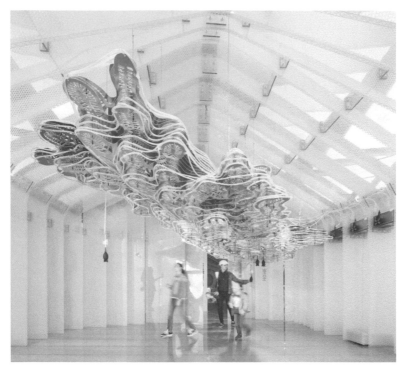

Figure 6.8 ecoLogicStudio, Bio.Tech Hut in Astana EXPO 2017.
Photo by NAARO.

The bio.Tech Hut is 180sqm in plan, can host a large family or group of people and supports 1600L of living cultures of cyanobacteria in its lab grade glass photo-bioreactors.

In optimal conditions, it produces approximately 1 kg of dry algae per day. Microalgae can contain up to 60% oil from which 1 kg of biofuel can be produced, releasing 10 KWh of energy. That is enough to power an average UK home, which makes Bio.Tech Hut energetically self-sufficient. But this principle of urban symbiosis extends to food and nutrients too. These are crucial cycles where important changes are required to feed a healthy diet to a growing urban population that is predicted to reach 5 billion in the next 15 years.

A microalga like *Chlorella* contains up to 60% vegetable proteins, every day the BIO.tech HUT produces up to 600g of proteins, enough to supply the recommended daily intake of 12 adults. This is the equivalent in meat-based proteins of 8 cows! (Figure 6.9).

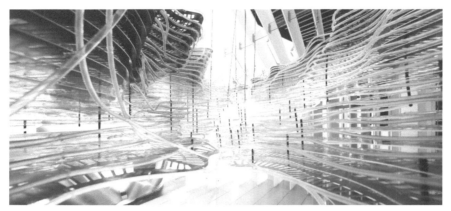

Figure 6.9 ecoLogicStudio, Bio.Tech Hut in Astana EXPO 2017.
Photo by NAARO.

And, of course, reducing farming also means reducing emissions of green house gasses. The living cultures of chlorella growing within the BIO.tech Hut's glass photobioreactors in optimal conditions can absorb 2 kg of CO_2/day and this is equivalent to the CO_2 adsorbed by 32 large trees, a family run urban forest.

This numbers give us a spatial and material dimension of the efficiency of building integrated cultures and of the ability of the urban fabric to synthesize resources. It is a crucial transition; the urban environment stops being just a container of programmes or functions, like in the modern notion of the machine for living, and becomes itself a dynamic process of production, a living machine.

And a living machine has the ability to harvest and process matter, information and energy that differs radically from how we produce and distribute energy today, even when looking at renewable ones.

Centralized energy grids, like the ones connecting contemporary power stations, or even large wind farms, to each one of our houses evolve into distributed networks of emergent collective intelligence, where every building, every park or public space is both producer and consumer at the same time.

Centralised grids are typically conceptualized like trees, connecting a central trunk to all branches. The model for such new kind of distributed network must look rather different.

6.5 *Physarum Polycephalum* as Speculative Model

In search for such model, ecoLogicStudio began working with living P.P. as an urban simulation tool 5 years ago. As mentioned at the beginning of this article P.P. is single celled organism with hundreds of thousands of nuclei. In the plasmodium phase, the nuclei interact with each other through biochemical reactions. P.P. accumulates traces of nutritional substrates in the environment and forms a distributed spatial memory of these interactions. This embedded memory is critical for collective intelligence to emerge in absence of a nervous system. It is through billions of local direct interactions that the behaviour and the overall morphology of P.P. emerges and evolves in time.

ecoLogicStudio developed several apparatus to experiment with and capture this behaviour. What appears at first sight are the remarkable similarities with urban networks as seen from above. But of course in case of P.P. there is no master planner, or engineer to rationally design those networks. They are the product of bottom-up emerging collective intelligence at work.

Today we are quickly familiarizing with the effects of ubiquitous digitalisation. Yet our understanding of the built environment remains determined by programmatic and functional determinism. A more significant shift will occur when we will develop cyber-natural prototypes, bio-digital buildings and other urban hybrids which would contribute to the dissolution of such determinism. Then cyberspace would become an integral part of the city and we will have created the conditions for a new kind of self-organizing habitat, populated with yet unknown components (Figure 6.10/Figure 6.11).

Often such models are called smart cities. No doubt, the infrastructure for connecting interactions will become more and more efficient and intelligent, but the key issue is how managing big data about billions of dynamic interactions could change the urban fabric itself. The Polycephalum offers an intriguing answer to this problem, one where intelligence or smartness can only be understood or formulated as embedded in matter, as articulated in physical space and real time.

This calls for an end to the production of speculative and often ideologically driven urban models based on a priori urban massing distribution, digitally enabled smartness and top down re-greening. The city must become an experimental Lab of emerging collective intelligence enabled by a new convergence of applied digital and biotechnologies. Real test bed to synthesize the future Urbansphere.

In this scenario the notion of bio-citizenship that, as mentioned before, includes microorganisms as well as robots and digital algorithms takes new

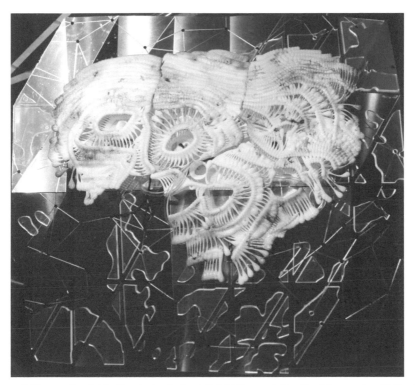

Figure 6.10 ecoLogicStudio, Arthur's Seat, B.I/O Powerstation for Menagerie of Microbes at Edinburgh Science Museum, 2016.

significance. This is critical in one important respect. While we may hail Artificial Intelligence, Robotics or IOT Smart cities as future game changers, few are realizing that if we do not implement these novel technological paradigms within a similarly renewed conceptual framework, that is beyond the current mechanical model of nature and urbanity, their value and potential will remain significantly locked in. This is already visible with many initial IoT pilot projects, which seem to take for granted the status of our current urban infrastructures and related morphologies and simply operate within their conceptual and physical limits.

The Polycephalum strategy illustrated in this article calls for harnessing the "dark side of nature", literally cultivate it. That is "culturalise" it to form the basis for a new form of urbanity. Therefore the design paradigm and tools presented here are grounded in science but have been developed at the service of culturalisation of the urban realm.

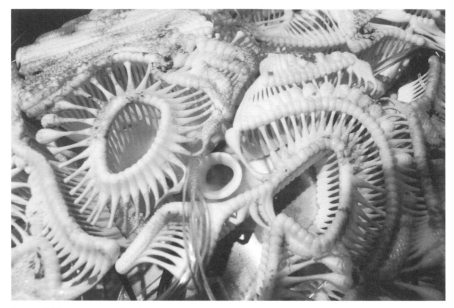

Figure 6.11 ecoLogicStudio, Arthur's Seat, B.I/O.Powerstation for Menagerie of Microbes at Edinburgh Science Museum, 2016.

In the case of cyanobacteria for instance ecoLogicStudio's work is promoting the emergence of new practices of urban algae farming. Algae currently exist in Labs and as part of the farming industry where they are still essentially just biomass. Integrating them in the fabric of architecture changes their status. Cyanobacteria are culturalised in an urban sense. This triggers a proliferation of urban design possibilities about what these organisms actually are and what they could become. They could become colour, ornament, biosensors of anthropic activity, super-food and so on. Cyanobacteria therefore become a medium to re-shape the Urbansphere in a transformative way for the discipline of architecture and urban design.

That is when architecture becomes an urban laboratory in its broader sense. In the case of ecoLogicStudio's prototypes they acquire a speculative edge, as tools to construct visions of future urbanity. The theoretical speculations presented here are grounded in them and in their experimental deployment in the city. These experiments are in this sense instruments to develop alternative narratives for the emerging Urbansphere. These narratives unveil a new nature, or perhaps aspects of a renewed paradigm of nature that will became significant to the future of architecture.

7

Living Screens: The Foraging of Atmospheric Patterns

Johana Monroy, Catalina Puello and Fabio Rivera

Institute for Advanced Architecture of Catalonia (IAAC),
Carrer de Pujades 102, Barcelona, Spain
E-mail: johana.monroy@iaac.net; catalina.puello.acosta@iaact.net;
fabio.rivera@iaac.net

A new emergent field of research focuses on bio-inspired material systems and computer-aided fabrication processes, allowing designers to experiment with new ways of production and novel design approaches. This debate, linked to a more responsive architecture and nature, highlights a conscious observation of biological processes into distinct and valuable design methodologies for architectural explorations. This chapter investigates the design possibilities through the research of the single-cellular organism *Physarum polycephalum*, also known as slime mould, and proposes an innovative material system for architectural purposes. The "Living Screens" project intends to maximize the biological properties of the slime mould, engaging a structural bio-machine capable of manifesting and articulating the cognitive relations between the user and the space. This research is divided into two parts: the first part focuses on the analysis of the natural properties of said organism, and the second part concentrates on the main question being how to apply these properties into an architectural artefact using computer-aided prototyping and the fabrication of the actual structure. The presented research, material tests and techniques demonstrate the first successful physical model result of the complex bio-machine capable of altering the interior space perception through the densification of the *Physarum polycephalum's* dynamic patterns.

7.1 Introduction

Architecture has experienced a special interest of exploring biological processes as part of the design practice; architects have drawn inspiration from natural systems for centuries. Unfortunately, with this creative genealogy, architecture has reliably been considered as a counter-form to nature staying purposely from the living world and favouring the part of a banal scene that supports nature by methods for clean inhibition. The vast amounts of tools offered by biology are stimulating the improvement of new forms of architecture that responds to environmental changes by incorporating the dynamic properties of living systems. Synthetic biology offers an innovative way of connection between the enormous advantages of living systems with architecture, to produce a true genuine and sustainable environmental design. Biological structures can inspire traditional methods of construction and materials, hence a building is not anymore a structure which only hosts human beings but should also promote the interaction of many organisms of different scales.

The unique physiology of the *Physarum polycephalum* makes it an ideal research organism for many fields of development (Stephenson and Stempen, 2000; Alvarado and Stephenson, 2017). The slime mould, due to its many properties, has been used for computation, urbanism, art and even medicine. It is not a fungus as the name implies but a large amoeboid organism consisting of a dendritic network of tube-like structures. The complex networks that it makes not only add aesthetic value to its growth mechanism but also clearly demonstrate its ability to solve spatial problems. This network of protoplasmic vein-like structures dynamically redistributes according to its nutrient sources. It would transform into a fan-like morphology that will ensure a better adaptation for nutrient absorption. This growth develops at a speed exceeding 1 cm/h. The slime mould is found worldwide and typically resides in dark and moist areas where it can take advantage of multiple sources of nutrition. The *P. polycephalum* possesses the ability to sense and migrate towards or away from certain chemical gradients. This foraging behaviour can be used to program the organism with strategically placed nutrient sources. Previous research has shown that slime mould is able to construct highly efficient network and solve maze problems, reaching its nutrients in the most practical way by finding the shortest path solution (Adamatzky, 2010, 2016).

As the slime mould migrates, it leaves behind a trace of slime, which are grown solutions over time. These traces are the organism's effluvia, the stored history of where it has been, that helps it navigate through its environment

with a natural strategy to solve foraging problems. The slime mould is a living example of the so-called smart material because of the way in which it combines robotic and control functions in a distributed manner throughout its constituent material; its intelligent and emergent behaviour, fast growing pattern-making and sensorial capabilities makes it an idea substrate for real-world fields such as performative architecture (Saul, 2015).

7.2 Project Description

Living Screens is a research project that studies the possibilities of using a living organism, the slime mould *P. polycephalum*, as a panel for interior spaces, which is actively responsive and constantly changes according to the users parameters. The material system consists of a series of transparent layers that compose the panel and creates a suitable environment for the slime mould to grow. The panel is designed to feed the slime mould so it increases the density of its natural patterns working as a living wall that filters the light in space. The system engages different customizations such as: opacity, translucency, transparency, pigmentation and shadows projection. The slime mould's growth is controlled by the nutrients source, which comes directly from a food-distributor machine. Said machine deploys the food in specific platforms inside the panel, allowing the patterns in each layer to be reciprocal thus having different densities. The panel also includes a humidifier dispenser that controls the levels of humidity inside it; the slime mould requires an airtight environment capable of maintaining the humidity and protecting it against outside agents that could alter its development. The result is a dynamic wall that not only changes in time, altering the interior space through colour and opacity but also affects the mood and experience of the spectator (Figure 7.1).

PHASE 1: Initial culture experiments

In the beginning of the project, we decided to work with a material that could manifest a dynamic behaviour based on growth and movement. In the immediate research, it was discovered that the organism *P. polycephalum* could be a suitable medium for this research since it could move and grow naturally. We studied the slime mould's characteristics and properties discovering that it has been used in many research fields and that it could be used for architectural purposes. For each property, we brainstormed on how we could use or embed these properties to a new material system. The analysed properties are:

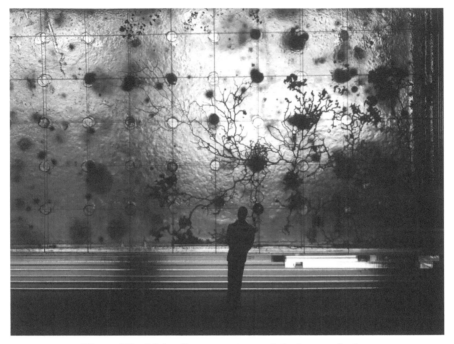

Figure 7.1 Living Screens system and shadows projection.

- REGENERATION: The slime mould could rebuild connections if these ones were removed artificially to assure the nutrients flow. The organism could regenerate in a manner that it re-colonizes some nutrients in case there is a new nutrients source in the same area, meaning it can go back and regenerate traces left behind. With this property, we thought that the *Physarum* could be used to explore and analyse types of regenerative and dynamic architectural systems.
- MEMORY: The slime mould is capable of extracellular spatial "memory" (Reid et al., 2012). As it migrates around its environment, it is able to sense chemicals where it can avoid some areas or detect if there is an alteration in areas previously visited. This memory allows the slime mould to solve navigation problems since it can recall where it has already foraged. This type of memory is being studied for bio-computational devices, since this change can allow learning and decision making in terms of connectivity.
- SENSORS: The plasmodium forages according to the position of nutrients but it is also responsive to external gradients in light and

humidity. The *Physarum* will propagate according to certain chemicals either chemoattractants (glucose, galactose, maltose, leucine, etc.) or chemorepellents (chloride salts, potassium, etc.).

- NETWORK PROPERTIES: *Physarum* has been used to recreate motorway network in the United Kingdom (Adamatzky & Jones, 2009) and rail network around Tokyo (Tero et al., 2010), being able to connect the stations in which cost, efficiency and resilience are appropriately balanced. The slime mould can organize itself to optimize the route of its growth, remembering obstacles so it can avoid them later.
- CONDUCTIVITY: According to Adamatzky (2016), the slime mould shows oscillating electrical potential of up to 5 mV with a period of 60–120 s. It displays electric oscillations by streaming contraction where it releases calcium ions. These ions on the protoplasmic tubes conduct a DC voltage approximately 90% of the input voltage. *Physarum*'s connections of 1 cm have a resistance of 3 MOhms (SD 0.715 MOhms), with amplitude of 0.59 MOhms in a period of 70 s. With this property, the slime mould could perform as an actuator for controlling a device or a driver for an architectural system.

With these proposals in mind, we performed material tests on the *P. polycephalum* (Figure 7.2). With Culture #1 and #2, our intention was to multiply slime mould patterns. In all experiments, the slime mould was cultivated on agar substratum. The agar is an organic jelly-like substance obtained from algae, which is a derived from polysaccharide agarose present in the supporting structure in the cell walls of some species of algae, and is released when boiled. Agar is used in microbiology to provide a growth medium where microorganisms can be cultured and observed under the microscope. Thanks to its texture and properties, agar is a suitable medium to study microorganism's motility and mobility. Its high level of viscosity maintains humidity, which recreates the ideal environment for organisms to grow. We rapidly increased our cultures of *Physarum* by giving them oat flakes, a nutrient that has been proven to be ideal for optimal growth. After reproducing the microorganism, we performed tests with current stimulations and LED red light. We succeeded to guide the slime mould towards the negative current and towards the red light, which showed its particular proclivity for this colour. Other experiments in this phase include growth with a minimal amount of sclerotia, placing the nutrients under the agar and changing the food source from oats to sugar. All these tests demonstrated how fast the slime mould would grow, its mobility capabilities and likes or dislikes to

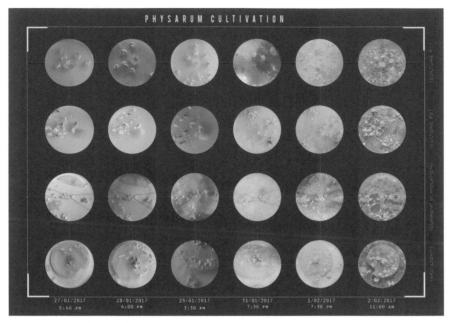

Figure 7.2 Physarum Cultivation Diagram: Initial Cultures.

certain food. We concluded that the slime mould's growth could be stimulated under certain conditions: a proper food source enriched with carbohydrates (preferably oat flakes) and red light could enhance the slime's growth towards a certain location or it could grow faster.

PHASE 2: Material tests – substratum

For this phase, we focused our experiments in material tests, in terms of change of substratum. Our aim was to analyse if the slime mould could grow on a different substratum other than agar. The different substratum's included paper, fabric, wood, brick, clay, water, sodium polyacrylic, gelatin, metal, paper tape and plastic (Figure 7.3). In most of the cases, the *Physarum* dried up since the medium was not moist enough and it was left in open-air conditions. The cultures that survived were the ones that were enclosed in a petri dish or a container, such as the plastic material test. With the clay substratum, we started to see the growth of other organisms such as mycelium, which in a few days consumed the slime. Parallel to this test, we started having multiple contaminations in other cultures. The food had to be changed periodically so other bacteria would not affect the slime mould.

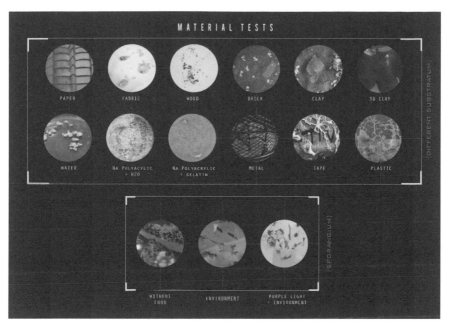

Figure 7.3 Physarum Cultivation Diagram: Material Tests – Change of Substratum and Sporangium Growth.

We concluded that the *Physarum* needs a humid environment and it has to be protected from open-air conditions to prevent contamination. We analysed that the slime mould could grow in different substratum if the humidity levels are stable enough. In this phase, we started experimenting how and what conditions could trigger the sporangium phase on the *Physarum*. We concluded that this sporangium phase would manifest if the cultures were left without food and in open air without a proper moist environment.

PHASE 3: Spatial tests and conductivity

In this phase, we performed spatial experiments and decided to go deeper in terms of exploring the conductive properties of the slime mould. We fabricated different matrices in agar and other materials to see if the slime mould could grow on a non-planar surface. From straws, to ramps and staircases of agar (Figure 7.4), we encapsulated the slime mould in small boxes of acrylic, controlling the periods of openings of such boxes so external agents would not affect the inside. In all of the cases, the slime mould grew successfully reaching the food sources in different locations in the matrix.

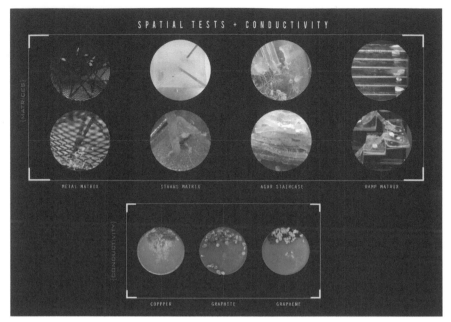

Figure 7.4 Physarum Cultivation. Spatial Tests and Matrices for three-dimensional growth.

We also concluded that the *Physarum* takes more time to grown in non-horizontal surfaces. At the same time, we started combining the food (oat flakes) with other components such as copper, graphite and graphene to test if the slime mould could ingest these particles and enhance its conductivity properties. Unfortunately, the slime mould did not grow as expected in any of these cases, and due to lack of proper equipment, we were not able to test if its conductive properties had been altered by such conditions.

PHASE 4: Environmental control

With all the experiments previously executed, we directed the project into an actuator system that displays physical data (from information pulled from the Stock Market to information that can be generated from the building that hosts the system). The *Physarum* could be a medium for displaying relevant information in the space, without being corrupted by outside sources, reducing the patterns of ignorance across the current state of society. As the slime grows, it leaves a trace of protoplasm allowing users to analyse this trace as a history of the information, which is being constantly updated. The slime mould's pattern cannot be altered and the organism would display

useful information in a legible manner. The project was thought of as a series of panels where the food would be distributed according to a data feed from a reliable source, allowing the amoeba to create a network of natural patterns and eventually display said information. In order to continue with this idea, we had to perform experiments to learn how to control the slime mould's growth or the directions of its growth. We started testing with a light path where the slime mould were located on the shadow section of the path; since the slime mould is photosensitive, the aim was to prevent its growth on the lightened path.

The system implies the use of a machine that automatically drops the food according to the data; for this reason, the food has to be in a liquid state. We experimented with liquid oats and normal oat flakes to see the slime mould's preference. To encapsulate the slime mould in panels, we had to understand the proper conditions of light intensity, humidity and temperature that would maintain the organism alive. We concluded that the optimal humidity should be above 70%, and the temperature should not be higher than 23%. In all of the cases, the light intensity was not a relevant factor for its growth as long as the humidity was met its standards. We also experimented with chemorepellents such as salt as a limiting component. The salt worked as expected preventing the slime mould from growing in most of the area where the salt was placed. The system also required the slime mould to act as an actuator, which led to experiments where we located the food on top of light sensors. When the slime covered the light sensors, it activated a LED light. All the experiments were successful, which led to the design of our prototypes. At the end of this phase, we realized that in order to create a performative prototype, we needed to narrow down the idea of visualizing physical data. For this purpose, a reliable data collector was needed to have this information displayed. Hence, the outcome of this idea was nebulous, the main concept was redirected into something more tangible; a performative and self-regenerating architectural system capable of using the slime mould's natural patterns to alter the users experience in the space.

7.3 Concept

When it comes to the human-organism coexistence, one can imagine that both organisms are reciprocally feeding. There is the human providing the food for the organism, and the organism growing and in time displaying patterns of light intensities that alter the occupied space. In this same scenario, the human-made space (architecture) and the exterior biological organism

(slime mould) interact with each other and exchange information. There is a direct interaction between the species and the user through the strategic customization of the nutrients arrangement, and the incorporated organism by the anastomosis of intricate patterns. These interactions evolve into a dialogue between the two organisms cognition where both of them acquire knowledge and experience from each other. This narrative performance is in constant mutation in which the user does not acknowledge the organism's behaviour, and the slime mould does not know where the user will arrange the nutrients source. The exercise of foraging and systematization generates a new language where the user-organism's coexistence becomes a discernment of the physical space where visually and atmospherically, the space is significantly altered by both entities.

Material is more than just an element that encloses and harbours protection; it is the play of textures, colour and light that sets the mood of a space and characterizes its existing reminiscence. It's the physical interpretation of the designed space where it gives it life and allows a set of multiple correlations between the user and the architectural artefact. The *Living Screens* project adopts an organism to create a new material system. The growing slime mould inside the panels will display its own natural behaviour. Human, mould and machine directly work together to enhance and transform the narrative of the space through a living material. This improvement and physicality is not only constituted by the organism's performance but also for the user's experience inside the phenomenological reality. Experience in built structures also contributes to neutral and less positive states of mind and shapes of how broadly the user takes in the environment. The ways we experience architectural objects may contribute to how we comprehend and interact with those objects[1]. The content and properties of the architectural experience most likely include emotive, sensorial and cognitive attributes.

The human experiences of space, light, colour and shape concede multiple interpretative possibilities across the architectural object. These perceptual tasks are constant and sometimes include other sensory modalities. The architectural experience should be proprioceptive, incorporating visual information into a broader set of stimuli to grasp bodily position and movement in relation to the built environment. Experiencing movement around an architectural artefact highlights the design and contributes to the cognition and apprehension of the artefact's formal features such as spatial patterns and rhythm, and perhaps other aesthetic attributes. The experience of movement

[1]"Philosophy of architecture" Saul Fischer (2015).

captures and connects the relation between the spectator and the built artefact, as well as the immersion in its context transmitting a sense of location. Therefore, light and movement are basic physical notions for the construction of the formal space and primal experiences that articulate the perceptual and sensorial cognition of said space. The perception of space is directly proportional to the way light integrates with it. The lightning situation is capable of determining the dimension of how the user analyses space, material and colour. Light is an intangible maker of material that constitutes a fundamental relevance for the design in architecture and conceives the atmosphere related to the psychological mood and general character.

> "...The atmosphere of a building seems to be produced by the physical form. It is some kind of sensuous emission generated by the stationary object. To construct a building is to construct such an atmosphere. Atmosphere might even be the central objective of the architect. In the end, it is the climate of ephemeral effects that envelopes the inhabitant, not the building. To enter a project is to enter an atmosphere. What is experiences is the atmosphere, not the object as such."
>
> (Wigley, 1998)

Levels of brightness, shadows, reflections, colours and glare are fundamental notions to spatiality where it is able to alter the interpretation and experience in which it can be perceived as monotonous, cheerful, private or public. Visual experiences enhance the ambiance of social interaction in a designed space; lightning is not only important but should be well thought out to intensify such enhancements that enrich the space in terms of health and psychological wellbeing. The *Living Screens* project reconstructs the space through an organism that is constantly altering the optical phenomena, the conceived physicality and the materialization of light and motion as an architectural element. The space is no longer static as the play of transparency is continuously being modified. The organism's density can be controlled in how it grows providing a layering effect that increases or lessens the amount of light that goes through the panel. In the project, the patterns produced naturally by the slime mould are the material, which adds not only functionality to the space but also an aesthetic value. The patterns and densities are always different and therefore the spatiality will always be different, producing a varied experience.

7.4 Prototypes and Applications

One of the main concerns for the prototype was how to provide a constant food source for the *Physarum* to grow inside the panel. Since it is an airtight capsule, a food distributer machine was designed and fabricated: "F.L.O.K.I" (Food Location for Organizational Kinetic Interaction). The mechanism is based on an X and Y-axis CNC milling machine that would move according to the users inputs. It drops a small amount of food that is later directed to the panel. For this task a peristaltic pump was needed so the food could travel from the source to the point of distribution. Initially, the concept included a series of distributing tubes that are connected to the food distributor and the food is pumped inside the panel. For the first design prototype, we decided to build the panel as a set of transparent layers of methacrylate. Since networks of tubes were entering the panel, space was needed. We fabricated the first layer using a thermoforming technique allowing the layer to have a smooth and curved finish that would leave enough space for the incoming tubes adding a magnifying effect to the panel. The system is designed to be self-standing or hanging. The food distributor is located on top of the panel so the food irrigation is enhanced by gravity.

For the final prototype, major modifications were done in order to improve the system's performance. We decided to simplify the panel design allowing the natural patterns of the *P. polycephalum* to be the main attractor for the project and not the overall design of the components. By simplifying the panel, the patterns are visually enhanced allowing it to perform correctly, altering the atmospheric experience in the space. We decided to modify the food-distributing system, by substituting the tubes network by small methacrylate platforms inside the panel. The platforms were designed with a genetic algorithm for the optimization of the platforms position in each panel. Instead of fabricating multiple components, we created one single panel with three layers of $1000 \times 700 \times 4$ mm transparent methacrylate. Each layer is coated with a hydrophobic spray (to prevent the excess of condensation), an anti-static spray (to prevent the adhesion of dust particles) and a 2 mm layer of agar (to keep the optimal levels of humidity inside the panel). The panel is airtight in all of its sides with a 2 cm sealant of silicone, and it is joined with 6 mm screws, bolts and nuts. The system is a floating wall capable of dividing spaces and performing alterations of light phenomena (Figure 7.5).

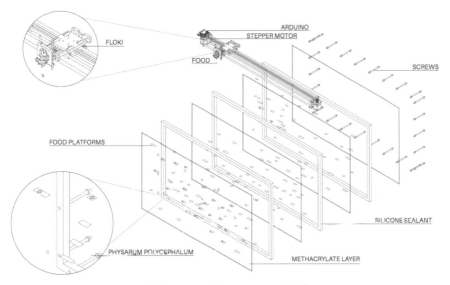

Figure 7.5 Living Screens assembly diagram.

Living Screens is a final product and a design tool, which adjusts its performance to any interior environment. Living Screens may follow a multitude of scenarios, evolving *in situ* and evoking dynamic experiences between the users and the architectural artefact. The flexibility of its performance allows it to be a suitable element for many events concerning the location. Although Living Screens is not only limited to the interior space, it can be placed as an exterior element such as the north facades for buildings where the solar radiation is not harmful of the *P. polycephalum*'s natural development (Figure 7.6). Living Screens design is capable of filtering the light in the spaces. Its dynamic patterns and conditional growth system can create transparent, translucent and opaque effects, as well as shadow projection and changes in pigmentation. Depending on the spatial program and interior conditions, different emergent patterns display can be executed. In order to visualize said performance, the food distributor machine "F.L.O.K.I" translates the user's desires into g-code, which is interpreted as coordinates for the food's arrangement. The system and the research have shown that it can be adjusted to the needs of each situation.

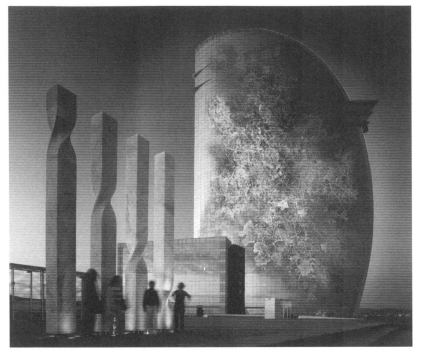

Figure 7.6 Living Screens case study, W Hotel in Barcelona, Spain.

7.5 Vision

The vision of this project is beyond the idea of visually seamless spaces, where the exposed relations are always shape-shifting the space and the outside context. With this symbiotic concept of co-design with nature, the system is projected to always change the architectural program through a transmogrified materiality, and the user's social interactions engages a more direct relation with the architecture and within themselves. Hence, society participates in the creation and customization of their own personalized environment, through the insertion of a natural organism that at the same time is making the space alive. Furthermore, the living space has its own performance without the implementation of high-energy-consuming systems. The space then, has acquired its own intelligence and sensorial adaptations that responds to the humans' emotions and experiences. In terms of the mechanics of the prototype, Living Screens is envisioned as a system linked to an interface, where users can take advantage of the new technologies to

project their inputs to the artefact. The panels also include a humidifier system that substitutes the layers of agar so the slime mould can grow as expected. The panels use a food distributor machine that can adapt to any geometry that the design would require. In terms of pigmentation, the slime mould could be used as a bioluminescent organism or material if fed with a phosphorescent pigment or algae, and be employed for sustainable nightlight applications.

Moreover, Living Screens is an adaptable system to not only outdoor applications but can also work as a hybrid system to display information (as contemplated before, see Phase 4). A data-driven artifice where data can change aesthetics: form follows information. The natural system would grow in order to visualize data such as circulations, events or concentrations of people. Even in a bigger scale, it can work as a predictive system for applications in the city related to traffic, weather and more by its natural optimization of its networks. The system could be envisioned as a potential receptor of environmental conditions thanks to the *Physarum*'s sensorial properties. Patterns of the organism can be seen and compared as patterns of the urban sphere and the society itself. Hence, the system is a natural simulation of the human's behaviour through the physicality of its traces.

Acknowledgements

The project was supported by Institute for Advanced Architecture of Catalonia (IAAC). The authors are grateful to Areti Markopoulou, Alexandre Dubor, Angelos Chronis, Núria Conde Pucyo, Angel Muñoz, Andrew Adamatzky, Tomohiro Shirakawa, Jeff Jones, Ami Nigam, Jesús Valenzuela, Ilker Bayer, Antoinette Chidiac and Zrinka Radic.

References

Adamatzky, A., and Jones, J. (2009). Road planning with slime mould: If Physarum built motorways it would route M6/M74 through Newcastle. *arXiv preprint arXiv:0912.3967*.

Adamatzky, A. (2010). *Physarum Machines: Computers from Slime Mould*. World Scientific.

Adamatzky, A. (2016). *Advances in Physarum Machines*. Springer.

Alvarado C. S., and Stephenson S.L. (2017). *Myxomycetes: Biology, Systematics, Biogeography and Ecology*, Academic Press.

Reid, C. R., Latty, T., Dussutour, A., and Beekman, M. (2012). Slime mold uses an externalized spatial "memory" to navigate in complex environments. *Proceedings of the National Academy of Sciences*, 109(43), 17490–17494.

Tero, A., Takagi, S., Saigusa, T., Ito, K., Bebber, D. P., Fricker, M. D., Yumiki K., Kobayashi R., and Nakagaki, T. (2010). Rules for biologically inspired adaptive network design. *Science*, 327(5964), 439–442.

Saul, F. (2015). Philosophy of architecture. *Stanford Encyclopedia of Philosophy*. (https://plato.stanford.edu/entries/architecture/)

Stephenson S. L., and Stempen H. (2000). *Myxomycetes: Handbook of Slime Molds*, Timber Press.

Wigley, M. (1998). The architecture of atmosphere. *Daidalos*, 68, 18–27.

8

Slimedia: *Physarum* as *Medium* and Cultural Mediator*

Sarah Choukah[1], WhiteFeather Hunter[2] and Tristan Matheson[3]

[1]University of Montreal, Montreal, Canada
[2]The University of Western Australia, Perth, Australia
[3]Concordia University, Montreal, Canada
E-mail: schoukah@gmail.com; whitefeather@whitefeatherhunter.com;
trifektion@gmail.com

8.1 Introduction: *Physarum* as Artistic *Medium*

In the past 20 years, *Physarum polycephalum* (a.k.a slime mould) foraged its way out of Petri dishes and herbarium drawers, and showed up in transdisciplinary[1] research laboratories, and art and design studios. *Physarum* also exposed itself to the scientific and general public in new ways. In the United States, Tim Grabham and Jasper Sharp released the first independent documentary on *Physarum* (2014). French entomologist Audrey Dussutour shared her unusual, captivating experiments on "the blob" with lay audiences in her book, *Tout ce que vous avez toujours voulu savoir sur le blob sans jamais*

*The authors wish to thank the Université de Montréal's department of communication, Concordia University's Milieux Institute for the Arts, Culture and Technology, the Critical Making Lab and Semaphore Research Cluster at the University of Toronto, as well as Studio XX, Inter/Access and DIYbio.TO for their help and support.

[1]We situate transdisciplinarity in contrast to *"plural – or multidisciplinarity* in which researchers meet and work together, but each discipline remains intact" as well as with *"interdisciplinarity,"* arising out of "situations in which methods from one discipline are adopted by another" (Hagoel and Kalekin-Fishman, 2016 p. 19). A transdisciplinary approach, in the words of physicist Basarab Nicolescu, is "not concerned with the simple transfer of a model from one branch of knowledge to another, but rather with the study of isomorphisms between the different domains of knowledge." (1987, quoted Hagoel and Kalekin-Fishman, *ibid.*).

oser le demander[2] (2017). Bioartists/researchers Heather Barnett (UK) and Theresa Schubert (DE), and community laboratory leaders such as Nurit Bar-Shai (US) have enabled novel, amateur DIY *Physarum* research and bioart experimentation (2013, 2014, 2016). Researchers Eduardo Miranda (UK) and Andrew Adamatzky (UK) broadened experimental and theoretical potential with *Physarum* in fields such as music and electronics, computation and mathematics (Adamatzky 2015, 2016, Miranda 2017, Miranda et al. 2011). US scholars, Steven Shaviro (2010), Eugene Thacker (2011, pp. 92–93), Aimee Bahng (2017) and Evelyn Fox Keller (2011) introduced *Physarum* to the humanities and social sciences through their research and writings.

Together, these contemporary initiatives illustrate *Physarum*'s potential to transform research, further connecting people and projects across institutional boundaries. They also showcase *Physarum*'s versatility, first as a *medium* of creative expression in the arts and sciences, and second, as a science and culture communication *medium* – an intermediary connection between expert and lay audiences. The notion of artistic *medium* thus acts as a departure point, a launch pad for *Physarum*'s traffic between theory and practice, between model and application, and between artists-researchers and publics.

Our contribution is part of a wider research agenda, an effort to explore a combination of *Physarum*'s affordances as *medium*. We propose that work with *Physarum* fosters: 1) new intersections between institutions and disciplines; 2) new paths between theory and practice and 3) new connections between artists, scientists and publics. We look at how *Physarum* facilitates art and research between disciplines *and* modes of expertise. We aim to draw from *Physarum*'s trajectories across design, arts, sciences and engineering to contribute further to existing, hybrid modes of bioart engagement, to enhance their reach and boost their accessibility. We also seek to document the opportunities and challenges presented by such hybrid approaches.

In this chapter, we report on recent explorations of *Physarum*'s capacities for community art exchange. We describe our engagement with building on *Physarum*'s ongoing transit between art, biology and technology in the context of bioart workshops conducted at Studio XX and Inter/Access, two Canadian artist-run centers. Through re-visiting our workshop experience at Studio XX, we recount how *Physarum* enabled first-time collaborations between artist-researchers WhiteFeather Hunter, Tristan Matheson and Sarah Choukah.

Following this visit, we show how *Physarum's* workshop affordances and constraints shaped a notion we call "plasmodalities", in reference to

[2]Translation: "Everything you ever wanted to know about the blob, but dared not ask".

the unique artistic modalities and interactions enabled by *Physarum*. We balance empirical experience with theoretical development throughout the *Plasmodalities* section, to show how everyday cultivation and care of slime mould changed our approach to ideas of individuality, community and communication through art. We amplify our suggestions in the subsequent section, were we discuss *Physarum*'s talent for facilitating new modes of *distributed artistic experimentation*. The section entitled, "*Slimedia*: connecting *Physarum*, artists and publics" follows up with our remarks on *Physarum* as *medium* by entertaining the notion of *Physarum* as cultural mediator. The *Slimedia* section also showcases artistic creations and novel approaches developed by Inter/Access workshop participants, instructors and co-researchers. We conclude our excursion by changing our focal lens, and recap on benefits, outcomes and future challenges of bioart practice with *Physarum*.

8.2 Routing between Disciplines and Institutions with *Physarum*

8.2.1 A First Workshop – Studio XX, May 2017

In the next two sections, we offer a rearview mirror into our work as workshop designers and instructors at Canadian artist-run centers, Studio XX and Inter/Access. We begin in Montreal, in May 2017, where *Physarum* brought WhiteFeather Hunter, Tristan Matheson and Sarah Choukah together in the context of cultural mediation activities in electronics and *media* arts. *Physarum* brings us next to Toronto, a few months later, as we see it acting in the context of a bio*media* workshop for electronics and *media* artists. In *Section 8.3*, we follow up on these two workshops to draw from our experience, charting implications for the design and practice of public bioart and biodesign workshops.

Independent, artist-run centers such as Studio XX (Montreal) and Inter/Access (Toronto) thrive on the fringes of academia[3], at the *avant-garde* of contemporary and fine arts institutions such as museums and private art galleries. The centers' founders first aimed to bolster opportunities and

[3]Over the years, Studio XX has collaborated with Québec university faculty members and research groups on numerous projects. Many Studio XX members are enrolled in art and art history departments. Graduate initiatives, such as Renata Azevedo Moreira's PhD research-creation project, betokened clear shifts in relationships between independent art centers and universities. We wrote, however, that Studio XX stands "at the limits of academia" because such shifts have only begun. We encourage a perspective where independent art centers' missions mutually complement those of art and education institutions.

education for local, emergent and culturally diverse technological/*media* artists. Studio XX, a bilingual *media* and technological arts center co-founded in 1996 by Kim Sawchuck, Patricia Kearns, Kathy Kennedy and Sheryl Hamilton, fosters solidarity, provides space to create community ties, empowers women/femme and LGBTQ2+ artists through Do-It-Yourself (DIY) and Do-It-With-Others (DIWO) ethics. For Studio XX, supporting marginalized, underfunded artists encourages otherwise unheard voices to take part in public dialogue and debate. However, such institutional boundary-work demands ongoing engagement with institutional funders, and active, inter-institutional discussion with wider publics to improve artists' visibility, working conditions and overall well-being.

We contend, in this section and the following, that *Physarum* not only lent itself as a flexible and sociable bioart workshop *medium*, but also as a cultural mediator – a social networker that allowed for unusual encounters between individuals, artist communities and wider cultural institutions, encompassing scientific, technological, and *media* arts. From an artistic perspective, *Physarum* provided for individual experiments with filamentous, networked movement in space-time, just as it facilitated the collective emergence of new networks, that of bioart and bio*media* workshops. In other words, just as it provided the material plasticity and affordability needed to create bioart workshops, *Physarum* also gifted instructors with unconventional routes between disciplines and institutions.

Our initiative for *Physarum* workshops followed 3 years after a first encounter with the artistic culturing of slime mould. In late 2013, Sarah Choukah came across "the blob" during a biodesign workshop she attended at Genspace, a Brooklyn-based biotech community laboratory (a.k.a biohackerspace[4]). Nurit Bar-Shai designed the activity to allow artists free encounters with *Physarum*'s maze-solving abilities. After a quick introduction to bioart with *Physarum,* Bar-Shai distributed Petri dishes, oats, and fresh slime mould inocula to the group, who were then invited to construct a *Physarum* foraging experiment as an artistic statement of collaboration with the blob. Choukah's fascination with *Physarum* soon gave way to a keen interest in other critters.

[4]Computer and electronics hobbyists, as well as makers, entrepreneurs and artists gather in hackerspaces the way fitness enthusiasts attend a gym club. For a monthly fee and/or contribution, members gain access to machines, instruments, equipment, components, workshops and the company of like-minded peers. Likewise, biotech and biology enthusiasts gather in biohackerspaces, DIYbio labs and community biotech labs to share equipment, expertise and ideas around projects. In other words, biohackerspaces are to biotechnology what hackerspaces are to computers.

She joined two Genspace lab members who tinkered on a bio-arcade game using *Paramecium sp.*, and started tinkering with electronics and Arduino microcontrollers that oriented the water-dwelling amoeba's movement.

Back in Montreal, Choukah, a volunteer board member at Studio XX, participated in a new initiative: *"Electronic Arts with Families"*. Natacha Clitandre, Studio XX's programming coordinator suggested the project, a series of Sunday afternoon workshops modeled after *Coding Goûters*, a French non-profit organization that initiates children in programming and craft electronics through weekend family activities, such as brunches and lunches. Municipal funding enabled collaboration between Studio XX's Cultural Mediation, Archives and Network Coordinator, Stéphanie Lagueux and local *media* artists, to develop accessible workshops for children aged 6–12, along with their parents.

WhiteFeather Hunter, a transdisciplinary artist, scholar, educator, lab technician and principal investigator at the Milieux Institute for Arts, Culture and Technology at Concordia University, has researched and developed new biomaterials and bio*media* through investigations of the symbolism, assumptions, politics and design of contemporary bioart and biotech. She exhibited this work internationally. She also designed, wrote and self-published an open-source book of bio*media* and biodesign protocols and theoretical frameworks for them (Hunter, 2015).

Tristan Matheson's interests in history, classics, music and archeological fieldwork nurtured his critical concerns for demystification and accessibility in biotechnology and medicine.

In October 2015, at Concordia University's Faculty of Fine Arts (FOFA) gallery, Hunter and Matheson collaborated to present intersecting theses research-creation outputs, during the annual international Media Art Histories (MAH) conference. The joint exhibition was entitled, *Biomateria + Contagious Matters*. Matheson's body of work featured some of the cultural and physiological dimensions of cancer through 3D time-lapse videos of live HeLa cells[5]. Hunter's various installations included a DIY CO_2 incubator that housed live tissue engineered biotextiles. In early 2016, Hunter and Matheson presented this work during an artist talk at Studio XX, with Choukah acting

[5]*HeLa* stands for *Henrietta Lacks*. Lacks' cancer cells, the first and oldest successfully immortalized cell lines, enabled unprecedented advances in contemporary biotechnology and medicine. Lacks, an African-American tobacco farmer who lived in Baltimore, United States, died in 1951 from cervical cancer. Her tumor cells were taken without her or her family's informed consent. Lacks' children only found out about the advances – and profits – made possible by HeLa cell lines more than 20 years after their mother's death (Skloot, 2010).

as moderator. Together, we explored issues of materiality of bio*media* in bioart, human/non-human sensing and some of the ways in which bioart could transform society. Through this mediated discussion, Hunter and Matheson's research projects sporulated into a collective set of questions and endeavours, informed by our backgrounds in the social sciences, humanities, fringe and contemporary arts.

Like many of our peers present that evening, we challenged the standard of siloed research groups and departments within the ivory tower of academia. Yet, the *Biomateria + Contagious Matters* exhibition also openly displayed the administrative and regulatory red tape that delimited possible experimentation in and out of biotech laboratories and art studios. Combining the two sites in new spaces for bioart practice had required intensive bureaucratic paperwork to land biosafety and security certificates, institutional support and permissions to even present the exhibition in a public setting. With such laborious investment required to establish the legitimacy of bioart and bio*media*, networking freely from academic and government institutions remained challenging.

Such challenges emboldened us to catalyze interest for bio*media* and bioart workshops in bilingual Québec and English-speaking Canada. Each artist-researcher sought to explore alternative forms of making, researching and disseminating bioart and bio*media* work while encouraging public participation. We actively offered open, DIY life sciences initiatives in and out of institutions. (Bio)Hackerspaces, DIYbio laboratories and institutionally backed centres such as the University of Ottawa's Pelling Lab for Biophysical Manipulation and SymbioticA International Centre for Excellence in Biological Art provided us original perspectives on bridging science, technology and art. They created space for creative human connection and provided resources to build projects both amateur participants and academic researchers could contribute to.

Inspired by these initiatives, we each developed critical awareness of accessibility and openness outside of institutional walls. This involved using background knowledge, positions, affiliations, credentials and networks, while reclaiming freedom to traffic in and out of institutional boundaries and limitations. Divisions between arts, sciences and humanities, despite our insistence and investment in transdisciplinary initiatives, constrained collaboration that went beyond the existing interdisciplinary programs and inter-departmental research clusters. We needed more affordable experiments. We also needed more flexible organisms – creatures that could thrive

well outside of controlled laboratory spaces, in places where distinctions between specialists and tinkerers could not only fade, but dissolve completely.

The *Electronic Arts with Families* workshop venue provided us new lanes for flight out of such divisions, prompting us to forge new, lightweight approaches against burdensome protocols. Erandy Vergara, the Studio XX programming coordinator at the time, suggested we team up again to join the series and develop a new bioart workshop. Referencing her previous Genspace experiences, Choukah determined that *Physarum* was the ideal workshop *medium* for children and their parents. Hunter and Matheson's experiences with leading educational technology, bioart and biohacking workshops contributed to early and rapid workshop prototyping. Our collaborative enthusiasm also led to *Physarum*'s entrance, as a new *critter in residence*, in Concordia's Speculative Life BioLab under Hunter's supervision.

8.2.1.1 "Your first pet slime mould"

As we brainstormed, we also started to confirm *Physarum*'s potential for 1) connecting and questioning, within and beyond disciplines and institutions and 2) cross-cutting assumptions of expertise and amateurism. The transdisciplinary aspect of artistic research is covered more in-depth in *Section 8.3.2*, where we discuss the distributed dimension of artistic experimentation with *Physarum*. In the remainder of this section, we explain how preparing and running our first *Physarum* workshop at Studio XX eased us into reconsidering power dynamics between participants and instructors, and to disrupt assumptions about expertise sharing found in more conventional and traditional technology education models.

After our first encounters with the *Physarum* organism(s) in online biological supplies catalogues, and after they moved into our apartments and affiliated university labs, *Physarum* cultures grew boisterous and unruly. They proliferated energetically and beyond the distinct walled spaces we offered them. As we witnessed them brimming over Petri dishes, around constructed agar gyms we built for them and peeking out curiously from laboratory cupboards, our ambitions also grew unruly; we pictured *Physarum* spilling over all their play spaces, drooling and pulsing over entire walls, not unlike the leading character of the classic Blob flicks though certainly in less sinister ways.

That was before our first experiences in *Physarum* stress management[6].

[6]Here we work with the biological notion of stress, which implies environmental disruption of an organisms' equilibrium.

Some of our cultures sporulated vigorously after a couple of weeks in incubators and kitchen cupboards, giving us their notice of intent to vacate. After a couple more months of tending, other cultures grew fragile and started to liquefy.

Hunter documented sporulation while she and Matheson tended to the troubled cultures. They found that *Physarum* decomposed into amorphous, unhealthy masses when scraped and crushed from one Petri dish to another. However, what may otherwise have been taken as *Physarum* culture failures provided great opportunity. Hunter became better familiarized with *Physarum* life cycles, which drew her into its many modes and phases of existence. Curiosity and disregard for pre-conceived notions of success and failure informed a variety of her experiments. Hunter encouraged *Physarum* growth on silk and cotton in order to obtain a vibrant yellow fabric dye that was deposited by the movement of the plasmodium over the cloth, and also observed her other cultures bridging across agar to connect two ends of silver conductive thread together. She and Matheson dyed agar and oats with food colouring, and obtained stunning photographs of *Physarum*'s colour uptake and visible changes when presented with the altered *media* (see Figure 8.1, photo by WhiteFeather Hunter, 2017).

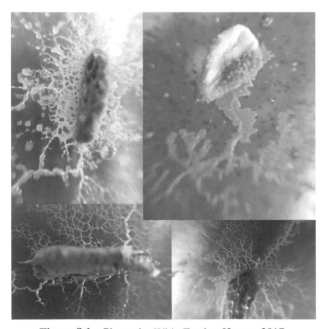

Figure 8.1 Photos by WhiteFeather Hunter, 2017.

In Toronto, Choukah sought to find out why, over weeks and months of kitchen culture, *Physarum* became more vulnerable to contamination. These attempts prompted extensive research and documentation online, and introduced her to several laboratory findings and protocols, some published well over a century ago (Clifford 1897, Langdon 1894). The variety of reported experiences indicated that, aside from a few constants, *Physarum* offered a wide range of experimental conditions. The diversity of methodologies and results further appealed to a sense of scientific practice as an experimental, tentative, contingent and pragmatic effort. They also grounded botanists' work in outdoors collection, and the subsequent easy, yet non-obvious domestication of organisms – such as *Physarum* – in the laboratory.

In the context of the approaching Studio XX bioart workshop, maintaining lively, as well as hesitant or sporulating cultures (even letting certain numbers of them rot) translated in explicit, open-ended guidelines. From the start, we voiced how we valued participant's own explorations, regardless of their new slime mould pets' fates. We introduced slime mould as gelatinous bodies of cell nuclei, attracted to things that were good for their growth, and repelled by detrimental things. We invited the emerging artist-participants to experiment with the moulds' environmental conditions. As *media* artists and researchers, doing so allowed us to stress the relevance of visual documentation, notably through photography with a camera or webcam.

At the same time, we stressed the basics. Hunter cautioned children and their parents about the cultures: "Very importantly," she stressed, "they will only grow and do well in the dark. [...] When you take them home, you'll be really excited and want to look at them a lot, and bring them out into the light, but they'll get a little bit upset and might produce spores." Thus, our months of care for *Physarum* had behooved us – after a quick, 5-minute introduction to the art, craft and science of slime mould – to get to the heart of culture matters. Instructions, in this case, stood in the middle of two extremes: our guidelines were designed to avoid an overly lax approach, where young participants would be equally rewarded regardless of their interest or engagement. We also refrained from boiling down our guidelines to stilted, parochial perspectives that would equate the most vigorous, most active cultures with best performance.

As soon as we concluded introductions with *Physarum*, we invited young participants to put on their extra small gloves and dive right into the fundamentals of medium making at home. "The stuff that's in here," Hunter said, pointing to a translucent, filled Petri plate in her raised hand, "is called agar, and it's just like Jell-O. You make it the same way you make Jell-O: you

put powder in hot water, so that's what we're gonna do." Every participant contributed to the agar-making, by pouring small tubes of agar powder that Hunter and Matheson had prepared. The two artists had also prepared and distributed colourful agar Petri plates, and later let each participant decide which food dye to colour their own plates with. Matheson knew from experience that colour was a major draw for children, and that *Physarum*'s vivid, yellow hue contrasted with different coloured agar in eye-catching variations.

Having grown slime mould for months allowed for generous distributions and showing numerous cultures in various states, on varying plate sizes and substrates. Choukah and Matheson distributed plates while Hunter tended to heating agar medium in a microwave. Participants were also introduced to techniques for observing slime mould through microscopes that had been borrowed from the Speculative Life BioLab, and via modified webcams[7] plugged into Studio XX's widescreen monitors. Participants kept their gloves on to build their first *Physarum* mazes out of freshly cooled, dyed agar plates. The young architects stooped over their agar gel foundations, manipulating pre-cut, coloured cardboard paper strips with the idea to trap *Physarum* in a region of the dish, or to compel it to climb over the strips to get to strategically placed oats.

Participants were sent home with their new Petri-dish-dwelling critters. Matheson handed them brightly coloured care instruction sheets that he had prepared, and encouraged parents to continue experimenting at home, accompanying children in making new agar dishes out of used, throwaway or recyclable containers, or to try culturing slime mould on wet pieces of paper towel. We also invited parents to help document their children's feeding and maze experiments. Choukah sent an email to the group with links to Heather Barnett's *Physarum* forum initiative, growth tips and accessible research that had been showcased in the workshop's introduction. The *Physarum* culturing experience thus continued outside the context of the workshop, and culminated 2 weeks later in a collective and festive exhibit closing the year's workshop series. Participating families brought back their living art pieces to showcase *Physarum*'s intricately networked, living habits and to give a momentary portrait of their co-habitation with slime mould tenants.

Our initial work with *Physarum* revealed a range of surprising behaviours and results, some of which could not be ignored in the context of a bioart

[7]With a manual twist of the lens, an old webcam can be turned into an affordable amateur microscope. The activity was directly inspired from a 2007 Hackteria community laboratories open science and hardware hacking project, developed by Marc Dusseiller in Zurich. See (Dusseiller, 2016).

mediation workshop. These conditions shaped our invitation, to participants and their parents, to step back from turning the unexpected into perceptions of failure or something gone wrong. That way, participants accessed a wider range of bioart experiment approaches. Children could decide to starve some of their slime moulds for a few days, or, if they wished to, could also decide to give *Physarum* other pantry foods – even create a gourmet menu – to see what, when presented with a choice of fava beans or cooked pasta, slime mould would feed on first. Pale slime deposits that formed quickly on agar indicated that the mould had already gone many places in the plates. As a relatively slow *biomedium*, slime mould explored its dish and tried to jump ship on the first occasion. Deciding to subculture plates, or not, was another artistic gesture at the young participants' disposal.

Starting from its desiccated form at a Carolina Biological supply centre, *Physarum* travelled to university laboratories in Toronto and Montreal where it was rehydrated, then on to Studio XX and finally into participants' basement closets and old shoeboxes. In this sense, *Physarum* embodied the kinds of connections we wanted to favour across institutions and disciplines, across sites of amateur and expert practices. In the context of the workshop, this allowed us to explore *Physarum*'s agency in simple, yet potent ways. For instance, as Hunter explained agar medium and slime mould behaviour, she employed creative analogies to make use of participants' cognitive bases in known, everyday experiences, to help them make sense of the new. Years of work as a bioartist, arts-based community manager and educator informed the use of such connections. Likewise, getting to know slime mould patiently, through care and experimentation, activated an ethos that brought otherwise easily devalued kitchen and domestic know-how into conversation with modern laboratory culture techniques.

8.3 Plasmodalities

8.3.1 Plasmodial Affordances

Here we leave the chronological sequence of workshop design, preparation, unfolding and conclusion. Instead, we home in on different aspects of those phases to discuss the art and design modalities of slime mould as an artistic *medium* of engagement with wider audiences. Bioart *media* such as *Physarum* key into art/science intersections and communication in many ways. Like model organisms in biology, and indicator species in ecology, we contend that *Physarum* affords distinct modes of engagement with biology, technology, philosophy and the arts.

Physarum as artistic *medium* has numerous advantages over other kinds of biological *media* such as bacteria, yeast or other genetically modified microorganisms. In contrast with much synthetic biology tinkering, *Physarum* doesn't require modification to "do interesting things".

All three instructors used 2% non-nutritional *agar* medium, boiled in the microwave and cooled in Petri dishes or used lunch containers. At least initially, *Physarum* can accommodate such casual sterilization methods. Isopropyl "rubbing" alcohol (70%) and nitrile gloves suffice to maintain a pseudo-sterile environment. With fewer requirements, the very basics of laboratory aseptic technique can be taught in a gradual manner to children and adults. Instruction can centre on sterilizing tools (forceps or tweezers, scalpels, scissors, etc.), countertops/tables and scales before manipulation of *Physarum* cultures. While our *Physarum* cultures were robust, plain tap water was used to make agar media, or to wash *Physarum*, without noticeable contamination. However, there are limits to *Physarum*'s health in home environments. Lax sanitation can eventually invite another unintended series of experiments, especially when other, true moulds start growing in the same containers with *Physarum*.

Physarum's vigour and easy maintenance make it a mobile *medium*. First, *Physarum* can be shared and shipped in sclerotized form. It can also be ordered in fresh, living state (see Figure 8.2). Once Choukah received the sclerota shipment, she sent individual samples to Hunter and Matheson in small envelopes, wrapped in black electrical tape. Rehydrated on agar, the packages of *Physarum* sclerota crawled out of their filter paper supports within hours.

As fresh cultures are established, *Physarum* can be segmented onto new agar plates to be re-sclerotized, providing for future supplies and enabling sharing with artists, students, workshop participants, etc. *Physarum* is completely innocuous to cultivate and dry. This enables bioart performances where *Physarum* is shared with the public, either on its own or within a bioart kit.

In contrast to other kinds of cultured organisms, experiments involving *Physarum* require little equipment and no expensive reagents or culture *media*. Affordable Petri dishes and scalpels can be obtained for a few dollars online or in medical or laboratory supply stores. We were able to obtain sleeves of Petri dishes, *etc.* from the local *Mycoboutique* in Montreal. We also found that clear unused deli containers provided a significant advantage

over Petri dishes, as *Physarum* would take a few more days to escape over the taller rims. As *Physarum* containers had to be changed regularly, we did not experience issues with contamination for several weeks, as long as the cultures were regularly subcultured and otherwise well maintained. Hunter kept *Physarum* cultures in Petri dishes, stored within a *Hunter* brand shoebox, at the Milieux Institute as well as at home. Choukah kept her cultures at the University of Toronto's Critical Making Lab as well as at home.

We found that 25 g packets of food-grade agar agar, obtained from small grocers, either *Telephone* or *Gold Cup* brands, provided more reliable results than expensive, organic agar agar powder sold in health food stores. Thai agar-agar proved just as reliable as lab-grade agarose. Kitchen measuring cups, paper muffin cups, scales, and mason jars were used to boil agar. Organic oats and commercial ACME brand oats were used to feed *Physarum* with no significant difference. Medical gloves, tweezers, paper towels and distilled water can all be purchased in pharmacies. In the context of bioart workshops, all supplies are very easy to source. Once a stable method of *Physarum* sclerotization is established, workshops can be set up and conducted quickly.

One of Inter/Access workshop participants cultivated *Physarum* at his workplace, enjoying the support of his colleagues in his endeavour. Choukah's colleagues at the Critical Making Lab, Gabby Resch and Curtis McCord, took care of *Physarum* cultures and sent pictures and notes on their growth when she could not be present to tend to them. Resch repurposed a 3D printer spool container into a *Physarum* incubator, and lined the incubator with a wet cloth to humidify *Physarum*'s environment. He also wired the inside of the incubator with a temperature and humidity sensor, itself connected to an Arduino microcontroller, logging temperatures and humidity levels on an hourly basis. Although these cultures seemed healthy for a significant period of time, contamination occurred quickly, especially when cameras and electronics were embedded in the plastic boxes. McCord also put forward numerous suggestions to reduce contamination, such as the creation of a miniature park, designed with mobile compartments to herd *Physarum* in fresh agar sections.

Physarum underlines the nature of instructors' encounters. *Physarum* encourages us to see that artists develop affinity for certain *media*, not only through finding themselves "good," or naturally at ease with them, but also through social and cultural experiences: travels, residencies, internships or membership in art collectives. *Physarum* highlights this aspect of artistic

practice through its particularly shareable character. Choukah travelled between Toronto and Montreal with deli containers brimming with slime mould.

When all that is needed is a 1 cm^2 piece of *sclerotium* to make slime mould bloom into luxurious plasmodial gardens, countless new encounters between artists and publics can occur, as well as between artists, scientists and engineers. Considering *Physarum*'s sociability as one of its affordances helps us reflect back on the modalities of all *media*, including conventional ones such as oil or acrylic paint, or digital photography with a single-lens reflex (SLR) camera.

As we worked with *Physarum* more and more, we realized that the critter was an ideal trafficker in broad concepts such as computation, sensing and individuality. Another part of the workshops was dedicated to exploring the interface between computation, electronics and biology. To disrupt established models, we led the course by thinking of *Physarum* as a computation maverick, a hacker of premises and presumptions of human and non-human intelligence, sensing and the embodied nature of art experience and practice. Of these premises, specifically disrupting the notion of a central organization/processing unit – such as a brain – as required for computation, consistently surprised participants. *Physarum,* with the bare vital organizational minimum of an amoeba, upended long-standing beliefs that simple organized life forms had limited sensing abilities, and very simple mechanical, positive and negative effects.

8.3.2 Distributed Artistic Experimentation

In addition to ease of sourcing for – and work with – *Physarum*, another major affordance enabled our collaboration. We found that work with *Physarum* could accentuate the decentralized aspects of practices and sites of laboratory work. The simplicity and affordability of required materials for *Physarum* culture made it possible to distribute research tasks and start preparing the workshop well in advance. While it was scheduled at the end of May 2017, we started brainstorming workshop design in January, by consigning all initial work to a shared Google Drive folder. Research and documentation efforts provided some of the workshop's main exploration themes.

Initial orders of slime mould were done through Carolina Biological's Canadian subsidiary, Merlan Scientific. We ordered *Physarum* in plasmodial as well as sclerotized form. Both shipped in less than a week. Living in

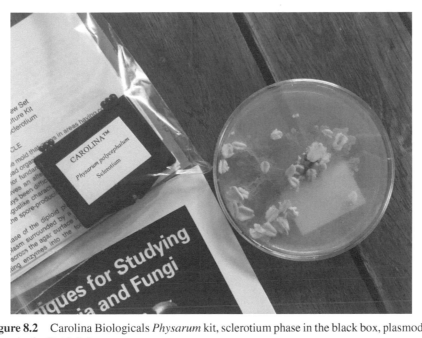

Figure 8.2 Carolina Biologicals *Physarum* kit, sclerotium phase in the black box, plasmodial phase in the Petri dish.

a small Toronto apartment, with her dog and partner, Choukah first culti-vated *Physarum* in an infrequently used winter clothing and shoe closet, in paper towel-lined dark plastic containers and Styrofoam packaging. She initially washed *Physarum* under a lightly running faucet, according to University of North Alabama biology professor Paul G. Davidson's instructions (Davidson, n.d.).

Workshop instructors' preparations for *Physarum* workshops were highly distributed, first across cities (Montreal and Toronto), laboratories (Milieux Institute's Speculative Life Lab at Concordia University, Critical Making Lab, part of the Semaphore Research Cluster at the University of Toronto, Inter/Acess as well as DIYbio TO, Toronto's community biotech laboratory).

While tending to *Physarum* cultures in more than one place at the same time, we also brainstormed ways to automate *Physarum* feeding and monitoring, conjuring up ideas of remote-controlled, miniature slime mould conveyor belts feeding them oats, or about Internet streaming of *Physarum*'s plasmodial streaming, that is, the back-and-forth, muscle-like electrical contraction and relaxation of *Physarum*'s tendrils, allowing for nutrient transportation, movement and growth.

In addition to distributed workshop design, participants could freely continue experimenting with slime mould in their homes. *Physarum*'s low migration rate afforded multiple sites of experimentation. This in turn gave a "distributed" aspect to the workshop, not only in terms of the activity's boundaries over time, which could be distributed over the next weeks or months, but also in terms of distribution in space, as home experimentation invited participants to redefine the concept of "workshop," a physically bounded workspace, for themselves.

We focused on distributed aspects of the *Physarum* workshop by inciting further exploration and experimentation at home. We encouraged participants to engage in unconventional "homework", to feed *Physarum* with different foods, and letting it forage on different substrates. Available pantry items, containers, fabrics, children and adult arts and crafts materials, used electronics, and more, combined into a unique and changing experimental set for each participant. The sets also tinged home experimentation into an unpredictable, creative experience of foraging for unusual contributions to slime mould "micro-environments". In compelling a search for unexpected combinations of foods and substrates, such "micro-environments" invited a reconfigured and re-appropriated view of everyday objects. Distributed homework research further connected participants to the inventiveness of life at home. In this way, items and components found in pantries, basements, closets, cupboards, store and stock rooms also pointed to the distributed character of artistic experimentation.

We found that, through its affordance for distributed research, work with *Physarum* analogically mapped into the distributed patterns it formed while growing. Workshop development unfolded in different work and life settings (at home, in laboratories, in independent art centres such as Studio XX). It also emerged in different cities, and transited between them by train within a 5-month period. Collaboration between instructors, colleagues and participants around *Physarum* sparked multiple, speculative art imaginings. Each idea revealed a different aspect of work with *Physarum,* and potentially turned into its own separate, yet related, project. The web of slime mould projects and workshop ideas thus emerged across space, time and people.

8.4 Slimedium: Connecting *Physarum*, Artists and Publics

We pursue our discussion of *Physarum*'s distributed affordances, and their potential for interspecies connections between slime mould, artists and publics. Here we thread from previous remarks to discuss how work with

Physarum can inform new connections between artists, publics and slime mould. We look at how those new connections, as ideas and practices grew within the context of a bio*media* workshop. We show how this two-evening workshop provided space for reconfigurations of the notion of "collaboration" in the art studio as well as in exhibits. We illustrate how these reconfigurations have materialized in new relationships between *Physarum*, artists and publics through the recent work of multidisciplinary artist Tosca Hidalgo y Terán.

From there, we show how slime mould, with its radically different sensorium, can help catalyze imaginations and create insightful, innovative bio-electronic experiences and hybrid exhibits. We locate the uniqueness of slime mould, as *medium*, in its artistic versatility on one hand, and on the other hand, in its potential to spark new questions on the nature of such artistic experiences. We call this domain of experimentation and enquiry, of practice and theory-making, *slimedium*.

Slimedial space was created throughout preparation and unfolding of the Studio XX workshop. It unfolded anew on two evenings, on October 5 and 12 2017. A small group of *media* artists, professors, students, practitioners and researchers gathered for a bio*media* workshop at the Inter/Access centre in Toronto, Canada. Inter/Access, founded in 1983, is "a non-profit gallery, educational facility, production studio, and festival dedicated to emerging practices in art and technology" ("About |InterAccess" n.d.). The workshop aimed at 1) facilitating *media* artist's explorations of *Physarum* as a new artistic *medium* and 2) querying notions of artistic agency through such explorations.

The first objective involved instruction on basic aseptic technique. Activities included making agar media at home, experimenting with substrates and food, and an informal exploration into the possibilities of interfacing electronics with slime mould.

The second objective called for an unusual approach to electronics and *media* arts workshop instruction. The workshop instructor, Sarah Choukah, invited participants to approach *Physarum* as an artistic *medium*, as well as a non-human alien. Taking her cue from Tim Grabham and Jasper Sharp's documentary *The Creeping Garden*, Choukah referenced movies such as *The Blob* (1958), *Invasion of the Body Snatchers* (1978) and *The Thing* (1982) as inspirations for renewed attention to the anxiety and uncertainty of imagined contact with the radically non-human.

In his 2015 book *Alien Agencies*, artist/researcher Christopher Salter examined a different kind of unpredictability. Salter did not presuppose an essential separation between humans and non-humans. Rather, he asked,

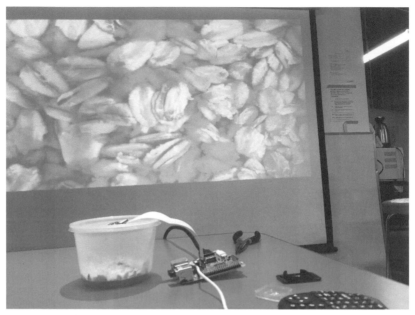

Figure 8.3 Physarum connected to Raspberry Pi 3 microcomputer.

Photo: Sarah Choukah, 2017.

"[H]ow are humans and media coproduced in the act of making things?" Thus, Salter's approach to bioart installation inspired, "an account of how materials like sound, biological stuff, and sensory inputs such as touch, taste, and light used in technoscientifically driven art practice act beyond human intent." (2015, p. xi).

Part of exploring such "act[ion] beyond human intent" appeared in glimpses of *Physarum*'s activity at different time-space scales. During the first workshop evening, a Raspberry Pi 3 micro-computer and Pi camera were set up to take pictures as the workshop took place, generating a *slime-lapse* animation through a simple Python script (see Figures 8.3 and 8.4). The slime-lapse was then screened on a projector at the end of the workshop. The .gif animation showed how simple lens magnification and timed image capture could animate slime mould. The sight of beating, pulsing slime feeding on the oats delocalized the site of art-making and performance, prompting questions of agency many bioartists continuously engage[8].

[8]See, for instance, (Kac et al., 2007; Broadhurst, 2007; Mitchell, 2010; Catts and Zurr, 2014; Hauser, 2014; Schubert, forthcoming 2018).

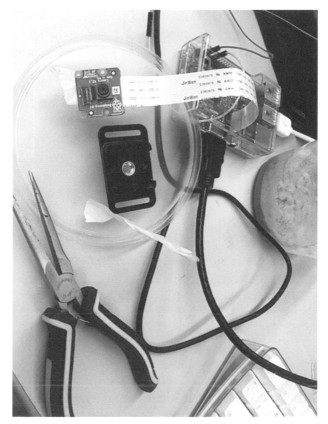

Figure 8.4 Raspberry pi 3 camera setup.

Photo: *ibid.*

That evening, workshop participants delved into cultivation and took on their own explorations of artistic agency. They also left the Inter/Access studio with custom slime moulds "kits" allowing them to inoculate cultures on several dishes and prepare agar media in their kitchen. Artists shared pictures, comments, questions, as well as their own time-lapse captures through a Slack channel – a team communication software and platform – set up by Inter/Access Education and Outreach Coordinator, Galen Macdonald.

With the workshop distributed into two separate evenings, a week apart from each other, exchanges on Slack further exemplified the distributed character of experimentation with *Physarum* we discussed in the previous section. Artists posted pictures of *Physarum* brimming over their Petri dishes and deli containers, growing in intriguing ways, especially when placed on

different substrates. They noticed how easily *Physarum* escaped from dishes, re-sealable plastic bags and boxes and how it turned into small, black sesame-seed like spores when deprived of food. Artists wondered to what extent *Physarum* could be used in sculptural, artistic interventions mobilizing clay, wood or 3D printed, three-dimensional mazes. Thus, within the distributed context of the workshop, participants experienced *slimedia* as versatile and promising in combination with other artistic *media*, yet as unpredictable from an experiment to the next.

In doing so, workshop participants explored different ways to relate with living *media*. Such relations developed out of felt tensions, of uncertainty arising from the combination of slime mould's unconventional behaviour and artists' interventions. In the context of workshop design, *Physarum*'s unpredictability at Inter/Access and in artists' homes and workspaces also informed Choukah's mindset as an instructor. From one week to the next, *Physarum*'s behaviour, even its aliveness, partly depended on factors beyond the artists' control. Choukah cautioned that, for one reason or another, and without regular inoculation in new dishes, contamination could take cultures away in a matter of days. In this sense, "collaboration" with slime mould involved taking in, being open to and making do with the unpredictability of artistic outcomes. It also involved taking environmental affordances and constraints into account, as well as connecting bioartistic practice with environmental life. Ultimately, such a situation invited the bioartist to contemplate their agency as a participant, among others, in hybrid environments.

In the Inter/Access workshop context, the notion of environment came forth as a capacious, creative *medium* of its own. As Macdonald helped facilitate the workshop, he also brainstormed new experiments in *Physarum* growth using Inter/Access off-the-shelf equipment and cast-off components. Adamatzky's *Thirty Seven Things to do with Slime Mold* inspired further ideas for interfacing slime mould with electronics (2017). With Physarum, an old loudspeaker could become a new experimental milieu, transforming into an environment artist and slime moulds could explore with surprising results. Communications *media* could turn into new milieus and as such could, in turn, provide spaces for artistic experimentation through connection with sensing and measuring technologies, like those of microcontrollers (Arduino) and microcomputers (Raspberry Pi)[9]. Such diverse modes of interfacing with

[9]For more on connections between different "instances of bio-mediality" as bioartistic probes into media as "milieus", "means of transformation" and "measure" apparatuses, see Hauser (2017).

communications *media*, along with the multiplicity of milieus humans could co-create with *Physarum,* modified the scale and situation of experiments every time for artists, and opened onto just as many potentials for collective experimentation.

Among the participants, Tosca Hidalgo y Terán was interested in creating a public conversation about, and through bio*media,* electronics and communication with the non-human. Since the 1980s, multidisciplinary artist Terán has been actively involved in the intersection of electronics, *media* arts and artistic *media* such as metal and glass. Founder of the Toronto-based *Nanopod: Hydrid Studio,* Terán developed her approach to technological and biological arts during a 2017 residence at the Ottawa-based Ayatana SciArt Research Program, and through co-founding the Baba Yaga collective. She also joined in the international BIO.CHROME collective, an artist group dedicated to art practice at the junction of technology, bio*media* and science.

Terán's contact with *Physarum* during the workshop inspired *Midnight Mushroom Music,* a multispecies soundtrack combining sonification techniques, using a pulse sensor, sound mixing and MIDI software and electronics such as the MOOG synthesizer to "pick up subtle fluctuations in galvanic conductance on the surface of [...] organisms" (Terán *in* Ecovative, 2018). Terán conducted bio-sonification experiments with mushroom mycelium[10], which she then introduced to *Physarum,* encountered at the Inter/Access workshop, as a "special guest". The special recording session was released on SoundCloud as well as iTunes Music services (Terán, 2018).

Midnight Mushroom Music used interspecies multimedia to connect artists and publics. It also hinted at the connection's potential for live performance. On September 29, 2018, the Baba Yaga collective and Toronto's ArtSci Salon, headed by Roberta Buiani, co-presented *CHAOS fungorum,* a BIO.CHROME collective art exhibit. Terán and her partner, Andréi Gravelle performed live with mycelium, amidst projected photos and videos of *Physarum* and mycelium. Her installation, a set of majestically growing *mycelium* sculptures connected to her bio-sonification console, provided exhibition goers and passersby with the experience of an evolving, living artwork continuously translated to sound. Likewise, Terán's *Midnight Mushroom music* provided a unique experience of music making, streaming and podcasting with *Physarum* and *Mycelium.*

[10]Mycelium is "[t]he vegetative tissue (thallus) of a fungus, typically consisting of a network of fine filaments (hyphae)" (OED 2003).

In this section, we touched on the novel artistic combinations and possibilities *Physarum* affords *media* and technological artists in a workshop setting. Through a performative approach (rPI, slime mould kits), the Inter/Access workshop provided generative, live intersections of theory and practice. We also discussed the emergent space for conversation and practice the bio*media* workshop provided. *Physarum*'s unique plasmodalities engaged a distinct, different view of the artistic agency in relation to vibrating, pulsing live *media*. Through presenting Terán's recent work, we also glimpsed at new kinds of technologically mediated, public experiences with bioart and bio*media*. We will conclude our contribution in the next section, as we discuss further opportunities and challenges of bioart workshops with *Physarum*.

8.5 Conclusion: Opportunities and Challenges

Adopting Physarum as an expressive *medium* allowed workshop instructors to connect their academic research, artistic approaches and community sharing ethics in new ways. By contrast, DIYbio, bioart and biohacking initiatives have provided unique benefits and challenges, several of which differed in the context of running education programs at independent art centres. For Studio XX members, the "Electronic Arts with Families" workshop series enabled parents and children to know artist instructors and their work. For artists, getting acquainted with art enthusiast families also provided participatory experiences that strongly differed from conventional exhibition modalities of engagement. Our art instruction practices further developed as we sought to communicate the ambiguity and uncertainty common to both professional and amateur modes of experimentation.

As artists, scholars and biohackers, these future experiments and possibilities open toward a "post-normal" academic epistemology. Academic norms, and their incarnations in everyday scientific work such as peer-review, experimental design and grant writing, structure research in dynamic and challenging, but also changing ways. Examples of these changes can be found in interest for new research and evaluation models, such as open science and open publishing. But deviation from some scientific norms is prohibitive, and can be catastrophic in the context of large and expensive research projects in universities and private laboratories. This can contribute to scientists and academics cultivating risk-averse mindsets, confining them to research areas with well-established funding, support and protocols. Such mindsets, however, can detract researchers from "unexpected results" that "rarely fit into the standard scientific narrative": "such behaviour is often

viewed as a frustrating distraction, rather than a phenomenon of scientific interest." (see Lehman et al., 2018, pp. 2–3).

Experimentation with an organism as innocuous, versatile and easy to cultivate as *Physarum*, especially when done at the intersection of arts and sciences, can de-escalate the fear of failure. It can also promote awareness of unusual, unsung dimensions of creativity and engagement with new biomaterials, bioart and bio*media*. We chose to foreground creativity and engagement at every step of the process of workshop creation. We found in *Physarum* a particularly versatile facilitator of exchange. As a *new medium*, *Physarum* connected together DIY and emergent communities of artists and families.

Discussing distributed artistic experimentation is only a start. As much as in laboratories where reproduction of conditions is an issue, challenges in distributed artistic experimentation also concern the use of at least some shared tools and protocols to make sharing and reporting reliable results easier. There is much more to be done to stimulate and foster active artist-researcher communities to develop and share conventions on documentation, experimental design and collaborative/communication platforms online. Educational approaches can be developed from within new and multimedia, fine or computational art, film and media departments through collaboration with university art/science initiatives.

In this sense, working with *Physarum* can be understood as working with new forms of social *media*. Both forms of work afforded communication between institutions such as universities, primary and secondary schools, and within arts and culture traditions focused on enhancing public participation; additionally with municipal, provincial and federal funders. *Physarum* thus acted not only as a fascinating workshop *medium*, but also a cultural mediator – in the sense that, in addition to being a living network connecting sources of food, it also created space for workshop participants to connect with new bioart *media*, to practice asking unusual questions and to become conversant with new artistic methodologies and epistemologies.

Opportunities for such interactions, outside of academic art and research activities, are still too few and far between. We find tremendous inspiration in recent initiatives, such as Heather Barnett's research-creation and public workshops, and the PhyChip (*Physarum* computing) project, which brought together researchers across five European universities and research institutes[11]. Potentials with *Physarum* artistic experimentation have begun to

[11]See Heather Barnett's website at https://heatherbarnett.co.uk/work/the-physarum-experiments/ and the PhyChip project homepage at http://www.phychip.eu/

materialize with such projects. For us, this is also only the beginning of a hybrid, human/non-human approach to artistic and technological bio*media*.

Future potential workshops and novel forms of distributed experimentation include three-dimensional maze-making with slime mould, as well as experimentation with underground mapping, or even surface mapping on other planets[12]. In the past few years, improvements in computer graphics processing and computer vision improved video game applications. Faster Internet connectivity and broadband capacity may allow for the creation of an *Internet of Slime* (IoS), or *Slimeweb*: connected environments allowing for synchronization of experiments over multiple locations.

Future workshop capabilities are far from limited to the university, maker- or bio-hackerspace. Geographic Information System's (GIS) technology can facilitate outdoors collection and mapping of indigenous *Physarum* species. They could also sustain novel collaborations between students of different universities, or between amateur groups, scientists, researchers and students, linking together citizen communities with their parks environments, as well as with natural observation or botanical societies.

We hope to use *Physarum* as a cultural and disciplinary mediator to create new initiatives, involving practitioners and researchers in unconventional working groups. We hope future collective work with *Physarum* compels opportunities to bring theory and practice together in innovative, unusual ways. Most of all, we hope this contribution can inspire inventive, affordable workshops. We hope they can spark new collaborations by bringing together people who otherwise may not connect with each other.

References

About|InterAccess. [n.d.] https://interaccess.org/about.

Adamatzky, A. (2013). Physarum machines for space missions, *Acta Futura*, 6, pp. 53–67.

Adamatzky, A. (2015). Atlas of Physarum Computing, (World Scientific, Hackensack, NJ).

Adamatzky, A. (2016). *Advances in Physarum Machines: Sensing and Computing with Slime Mould*, Emergence, complexity and computation, 21, (Springer International Publishing, Cham, Switzerland).

[12]In inspiration from (Adamatzky 2013; Mihklepp 2014).

Adamatzky, A. (2017). Thirty Seven Things to Do with Live Slime Mould, *Advances in Unconventional Computing, Emergence, Complexity and Computation*, A. Adamatzky, ed., (Springer International Publishing, pp. 709–738).

Bahng, A. (2017). Plasmodial Improprieties: Octavia E. Butler, Slime Molds, and Imagining a Femi-Queer Commons, *Queer Feminist Science Studies: A Reader*, C. Cipolla, K. Gupta, D. A. Rubin, and A. Willey, eds., (University of Washington Press, pp. 310–327).

Barnett, H. (2014). *What humans can learn from semi-intelligent slime*. TED talk. https://www.youtube.com/watch?v=2UxGrde1NDA.

Barnett, H. (2016). A Malleable Metaphor: *Physarum Polycephalum* As Artistic and Educational Medium, *Proceedings of the 9th EAI International Conference on Bio-inspired Information and Communications Technologies (Formerly BIONETICS)*, BICT'15, (ICST (Institute for Computer Sciences, Social-Informatics and Telecommunications Engineering, ICST, Brussels, Belgium, Belgium), pp. 594–595.

Barnett, H., Grushkin, D., Jones, J., and May, A. (2013). Being Slime Mould, *Art/Design Item*, (http://ualresearchonline.arts.ac.uk/7272/).

Broadhurst, S. (2007). *Bioart, Digital Practices: Aesthetic and Neuroesthetic Approaches to Performance and Technology*, S. Broadhurst, ed., (Palgrave Macmillan UK, London, pp. 161–184).

Catts, O., and Zurr, I. (2014). Growing for different ends, *The International Journal of Biochemistry and Cell Biology, Regenerative Medicine: The Challenge of Translation*, 56, pp. 20–29.

Clifford, J. B. (1897). Notes on some Physiological Properties of a Myxomycete Plasmodium1With Woodcuts 3, 4, and 5, *Annals of Botany*, **os-11**, No. 2, pp. 179–186.

Davidson, P. G. (no date). A Simple Method of Growing the Plasmodial Slime Mold, Protistan Fungi, http://www.buildingthepride.com/faculty/pgdavison/PHYSARUM%20culture%20for%20web.html.

Dusseiller, M. (2016). DIY microscopy – Hackteria Wiki, http://hackteria.org/wiki/DIY_microscopy.

Dussutour, A. (2017). *Tout ce que vous avez toujours voulu savoir sur le blob sans jamais oser le demander*, (Équateurs, Paris).

Ecovative. (2018). GIY Maker Spotlight: Tosca Teran, Ecovative Blog, https://ecovativedesign.com/blog/178.

Fox Keller, E. (2011). Slime Mold, *Evocative Objects: Things We Think With*, S. Turkle, ed., (MIT Press, Cambridge, Mass.), pp. 296–306.

Grabham, T., and Sharp, J. (2014). The Creeping Garden, *Documentary*.

Hauser, J. (2014). Sculpted by the Milieu – Frogs as Media, *[Plastik], No. 4, Art et biodiversité: un art durable?*

Hauser, J. (2017). Art Between Synthetic Biology and Biohacking, *Leonardo Electronic Almanac*, (L. Aceti, P. Thomas, and E. Colless, eds.), **22**, No. 1.

Hagoel, L., and Kalekin-Fishman, D. (2016). *From the Margins to New Ground: An Autoethnography of Passage Between Disciplines*, (SensePublishers, Rotterdam).

Hunter, W. (2015). *Biomateria: Biotextile Craft*, (A self-published artist book, Montreal).

Kac, E., Thacker, E., Nadarajan, G., Andrieu, B., Doyle, R., Bec, L., Wolfe, C., Nelkin, D., Lestel, D., Andrews, L. B., Gessert, G., Harvey, D., Ackroyd, H., Perry, P., Menezes, M. de, Catts, O., Zurr, I., Davis, J., Zaretsky, A., Vanouse, P., Trindade, R., Jeremijenko, N., Ballengée, B., Quinn, M., and Fleming, A. (2007). *Signs of life: Bio Art and Beyond*, (MIT Press, Cambridge, Mass).

Langdon, F. E. (1894). Myxomycetes, *The Asa Gray Bulletin*, **2**, No. 6, pp. 33–35.

Lehman, J., Clune, J., Misevic, D., Adami, C., Beaulieu, J., Bentley, P. J., Bernard, S., Beslon, G., Bryson, D. M., Chrabaszcz, P., Cheney, N., Cully, A., Doncieux, S., Dyer, F. C., Ellefsen, K. O., Feldt, R., Fischer, S., Forrest, S., Frénoy, A., Gagné, C., Goff, L. L., Grabowski, L. M., Hodjat, B., Hutter, F., Keller, L., Knibbe, C., Krcah, P., Lenski, R. E., Lipson, H., MacCurdy, R., Maestre, C., Miikkulainen, R., Mitri, S., Moriarty, D. E., Mouret, J.-B., Nguyen, A., Ofria, C., Parizeau, M., Parsons, D., Pennock, R. T., Punch, W. F., Ray, T. S., Schoenauer, M., Shulte, E., Sims, K., Stanley, K. O., Taddei, F., Tarapore, D., Thibault, S., Weimer, W., Watson, R., and Yosinksi, J. (2018). The Surprising Creativity of Digital Evolution: A Collection of Anecdotes from the Evolutionary Computation and Artificial Life Research Communities, *arXiv:1803.03453 [cs]*.

Mihklepp, M., Domnitch, E., Gelfand, D., Foing, B. H., and van der Heide, E. (2014). Star Mapping with Slime Mold *Physarum* Polycephalum, *European Planetary Science Congress, 9, pp. EPSC2014-830*.

Miranda, E. R. (Ed.). (2017). *Guide to Unconventional Computing for Music*, (Springer International Publishing, Cham).

Miranda, E. R., Adamatzky, A., and Jones, J. (2011). Sounds Synthesis with Slime Mould of *Physarum* Polycephalum, *Journal of Bionic Engineering*, **8**, pp. 107–113.

Mitchell, R. (2010). *Bioart and the vitality of media*, (University of Washington Press, Seattle).

Mycelium, n. (2003). *OED Online*, (Oxford University Press, Oxford).

Osborne, P. (2015). Problematizing Disciplinarity, Transdisciplinary Problematics, *Theory, Culture and Society*, 32, No. 5–6, pp. 3–35.

Schubert, T., and Adamatzky, A. (Eds.). (2015). *Experiencing the Unconventional*, (World Scientific, Singapore).

Schubert, T. (2018). *Nichtintentionalität und Agency in Biomedia Art*, (Bauhaus-University Weimar, Germany).

Shaviro, S. (2010). Fruit Flies and Slime Molds, *The Pinocchio Theory*. http://www.shaviro.com/Blog/?p=955.

Skloot, R. (2010). *The immortal life of Henrietta Lacks*, (Crown Publishers, New York).

Terán, T. (2018). Midnight Mushroom Music, *SoundCloud*, https://soundcloud.com/nanotopia/sets/midnight-mushroom-music.

Terranova, C. N. (2016). Bioart and Bildung-Wetware: Art, Agency, Animation, an Exhibition as Case Study, *Journal of Microbiology and Biology Education*, 17, No. 3, pp. 409–416.

Thacker, E. (2011). *In the dust of this planet*, (O Books, Winchester).

9

Explorative Growth for Art and Architecture

Petra Gruber[1], Angelo Vermeulen[2], Ceren Yönetim[3] and Barbara Imhof[4]

[1]Biomimicry Research and Innovation Center BRIC,
The University of Akron, Akron, USA
[2]Systems Engineering and Simulation, Faculty of Technology,
Policy and Management, Delft University of Technology, The Netherlands
[3]Vienna, Austria
[4]LIQUIFER Systems Group and University of Applied Arts,
Vienna, Austria
E-mail: pgruber@uakron.edu; a.c.j.vermeulen@tudelft.nl;
cerenyonetim@gmail.com; barbara.imhof@liquifer.com

9.1 Introduction

This chapter describes how architects and artists develop their work through looking at nature and finding role models for proto-architectural applications. Artistic research methodologies are being used to transfer growth strategies in nature into concepts for a new living architecture. The chapter also describes the example of the artistic research project GrAB – Growing As Building, which was conducted between 2013 and 2016 at the University of Applied Arts in Vienna with an interdisciplinary and international team of architects, artists, engineers and scientists. The project was funded through the Austrian Science Fund, a funding institution for fundamental scientific research in Austria. The programme of developing and enhancing the arts is part of the FWF services and represents a unique opportunity to develop research in an artistic context.

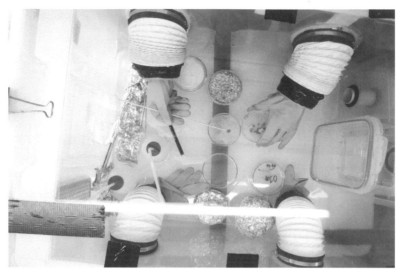

Figure 9.1 Slime mould in a glovebox and Petri dish.

Photo: GrAB team, 2014.

GrAB emerged from another artistic research project funded by the FWF: Biornametics – Architecture Defined by Natural Patterns explored a new methodology to interconnect scientific evidence with creative design in the field of architecture. GrAB took this exploration further and specifically looked at growing structures with focus themes on explorative growth, material systems, technological transfers and closed-loop systems. The investigations were multifaceted and broad at the beginning and were narrowed down to biological role model research which could be conducted in a biolab established at an art school (Figure 9.1).

The slime mould was investigated as part of the theme of explorative structures. Looking at the slime mould through an artistic lens, informed by renowned biologists yielded new insights into the interpretation of its behaviour and proto-applications for architecture and the arts.

9.2 Art, Architecture and Science Template

Artistic research is becoming a research area in its own right applying similar methods to those found in the scientific and humanities' fields of research. This starts with the same operational system of writing proposals, formulating research questions and describing methods of approaching the problem at

hand. Artistic research is a discovery-led form of knowledge production, (Von Borries, 2015) similar to exploring the 'what', 'why' and 'when' of our universe, where the actual questions and methods are only gradually revealed. This kind of artistic research transitions into other disciplines and previously unexplored territory, leading to the discovery of new paths and outlooks. Both art and science are driven by a desire for fundamental understanding (or truth) and a desire for new products (Borgdorff, 2009).

This growing interest in the intersection of arts and sciences has led to a number of research programs and opportunities that take a transdisciplinary approach. 'Artistic research' and 'Research by design' acknowledge the investigation of possible futures as valid scientific approaches, and scientific findings are increasingly taken up and translated by artists and designers (Badura, 2013).

In the project Growing as Building, the multi-disciplinary team looked at growth principles through an artistic and scientific lens using and borrowing methodologies from different disciplines. The project is also understood as an endeavour to reconnect highly specialised fields and the common exploration of yet unknown areas. This unification of different fields is not new but has not been in the focus of our work and production in the last 200 years.

Already Rene Descartes introduced the concept of the unity of sciences (Descartes, 1905, Descartes, 2015) and thus marked a revolution in the search for the truth. Today, at the convergence of fields such as biology and technology (biotechnology), or mechanical engineering and electronics (mechatronics), this perspective has become the state of the art.

> The problems challenging us today, the ones really worth working on, are complex, require sophisticated equipment and intellectual tools, and just don't yield to a narrow approach (Brown, 2018).

We have to solve complex problems; therefore, more people with different kinds of skills and expertise need to collaborate since no single person has all the traits required to tackle the world's big environmental issues, migration streams and population growth.

The arts have played a side role in our industrialised society. The arts are viewed as inspiration, an add-on to our lives producing joyful contemplation, sometimes the arts were used as propaganda tool, e.g. during the cold war but hardly in their true capacity: a potential to create a critical perspective on the "things" happening around us. Art allows for broad investigation and interpretation and this is why the funding bodies support artistic research.

9.3 Problem Statement

9.3.1 Philosophy

The now obvious impact of human activity on the planet has changed the worldview and this era has been defined as the Anthropocene. However, moving forward and preserving the human live on our planet, some changes are inevitable: firstly, environmental protection is not to protect our surrounding and biodiversity for the sake of other creatures but because it is a key to our human survival on our planet. Humans cannot adapt within a few generations to completely new environments and are living systems, which can only exist in a small spectrum of temperature, atmospheric composition and surrounding pressure. Some animals or plants can adapt fast and can live in a greater variety of conditional range, such as amphibians or cockroaches, which can hibernate and are hardy animals being able to withstand higher dosages of radiation.

Despite the fragility of humans and our absolute dependence on the right climate, we have, secondly, developed a false dichotomy of human and nature. This developed from our history of having to shelter from the wild when it was still a dangerous place. However, always have "humans been part of nature, and not apart from nature." Indian physicist Vandana Shiva has described this "apartheid" because like us she is confronted with an unprecedented speed of change. "In the last six decades, anthropogenic forcings have driven exceptionally rapid rates of change in the Earth System" (Gaffney and Steffen, 2017). Scientists researching the rate of change in climate, atmosphere and biodiversity talk about the "Great Acceleration", hinting to a "fundamental shift in the state and functioning of the Earth System" (Steffen et al., 2015).

The built environment holds a large share in the exploitation of the planet.

> Because of their size, economic strength, and profound societal importance, construction activities and processes are among the largest consumers of materials and energy and significant polluters on the global scale (Horvath, 2004).

An estimated 33% of materials consumption globally is attributed only to construction materials (Steinberger, K. 2009).

Approaching a world population of 8 billion humans soon, we need to address these issues in the way we build and live our cities and dwellings. Concepts for sustainability, renewable energy, alternative building techniques and refined materials including the use of technology will support us in

creating architectural designs that are resilient, adaptive, reactive, sensing and attributed with life-like characteristics so we can actually survive on this planet. Therefore, we need to develop the self-growing house with all these above-described characteristics because in the future, most people will live in cities. Cities will also be where most of the world's pollution is produced. We are already faced with metropolitan sizes of nearly 40 million inhabitants and the consequences of problematic decrease in elementary resources such as clean air and water, and the challenges of massive waste production (Bushan, 2009).

9.3.2 Why GrAB

Being confronted with these challenges, the project GrAB, Growing as Building, addresses these challenges with the aim of creating a new living architecture, focusing on dynamically growing architecture which can adapt to the environment and the needs of users in a process of constant evolution. The GrAB interdisciplinary team looked at a broad spectrum of growth principles and focused on the following four key research areas:

- the slime mould, self-organising and with 'explorative' growth nature as a co-designer of complex architectural structures (Figure 9.2),
- mushroom mycelium as a lightweight, naturally grown material system,
- algae that produce oxygen and biomass within a bioreactor,
- the development of novel, mobile 3D printers capable of mimicking biological structures and processes, optimising material and energy use.

The artistic research project incorporating four different biologists (botany, ecology, microbiology and biomimetics) aimed at transferring qualities present in biological growth; for example, adaptiveness, exploration or local resource harvesting into technical design and production processes (Bushan, 2009).

In implementing principles of growth into the built environment, the team searched for proto-architectural applications that could potentially transform the way we construct our buildings and cities today. The aim of project GrAB was to develop ways for a more integrated and sustainable setting, a new living architecture (Bushan, 2009).

Through new technologies, such as 3D printing or contemporary computing, and robotics, GrAB investigated in merging program and tool and process and result. Growth, as one of the important characteristics of living organisms, was used as a frame for research into systems and principles that

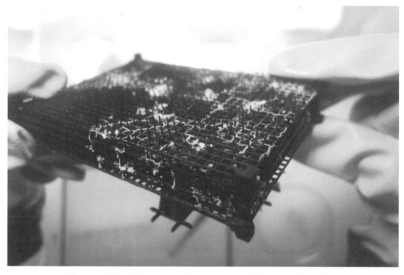

Figure 9.2 Slime mould growth in a 3D printed model.

Photo: GrAB team, 2014.

the team believed to deliver innovative and sustainable solutions in architecture and the arts. Biomimetics as a methodology was used to create and guide information transfer from the life sciences to innovative proto-architectural solutions and for the vision of a self-growing house.

For the future, the team wish for houses that behave more like living things which include buildings that

- grow through biological and technological processes;
- end its own site through self-organisation;
- can adapt to the climate and its environment;
- keep growing whenever sufficient space and material resources are given;
- produce no waste and dissolve itself when its lifetime has expired.

9.4 Life as a Paradigm

Life has a lot to offer to architecture and design. Life is in constant flux, in an ongoing process of seeking equilibrium. And it is open ended, in permanent exchange with its surrounding environment. These dynamic aspects of life have a lot of potential to transform inert structures into more responsive and resilient environments.

Biological research and role models from nature increasingly inform technological solutions, and architects and engineers also look to nature for inspiration. The investigation of the overlaps between the fields of biology and technology, biomimetics, has gained ground in research and development (Bushan, 2009; Bar-Cohen, 2012; Goel et al., 2014). Signs of life, as defined by the life sciences, are introduced into former static and unresponsive buildings so that sensing, reactivity, adaptation and also evolutionary development are found in contemporary architectural design (Gruber, 2011; Schumacher, 2016; Gruber et al., 2017).

Biomimetics as a methodology allows for the purposeful search for solutions in biology that can help achieve innovate human technology to meet the current global challenges. Some of the most striking aspects that are found in biological systems and we wish for ideal buildings are defined in the following:

Adaptation

Survival of an organism depends on its ability to adjust to, or resist, external events. This requires appropriate behaviour, internal chemistry, morphology and control systems. If an organism can adjust these variables such that it survives, it is said to be well adapted.

Resilience

The term describes the capability of a system (plant, fungus, animal, building, machine, etc.) to cope with internal or external changing influences or interferences.

Self-organisation

Self-organised systems are capable of spontaneously developing and maintaining order with no control from outside, and stability and change of self-organised systems depends on feedback mechanisms.

Aspects such as adaptability and resilience that biological systems exhibit are highly sought after in the built environment. Complex feedback systems are a prerequisite for adaptive capacities in natural systems. Biological systems that increase resilience and withstand unforeseen environmental developments, especially vulnerability during the processes of transformation, can serve as valuable role models for architectural applications. The biomimetic approach of deriving technological processes from research into biological growth principles provides insights that might improve or completely change contemporary traditions and technologies of building (Imhof et al., 2015).

9.4.1 Design with Nature/Organisms

Designing with nature is defined here as relinquishing part of the design process to living biology, with the goal of generating co-created solutions that exhibit some of the characteristics of the natural world.

Landscape architecture is probably one of the oldest examples of 'designing with organisms'. The landscape architect defines structures, boundaries and constraints in which nature operates. The resulting emergent landscape is a constant dialogue between man's interventions and nature's internal dynamics.

9.4.2 Design with Biotechnology

Through biotechnology such staged relationships between the living and non-living have taken entirely new dimensions. In tissue engineering, for example, porous scaffolding material is used as a template to guide the growth of new tissue. In a way, tissue engineering can be regarded as an extension of the same logic found back in landscape architecture: man-made structures and interventions guiding the growth of living biology (Dodington, 2009). Art projects such as *Victimless Leather* (2004) by the Tissue Culture and Art Project, and the *Semi-Human Vase* (2015) by Hongjie Yang explore the ethical consequences of such cell-based design methodologies. In designing with nature, the level of autonomy of the biological agents can be varied, and either a top-down or bottom-up perspective can be applied. Are organisms or cells merely allowed to grow along to a predefined path, within for example a specifically shaped mould? Or is their agency used as an asset to allow for a more emergent design?

9.4.3 Organisms as Co-workers

In biofabrication, organisms 'naturally' produce materials for manufacturing and construction. This can happen in bulk in semi-open systems, guided along scaffolding, or inside closed moulds. Biofabrication is essentially a top-down approach in which organisms such as fungi, bacteria and insects are coerced into the role of co-workers (Collet, 2018). Fungal tissue or mycelium can be dried, and the resulting product is both strong and lightweight. Because of these properties, it has been used as a structural material in a range of architectural research projects, such as GrAB (Growing as Building) in Vienna (2012–2013) (Imhof et al., 2015) and the Hy-Fi tower by David Benjamin in NYC (2014). In both these projects, mycelium was grown

inside moulds resulting in bricks and simple structural elements that could be stacked to create larger architectures. Bricks can also be created with entirely different organisms and materials as demonstrated in the Biobrick project of Ginger Krieg Dossier. Here bacteria cement together sand grains using urea and calcium, thus producing bricks without the need for fire and baking (Dosier, 2010). Soft materials can also be useful in architectural construction. In the Silk Pavilion of MIT, silkworms weave along a predefined architectural structure, and consequently reinforce and close it (Oxman et al., 2014). And in the BioCouture project of Suzanne Lee bacteria and yeast cells create bacterial cellulose with the properties of a 'vegetative leather'. The resulting material can be used to make clothing and shoes (Cecchini, 2017). In all these examples, the organisms produce the physical material to be subsequently used by the architect or designer. In another role of co-worker, organisms can also replace the function of processing plants. Through such bioprocessing, waste materials can be transformed into useful chemical compounds as exemplified in the LIAR (Living Architecture) Horizon 2020 project (http://livingarchitecture-h2020.eu as viewed 31.8.2018). Organisms can also be passively embedded inside materials only to become active when damage occurs. Through their particular metabolism, the damage is then repaired again. Bio Concrete developed by Henk Jonkers at TU Delft is a good example of this (Jonkers, 2011). The common thread in all these examples is organisms taking over labour from humans and machines in the production of more natural materials.

9.4.4 Organisms as Co-designers Integrated Organisms in the Design Process

When we include organisms in the actual design process, and welcome their creative agency and intelligence, we open up an entirely new set of possibilities. Through such a bottom-up approach, we relinquish part of the control of the design process to the organism itself, enabling the emergence of novel designs with unique visual qualities or increased efficiencies. Some designers use growth patterns or organism behaviours to help in generating visual patterns. In the Bio Lace speculative design project of Carole Collet, for example, roots of bioengineered plants generate textiles with particular geometric qualities. In the ironic Miserable Machines: Soot-o-Mat art project of Špela Petric, mussel contractions create visual patterns on small glass lamp shades. But from a design perspective, living biology can do more than generate visual patterns. Organisms are in constant interaction with

an environment in flux, and compute optimal solutions for ever-changing challenges. Nature is characterised by adaptability and efficiency, and it is precisely these qualities that can be harnessed in the design process. There is a multitude of experiments that have, for example, shown that slime mould can realistically optimise traffic networks (Adamatzky et al., 2013, Adamatzky et al., 2013). In MIT's Silk Pavilion, the formation of fibre structures by the silkworms with varying spatial and environmental microconditions was used as a computational schema for shape and material optimisation of fibre-based surface structures (Oxman et al., 2013).

9.4.5 Integration of Living Biology

All of the above are essentially examples of 'organism aided design'. The organism itself is absent in the naturally produced artefact. In contrast with this, bio-design is defined as design in which living organisms are an integral part of the final product (Myers, 2012). Through this radical integration of living biology, these products exhibit characteristics of the natural world such as adaptability and explorative capacity. In Growth Pattern by Allison Kudla, tobacco plant leaves are cut into decorative patterns, after which local hormone delivery stimulates the plant cells to grow. The cells move beyond the original boundaries, and as a result change the entire living pattern. In so-called botanical architecture, plants actively co-construct architectures. The Fab Tree Hab (2005) of Mitchell Joachim is a speculative design project in which an entire dwelling is gradually created by growing trees. Project Footbridge (2005) and Project Tower (2009) of Baubotanik are real examples of architectural structures created with living, growing trees. In fact, the idea of using growing plants to create architecture goes back centuries. The living root bridges in Meghalaya in India are an excellent example of this (Myers, 2012).

9.5 Methodology

The methods used are an important part of interdisciplinary research projects and artistic research. Methods of science and art were merged and introduced into architectural and artistic context. The tools of the QFD (Quality Function Deployment) were taken from product development: QFD is used in commercial research and design for combining ideas with outcomes, and for quantifying qualitative relationships. The introduction of a Biolab, a hands-on laboratory space constructed from simple off-the-shelf

components was the second important approach in the GrAB outset. The rhythm and flow of the project work was characteristic of interdisciplinary collaborations – time needed to familiarise with the other discipline was allocated in intensive workshops. In those workshops team members exchanged knowledge but also collaborated on navigating the project within the frame of the roughly predefined goals.

9.6 Slime Mould

Analogy

The slime mould experiments use the explorative capacity of the organism in the frame of a human design task. The ability to find efficient pathways to and between food sources is applied to similar and scaled setups for traffic networks, whose computational optimisation is complex and was solved mathematically only a decade ago. Letting slime mould to the task seems to be a reasonably simple method that elevates the role of the organism to that of a co-designer, a relevant participant in the process. In this way, the slime mould projects are bio-utilisation rather than biomimetic, as they make use of the organism itself, instead of finding an abstracted translation into technology.

> Cellular slime mould cells move around as individual amoebas throughout their substrate. However, they can change their behaviour and start aggregating to become a single multi-cellular body as a reaction to a changing environment. Cellular slime moulds are thus of great interest to developmental biologists, because they provide a comparatively simple system for understanding how cells interact to generate a multicellular organism (Imhof et al., 2015).

> The goal of the slime mould experiments within the GrAB Project was first to cultivate the model organism Physarum, to be able to grow it in different environments, and then to observe and analyse the slime mould's behaviour. There are two main areas of research that could greatly expand current knowledge in slime mould behaviour and use. First, three-dimensional growth of slime moulds which in turn concentrates on vertical growth and on growth in three-dimensional grids (Figures 9.2 and 9.3). Second, the growth

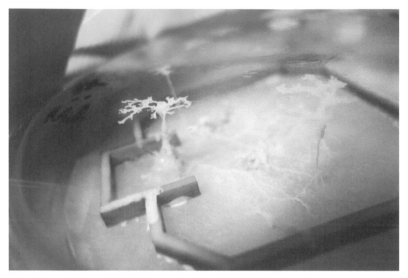

Figure 9.3 Slime mould growth in 3D, first experiments.
Photo: GrAB team, 2014.

patterns of the organism were studied in order to use slime mould as a co-designer. For the GrAB research the slime mould was solely used as a tool to generate optimised patterns, which can then be translated into architectural structures (Imhof et al., 2015).

9.7 Explorative Growth

The capacity to explore is one of the most striking features of biological growth. Exploration is carried out to reach a suitable environment, and this phenomenon is especially interesting in the plant kingdom. Although plants cannot usually move freely around, because they are bound to a specific location, they have developed strategies to explore space by growth. In higher plants, the capacity to explore is limited to sensing and adaptive growth. Explorative behaviour in growth is also observed in the kingdom of protists (unicellular organisms including slime moulds). Slime moulds exhibit a collective intelligence to discover food sources and grow optimised networks. Slime moulds explore their environment by growth, being capable of "knowing" about their surroundings, able

to find their paths efficiently and to find a suitable environment for producing fruiting bodies. It is not fully understood how those processes function in this simple organism. Some aspects, such as the sensing of past presence by chemical tracers, have been described and could be mimicked in technical systems (Imhof et al., 2015).

Exploration means moving through space and assessing certain aspects that are critical for a reason. We can look for a water source in the Sahel zone, or specific details of Indonesian temple architecture. Both would be called exploration, and both are critical for our survival as a species.

How can we use another organism to explore? What is the benefit?

- Exploiting the intelligence of the slime mould in finding efficient pathways.
- The organisms search for a living environment entails a set of aspects that it evaluates and also processes into a generic answer.
- We do not need to lead the process, the process happens by itself due to the activity of the organism. All we need to do is record it.
- We may not be fully aware of the single aspects that contribute to a decision.
- By using the decision-making process of another organism, we might even integrate new aspects into the design process, that were not considered before, or that were not sensed by the technology we commonly use. In this way, by relying on the organism's intelligence, besides improving the design, we might also be able to learn new aspects about preconditions for life.

9.7.1 Background Environment and Context

Architecture and urban design is about creating a built environment, a space to live, work and thrive for people and societies.

Environment and context describe a location and area that is not clearly defined. It can be a few square metres, or may square kilometres, depending on the organism and the aspect that is investigated. For example, whales swim thousands of kilometres crossing oceans, fleas live on small animals and inhabit specific small regions of their bodies, and microbes are capable of moving over distances like a few millimetres. Roaming neighbourhood for good options means to look for food, shelter, warmth, mates or anything else that is needed for survival. So, environment has the notion of an immediate surrounding area with all that it entails, whereas context has the notion of all

that has a connection with or is influential for whatever is the focus of the observation.

For humans, cultural environments evolved as very specific systems, providing those resources for large numbers of people within a small area. Flows of matter, energy and information constitute infrastructure and functional space for living, working, moving, driving, storing, changing, etc.

9.7.2 Information in Biology and Technology

In biology, information on the environment is gathered by sensing, and the connection between the sensing organism and the aspect is usually strong, but some animals have developed amazing strategies. For example, insects can sense certain chemical compounds at extremely diluted rates, so that the distance to a food source or a potential mate can be kilometres.

In technology, we have created an amazing collection of data about our environment, which is representing a virtual world, where we can move and search and find without actually moving around. Still, our data and simulations only capture a small fraction of what we think of as reality. Also, we cannot capture the dynamics of everyday changes, and we do not care to assess aspects that do not translate into an immediate need. The capacity of biological sensing on the one side, and our narrow framework in human technology on the other side make it even more interesting to move towards a hybridisation.

9.8 Results

The slime mould experiments in GrAB extended the explorative capacity of the organism into the three-dimensional space.

> Until now, Physarum polycephalum has been used to solve shortest path problems, creating complicated networks between nutrient sources optimising for efficiency, fault tolerance and cost. However, these experiments were limited to topological surfaces. The research GrAB focused on was the three-dimensional growth of slime mould in order to prove similar growth methodology and resource management results as in planar environments (Imhof et al., 2015).

After proving the possibility of vertical growth in preliminary experiments, the second stage of the investigation was conducted.

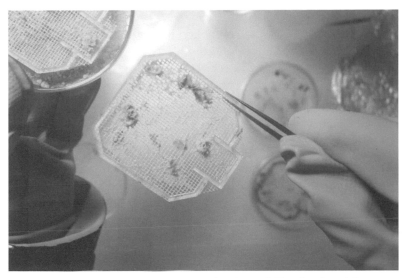

Figure 9.4 Slime mould growth in a layered 3D printed model.
Photo: GrAB team, 2014.

The goal was to research whether three-dimensional growth of slime moulds would follow the same patterns as in the commonly seen planar growth of slime moulds. The hypothesis was that, given ideal conditions, the slime mould would spread through the three-dimensional space equally in all directions. Possible deformations of the circular spreading could be based on gravity or irregularities in the workspace. After finding food it would choose the shortest path in the three dimensions (Imhof et al., 2015).

3D printed grids in form of white cubes were used as scaffolds for the slims mould growth (Figure 9.4). It could be demonstrated that slime mould could make use of the scaffolds and grow in all directions. The boxes that were used were just a few centimetres large, and the cultivation under those conditions was challenging. In a follow up experiment, black material was used for the prints, and the growth proved to be more successful under the same atmospheric conditions (Imhof et al., 2015).

Because slime mould exhibits multidirectional growth, it can create complex three-dimensional networks and structures. This specific capacity offers interesting perspectives for architectural design. The organism always tries to optimise its own physical configuration

in terms of efficiently accessing food and circulating nutrients to different parts of its body. As mentioned before, this characteristic has been harnessed to optimise traffic networks. In the same vein, slime mould can also help optimise spatial design challenges within a three-dimensional lab environment. In this way slime mould becomes a co-designer that can provide optimised circulation patterns or spatial/programmatic arrangements (Imhof et al., 2015).

The Maunsel Sea Fort of the Thames Estuary was chosen as an exemplary location to redevelop and renovate, aided by the intelligence of the slime mould, and representing the approach to use existing architecture for further development.

The Maunsell Forts are a remnant of the Second World War and were originally built as defence structures against the German air raids in the Thames river mouth. Seven interconnected platforms were erected, joined with metal grate bridging connections, and operated by the army and navy forces. Today, only the tower structures are left, and the bridges have mostly decayed. More recently, through artists and journalists, the Maunsell Forts have come into the light of the public again, as a memorial but also as a picturesque decayed assembly in the sea. Therefore, this building was an interesting structural pattern to rebuild in a scale that a slime mould could access inside the glovebox. Apart from redesigning the overall structure of the fort, slime mould could also help in rethinking the interior circulation patterns of the individual units.

> This design experiment was carried out by letting slime mould grow within a three-dimensional scale model of the historic site of the Maunsel Fort. Two experiments were carried out using a 3D printed 3D grid through which the slime mould could potentially navigate and grow in all directions. Oats were strategically placed throughout the grid to indicate key locations that needed to be connected (Imhof et al., 2015).

The first experiment used a 3D printed scaled model that was an interpretation of the floor levels within one tower of the Maunsell Fort structure. The slime mould successfully accessed the model in the vertical, horizontal and diagonal axes.

> The organism could bridge the 2 mm distance between the grid layers. Growth conditions were optimised by using a humidifier

that led to a healthy growth time of 20 days. After the culture was well developed, a simple photogrammetric process was used to extract a digital point cloud. The slime mould data was then used to help design structural inlays for the fort (Imhof et al. 2015).

The second experiment composed of a 3D printed abstracted model of all Maunsell Fort towers and the GrAB team was interested to see how the slime mould would three-dimensionally connect these towers recreating the lost bridges again.

The slime mould was used as a tool to find optimised patterns in three-dimensional space representing the connections between different floors of different buildings (Imhof et al., 2015).

The final growth stage of the slime mould was recorded with photogrammetry and CT imaging technology, and the 3D information processed in architectural software (Imhof et al., 2015) (Figures 9.5 and 9.6).

Naturally, this design methodology in making living organisms into co-designers requires quite some effort and thus might not be considered in everyday design developments. However, the question of how to create a

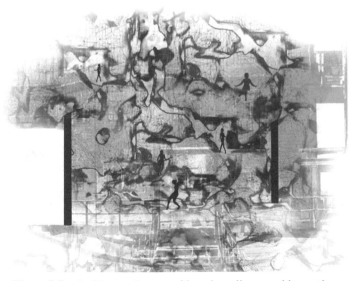

Figure 9.5 Architectural proposal based on slime mould growth.

Photo: GrAB team, 2014.

Figure 9.6 Architectural proposal based on slime mould growth.

Photo: GrAB team, 2014.

network and a sensible composition between two structures remains. Computer simulations of slime mould behaviour can aid here without having to deal with an organism. The GrAB team regards the slime mould as analogy of agent-based design, creating optimised connections which can be then interpreted and developed into an actual architectural structure. Furthermore, with this particular experiment, the team has proven that the slime mould can also grow in a 3D-grid mesh structure and not only on topological surfaces.

9.9 Conclusions

When working with a multitude of interacting organisms, the advantages of decentralisation and self-organisation can be harnessed within bio design. The interaction between the multiple agents and with the environment creates a solution-rich space and also enhances some of the advantages already mentioned (such as responsiveness, adaptability and emergence). In the aforementioned examples of botanical architecture, only a limited number of semi-static plants are co-creating the desired structure. But with larger swarms of interacting individuals, design becomes more emergent, potentially leading to more surprising outcomes and innovative design solutions.

To assess a complex urban environment, it would be interesting to go further with abstracting the idea of exploration to other organisms, whose survival and presence would act as a sensing device for aspects like temperature, chemical gradients, air quality and so on. Those bioindicators are already commonly used, but not strategically applied to urban space. A combination of those living sensors would allow for a close monitoring and discovery of quality sets in the environment that again could relate to a specific function that could be implanted into that space. The application of organisms in a strategic way into public space would also involve an assessment of potential hazards to humans and existing ecosystems.

9.9.1 Further Abstraction and Translation into a Technological Context

Inviting nature as a co-designer in the creative design process has a wide range of advantages. As explained before, organisms exhibit a computational potential for maximised efficiency which can be used to create optimised solutions. But it is in the bio design approach with its embedding of living organisms that the advantages of working with nature become most apparent.

A full technical abstraction would be a swarm of sensing devices, exploring the environment and recording data throughout the dynamics of the day and the seasons. In urban environment qualities like surface temperatures, humidity, pollution levels, noise levels, sunlight exposure, vibration, wind, etc. as standard data could be recorded, mapped and used to locate situations that fit to architectural or programmatic implementations.

9.9.2 True Integration of Living Organisms into Buildings – Hybrids

First of all, structures can be created that grow themselves. This brings architectural concepts of on-site production and self-deployment together into an efficient and self-organising system. Additionally, self-repair can be achieved, and structures can be created that are responsive, adaptive and evolvable. Moreover, through the internal presence of living organisms, structures can exhibit properties of movement and even exploration through their surrounding environments.

9.9.3 Further Exploration – Adaptation to Environment

Next steps in the process would be the adoption of new and yet unknown environments as a design space. The current expansion of human environment into more extreme terrestrial, but also the ambition to expand into extra-terrestrial space creates new contexts that need to be explored. The integration of living organisms into this venture allows for a radically different, hybrid approach that could lead to a yet unimaginable future. The resulting blurring between architecture and natural environment coming out of the practice of co-designing with nature could be an answer to the problematic opposition between the built and natural environment. Co-designing the world with organisms could potentially engender a different relationship with nature, one that is less anthropocentric, and leaves more room for the agency of nature itself. However, we still have a long way to go before nature can reclaim

an equal position within the design process. In most of the examples above, nature is harnessed to perform functions for the betterment of mankind. One can ask where the benefits for the organisms lie. Aren't we simply forcing nature to unilaterally solve our problems? Also, organisms are not deliberately designing for the sake of design. This is an externally applied concept; the organism only tries to survive (Adamatzky et al., 2013). This makes the ethical considerations of all forms of life within the practice of co-design even more complicated. Nevertheless, we do believe that creating a world in which the agency of life and the principles of nature are tangibly present is a first step in the direction of a more balanced future.

References

Adamatzky, A., Armstrong, R., Jones, J., and Gunji, Y.P. (2013). On creativity of slime mould. *International Journal of General Systems*, 42(5), 441–457.

Adamatzky, A. et al. (2013). Are motorways rational from slime mould's point of view? *International Journal of Parallel, Emergent and Distributed Systems,* 28(3), 230–248.

Angewandte. Birkhäuser Verlag AG. https://www.degruyter.com/view/product/466102.

Badura, J. (2013). Explorative practices in dialogue. Art-based research at the interface of arts, sciences, and design. *In What Is the Architect Doing in the Jungle?* Biornametics; Imhof, B., Gruber, P., Eds. (2013). Edition Angewandte; Springer: Wien, Austria, pp. 14–19.

Bar-Cohen, Y. (Ed.) (2012). *Biomimetics Nature-Based Innovation;* Taylor & Francis: Boca Raton, FL, USA.

Borgdorff, H. (2009). *Artistic Research within the fields of science,* http://www.pol.gu.se/digitalAssets/1322/1322679_artistic-research-within-the-fields-of-science.pdf, as viewed 2.12.2015.

Brown, T. (2018). https://www.nature.com/news/how-to-solve-the-world-s-biggest-problems-1.18367, as viewed 7.8.2018

Bushan, B. (2009). Biomimetics: Lessons from Nature—An Overview. Philos. *Trans. R. Soc. A,* 367, 1445–1486.

Cecchini, C. (2017). Bioplastics made from upcycled food waste. Prospects for their use in the field of design, *The Design Journal*, 20: sup1, pp. 1596–S1610. doi: 10.1080/14606925.2017.1352684

Collet, C. (2018). Design and Living Systems Lab. http://livingarchitecture-h2020.eu as viewed 31.8.2018.

Design and Living Systems Lab. http://www.designandlivingsystems.com/ about [consulted on 05/08/18]

Descartes, R., and Gröber, G. (1905). *Discours de la méthode:* 1637. Heitz.

Descartes, R. Rules for the Direction of the Mind; Rule I, translated by Elizabeth Anscombe and Peter Thomas Geach in 1954. https://en.wikiso urce.org/wiki/Rules_for_the_Direction_of_the_Mind; as viewed 2.12.2015.

Dodington, E.M. (2009). *How to Design with the Animal: Constructing Posthumanist Environments.* Rice University.

Dosier, G.K. (2010). Production of masonry with bacteria, *US Patent No US9796626B2.* https://patents.google.com/patent/US9796626B2/en [consulted on 05/08/18]

Gaffney, O., and Steffen, W. (2017). The Anthropocene equation, *The Anthropocene Review*, Vol 4, Issue 1, pp. 53–61. https://doi.org/10.1177/ 2053019616688022

Goel, A., McAdams, D.A., Stone, R.B. (2014). *Biologically Inspired Design – Computational Methods and Tools;* Springer: London, UK.

Gruber, P. (2011). *Biomimetics in Architecture – Architecture of Life and Buildings;* Springer: Wien, Austria.

Gruber, P. and Imhof P. (2017). Patterns of Growth – Biomimetics and Architectural Design. *Buildings,* 7(2). https://doi.org/10.3390/buildings 7020032.

Horvath, A. (2004). Construction Materials and the Environment, *Annu. Rev. Environ. Resour.*, 29, 181–204. doi:10.1146/annurev.energy. 29.062403.102215

Imhof, B., and Gruber, P. (2015). *Built to Grow: Blending Architecture and Biology.* Edition.

Jonkers, H. (2011). Bacteria-based self-healing concrete, *Heron,* Vol. 56, No. 1/2.

Myers, W. (2012). Bio Design: Nature. *Science, Creativity.* London: Thames and Hudson.

Oxman, N. et al. (2013). Biological Computation for Digital Design and Fabrication, eCAADe 31: Biomimetics and Bio-Inspiration, Volume 1, Computation and Performance.

Oxman, N. et al. (2014). Towards Robotic Swarm Printing, *Architectural Design, 84*, (3) (May/June): 108–115.

Schumacher, P. (Ed.) (2016). *Parametricism 2.0: Rethinking Architecture's Agenda for the 21st Century.* In Architectural Design AD Special Issue; Wiley: London, UK.

Steffen, W., Broadgate, W., Deutsch, L., Gaffney, O., and Ludwig, C. (2015). The trajectory of the Anthropocene: The Great Acceleration, *The Anthropocene Review*, Vol. 2, Issue 1, pp. 81–98. https://doi.org/10.1177/2053019614564785

Steinberger, K., Krausmann, F., and Eisenmenger, N. (2010). Global patterns of materials use: A socioeconomic and geophysical analysis, *Ecological Economics*, Volume 69, Issue 5, pp. 1148–1158. https://doi.org/10.1016/j.ecolecon.2009.12.009

Von Borries, F. (2015). Artistic Research – Why and Wherefore? JCOM, *Journal of Science Communication.* http://jcom.sissa.it/archive/14/01/JCOM_1401_2015_C01/JCOM_1401_2015_C06 as viewed 12.9.2015.

10

Interspecies Urban Planning, Reimagining City Infrastructures with Slime Mould

**Teresa Dillon, Elliott Ballam, Richard Mayne, Neil Phillips
and Andrew Adamatzky**

University of the West of England, Bristol, UK
E-mail: teresa.dillon@uwe.ac.uk; teresa.dillon@polarproduce.org;
elliottballam@hotmail.co.uk; richard.mayne@uwe.ac.uk;
neil.phillips@uwe.ac.uk; andrew.adamatzky@uwe.ac.uk

The slime mould *Physarum polycephalum* optimises its shape in a geometrically constrained space. We explore this property in order to reconsider how we could develop more inclusive, interspecies approaches to urban planning and infrastructure. Working with slime mould we look towards developing new and urgent forms of dynamic interspecies urban planning.

10.1 Infrastructural Planning and the City

Kevin Lynch, the influential urban planner, describes a city as the 'characteristic physical and social unit of civilisation' (Lynch, 1954), whose properties (size, density, grain, outline and pattern) are shaped as much by people who live in it, as it shapes them. City populations are most often described in relation to their administrative (city proper), continuity (urban agglomeration), commuter belt (metropolitan) or hinterlands (city region) zones. In the United Nations (UN) report 'The World's Cities in 2016', estimates show that 54.5% of the world's population now live in urban settlements, with this rising to 60% by 2030 (Habitat, 2016). Storper and Scott define this period of human history not only as a global but also as an "urban era", in that population, productive activity, and wealth are highly

and increasingly concentrated in cities (Storper and Scott, 2016). How we live, define and plan cities has therefore become one of the most important questions of our time, as they have become the main habitat in which human activity is centred.

The growth of cities puts immense pressure on infrastructures and resources. Yet, as many researchers and theorists have shown, it is the city's daily and weekly rhythms of life that not only give it character but also embody how its labour markets, cultural norms and patterns of commuting are articulated (Edensor, 2002, 2016; Axhausen et al., 2002). Equal access to good jobs, commutability, green areas and fresh water are now considered as 'criteria' through which a city's creativity, sustainability and liveability are measured. How cities provide for such measures and grow in a sustainable manner has now become a global challenge. Although there is no unified solution to this issue as each city is so different, there is no doubt that analyses of current usage, as well as social, technical and historical reviews of how infrastructures were installed and planned, can help us to understand what is not just possible but also what can be achieved and (re)imagined. In this chapter we also ask how can bioinspired analogue process also help us think through new forms of infrastructural planning and city design.

The history of urban infrastructural planning can be traced back to the earliest civic records; however, it was the Parisian prefect and administrative lead Georges Haussmann, and the Catalan Spanish engineer Ildefons Cerdà, who are most often credited as the 19th century agents responsible for giving rise to what we think of today as modern urban planning (Neuman, 2011; Fraser, 2011; Paetzold, 2013). Haussmann and Cerdà were dealing with similar problems, common to many cities at this time – relatively new, large urban populations, resulting in cramped conditions, poor housing and a severe lack of sanitation. Their revisionist plans for Paris and Barcelona have become cornerstones in the history of how large-scale public infrastructural works and the creation of boulevards and parks can radically change the urban morphology of cities. While Haussman and Cerdà were mainly dealing with the boundaries of what defined Paris and Barcelona, they also faced the challenge of how the cities connected to other urban centres, both nationally and internationally (e.g., access and transport routes to other industrial or port cities). While we still deal with similar issues today, urban thinkers such as Brenner and Schmid now define our time as planetary urbanism, noting "it is clear that settlement based understandings of the urban condition have now become obsolete. The urban cannot be plausibly understood as a bounded, enclosed site of social relations that is to be contrasted with nonurban zones

or conditions. It is time, therefore, to explode our inherited assumptions regarding the morphologies, territorializations and sociospatial dynamics of the urban condition" (Brenner and Schmid, 2014).

As living, dynamic systems, cities are constantly evolving and changing over time, as the power dynamics of industry, trade and information shift. While responsive planning is an ideal, it can be difficult to achieve. It is clear from the research on infrastructure (road, rail, electric grids, internet) that the everyday concerns about urban systems are not only professionalised but also bounded up in capital imperatives (Sassen 2000, 2016; Hirt and Zahm, 2012). Ordinary citizens are therefore often locked out of high stake urban planning decisions. Even when citizens' views are taken into account the process can be limiting, leading in the worse case to unsatisfactory outcomes for all parties involved.

Additionally many of us are not really that concerned about how the city infrastructures work, until they break down. Yet city systems are increasingly becoming 'smart' meaning that the computation processes which support them become more complex, interconnected and self-regulated. Understandings therefore of cause and-effect relationships can become even more difficult to decipher and trace. In their social and historical analyses of infrastructures in general (railroads, electric power grids, telecoms, internet etc.) scholars in the field of cyberinfrastucture, Edwards et al., found that such issues could be referred to as base level tensions, which are in constant battle with each other and include (Edwards et al., 2007):

Time: referring to how short-term funding decisions can work against the longer time frames that are necessary for building and implementing infrastructures

Scale: addresses the disconnect between global interoperability and local optimisation

Agency: examines the navigation processes of planned versus emergent change in complex and multi-determined systems

Adding to this, Storper and Scott note that distance, which is perhaps considered as diminished in our digitally networked worlds, "is not dead", as substantial elements of our urban lives are anchored in spatially and temporally constrained urban systems (Storper and Scott, 2016). Taking these issues into consideration, as a loose interdisciplinary group of practitioners (artist, urbanist and social psychologist, architect and three computer scientists) working across different schools within the same university, we began to look towards the potential of unconventional computing methods

as a means to experiment with how urban planning practice could inform and address contemporary concerns relating to time, scale and agency.

Specifically we began to examine how the plasmodial life cycle stage form of the slime mould *Physarum polycephalum* (which we will refer to from here on in as 'slime mould') can be used to imitate human-made transport pathways and architectural plans. While we appreciate that this approach may come across as anthropogenic, the processes of imitation modeled here could also be used to explore other non-human forms of pattern making and agency.

10.2 Following the Extracellular Matrix

Many of the authors who contributed to this paper have been working with slime mould for some years. The reason for our interest in slime mould is that it represents a 'universal' and user-friendly living substrate for designing unconventional computing, sensing and actuating devices (Adamatzky, 2010, 2012, 2016; Mayne, 2016).

Research has shown that as the slime mould moves it leaves behind a trace of glycoprotein-rich extracellular matrix — or more concisely, the 'slime' from which the organism derives its name. These traces are the organism's effluvia, but may be utilised by the organism as a self-generated stored history of where it has been, which helps it navigate through its environment towards nutrient sources and solve the geometry-based problems (e.g., labyrinth navigation, morphological operations) for which it has recently received significant attention (Reid et al., 2012; Beekman and Latty, 2015).

10.3 Reimaging City Infrastructures with Slime Mould

Building on this work our key interest was to further explore how slime mould could be used within the field of urban planning and architecture. To this end we carried out the following experiments.

Experiment 1:
How can slime mould be used to visualise complex city networks by aiding large-scale design decisions and test proposals before real world implementation.

Experiment 2:

How can slime mould be used to evaluate architectural drafts of individual buildings.

10.3.1 Experiment 1: Visualising Complex City Networks

This set of interrelated experiments explored how slime mould could be used to reimagine city networks by adding a new and novel element to how decisions are made for large-scale urban works (Figure 10.1). Prior to the experiments being implemented, various tests were carried out, which explored the best conditions in which slime mould developed; for example, growing slime mould on a non-nutritive hydrated substrate in the absence of repellents.

10.3.1.1 Thematic networks

A series of nine Bristol maps were created, with each map highlighting what was referred to as a particular theme, meaning that their subject matter related to commonly used urban amenities: 1) car parks; 2) educational facilities; 3) entertainment venues; 4) green spaces and parks; 5) health care services; 6) hotels and hostels; 7) tourist attractions; 8) office blocks; and 9) retail spaces (Figure 10.2).

This choice of locations has been informed by the sections outlined in the Bristol Central Area Plan and categorised into themes such as retail outlets, green spaces, educational facilities etc. An inoculation point for all experiments was Temple Meads Station (Bristol main train station), as this is one of the main arrival points into the city and is the focus of development within Bristol's vision of strengthening its connection to the rest of the city centre and beyond. The maps (or algorithms) themselves have been devised by one of the authors, but they challenge the notion of authorship, as the slime mould is left to create its network of its own accord. It could be seen as a process of co-creation between person and biological matter, or it could be viewed as an emergent design in response to a set algorithm.

Either way this approach challenges the agency of power and control of the urban designer, and seeks inspiration from elsewhere in generating the material upon which is to be analysed. The maps generated illustrate and visualise the complex and invisible connections between specific thematic facilities within Bristol's existing urban fabric.

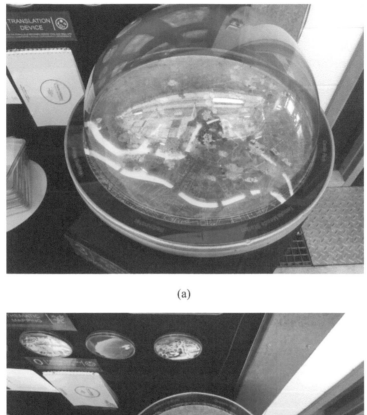

(a)

(b)

Figure 10.1 An experimental setup. (a) Side wide. (b) Top view.

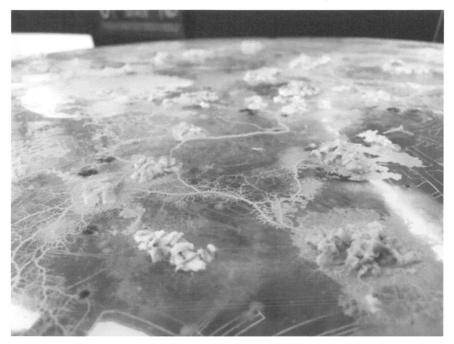

Figure 10.2 Slime mould propagating on an agar gel with oat flakes representing urban amenities of Bristol city. River Avon is illuminated by blue luminescent sheet from underneath to make difficult to propagate through obstacle.

10.3.1.2 Overlaying networks

The next stage of the research further explores the notion of authorship, and brings control and power back to the designer (or viewer at the exhibition). The designer can be selective in choosing which themes they deem appropriate to compare/overlay. Subjective (and also potentially objective) data can then be withdrawn from this process.

The example shown opposite overlays the network of 'Car Parks' with that of 'Tourist Attractions' in order to explore the relationship between the two. This could be a useful exercise for a governing body like Bristol City Council to gain an understanding of the distribution of public car parks in relation to visitor attractions. Overlaying the networks in this manner will allow the bigger picture of the invisible networks existent across the city of Bristol to emerge. Likewise by choosing specific themed maps, the designer or viewer can analyse (compare and contrast) the direct relationships.

Through this collaborative process of co-analysis between biological matter and urban designer, it is proposed that such subjective or objective results could be utilised to help make informed decisions about the most suitable location of new developments and potential approaches to urban design strategies.

10.3.1.3 Scenario – playing

Informed by the previous two aspects of work, the research also investigates the extent to which we can utilise the activity of slime mould to play out scenarios, and test the implications of new developments and urban design strategies.

This aspect of the research again explores the notion of co-analysis, but now looks to slime mould as a design tool to help visualise and test the impacts of developments that have been proposed. This process allows the designer to see the impacts of their proposal/strategy which would otherwise be unseen, or even unconsidered, the outputs of which could then inform the designer of beneficial changes before real world implementation.

Additionally, this approach investigates the notion of authorship and explores the role of architect/urban designer as simultaneously researcher and creative agent, and implies consideration of interfaces between roles and of where that agency lies. The research looks towards a position of mutual equality between person and biological matter in terms of who (or what) has the right to make design decisions, and who (or what) controls the process. The maps generated by the slime mould in such scenarios visualise the impacts that the proposed developments would have on the existing urban network – mapping the invisible network of the future.

10.3.2 Experiment 2: Evaluation of Architecture Drafts of Individual Buildings

10.3.2.1 Rationale

We envisage that the reimagination of cityscapes into bioinspired designs has the potential to enhance the wellbeing of a city's inhabitants, whether through creating efficiencies in transportation networks or otherwise by enhancing the aesthetic value of its subcomponents. This raises an important question, however: what are the relative scales at which network optimisation may be efficiently reinterpreted by slime mould? It is, after all, somewhat arbitrary to base our hypotheses on network bioevaluation on the specific sublevel of a city. This section details experiments in a similar vein but at a

smaller conceptual scale: throughout an individual's home, via the medium of bioevaluation of two-dimensional architectural drafts.

In keeping with the theme of the previous experiments, the experiments presented here also capitalise on photophobic and chemotactic responses of *P. polycephalum* in order to represent two-dimensional architectural drawings in a form that slime mould can interpret, i.e. as attractant and repellent gradients, towards deriving a bioinspired interpretation of how space is allocated in a home.

10.3.2.2 Methods

Samples of *P. polycephalum* were taken for experiments by homogenising approximately 1 cm^2 of stock plasmodium with a scalpel blade and transferring them to the experimental environment described below.

Experiments were conducted as illustrated in Figure 10.3: 12 cm square plastic Petri dishes were filled with a layer of 2% non-nutrient agar gel and affixed to an underlying laser-cut acrylic representation of an architectural draft. The rooms in this draft were represented by opaque black acrylic squares whilst its walls, corridors and mounting plate were clear acrylic. The agar gel within the Petri dish was cut so that its boundaries corresponded to the portions of the draft that represented external wall boundaries. In the experiments presented here, the draft was for a 1970's style British flat. Single oat flakes were placed overlying the centre of each black acrylic cut-out that represented a room in order to encourage the organism to propagate throughout the agar layer. The slime mould was inoculated into the space representing the hallway of the flat.

The Petri dish was placed overlaying an electroluminescent sheet (ELS) outputting 196 Lux, in an environment that was otherwise devoid of light sources. The architectural draft that separated the Petri dish from the ELS therefore acted as a "mask", where rooms were represented as shaded areas by virtue of their being opaque and hence preventing the transmission of light. Conversely, non-habitable spaces (walls and corridors) in the acrylic layer permitted the transmission of light and hence were represented on the Petri dish as illuminated zones.

These methods were used to represent the architectural draft in a manner that the slime mould could interpret, i.e. through representing habitable zones as attractant gradients and non-habitable zones with repellents. Experiments were run for 36 hours and photographed at six-hour intervals.

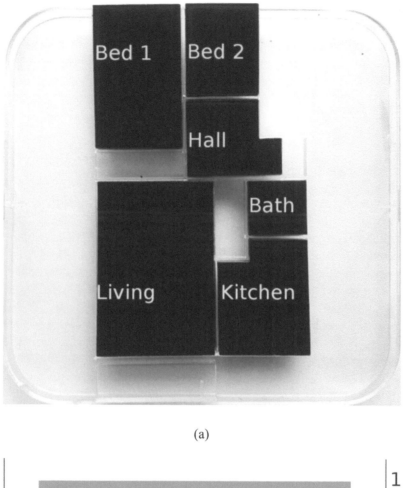

(a)

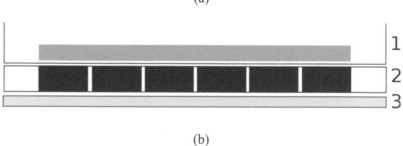

(b)

Figure 10.3 Experimental setup. (a) Photographs to show experimental setup. A laser-cut acrylic architectural draft of a flat, where rooms (labelled) are represented by black squares and non-habitable regions are clear. (b) Schematic to show the experiment in cross section: (1) The Petri dish layer, comprising a layer of agar (grey) cut to the size of the acrylic layer, with slime mould (yellow) growing on top. (2) The acrylic layer, comprising clear and opaque sections. (3) Electroluminescent sheet.

10.4 Findings

10.4.1 Experiment 1

This investigation into the extent to which slime mould can be used within the field of urban design has unearthed some interesting results. With reference to the initial research objectives and outputs, the key findings are as follows.

Translation device

It has been possible to develop a translation device that can draw parallels between real world urban design factors and slime mould culture. Although this is still at a relatively simplistic level, discovering and developing these rules and parameters to influence and facilitate the slime mould culture is an important step towards fully enhancing its fascinating capabilities. This algorithm sets up an organic parametric process to analyse existing urban fabrics.

Thematic maps

Applying this translation device to the city of Bristol allowed the research to become further grounded in the real world and explored the layered reality of the city as a complex territory where many networks co-exist and collide. The results of this co-authored (human input and slime mould culture) process generated a range of thematic maps which discovered and illustrated invisible networks of the city far beyond our human comprehension.

These findings were both fascinating to look at, but also interesting to analyse subjectively when referenced back to the original map (Figure 10.4). The route and strength of the slime mould's network, as well as the areas it ignored or vacated, allowed conclusions to be drawn as to what this means at an urban design level. These results visualise how slime mould can certainly provide responses beyond the analogue (yes or no).

Analysing mechanism

When brought together, comparing and contrasting these thematic maps facilitated another level of urban analysis. Exploring the relationships of specific maps allows the designer (human) to start utilising the slime mould's culture as a form of analytical design tool.

In addition to co-analysis, this mechanism explores the notion of co-creation. Overlaying these unbiased networks of swarm intelligence, can help aid designers in making decisions on urban strategies or most suitable sites for proposed developments. This explores the role of the architect or designer as simultaneously researcher and creative agent.

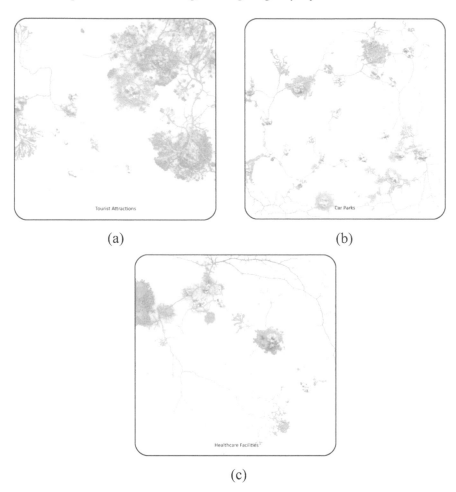

(a) (b)

(c)

Figure 10.4 Mappings of urban amenities by slime mould. Oat flakes represent locations of (a) tourist attractions, (b) car parks, (c) healthcare facilities.

Scenario-playing platform

Finally, the research turns its attention to utilising slime mould to test the impacts of proposals that have been co-authored by the slime mould and designer.

At the time of writing this report the experiment is in progress. But it is hopeful that the slime mould will generate a network that displays a bottom-up response to a top-down decision, challenging the question of power and control in making design decisions.

10.4.2 Experiment 2

A representative result is shown in Figure 10.5. In this experiment, the organism opted first to move northwards into the second bedroom, before doubling back and describing a ring through the remaining rooms, in the order bathroom, kitchen, living room then master bedroom.

What does this tell us about the slime mould's interpretation of the draft? Unsurprisingly, it initially migrated to a nearby nutrient source, before navigating around the rooms sequentially. The route it took was efficient in that it visited each room, but its initial reversal made the route longer than the theoretical minimum path length to visit each room. A bioinspired interpretation of this would be to assume that the most efficient designs would place either the most-used rooms, or at least the rooms most-frequently visited when returning home (debatably, the kitchen or lounge), closest to the

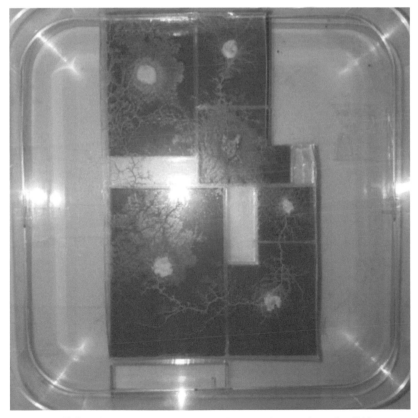

Figure 10.5 Photograph of a representative experiment taken after 24 hours.

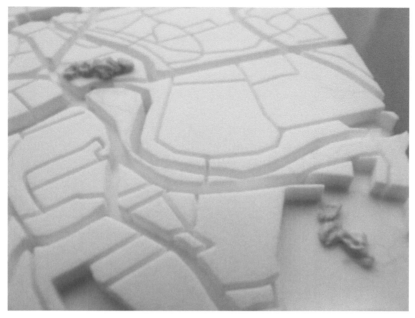

Figure 10.6 An attempt to imitate crowd dynamics in 3D template of Bristol city centre (around Temple Meads Train Stations).

entranceway. In this case, we may reason that the draft presented is not the most efficient subdivision of the space available, although this is a hugely subjective assertion that is very much open to interpretation.

With regards to route planning, it is interesting to note that the organism opted to traverse a hallway in order to travel from the living room to the master bedroom. Examining the biological consequences of spanning an illuminated area, we must assume that the organism was able to balance the deleterious effects of light irradiation (such as potential DNA damage and dehydration) with the benefits of migrating to the new area, likely to be principally the extra nutrients and moisture. In any case, it could be interpreted that the area traversed by the organism represents an efficient corridor placement because the organism found it to be the best place to migrate along, despite the repellent field.

As the example presented here is only a single observation of an experiment representing a very simple architectural draft, it would be unscientific to make any sweeping statements regarding the usefulness of slime mould bioevaluation of architectural drafts. It must be considered, however, that there are many ways by which the internal space of a building

may be subdivided, where not all of them are necessarily aimed towards the benefit of the eventual occupants (we are thinking of instances where cost efficiency is a priority, rather than malevolence or poor thought on the part of the architect!). We propose, therefore, that slime mould evaluation of architectural drafts is an interesting and novel route towards problems of space distribution that is worthy of further research, especially in applications where optimisation of room layout is critical, such as designing spaces for people with physical disabilities.

10.5 Messy Matters

As noted in our opening section, cities are messy matters, and no one unified solution or approach can define how we structure or plan their development. Taking this into consideration, our goal was to understand how bioinspired, interspecies processes help us think through new forms of infrastructural planning and city design.

Acknowledging that responsive planning is ideal but can be difficult to achieve, we approached working with *Physarum polycephalum* as an interspecies collaboration, one in which our intra-actions (Barad, 2007) with the organism could assist in the co-creation of an analytical design tool, which alongside other methods and approaches could illustrate how more inclusive forms of urban design practice could evolve.

Returning to Edwards et al's (2007) analysis of the dimensions that are required when deploying new urban infrastructures, including time (referring to short, medium and long term), scale (referring to global interoperability and local optimisation) and agency (referring to planned versus emergent change), and Storper and Scott's (2016) emphasis on distance and proximity, we review our findings in relation to these parameters.

Our experiments addressed these dimensions at the micro scale (individual home) and macro scale (Bristol city), with the latter illustrating a number of thematic situations and scenarios at the local administrative city level. The maps produced revealed the spatial distribution between nodes from which proximities, distance and effort can be extrapolated. While the flexibility and adaptability of the maps illustrate how they could in future settings be useful in exploring global and 3D urban relationships, our study was limited to an individual home and a city with a population of less than 1 million people. Further tests would need to be carried out in order to explore such global and dimensional complexities.

Additionally, while collaborations with slime mould can provide a relatively quick medium through which to communicate new urban designs and plans, this needs to be balanced with the time it takes to cultivate slime mould. Taking this into consideration, our work nonetheless provides a solid base from which to show how slime mould maps could provide a legitimate mode through which to explore infrastructural decisions. While our experiments were limited to human-centric needs, we feel the maps provide important evidence for more interspecies urban futures.

The emergent nature of the maps demonstrates a distinctively bottom-up approach, one which could also be argued is playful, engaging and species inclusive. This, we believe, is one of the key benefits of the approach; as an inclusive practice it could, for example, be used in schools with children and young people. It also combines interdisciplinary thinking skills and understanding (biology, science, computing and planning) and would be well suited to cross-curricula contexts. In light of more current eco-feminist approaches to spatial planning (Hoepler 2011; Mazé, 2017; Tsing, 2016), we view the maps we have created as co-productions with slime mould. In this sense, we see our work as taking an important step towards illustrating how more unconventional and radical planning practices could evolve, particularly ones in which other species are co-producers of maps. Whereby the mutual and interdependent relationship between person and biological matter in terms of who (or what) has the right to make design decisions, and who (or what) controls the process is taken into account. This direction also signals how, in a climate of mass extinction and ecocide, we could move away from capitalist, human-centric approaches to urban planning to more interspecies or companion species mapping processes (refer to Haraway, 2016). If we are to take up Brenner and Schmid's (2014) call to explode our inherited assumptions regarding the morphologies, territorialisations and sociospatial dynamics of the urban condition, we see such an analysis as contributing towards a new and urgent form of dynamic interspecies urban planning.

Acknowledgement

The authors extend their thanks to Matthew Hynam for preparing the laser cut architectural draft used in experiment 2.

References

Adamatzky, A. (2010). *Physarum machines*. World Scientific.

Adamatzky, A., editor (2012). *Bioevaluation Of World Transport Networks*. World Scientific.

Adamatzky, A., editor (2016). *Advances in Physarum machines: Sensing and computing with slime mould*, volume 21. Springer.

Axhausen, K. W., Zimmermann, A., Schönfelder, S., Rindsfüser, G., and Haupt, T. (2002). Observing the rhythms of daily life: A six-week travel diary. *Transportation*, 29(2):95–124.

Barad, K. (2007). *Meeting the Universe Halfway: Quantum Physics and the Entanglement of Matter and Meaning*. Duke University Press Books.

Beekman, M., and Latty, T. (2015). Brainless but multi-headed: decision making by the acellular slime mould physarum polycephalum. *Journal of molecular biology*, 427(23):3734–3743.

Brenner, N., and Schmid, C. (2014). The 'urban age'in question. *International journal of urban and regional research*, 38(3):731–755.

Edensor, T. (2002). *National identity, popular culture and everyday life*. Bloomsbury Publishing.

Edensor, T. (2016). Introduction: Thinking about rhythm and space. In *Geographies of rhythm*, pages 13–30. Routledge.

Edwards, P. N., Jackson, S. J., Bowker, G. C., and Knobel, C. P. (2007). Understanding infrastructure: Dynamics, tensions, and design.

Fraser, B. (2011). Ildefons cerdà's scalpel: A lefebvrian perspective on nineteenth-century urban planning. *Catalan Review*, (25):181–200.

Habitat, U. (2016). World cities report 2016. *Urbanization and Development: Emerging Futures*. New York: Pub. United Nations.

Haraway, D. J. (2016). *Staying with the Trouble, Making Kin in the Chthulucene*. Duke University Press Books.

Hirt, S., and Zahm, D. (2012). *The urban wisdom of Jane Jacobs*. Routledge.

Hoepler, K. (2011). *No Maps for these Territories: Cities, Spaces, and Archaelogies of the Future in William Gibson*. (Spatial Practices). Brill Rodopi.

Lynch, K. (1954). The form of cities. *Scientific American*, 190(4):54–63.

Mayne, R., editor (2016). *Orchestrated Biocomputation: Unravelling the Mystery of Slime Mould Intelligence*. Luniver Press.

Mazé, R. ed. (2017). *Feminist Futures of Spatial Practice: Materialism, Activism, Dialogues, Pedagogies, Projections*. AADR (Spurbuchverlag) (May 1, 2017).

Neuman, M. (2011). Centenary paper: Ildefons cerdà and the future of spatial planning: The network urbanism of a city planning pioneer. *Town Planning Review*, 82(2):117–144.

Paetzold, H. (2013). The aesthetics of city strolling. *Contemporary Aesthetics*, 11(1):23.

Reid, C. R., Latty, T., Dussutour, A., and Beekman, M. (2012). Slime mold uses an externalized spatial "memory" to navigate in complex environments. *Proceedings of the National Academy of Sciences*, 109(43): 17490–17494.

Sassen, S. (2000). New frontiers facing urban sociology at the millennium. *The British journal of sociology*, 51(1):143–159.

Sassen, S. (2016). The global city: Strategic site, new frontier. In *Managing Urban Futures*, pages 89–104. Routledge.

Storper, M., and Scott, A. J. (2016). Current debates in urban theory: A critical assessment. *Urban Studies*, 53(6):1114–1136.

Tsing, A. (2016). *The Mushroom at the End of the World: On the Possibility of Life in Capitalist Ruins*. Princeton University Press.

11

BioLogic – Living Structures and Swarm Bodies

**Maurizio Montalti[1], Alessio Erioli[2], Andrea Graziano[2],
Tommaso Casucci[2], Mirko Daneluzzo[2], Sonja Bäumel[3],
Massimo Moretti[4] and Pieter van Boheemen[5]**

[1]Officina Corpuscoli, Witte de Withstraat 108 hs, 1057 ZG Amsterdam,
The Netherlands
[2]Co-de-iT, Via Agostino da Montefeltro 2, 10134 Torino, Italy
[3]Studio Sonja Bäumel, Witte de Withstraat 108-H, 1057 ZG Amsterdam,
The Netherlands
[4]WASP, Viale Zaganelli, 26, 48024 Massa Lombarda RA, Italy
[5]WAAG, Sint Antoniesbreestraat 69, 1011 HB Amsterdam, The Netherlands
E-mail: info@corpuscoli.com; alessio.erioli@unibo.it;
arch.a.graziano@gmail.com; tommaso.casucci@gmail.com;
mirko@nyxostudio.com; info@sonjabaeumel.at; info@3dwasp.com;
p.vanboheemen@rathenau.nl;

Over the past few decades, biology has entered the collective debate more
than any other science field[1].

One main reason for this is possibly that such investigative field is highly
concerned with subjects and issues that affect each of us; phenomena, which
are still mysterious and fascinating as life itself. We have been learning that
organisms, when considered as organized information, can be utilized com-
bining different features in order to perform specific functions (e.g. plants'
genetics).

[1]Biology is nowadays conceived not only as a form of technology but also as the new design
playground, which will strongly affect the near future (e.g. activities and projects from Ideo,
Autodesk, MIT, etc.)

As renewed artist and researcher Oron Catts stated: "Biology is becoming engineering, life is becoming a raw material to be engineered. Once that happens designers will move in and start designing living biological products." [2]

While critically observing and questioning this potential through a designer's lens, we cannot be careless about the contribution of scientific advancements that enable a paradigm shift in respect to the design tools, changing them from a system of representation of a product to a direct materialisation of the product through novel specific manufacturing processes, where designing and making tasks take place simultaneously (i.e. 3D modelling/printing)[3].

This, by defining a new balance between the autonomy of the process itself and the will of the designer, giving life to a renovated vision for the construction of the world we live in and of our systems and tools, allowing us to trigger sensitive interactions with the cycles of the ecosystems we are part of.

Understanding the complex dynamics characterising organic systems could in fact allow us to design by means of already largely available resources, making use of logics and processes that are already embedded in living systems.

How do biological entities and digital algorithms relate to each other? How could the study of such interaction be visualised, its potential harnessed

[2]See video at: https://www.facebook.com/virtualfutures/videos/1436687913049392/

[3]"Alphabet and the Algorithm" – Mario Carpo: "... things go even deeper when we can set behavioral rules that dictate both morphology and physiology of what we are making..."

and the outcomes translated into a more tangible and immediate experience? And what would be the applications and the implications which could derive from such a study? Which disciplines could be affected?

On January 24th and 25th, 2013, the Bio-Logic project took place in Amsterdam in the form of a workshop, aiming to explore and to experiment on possible methods and techniques to design artificial systems, by combining digital strategies with living material. The living protagonist of the 2-day experience was, without any doubt, a microorganism – *Physarum polycephalum* – commonly known as slime mould.

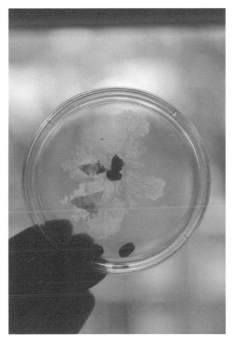

Physarum polycephalum.

One of the primary intentions of the workshop was to invite participants to reflect on the potential interactions between algorithmic design techniques and physical/biological computation, as performed by the living organism. Therefore, each participant was encouraged to question the role of the designer, when confronted with the possibility of matching controlled interaction with the organism's behaviour and to work on developing ways for influencing biological processes characterising living materials, while steering them to fulfil design goals.

Slime moulds are neither plants nor animals nor fungi, but they could be considered a hybrid living organism with a unique development cycle and behaviour. Also known as myxomycetes, they are a group of heterotrophic organisms, which use organic substrates to get chemical energy for their life cycle. *Physarum polycephalum* is an acellular slime mould, usually inhabiting forests in many parts of the world, and it is most commonly found in its vegetative stage, a plasmodium, which consists of a single cell containing millions of nuclei. Plasmodia can move as quickly as about one centimetre per hour, by forming vein-like structures that function similarly to human muscles: they contract and relax at minute intervals and thereby pump cell cytoplasm back and forth.

The plasmodium phase of *Physarum polycephalum* is very well known for being a master amongst living creatures for defining prototypes of future and emergent computing architectures. Its ability to solve a wide range of computational geometry and logic problems can be observed by representing a problem's data as a spatial configuration of nutrients and by subsequently allowing the slime mould to span the nutrients with its protoplasmic network. The architecture of the network represents the slime mould solution to the problem. The queries that the *Physarum polycephalum's* plasmodium seems to be capable of solving include shortest path, implementation of storage modification machines, Voronoi diagram, Delaunay triangulation, logical computing, and process algebra.

Previous works in this direction, like the one performed by Toshiyuki Nakagaki and his team (Tokyo Railway Network), or the extensive research conducted by Andrew Adamatzky and partners (U.S. transport network), contributed to inspire the development of this specific investigation.

However, instead of providing the slime mould with established reference points, usually represented by oat-flakes (one of slime mould's favourite food sources) placed on a surface of non-nutrient agar, we decided to conduct our investigation by trying and "confuse" the organism. This, by making a large amount of nutrients available through embedding in an agar layer and by organising them in configurations deriving from the logic standing behind a number of specifically selected, computational algorithms. In short, through such approach, we aimed to explore in which way slime moulds' intelligence could be implemented for reading and interpreting digital algorithms conceived by humans, which in certain cases are inspired by the very behaviour of the slime mould itself (i.e. swarm intelligence).

Taking into consideration such ambitious plan, the BioLogic workshop was designed as a first step to create a common playground for collaboration

and cross-contamination between different know-hows and competences, while the performed experiments and the resulting outcomes clearly exemplified the adopted multi-disciplinary approach.

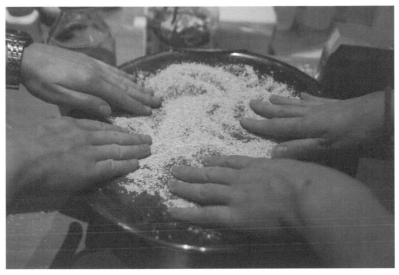

Workshop participants preparing food for *Physarum polycephalum.*

The workshop participants were introduced to several focus areas and had the chance to practice with a multiplicity of related skills and methods, ranging from Computational Design strategies and 3D Modelling, to 3D-printing and Biology.

The activities started by diving into Computational Design. The tutors provided an initial, basic set of insights for allowing the participants to understand the Java language and to start programming simple algorithms in a Processing environment. As a result, each individual had the opportunity to get familiar with the elementary architecture of algorithms and learned about how to read them through. Five different processing-based softwares for pattern generation and a related accessible interface were developed to enable the users to easily define the desired patterns by means of a simple software where by moving sliders one could affect values and parameters. Participants were also challenged to directly intervene by modifying the written codes. In this way, each participant defined and developed his/her own experiment and the related strategies (generative patterns) for triggering slime mould's behaviour.

Processing-based softwares for pattern generation and a related simple interface.

While exploring different digital strategies to drive/influence the growth of slime mould, a digital agent-based model of the slime mould behaviour, based on the model developed by Jeff Jones (2010)[4], had been created.

[4]"Characteristics of Pattern Formation and Evolution in Approximations of *Physarum* Transport Networks" – https://dl.acm.org/citation.cfm?id=1739142

Far from trying to exactly reproduce slime mould's behaviour, the model was utilised for loosely predicting slime mould's interaction with potential food sources, with the objective of producing quick initial feedback for the participants, while designing different deposition patterns.

Since the experiments involved living organisms, participants were also introduced to essential biological techniques, such as media/plates preparation, sterile techniques, inoculation, incubation, bio-hacking, etc. Such hands-on activities allowed them to understand and learn about the importance of working in sterility, when willing to grow selected microbial cultures.

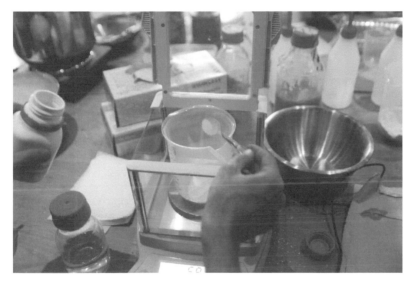

Preparing a mix of PDA (Potato Dextrose Agar) with ground oat flakes and placing it in the pressure cooker in order to sterilise the nutrients for the slime mould.

Due to the nature of the very practices and of the tools involved, this was is fact one of the most problematic issues the team faced when the workshop was still in a development phase. Aiming to minimise the potential chances of contamination by spoiling agents, a D.I.Y. sterile hood, equipped with HEPA filter and UV light, was designed and built to accommodate a hacked 3D printer, capable of extruding organic, agar-based materials.

Inoculating the slime mould on the agar-based plates.

D.I.Y. sterile hood, equipped with HEPA filter and UV light.

The 3D printer provided by WASP (i.e. EVO 3D) was hacked and equipped with a bespoke extruder that included a special, screw-controlled, volumetric extrusion device, a heated syringe and an interchangeable nozzle.

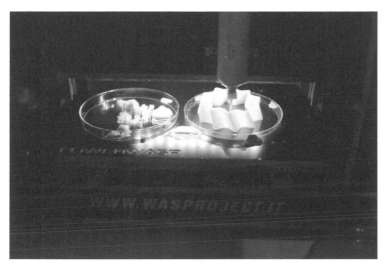

Hacked 3D-printer, provided by WASP.

As part of the overall design challenge related to the hardware, the team needed to identify and to optimise ways for controlling the machine parameters as design variables. By putting such need in direct relation with the presence of a custom extruder and with the geometries and shapes of the designs that would have been printed, it revealed necessary to integrate a custom G-Code generator in the Processing definitions.

An important aspect of the work was then assessing and refining the interactions between the new hardware and the processing-based software, in order to directly generate the G-code instructions for the machine. The related G-Code(s) were then sent to the hacked 3D printer.

The materials that the team specifically developed for implementation in the hacked 3D printer resulted from an attentive, well-balanced mix of PDA (Potato Dextrose Agar) and ground oat flakes, as those ingredients were identified to constitute a fertile ground for the slime mould to grow on, while allowing the material's extrusion and deposition. However, defining the right consistency of the material, which could satisfy both the printing process and the slime mould "taste", together with the essential need of operating in sterile conditions, was surely not a straightforward process and revealed being the most challenging part of the whole set of activities.

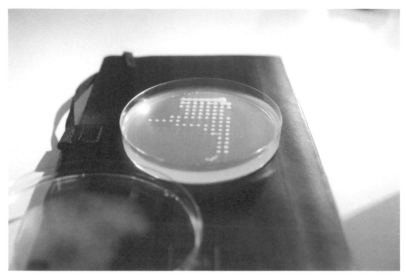

Printed 2D pattern consisting of agar-based, composite materials.

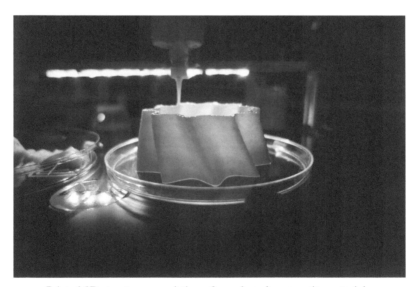

Printed 3D structures consisting of agar-based, composite materials.

Nevertheless, the team reached its goal by succeeding printing both 2D patterns and 3D structures with agar-based, composite materials. In order to better analyse the interaction of *P. polycephalum* with the printed patterns, the team created a single image resulting from the overlap of a number of

time-lapse frames, which were shot during different growth stages, describing the way in which the slime mould explored different paths' and nutrients' distributions.

During the workshop days, a range of different presentations, lectures and discussions revolving around topics such as Design & Science, Synthetic Biology, 3D printing and Computational Design contributed to contextualise the overall framework of the project, particularly by opening up different reflections and bringing up critical questions, useful for identifying follow-up directions and to debate about the impact of such typology of practices.

In this sense, the many different backgrounds and skills of the people who joined the workshop surely revealed to be of great advantage, enabling diverse viewpoints and perceptions, mixed with a great dose of enthusiasm.

Each participant had the chance to explore his/her own curiosity and to challenge his/her own skills, by developing an individual set of experiments, both with the aid of the printer (by printing their own generative pattern) and/or with the adoption of a more traditional approach.

All the generated nutrient distributions on plates were then inoculated with *Physarum polycephalum*. Despite the fact that during the workshop several 3-dimensional structures were printed, the team decided to mainly keep focusing on patterns with a small elevation for the time being, and to further explore 3D landscapes at a later stage, inspired by the preliminary conclusions deriving from the project experience.

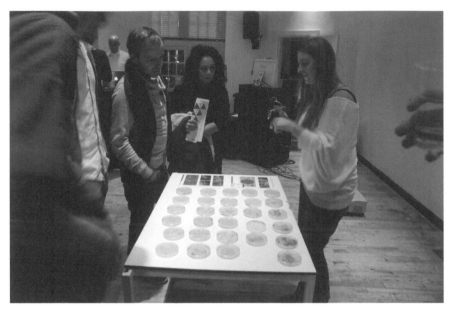

Agar-based plates inoculated with *Physarum polycephalum.*

As final outcome of the Bio-Logic project, we collectively developed a set of six main experiments/systems, to help us visualising, analysing and subsequently interpreting the slime mould's behaviour, as related to the printed patterns and to the configurations we fed the organism with.

Such physical experiments have been developed aiming to identify a feedback-loop process where digital strategies transfer information to living systems and where living system provide feedback for adjusting digital strategies.

How can slime mould organisms suggest us about how to design artificial structures generated from the combined action of digital strategies and a living technology? Could this information allow us to explore potentially effective strategies for printing with living material?

The project, tackling such main research questions, was initially set as an opportunity for artists, designer, architects, etc. to explore and understand the genesis of products in a more comprehensive manner, from the material system to the tools, know-how and shape. We believe that understanding the dynamic of organic complex systems will allow us to design by making use of abundant resources, such as the logics and the processes, which are already deeply embedded in living systems.

In this sense, the Bio-Logic project and the related workshop, complemented by a final public presentation of the activities' outcomes could be considered a successful experience, as they offered a set of preliminary, intellectual and operative tools leading towards a conscious experimentation in a relatively young field of endless possibilities and development.

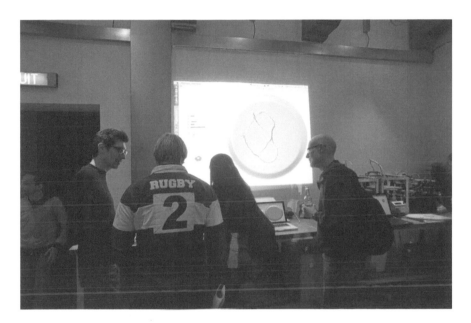

The BioLogic project created space for multidisciplinary explorations. Instead of a conclusion-driven workshop, it morphed into the start of a collective-driven research, lead by a strong focus on hands-on experimentation and enhanced by the integration of digital tools and computation. Success was met in creating a suitable processing-based software allowing to print both 2D patterns and 3D structures, using agar-based composite materials' formulations. The produced time-lapse video[5] and the related graphical mapping offered the chance to observe and to better understand slime mould's behaviour. However, the overall analysis process could certainly improve, benefiting from a higher level of systematization. Bio-Logic was certainly not our last collective experiment, but yet another processual-driven exploration within a continuing attempt.

[5]https://vimeo.com/88166497

Public presentation of the workshop's outcome.

BioLogic was conceived, designed and organised by:

Officina Corpuscoli (Maurizio Montalti)
Co-de-iT (Alessio Erioli, Andrea Graziano, Tommaso Casucci,
Mirko Daneluzzo)
Studio Sonja Bäumel (Sonja Bäumel)
WASP (Massimo Moretti)
WAAG (Pieter Van Boheemen)

Credits

Tutors Computational Design → Tommaso Casucci, Mirko Daneluzzo
Tutors Design and/with Biology → Sonja Bäumel, Maurizio Montalti
Software development → Tommaso Casucci
3D-printer development → Massimo Moretti and Tommaso Casucci
Sterile Hood development → Pieter Van Boheemen, Maurizio Montalti
Timelapse video → Maurizio Montalti

Photos

Google Drive:
https://drive.google.com/open?id=0Bw8kGpzQ3MLAYlR5TURRWFR4S3c

Flickr_1: https://www.flickr.com/photos/co-de-it/sets/72157640140974623
Flickr_2: flickr.com/photos/co-de-it/sets/72157640140974623/
Flickr_3: flickr.com/photos/corpuscoli/sets/72157640635188595/

Videos

https://vimeo.com/88166497
https://www.youtube.com/watch?v=ONXOdwxw9bY

Websites

http://waag.org/en/blog/bio-logic-workshop-waag
http://www.corpuscoli.com/projects/bio-logic/
http://www.co-de-it.com/wordpress/nexto-biologic-workshop-report.html

12

Slime Intelligence

Elvia Wilk[1] with Jenna Sutela

[1]The New School For Social Research, 235 Bowery, New York,
NY 10002, USA
E-mail: elviapw@gmail.com; jenna.sutela@gmail.com

12.1 Many Heads, No Brain

Physarum polycephalum is a single-celled organism with a theoretically infinite number of nuclei. In its ideal conditions – dark, wet and bacterial – it multiplies into a bright yellow mass that spreads ostentatiously, fanning out in veins or erupting in polyp-like protrusions. The population of autonomous nuclei acts like a single being, a mega-cell known as "plasmodium," moving and spreading with efficiency and coordination to find food and avoid light. Although it has no brain or nervous system, the group organism demonstrates advanced spatial intelligence.

Polycephalum, meaning "many headed," is a species of slime mould. Long assumed to be a type of fungus, slime moulds are now considered Protists, "a taxonomic group reserved for 'everything we don't really understand.'"[1] Slime moulds are ancient: they arrived hundreds of millions, perhaps a billion years ago, and theoretically, they are immortal. If the slime cannot find resources it goes into hibernation, turning into a scab ("sclerotium") or growing spores to await future conditions when it can regenerate. In other words, it is one of the earthly creatures best suited to survive planetary

[1]Ferris Jabr, "How Brainless Slime Molds Redefine Intelligence," *Scientific American*, November 7, 2012, http://www.scientificamerican.com/article/brainless-slime-molds/?print= true.

extinction. Lynn Margulis, the evolutionary biologist, argued that "those great evolutionary survivors, the lowly slime moulds, would inherit the earth."[2]

Jenna Sutela: *Many-Headed Reading*, 2016.
Photo: Mikko Gaestel.

In the early 2000s, a Japanese researcher named Toshiyuki Nakagaki placed *Physarum sclerotia* into a labyrinth with flakes of oatmeal at two ends. The slime quickly foraged the most efficient path between both food sources, finding the shortest route between two points – a job for which humans typically need equations or computational aids. Nakagaki then tried arranging the oats into an approximation of the geography of Tokyo and surrounding cities; the slime carefully extended itself across the oat-map into a shape remarkably similar to the existing railway network. In fact, unaffected by human bias and politics, Nakagaki says the slime actually may have improved upon the design of the railway system.

In April 2016, Jenna Sutela made a research trip to Japan to interview Nakagaki and other slime scientists to document and learn from their work. Sutela's artistic practice has been following the trail of slime: the organism

[2]Steven Rose, "Lynn Margulis Obituary," *Guardian*, December 11, 2011, https://www.the guardian.com/science/2011/dec/11/lynn-margulis-obtiuary.

has become a collaborator/performer, growing inside recent sculptural works, while providing an ever-expanding rubric for material-based research into organizational intelligence and computation, both natural and unnatural. "The slime mould has served as a kind of a paranoiac-critical agent, helping me make connections where none previously existed. I trust its movement will take me where I need to go."[3]

Sutela does artistic research; I research artistic research. We overlap, we leave traces, we circle back on one another. We write this essay back and forth, to articulate each other's thoughts: two heads working laterally through movement, tracing slime-like intelligence by simulating its collaboration. As Donna Haraway says: "To be a one at all you must be a many, and that's not a metaphor."[4] What can we learn from a primordial organism about decentralized cooperation, material problem solving, and the limits of consciousness? How does the slime mould know what it knows? How do *we* know what we know?

12.2 Beginning to Think

Understanding the behavior of *polycephalum* demands a reconsideration of the meaning of intelligence. Contemporary theories of intelligence almost universally rely on the "information processing" metaphor, that is, the idea that the intelligent brain processes data through computational actions like storage, transfer and retrieval – though this is probably nothing like what brains really do. Computational intelligence as a metaphor for all intelligence is a historically specific construction, just like theories of mind throughout history, which tend to mirror the most advanced technologies of the time – at various times the brain has been described as a hydraulic system, an electrical circuit, and a set of chemical reactions.[5] Many, including Noam Chomsky, have argued that no technological comparison will be accurate until we understand how consciousness works first; even if it could be artificially replicated, the process can't be initially grasped through stabs at modeling it.[6] So, what if instead of looking for the most advanced metaphor to account

[3] Jenna Sutela, "Many-Headed Reading" (Centre Pompidou, Paris, May 3, 2016).

[4] Donna Haraway, "Anthropocene, Capitalocene, Cthulucene: Staying with the Trouble" (lecture, University of California, Santa Cruz, May 9, 2014), https://vimeo.com/97663518.

[5] Robert Epstein, "The Empty Brain," Aeon, May 18, 2016, https://aeon.co/essays/your-brain-does-not-process-information-and-it-is-not-a-computer.

[6] Noam Chomsky, "Lecture on Artificial Intelligence" (lecture, Harvard University, April 26, 2013), https://www.youtube.com/watch?v=TAP0xk-c4mk.

for consciousness, we were to look to a "primitive" organic being like the slime mould, not only to understand or imagine how one brain works inside the skull, but also the way many brains work in concert?

Unlike a typical programmable agent that processes information through memory, slime mould decision-making cannot be predicted or replicated, since it coordinates itself entirely through sensory feedback with its environment. Exactly how this feedback happens is still unclear, but it has something to do with the extracellular slime traces that the cell leaves behind to tell itself where it's already been. It does not make internal memories, but it does make choices based on past behavior. Its cognition is identical to movement; it knows exactly and only what it does. "*Physarum's* spatial memory works," writes Steven Shaviro, "not by internal representation, but rather by a physical marking of the very space that is being remembered. In this case, the map actually coincides with the territory."[7]

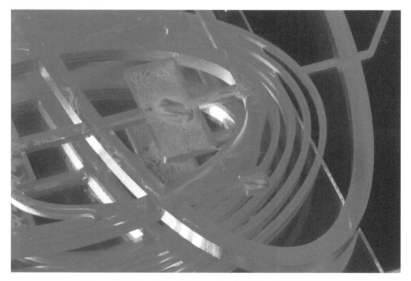

Jenna Sutela: *From Hierarchy to Holarchy*, 2015.
Photo: Mikko Gaestel.

Shaviro likens this behavior to the theory of Extended Mind, a philosophical concept put forth in the late 1990s that the brain and its environment can be seen as an indistinguishable, coupled system. Nakagaki,

[7]Steven Shaviro, *Discognition* (London: Repeater, 2016), 213.

on the other hand, compares it simply to the human unconscious response to stimuli. Both theories are metaphorical attempts to move beyond the information processing metaphor, by relocating intelligence altogether from the brain itself to a type of distributed, physically situated (site-specific) system. Shaviro writes: "*Physarum* does not need to have a brain, any more than it needs to have a mouth. The entire organism, in its environment, 'acts as a brain' already."[8]

If a seemingly simple organism can solve spatial problems through movement, artificial intelligence could conceivably do the same. Many scientists believe the future of robotics lies in such processes of decentralized movement, and the bodies of newly developed "soft robots" are designed to adapt and learn by moving through what are often called "genetic" or "evolutionary" algorithms. A research group led by Akio Ishiguro at Tohoku University, which Sutela visited, developed a soft-bodied amoeboid robot inspired by the slime mould's plasmodium. The robot, whose working title at one point was "Slimy," moved "as a result of the interaction of neighboring modules and friction from the surrounding world," in the words of lead researcher Takuya Umedachi.[9] While traditional robotics focuses on controlling movement through motorized joints, soft robots adapt to their environments in real time, expressing ever-greater degrees of freedom than their rigid counterparts.

12.3 Organization, Organism, Orgasm

The slime mould is an organism but it is also an organization – not a train but a railway system. Like robotics, infrastructure design has begun to learn from the notion of decentralized, environmentally specific intelligence. Keller Easterling describes the evolution of massive worldwide infrastructure systems: "When the object of design is not an object form or master plan but a set of instructions for an interplay between variables, design acquires some of the power and currency of software. [. . .] It is an 'abstract machine' generative of a 'real that is yet to come.' "[10] Sutela's artworks involving *Physarum* become such abstract machines generating alternate realities. However, the design is not only a set of immaterial "instructions" – in this case better thought of as suggestions or provocations – but also the materials through

[8] *Ibid.*, 229.
[9] Takuya Umedachi, interview with Jenna Sutela, April 12, 2016.
[10] Keller Easterling, *Extrastatecraft* (London: Verso, 2014), 102.

which those instructions are enacted (or not). That the slime mould is incorporated into the work outsources some of the decision-making process to spatial, non-human intelligence, which is interpretable only through its movement. The abstract machine becomes a soft machine.

Working with a living organism as an artistic material requires adapting along with it: besides the act of keeping it alive, there's the fact that not every museum or gallery wants bacteria-eating plasmodium spreading around the exhibition, and so the life-form must stay contained in its artwork. Building a host sculpture therefore becomes an infrastructural design challenge, a calibration of multiple parts to form a whole. "Creating the works is like creating a laboratory," she says. "The slime needs a habitat – not just an installation, but an architectural space."[11] The habitats she builds are interactive, often resembling mazes. The labyrinth as a generative form contains not only the formal history of computational problem solving and theories of mind, but also represents the collision of natural and artificially constructed space.

Sutela's works are grouped into an ongoing project called Orgs, which stands for organization, organism, and orgasm. A circular motif recurs throughout the works: a feedback loop, a zero, an open mouth, a Petri dish. A living slime mould draws itself across a maze of three-dimensional Plexiglas forms derived from organizational charts and networking diagrams, the surfaces of which are coated with agar for moisture and dotted with oats for nutrition. In one of the most recent iterations, a series of three hanging, transparent, hand-sized spheres called *Orbs* (2016) were shown in an exhibition at Future Gallery in Berlin, the microclimates also containing sticks of activated charcoal to purify the air within each orb. Housed in the dark gallery basement, the orbs are illuminated by infrared light; while *Physarum* is unique for a protist in that its activity is visible to the naked eye, it paradoxically does not like to be seen, adding to the logistical and theoretical puzzle of putting it on display.

One *Orb* contains an explanatory blockchain diagram; another contains a "Minakata Mandala," or a shape drawn by the famous Japanese naturalist Minakata Kumagusu, who collected slime mould samples in the 1920s for Emperor Hirohito (also a biologist who had an affinity for the organism). In a letter to a Buddhist monk, Kumagusu represented his view of the world through this mandala drawing: With humans placed at the center of the diagram, our ability to comprehend causal connections between things diminishes as they are located further outward from the center and our

[11] From a conversation with Jenna Sutela, 2016.

awareness of them becomes more tenuous.[12] The mandala is also a manifestation of the limits of anthropocentrism and the existence of systems beyond cause-and-effect chains of connection. The juxtaposition of shapes inside the *Orbs* connects systems of belief, exposing the iconographic power behind ostensibly functional, empirically produced systems.

The third sphere contains a "holacratic" organizational chart. The term originates in an essay from 2007, wherein which the American software engineer Brian Robertson used the word "Holacracy" to describe a system of corporate self-organization by which a company is organized into overlapping "circles," teams of employees who come together spontaneously around specific tasks.[13] Robertson borrowed the term from Arthur Koestler's 1967 philosophy/psychology book *The Ghost in the Machine*, in which Koestler invents the word "holon" to describe nested hierarchies of entities in any organization, including the organization of thoughts. Koestler argued that the brain is made up of holons that are autonomous and self-determining yet also fundamentally dependent on the brain as a whole.

Contemporary management theory has generally come to treat social groups as organisms possessing their own form of intelligence. Circles and holons replace linear organizational charts; role definitions become fluid, relationships become transient. Holacracies may retain hierarchical forms, but they are "value-neutral" hierarchies.

As a living model of nonlinear action and lateral collaboration, the slime mould prompts the question of whether organizations could ever truly develop "naturally" as an organism, devoid of top-down controls, or whether imposed horizontality only advances the interests of external forces governing the body, instead of the interests of its constituent parts. The idea of a "conscious" organization is as disturbing as it is compelling. A decentralized, autonomous organism has no ideology, ethics, or accountability, whereas it might be preferable for a corporation to act according to a core logic beyond self-serving opportunism. In the case of holacratic systems of corporate organization, it's hard to imagine the "oatmeal" driving the participants as being anything other than capital. In a 2016 text for *e-flux Journal*, Mike Pepi

[12]Minakata Kumagusu, based on his writings to a Buddhist monk, accessed at the Minakata Kumagusu Archives, Tanabe, April 14, 2016.

[13]Brian Robertson, "Organization at the Leading Edge: Introducing Holacracy™ Evolving Organization," *Integral Leadership Review* (June 2007), http://integralleadership review.com/5328-feature-article-organization-at-the-leading-edge-introducing-holacracy-evo lving-organization/.

describes the trouble with decentralized organizations in terms of "asynchrony," or nonlinearity: "We have dreamed about the revolutionary potential of self-organization for generations, but the apparent harmony between asynchrony and anarcho-syndicalism, libertarianism, or horizontalism obscures the extent to which an engineer's fantasy has become management's best friend. The decentralization achieved by asynchrony is different from the political ideal of decentralization. From the perspective of the individual worker, asynchrony doesn't remove authority as much as displace it."[14]

For humans to act as a decentralized system constantly oscillating between competition and collaboration to the point where the two can no longer be distinguished, moving in the most efficient ways according to self-serving opportunities – that is already the condition of the free market. Economist Alan Kirman made this connection in 2015: "Economies are like slime molds, collections of single-celled organisms that move as a single body, constantly reorganizing themselves to slide in directions that are neither understood nor necessarily desired by their component parts."[15] And yet, it's also the condition of resistant, resilient, "polycephalous" political movements, those adaptable, semi-coordinated networks of individual nuclei who join together and multiply, becoming increasingly visible as they expand. The remarkable intelligence of *polycephalum* is not in its asynchronicity, but in its lack of any need for a manager governing that decentralized movement at all.

12.4 Becoming Other

Sutela ingests a small amount of dried *Polycephalum sclerotium* before beginning the performative *Many-Headed Reading* (2016) as part of the Centre Pompidou's programming. Nearby is a sandwich of three Plexiglas plates. The plate at the center of the sandwich has a "word maze" engraved on it, and is covered with agar, oats, and *polycephalum* plasmodium – which is quickly growing in size to get to the oats. The bottom plate, colored red to distort light passing through so as not to disturb the slime with brightness, has an interpretation of the Minakata Mandala drawn over it. The protective

[14] Mike Pepi, "Asynchronous! On the Sublime Administration of the Everyday," *e-flux Journal 74* (June 2016), http://www.e-flux.com/journal/74/59798/asynchronous-on-the-sublime-administration-of-the-everyday/.

[15] Alan Kirman paraphrased by Kate Douglas in "After the Crash, Can Biologists Fix Economics?" *New Scientist,* July 22, 2015.

top plate has a circle of arrows creating a shadow on the slime, potentially affecting its movement due to its affinity for darkness.

The word maze consists of lines leading in a star-like pattern to the letters of the words "organization," "organism," and "orgasm." In her reading, Sutela gives clues as to the connections between these words, at one point explaining: "Orgasms may induce a brief loss or weakening of consciousness, *la petite mort.* According to Nakagaki, by focusing on the level of unconsciousness, we may find clues to the similarities between the information processing of humans and other forms of organic and synthetic life. [...] Artificial intelligence has been trapped on the level of consciousness for too long."[16] Imagining that the behavior of the *polycephalum* she's ingested is "programming" her speech, the speech act itself becomes a form of artificial intelligence. The reading is co-designed, moving toward the unconscious.

Nakagaki also once felt an irresistible urge to eat the organism he devoted his life to studying. From his description, it is hard to identify a scientific goal in doing so; he had veered into the territory of non-empirical experimentation at that point. There is, from the other side, a long history of artistic fascination with biological organisms that at times becomes twinned or overlaps with scientific methodology, but that often winds up in the same not-quite-empirical territory too. John Cage, for one, became biologically inclined via his adoration for all types of mushrooms. His mycological obsession likewise led him to eat them (including poisonous ones) as if driven by a desire for understanding through symbiosis, a non-codified type of knowledge. Like the slime mould, mushrooms were particularly interesting to him because they are so difficult to taxonomize – in reading his accounts, it seems as if only by achieving physical oneness with the organism did Cage feel he could begin to understand the mysteries of mushroom intelligence.

However, while Cage sought chance encounters without making conclusions, claiming that artists should ask questions rather than seek to provide answers (referring to a type of artistic "divination"), Sutela's interest in slime mould's intelligence includes an interest in answers – there is a real element of experimentation in each of the physical works she creates. Will the slime mould react to the conditions of light and darkness she sets up each time? Will its presence affect her performance? What word(s) will it spell out as it grows across the maze? How does it communicate with the viewer? The behavior of her companion species enacts a type of knowledge beyond codified systems

[16]Toshiyuki Nakagaki, interview with Jenna Sutela, April 5, 2016.

of representation. And likewise the artwork becomes a living, unpredictable, unknowable entity.

Art constructs systems of knowledge and belief that can be as rigid as any other and often does this by (over-)explaining what it knows. Sutela's Orgs suggest the potential for other kinds of knowing that cannot necessarily be transmitted through existing channels of artistic or scientific research. She invents a new type of movement, a new language of forms – "form as action" as opposed to "form as object." Artwork whose form is action is self-learning artwork – software rather than hardware. This could also be described as the distinction between "knowing that" and "knowing how."[17] To know that the slime mould moves in a certain way because of certain capabilities – that is scientific research. To know *how* through the act of moving along with it – that is the work of the artist.

An earlier version of this text was published by *Rhizome* in summer 2016. See also Jenna Sutela (Ed.), *Orgs: From Slime Mold to Silicon Valley and Beyond* (Helsinki: Garret Publications, 2017), 16–40.

[17]Gilbert Ryle makes this distinction in *The Concept of Mind* (Chicago: University of Chicago Press, 1949)

13

Pulse, Flow – Artistic Exploration of *Physarum polycephalum*

Nenad Popov

Independent Scholar, Berlin, Germany
E-mail: nesa@morphogenesis.eu

13.1 Introduction

In this chapter, I will briefly explain the conceptual background and a series of small experiments that led to the audiovisual installation "Pulse, Flow", which gently transfers the audience into the slow-pacing world of *Physarum polycephalum*.

Between 2008 and 2013, I was co-leading CodeLab, a lab at the ArtScience department in the Netherlands that dealt with alternative ways of using computers in art. We were very much interested in alternative ways of computing as well, and we did things like rule based bird flock simulations and Voronoi-diagram calculating board game. While researching these subjects, I saw a YouTube video of Physarum approximating Tokyo railroad network.

It was love at the first sight!

Physarum was impressive on two levels, first one being visual/aesthetic and the second one conceptual. On the visual level, I was very curious about it is bright yellow color, very loosely defined shape and even sinister looking dark fruiting bodies which were beautiful in a way I could not put my finger on yet.

On the conceptual level, I was fascinated by its veiny networked structure, flickering time lapses (suggesting something curious about timescales), spreading wide while searching and quick contraction after conquering

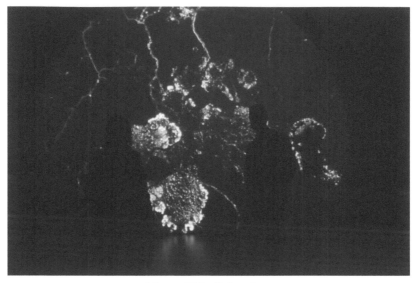

Figure 13.1 Pulse, flow.

the area and optimizing the nutrition flow – effectively solving traveling salesman problem.

The lack of skin was also quite fascinating: loosely defined what is inside and what is outside – making it hard to quantify and put a price tag on. The whole thing is driven by internal fluid fluctuation, which was tying into my previous work with reaction-diffusion systems, inspired by the Alan Turing's work *Chemical Basis of Morphogenesis*. I really wanted to make this internal aspect for *Physarum p.* visible to everyone, and that is what led me to the development of "Pulse, flow"(Figure 13.1).

13.2 Experiments

One of the first things that I wanted to explore was the growth-patterns of the slime mould: changes that happen on the scale of hours and days. This followed a series of studies on sonification of morphological properties of grown networks, including making a sound-generating program in a graphical programing language Max/MSP. After the artistic studies, I made several technical studies about Physarum's life support system as well as imaging and video processing techniques needed for the final work.

13.2.1 Growing a Movie

13.2.1.1 Temporal isolation

Because a time-lapse movie is basically zooming out within the time domain, it was necessary to isolate Physarum's time from the external time (day/night cycle, etc.). For this purpose, custom setup was built in which a plate with Physarum was placed at the bottom of a light-isolated black box. On the top of the box was an opening for the camera lens and optional flash.

13.2.1.2 Lighting

Near the top of the box was a diffuse light source, whose intensity is controllable from outside. In one case, light source was a simple array of led lights diffused by a layer of tissue paper. In another experiment, light was reflected from light-diffusing reflectors that can be found in old laptop screens.

13.2.1.3 Camera

The camera used for these experiments was a Canon IXUS 115 HS, 12MP consumer photo camera. This camera was chosen because of the availability of hacking its internal software to add custom functionality (Figure 13.2), like

Figure 13.2 A peek on the timelapse camera hack.

taking a photo at regular intervals, fixing the focus, etc. Another necessary hack for this camera was connecting an external power source through a fake battery.

Camera is placed at the top of the box, its lens going through the opening in the box. This way camera can be operated without disturbing the recording.

13.2.1.4 Compositional aspects

Time interval between shots was 10 s during the period of 12–48 h. The growth medium, which was also movie background, was moist black foam, chosen in order to accentuate its bright yellow color. Two instances of Physarum were placed on the left and right side of the plate, equal distance from the center. Around the center area of the plate were placed pieces of food. All timelapse experiments were done using pieces originating from the same plasmodium.

In this experiment, multiple instances were placed in order to see if Physarum would fight itself over food.

13.2.1.5 Results

Physarum propelled itself towards the food, exhibiting curvy elegant lines (similar to Victorian floral patterns or perhaps Tim Burton style decoration). The growth and branching would occur in short bursts, reminiscent of aggressive behavior. The branches are spanning in the directions of empty space, not favoring the food specifically. In the beginning of the process, it appears that Physarum tried to avoid contact with itself or its clone. Due to this self-avoidance vs. conquer the whole space, the process is similar to the process of human doodling: Lines are first enclosing smaller sections, then filling them up, process is being repeat until the whole surface is filled.

After most of the space was covered by slime mould, the process of network optimization started. In this stage, the thin surfaces were slowly disappearing in favor of network of veins connecting the food sites. Some overlapping points of two clones merged and the entire network was one organism again. The image gradually changed from low-contrast overfilled feeling to a more graphical style with strong lines connecting larger patches.

Due to the internal fluctuation of liquids in the Physarum the final video exhibits mild flickering over the surface of the organism.

Some time-lapse shots were discarded due to the errors such as slime-mould escaping the box, dying from the lack of water or food over longer periods of recording, too much UV/IR radiation while experimenting with different light sources, sporulation in the middle of the process, overgrowth, etc.

13.2.2 Sonification Experiments

13.2.2.1 Reinterpreting Mycenae alpha by Iannis Xenakis

Mycenae Alpha is a piece by Iannis Xenakis made for his UPIC system. UPIC system can translate a drawing into various aspects of a sound process, like pitch, amplitude or filter properties. Mycenae Alpha is a musical composition whose score has organic-like branching structures (Figure 13.3). This score is then fed into UPIC system, which created the final sound output.

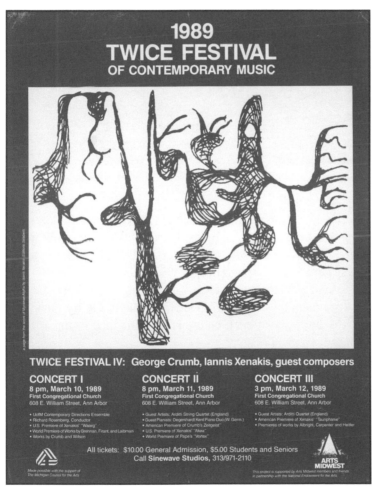

Figure 13.3 Event poster featuring the score for Mycenae Alpha (1989 Twice Festival of Contemporary Music) by Iannis Xenakis[1].

[1]http://www.centre-iannis-xenakis.org/items/show/48

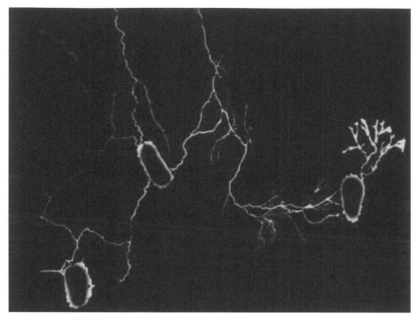

Figure 13.4 *Physarum polycephalum* as a graphical score.

In this experiment, Slime mould was growing on the clear black surface. Food was placed over a mostly sinusoidal path. When the plasmodium connected all the food nodes, a snapshot was taken. This picture is then fed into UPIC-like system and the sound output was recorded.

Within the sound generating system, horizontal axis represented time. Vertical axis was divided into 256 cells corresponding to the frequencies in a musical scale. The intensity of each cell was then mapped to the volume of the corresponding frequency (Figure 13.4).

The result was a rich sonic composition, pale in the comparison to the original but remarkably similar in the types of expression – long glissando, 'branching' of frequencies, etc. (e.g., sound clip available at https://vimeo.com/35433020).

13.2.2.2 Translating the growth to sound

Previous experiment dealt with a snapshot of time, but I was also curious what sonic properties can arise over a longer time period. To explore this, I created a simple computer vision software that could analyze all the changes between the frames in a time-lapse movie and track the direction and velocity of those changes.

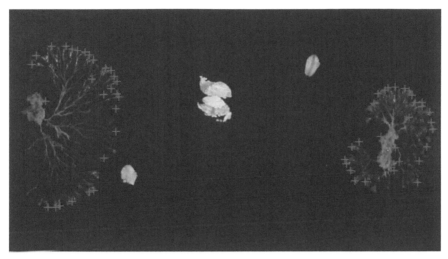

Figure 13.5 Red crosses indicate newly conquered areas by Physarum as it grows. This process drives sound synthesis.

Each inoculation point was used as a reference point for the cluster around it. The angle between the reference point and emerging tracking point was used to drive the pitch of the synthesizer, and velocity was mapped to the volume (Figure 13.5). An example recording of this process is available at https://vimeo.com/35434923

13.2.2.3 Outsourcing to non-humans: slime mould programming in Max/MSP

Max/MSP is a visual programing environment where placing boxes containing various functions and connecting them into larger structures using virtual cables make programs. A Max/MSP program looks like a tree structure, sometimes even a network-like structure.

In this experiment, a few sound generating and processing objects were placed randomly over the programming area within Max/MSP environment.

After this, a Petri dish representing the programing area was prepared, and the small pieces of food were placed in it, reflecting the placement in the programming environment (Figure 13.6). Slime mould was then inoculated from the point representing the sound output function, and the growth was recorded over a period of 2 days.

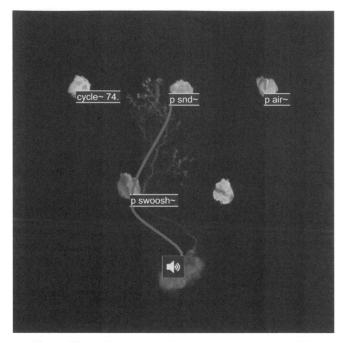

Figure 13.6 Physarum making connections in Max/MSP.

The connections made by slime mould were then manually recreated in the programming environment, and the change in the sound output was monitored.

There is also an automated system in the works (not completed at the time of writing this article) where the computer vision system is continuously monitoring the Petri dish and looking for new connections (Figure 13.7).

Once that part is complete, it would be interesting to create an x–y sliding system to influence the Physarum and make it aware of changes in the programming environment, creating a full feedback loop.

13.2.3 Life Support

How to keep the slime mould alive and healthy? Primary issue was to make an automated life support system that would have minimal influence on the actions of slime mould. For example, in the case of time-lapse movies, it was necessary to have at least the surface moist during the several days that the filming took place, without interrupting the time-lapse.

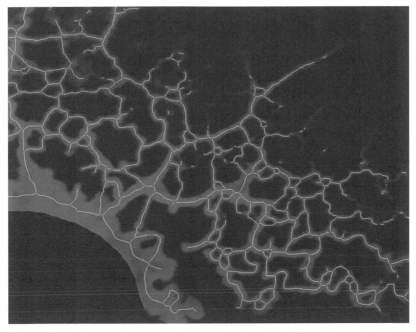

Figure 13.7 Automatic extraction of skeleton (green) and branching points (red).

To address this, I developed several DIY versions of automated life support systems, using Arduino microcontrollers and off-the-shelf components (Figure 13.8).

Time-lapse movie setup had a sprinkler system made using automatic soap dispenser coupled with a nozzle from a plant sprayer. I would activate this system manually right after the shots, so that the liquid would soak/diffuse before the next photo is taken.

"Pulse, flow" installation had a bit more automated setup: there was a tiny food heater plate connected to the temperature sensor to keep the temperature at ideal level. The moisture level was controlled by two electrodes connecting the substrate to the micro controller that would check the resistance every few hours. If the check occurs during the night, then Arduino microcontroller would immediately activate the hacked soap dispenser and add the water to the substrate. If the check happens during the audience visits, and the substrate is dangerously dry, the system would pause the installation for a minute, add some water and then reset the computer vision time-filters (Figure 13.9).

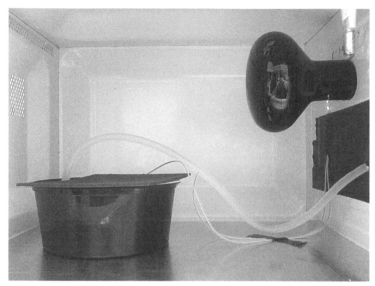

Figure 13.8 An early DIY life support system: IR light adding the heat, a pump adding the water to the substrate and electrodes measuring the substrate resistance.

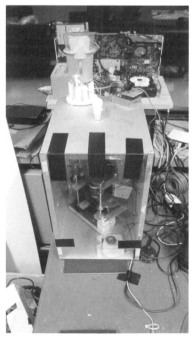

Figure 13.9 Imaging and life support early prototype.

13.3 Pulse, Flow

After playing around with various aspects of *Physarum p.*, it became clear that the multi-scale timing was the aspect I would like the audience to focus on.

One interesting time scale is on the brink of our perception (or attention span), on the level of minutes – the internal flow of the protoplasm.

Another time scale is on the level of hours – small growth during the site exploration.

Third time scale would be on the level of days: overall structure should considerably change as the slime mould had enough time to explore most of the available area.

Apart from the time and aesthetic aspects of Physarum, it was also important to point out to the fact that a living creature is present and is integral element of the art piece.

Out of these choices emerged a solution for the installation setup: isolated space, large projection, immersive sound and the object within which everything emerges: slime mould/computer hybrid.

The surface where the slime mould grows takes about 10 cm^2. It is big enough to be visible with the naked eye, and that is why it is placed in a transparent box and shown to the audience. It is the source. However, it does not take the focus away from the entire space, its function is more a clue than an explanation.

This surface of 10 cm^2 is then enlarged and projected on a surface of about 5×4 m. The average size of the spread-out piece of plasmodium is than matched to the average human height. The dish is filled with bigger islands around food sources connected through intricate network of tubes.

Projection is circular in shape to maintain the connection with Petri dish, but also because a circle is more friendly shape than a square. This circle is not shown fully: about 1/5th is cut out on the bottom to create the sensation of disc rising out of the floor. During the exhibition, the audience reported that this shape reminded them of rising sun, a gateway, a tunnel exit, a planet or a galaxy.

The total size of the projection makes the intricate details of growth patterns visible with remarkable detail and attracts the audience to examine them from up close (Figure 13.10). The whole growth process happens on a timescale of 24 h.

Physarum has an oscillating process within its body very similar to our breathing. Parts of its surface are rising and falling in a steady rhythm. This rhythm is slow compared to our respiratory rate, between 0.5 and 1 "breaths"

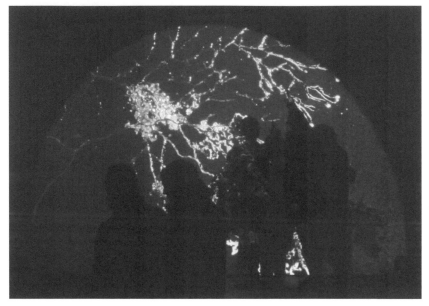

Figure 13.10 Audience discussing the Physarum during the STATE Experience Science festival in Berlin.

per minute compared to our 12–24 breaths per minute. One aspect of this work is dedicated to helping us slow down, breath deeply and get closer to the timescale of the slime mould.

This breathing process might be considered slow, but it is still perceivable. With a considerable patience, it is possible to observe these motions just by looking at the Petri dish with the naked eye under special lighting. However, this installation tries to help us perceive these changes in an easier way. Easy way is important choice because the goal is to offer a contemplative space where spectators mind is free to float in and out of the scope of installation instead of overloading their intellectual faculties with one fixed point.

This choice manifests itself in both the visual and sonic aspects of the piece.

In the projection, breathing phases are emphasized using two different colors, and audience can see the intricate wave-like reaction-diffusion patterns sliding across the entire body of slime mould on a timescale of couple minutes. On the very edge of the capabilities of imaging equipment, it is also possible to see noisy fluctuation on a timescale of few seconds provided that the audience gets really close to the projection surface and looks at the individual pixels.

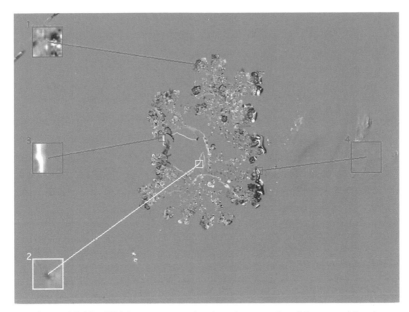

Figure 13.11 Thickness measuring locations used to drive sound levels.

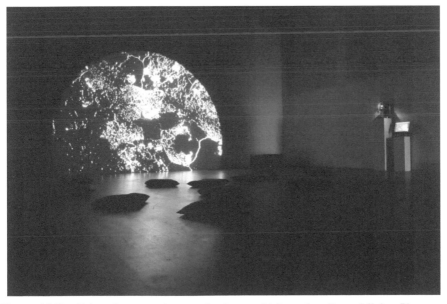

Figure 13.12 Pulse, flow overview: projection, multichannel audio and living Physarum setup on the right.

Sound part of the installation is offering an immersive experience of the internal liquid fluctuations within the slime mould. A set of five speakers is spread around the projection. The current breathing phase of Physarum is used to drive a technically simple sound composition (Figure 13.11). This sound is reminiscent of a slow sea waves or a rising wind – flow of air or flow of water.

The pace of the seemingly repeating waves has a slightly hypnotizing and calming effect, and for that purpose, it is important to set volume levels to not too loud to be distracting and not to quiet to be unperceivable or confusing.

All these aspects together offer a place quite different from our everyday environment, place where the rush hour of outside life is paused for a moment and we can let our mind think or perhaps even better – let the eyes and ears do the thinking (Figure 13.12).

14

Disruptive Material Intelligence of *Physarum*: Liquid Architecture of a Biological Geometry Computer

Liss C. Werner

Technical University of Berlin, Germany
E-mail: liss.c.werner@tu-berlin.de

Physarum polycephalum, also called slime mold or *myxamoeba*, has started attracting the attention of those architects, urban designers and scholars, who work in experimental trans- and flexi-disciplines between architecture, computer sciences, biology, art, cognitive sciences or soft matter; in short, disciplines that build on cybernetic principles. Slime mold is regarded as a bio-computer with intelligence embedded in its physical mechanisms (Adamatzky, 2013; Jones, 2016). In its plasmodium stage, the single cell organism shows geometric, morphological and cognitive principles potentially relevant for future complexity in human–machine networks (HMN) within architecture and urban design. The parametric bio-blob presents itself as a geometrically beautiful[1] graph structure–morphologically adaptive, logistically smart. It indicates cognitive goal driven navigation and the ability to externally memorize, similarly to ants (Johnson, 2001). *Physarum* communicates with its environment. The chapter introduces the 'creature' in the context of 'digital architecture'[2]: (a) in an overview of the current state of architectural and urban projects based on slime mold, (b) in digital

[1] The emotional and subjective term 'beautiful' may generally be inappropriate for a scientific publication; here it refers to the three qualities of architecture coined by the Roman architect and engineer Vitruvius (80–70 BC–15 BC). The Vitruvian Triad, firmitas, utilitas, venustas, describes the quality of architecture as scientific means of measure.

[2] 'Digital architecture' here refers to the 'first digital turn' in the 1990s (Novak, 1991).

theory with a glimpse into *Physarum*'s parallels to our digitally networked multi(cyber)space, (c) I will consider *Physarum* as liquid geometry computer – a cybernetic disruptive bio-architectural device. A discussion on its algorithmic and parametric design strategies for architectural optimization and computational urban planning for a lean networked (un)conscious city is envisaged at a next stage.

14.1 Introduction

Physarum structure reveals two distinct geometric patterns: (a) on the edges *Physarum polycephalum* develops thin branches, searching their environment for food (Figure 14.1(a), (b)), (b) at a 1:10 enlargement the tips of the branches reveal a double-curved surface geometry of bulging droplet-like blobs[3], which occasionally turn into elongated three-dimensional oval shapes. Those clusters of blobs have an intricate topography at their edges demonstrating a landscape of regularly shaped and rounded hills (Figure 14.2(a), (b)). They can be seen as the edges where foraging growth is happening through the actuation the protein actin enabling the construction process of the contracting filament membrane, ectoplasm as outer layer and endoplasm, the liquid found within. Actin is partly responsible for the built up of contractile filaments of muscle cells (D'Haese, 1978). Once the organism grows and the branches with the bulging blobs at their tips become longer through foraging, they divide into further branches and link up like veins. Self-organizing growth is triggered through cytoplasmic liquid pumped back and forth in a rhythmically oscillating manner inside the membrane (Kishimoto, 1958; Zonia, 2007). Eventually, the organism grows a regular – slightly noisy – Voronoi pattern. The links (the edges surrounding the Voronoi cells) connect corresponding nodes (vertices). Once the slime mould moves, location and size of vertices and edges change, disappear or merge; new links and vertices (nodes) develop (Figure 14.3(a)–(c)). They traverse according to the geometrical and structural change of the blob, steered by external and internal parameters. The large membrane acts as transport network for

[3]The term *blob* stands for binary large object. In architecture, the *blob* was introduced by the architect Greg Lynn in the 1990s, the era of the first digital turn in architecture. It describes an amoeba-like architectural forms. See 'Folds, Bodies and Blobs', (Lynn, 1995; Lynn, 1998). Since then blob-itecture or blob-architecture has been established as a formal typology of architectural round forms modelled or generated using digital tools and became part of digital theory in architecture – especially in the discussion around *bio-digital and genetic architecture* (Sykes, 2010; Werner, 2015).

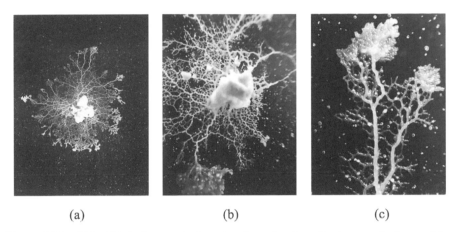

(a) (b) (c)

Figure 14.1 1(a), 1(b) (left, centre). Branches departing from food source (oat), searching for nutrition, Voronoi pattern partly formed. (c) (right). blob-like *physa* bubble at end of searching branch.

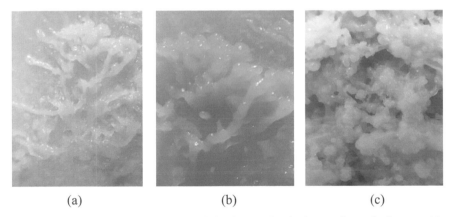

(a) (b) (c)

Figure 14.2 (a), (b) (left, center). Blob landscape developing at the end of a searching branch. Swelling blobs move forward through the oscillation of a liquid within the membrane–specimen magnified. (c) (right). Blob landscape. *Physarum polycephalum* has created a morphing liquid topography and continues growing–specimen magnified.

nutrients and sensor in constant exchange with its environment; its foraging is governed by the organism sensing influences alien to its own. In the case of our *Physarum* those are, e.g., noise (Meyer, 2017), light intensity, temperature, amount or nutrition in the substrate. Jakob von Uexküll's fundamental findings in the systematics of living systems being informed by their

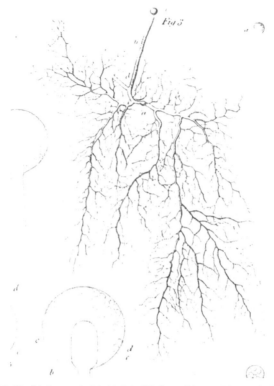

Figure 14.3 (a) (left), (b) (centre), (c) (right). 2D-branching to Voronoi *phase* 01, 02 and 03. Over the course of 3 days *Physarum polycephalum* has developed a network between the food sources.

environment, its *Umwelt* (Uexküll, 1909) come into effect. As a living organism, which is well described in Jakob von Uexküll's diagram on *Merkwelt* and *Wirkwelt* (1920), *Physarum* is assumed to also be equipped with sensorial capabilities, that receive information from 'the world as sensed'(Uexküll, 1909), an *organ* that can remember and an *organ* that can actuate reaction. Speed and direction of growth can be trained through the moulds capacity of memorizing externally (Reid, 2012). The cellular slime mould shows the behavioral pattern of a biological computer adapting cybernetic principle of learning through conversation with its environment. It "can be considered as a reaction-diffusion, or excitable medium encapsulated in an elastic growing membrane." (Adamatzky, 2009)

The wonder of form-making performed by the slime mold occurs in the stage of its life -cycle called *plasmodium stage.* The life cycle of the

slime mold can be divided into three main stages with twelve sub-stages–summarized from (Stephenson): (a) the vegetative (plasmodium or slug) stage: a countless number of cells are aggregated and merged into a giant amoeba-like body, a multinucleate mass, enclosed in one membrane–this stage is relevant to the present research paper, (b) the fruiting stage, in which the mold transforms and develops spores to release in case 20% of the cells in the 'slug' have died. Individual spores turn into 'new' amoeba, (c) the sexual reproduction stage, where single amoeba aggregate and partly cannibalize each other in order to survive. The life cycle subsequently continues at the vegetative stage (a) as described in (a) as a new iteration.

Slime mould was discovered in 1869 by the German mycologist Oskar Brefeld, who described the 'new' species in his article "Dictyostelium mucoroides, ein neuer Organismus aus der Verwandtschaft der Myxomyceten" (Brefeld, 1869). In 1884, Brefeld revisited the slime mold and showed its 'cellular' behavior in "Botanische Untersuchungen über Schimmelpilze". Volume 1 of 2 includes corresponding hand-drawn illustrations of the relating organism *Mucor Mucedo*. They depict the branching behavior on one hand and its morphing to the sporangia stage, growing spore stalks, eventually leading to fruiting of the organism on the other (Figure 14.4) (Brefeld, 1884). The most notable 20th century scholar on the subject of slime mould is likely to be Kenneth Bryan Raper, who in the 1930s

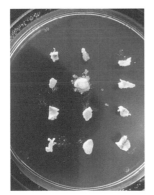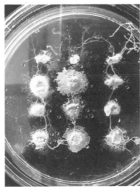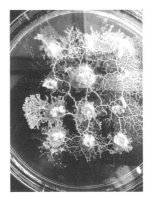

Figure 14.4 Illustration by ©Oskar Brefeld, showing the branching of a Mycelium of *Mucor Mucedo*, akin to *Physarum*. (Brefeld, 1872), p. 65.[4]

[4]Original description in Brefeld, Oskar, 1884: "Gestalt und Verzweigung eines ausgewachsenen Myceliums von Mucor Mucedo aus der Spore in Mistdecoct auf dem Objektträger gezogen." p. 57. Decoct = Sud/Abkochung; drawing see p. 65.

revived the research on cellular slime mold. Raper's research built on that of E. W. Olive's research results (1902) in which Olive described all phases of the slime mold in detail. Raper later focused on multicellular migration and the subsequent process of sporing (Bonner). His work has culminated in "The Dictyostelids", first published in 1884 (Raper 2014).

14.2 Literature and Project Review for Slime Mold in Architecture, Urban and Regional Planning and Design

In 2000, Toschiyuki Nakagaki published "Intelligence: maze-solving by an amoeboid organism" on the smartness of the slime mould *Physarum polycephalum* (Nakagaki, 2000). Nakagaki observed the intelligent decision-making behavior of the *Physarum polycephalum* plasmodium. The organism was challenged with a maze-solving problem in order to reach the vital food, deposited on either entrance of the maze. The question was how would the mold to 'decide' its path, which food source would it approach, or would it connect either, in order to ensure a balanced nutrition flow within its entire body. The organism grew one connection on the shortest path possible between both sources, retracting all other links it had created prior to realizing that the food sources were connected (Nakagaki, 2000). Nakagaki's findings illustrated how a problem of computational complexity could be managed by a living system without brain by applying biological intelligence. In architectural sciences we regard this particular problem as the *Botenproblem*, the *travelling salesman problem* (TSP); this might differ from the definition of the *TSP* in the hard sciences, life sciences or computer sciences. Research findings of Nakagaki's maze experiments, were complimented by experiments to serve urban and regional transport infrastructure. In 2010 Andrew Adamatzky and Jeff Jones in the UK, and Toschiyuki Nakagaki in Japan, triggered a new wave of experimentation with cellular slime mold in a variety of applications, including unconventional computing, art, network theory and urban planning and architecture (Adamatzky, 2010; Tero, 2010). From 2010 onwards, Adamatzky and Jones investigated in and compared the slime mold's intelligence in growing efficient 'road networks' for Germany and the USA in comparison to the country's actual motorway/autobahn system. In the case of the USA, food sources where placed on either side of the country in Boston and San Francisco, in order to observe how the slime mold would traverse across a 2D- and a 3D-terrain simulating the topography. In the case of Germany, the researchers placed

food sources on points furthest north (Flensburg) and furthest south (Füssen) of the country to observe the moulds travel behaviour across the 2D- and 3D-terrains of Germany (Adamatzky, 2014). The experiment describes one out of a series testing, if and how *Physarum* approximates man-made travel routes, by finding the shortest path. Countries taken in consideration include e.g., Mexico, the Netherlands, Australia, Brazil, the UK, Russia (Adamatzky, 2011; Adamatzky, 2013; Adamatzky, 2012; Adamatzky, 2011). Part of the research included the 'reaction' of *Physarum polycephalum* of unforeseen obstacles in a regional terrain, such as sudden floods. The analysis shows great potential for transfer into the applied field of urban design, regional planning and architecture.

The rise of the relevance of emergence and system-based design strategies enforced experimenting with the biological liquid geometry machine. Similarly to the team around Adamatzky and Jones, the team around Atushi Tero and Toshiyuki Nakagaki also focused on solving network problems in urban planning by 'testing' the efficiency of the Tokyo railroad system utilizing the intelligence of slime mold; first in material tests, later as prove of concept in their paper "Traffic optimization in railroad networks using an algorithm mimicking an amoeba-like organism, *Physarum plasmodium*" (Watanabe, 2011). The Tokyo railroad project was the first of its kind that found entry into schools teaching experimental computational architecture.

In 2016 Pedro Veloso and Ramesh Krishmanturi[5] took the idea of the slime mold algorithm on board for generating, designing and optimizing corridors in architectural spatial arrangements. The publication "On Slime mould and Corridors" results of a collaboration between the Computational Biology Department and the School of Architecture at Carnegie Mellon University in Pittsburgh, USA. The research links biological computation with circulation problems in buildings and urban spaces focusing on the development of networking methods, such as *Adjacency Graph Selection* (AGS) the authors developed (Veloso, 2016).

The rise of the slime mold around 2010 coincided with a global fascination and engagement – of architects, architectural scholars and students – in generative design tools, such as the computer language *Processing* or visual

[5]Prof. Krishmanturi, Ph.D, joined the faculty of the School of Architecture at Carnegie Mellon University in 1989 to become a full professor in 1994. In 2000–01 and 2002–03, I served as the Chair of the Department's graduate program. Krishmanturi's research topics included object-agents in design environments, knowledge-based design systems, the integration of natural language and graphics, spatial algorithms, robotic construction, computer simulation.

scripting in *Grasshopper for Rhinoceros*. A snowball effect of investigations into self-organizing and systems based on the algorithms, partly utilized by slime mould, began. However, only few research results and experiments carried out or published were directly connected to slime mold and have been since. A large number of users may have known about the bio-computer or may not have realized that they were dealing with slime mold in its virtual flesh. We have applied – and still do – an algorithm to simulate the pattern generation of the slime mold: diffusion-limited aggregation (DLA), swarm intelligence or collective cell migration based on the *Boids*, developed by Craig Reynolds in 1986, and cellular automata. The keyword was and still is *self-organization*.[6] The reader may note that I am referring to the simulation of the pattern growth and not to the actual physical growth of the material slime mold. The material growth is an additive process whereby material is produced by the organism. In contrast to the natural growth of *Physarum* the virtual growth is simulated through adding particles from a source of attraction; meaning that the natural material growth from within and the virtual material is added to from an external source.

In 2015, Barbara Imhof and Petra Gruber have been envisioning and explorative testing possibilities of "Blending Architecture and Biology" at the architecture school, *die angewandte* in Vienna (Imhof, 2015). Growth and structure of slime mould was tested in a variety of environments and directions, e.g., vertical growth on a 3-dimensional matrix. In her book, Imhof refers to the project 'Convergent Ambiguities | From Slime Mold to Temporary Autonomous Architecture', 2012, carried out in the author's studio *Codes in the Clouds* – run by the author at DIA[7] – by Andrea Rossi and Lila Panahi Kazemi, extensively simulating the behavior of slime mould in 3D virtual space and transferring it to a visionary architectural proposal (Figure 14.5). Rossi and Panahi Kazemi suggest the project

"Convergent Ambiguities' explores [...] biological organisms [...] as repertoire of active production systems. [...] Situated in the near future, where censorship and repression are harming the freedom and the self-organized nature of the biggest network ever built by humans, the World Wide Web, we envisioned an architecture able to host the operations of the

[6] at that time, approx. 2010, the notion of feedback, learning systems and artificial intelligence re-arose after decades of absence, left behind in the 1960s.

[7] Computational Design Studio *Codes in the Clouds*, 2010–2016, led by Liss C. Werner, Dessau International Architecture Graduate School, Anhalt University of Applied Sciences, Germany.

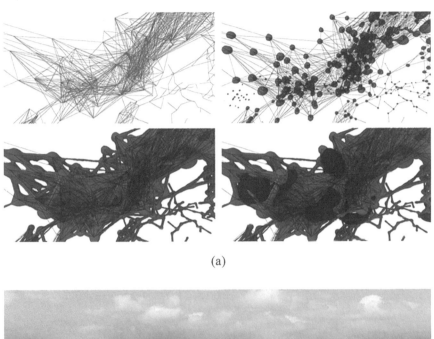

(a)

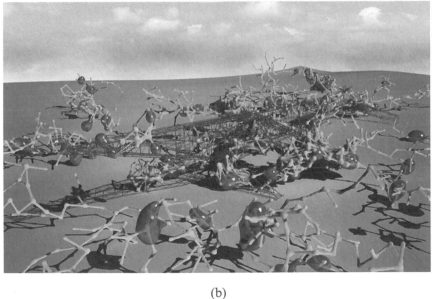

(b)

Figure 14.5 (a): Cluster formation, (b): Conceptual architectural proposal based on swarm intelligence as found in the behaviour of slime mould. 5a and b by ©Andrea Rossi and Lila Panahi Kazemi, DIA, *Codes in the Clouds II, Convergent Ambiguities.*

rebels of the new millennium. The network logic derived from Slime Mold informs [...] a virtual communication network between the different abandoned buildings [...], transforming them into pulsating nodes of an alternative topography of insurrection, hiding them and at the same time connecting them to the common world through the virtual realm of the internet. The nodes created become the place of birth of a new kind of architecture: non-planned, self-growing and self-sustaining, these "living organisms"'" [...] (Rossi, Panahi Kazemi, 2012)

In the studio, we applied multi-agent systems as intensely as diffused-limited aggregation in order to generate and understand self-organization as architectural design strategy. Projects included problem solving propositions in a variety of scales, e.g., for directionally steered urban growth (Maribor), optimization of circulation in urban spaces (Venice, Italy) (Figure 14.6), and led to current research on façade and building designs to reduce noise pollution (Berlin, Germany).

'Cities as biological computers', developed in the *Urban Morphogenesis Lab* at UCL in London in 2015/16 by Claudia Pasquero, Marco Poletto, suggests a biotechnological one-ness where human infrastructure, biological infrastructure and energy infrastructure converge (Pasquero, 2016). The authors present physical model of their project activating the idea of the

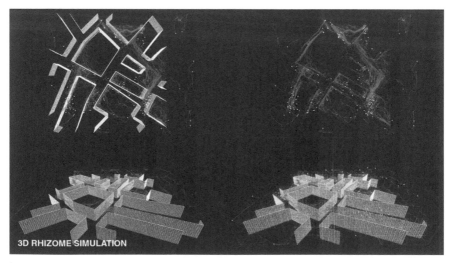

Figure 14.6 Simulation of circulation in Venice, ©Jordan C. Parsons, CMU, The Rhizome, *Codes in the Clouds IV, Atrophic [Re]Topography*. The project utilized swarm algorithms, also being used in the simulation of slime mold.

Physarum Machine. On a smaller, architectural/interior scale the *Advanced Architecture Group at IAAC* (Institute for advanced architecture in Catalonia) has been cultivating slime mold to research the growth algorithms, the organism's food 'preferences' (attractors and repellents). One possible architectural application is a living screen, where *Physarum* is re-directed through automated redistribution of food (IAAC editor, 2017).

The increase of researching slime mold, *Physarum polycephalum*, and its possibilities for architecture and urban design is reflected through an observable convergence of the fields *research by making* in experimental computational architecture together with unconventional computation, network theory and biological robotics. Correlating publications, projects and collaborations between research institutions reflect the interdisciplinary nature of the subject.

14.3 Digital Theory of *Physarum*

The discovery of *Physarum polycephalum* does raise questions and open up opportunities for optimization of architectural networks of all kinds and scales, physically and digitally. Apart from technology based and driven research to come, the phenomenon winds itself into one equally relevant domain of architecture, namely the one intertwined and strongly linked with how we understand architecture as component of our culture, manifested embodiment of the evolution of man, archive for craftsmanship and the heritage of technology and technique. Architectural theory, which embraces the above, has, similarly to the perspective to (digital) craftsmanship experienced a revival. Digital theory in architecture certainly existed before August 23^{rd} 1991, the day when the World Wide Web (WWW) became available to the general population of planet Earth; it was however that era, when computers became available, scripting started invading the designer space and 3D-modelling programs were introduced in architecture schools.[8] In 1991, Michael Benedikt introduced projects related to the fantastic and eternal spaces with unforeseen and emergent changes in spatial configuration as seen in Walt Disney's *Tron,* produced in 1982. "Cyberspace–First Steps"[9]

[8]First 2D-drafting and 3D-modelling software existed as early as the 1960s (e.g., Sketchpad by Ivan Sutherland), AutoCad released their first version in 1982, '3Ds Max' was released first time in 1988 as '3D Studio Prototype'.

[9]Michael Benedikt, in 1991, defines Cyberspace as "a globally networked, computer-sustained, computer-accessed, and computer-generated, multidimensional, artificial, or "virtual" reality." (Benedikt, 1994)

introduces the leap from *Euclidean Space* to *Cyberspace*. He features projects and visions by Marcos Novak on *Liquid Architectures in Cyberspace* (Novak, 1991) and *The Excess of Possibility*. The 1990s presented the time of the first digital turn, followed by a phase of developing, testing and playing with software, hardware, matter and thought. In 2010 Krista Sykes and Michael Hays published an anthology of essays discussing the new agenda that had developed between 1993 and 2010 (Sykes, 2010). Essays included the key texts "Field Conditions" by Stan Allen (Allen, 1999) "Architectural Curvilinearity: The Folded, the Pliant and the Supple" by Greg Lynn (Lynn, 1993) and "Design Intelligence" by Michael Speaks (Speaks, 2002). The book followed a previous influential publication by Kate Nesbitt on architectural theory between 1965 and 1995 (Nesbitt, K. 1996). During the 2010s, architecture has started to liberate itself from what we could call the era of *Genetic and bio-digital Architecture* (Werner, 2014). Beyond the goal of creating images (1980s)[10] and later on objects inspired by and mimicking biological form stands the desire for creating and building biological architecture with cognitive features, networking capabilities and material intelligence. Experimental architecture and urban design is longing for an (un)conscious habitat, efficient, balanced, sustainable and beautiful at the same time. Over the last decade, we have proved that the architect is increasingly designing with and through a systemic understanding, using digital tools, that allow for creating architecture, urban spaces and programs as nodes, edges or cells in distributed morphing networks. Currently this mainly applies to large-scale networks, urban, small-scale interventions[11] or building components such as cellular envelopes. The aim, however, is to create projects on all scales that combine parametric digital tools for design, material intelligence though embedded mechanisms, tactile and other sensoria, internal connectivity through microprocessors and external networking via the Internet. While architectural still remains in the age of the mechanical and pre-industrial by refraining from engulfing industrial pre-fabrication, mass-customization and modularized construction and assembly techniques, digital architectural theory and research has started learning about and implementing networked, metabolic and biological architecture. The vision of liquid architecture in Cyberspace by Marcos Novak at the end of the last century as "an architecture

[10]Christian Norberg-Schulz points out that "[...] architectural practice, where functionalism is abandoned while new architectures of images is emerging." (Norberg-Schulz, 1983)

[11]As seen in the numerous parametric pavilions designed, scripted and digitally fabricated globally, e.g., at the Architectural Association, Polytech Milano, ICD Stuttgart, Michigan University and more

that breathes, pulses, leaps as one form and lands as another [...] whose form is contingent on the interests of the beholder: [...] an architecture without doors and hallways, where the next room is always where I need it to be and what I need it to be" has provided a script for future development, can presents one foundational column for digital theory in architecture now and computational architectural practice in the future. Around 2010, the advent of the second digital turn in architecture, allowed the notion of feedback, learning systems and artificial intelligence to be included into (digital) architectural projects) after decades of absence, left behind in the 1960s. Cybernetics re-rose from the ashes (Werner, 2011); cybernetic systems, in large scale smart and/or digital cities were envisaged (Leach, 2009; Handlykken, 2011), ideas suggested by William Gibson (Gibson, 1986) landed in the 'real' world, and 'emergence' (DeLanda, 2011; Johnson, 2011) became a driver for computational design strategies and digital theory in architecture.

The emergence of slime mold as inspiration and blueprint for the architecture of the 21st century is one of the triggers for the emphasis on digital theory. Since the 1990s, the relationship to material and hence the 'stuff' buildings and cities are made of has changed. The notion of phenomenology in the 1980s and 1990s as discussed by Christian Norberg-Schulz (Norberg-Schulz, 1980), especially through his theories on the *Genius Loci*, the spirit of the place, has been extended. Norberg-Schulz discussed architectural theory through Louis Khan and Martin Heidegger, both concerned with the human being-in-the-world; Khan through an understanding that the psyche[12] is the source of form, order and design, Heidegger through an understanding of an underlying structure, of the world's elements. The extension stretches in fact back to the treatises by Herman von Helmholtz, Jakob von Uexküll, Ludwig von Bertalanffy or D'Arcy Wentworth Thompson on theoretical biology. All of them laid the foundations for reaction, interaction, networked communication and the generation of form as a process of convergence between a genetic code (algorithm) internal and external forces (parameters)[13] (Thompson, D.W. 1961). Parameters drive function (utilitas), vitality (including structural stability – firmitas), form and appearance (venustas). The difference to an architectural understanding before the (bio-)digital and after is that

[12]"Kahn's *weltanschauung* was founded upon an intuition of a transcendent and omnipresent ground within and behind all physical reality – a World Soul that he called **psyche.**" (Burton, 1998)

[13]All of them also have laid the foundations for cybernetics, which in the era of information exchange and attempts to create architecture on a 'molecular' level in conjunction with the digital, is becoming increasingly relevant.

of a more direct, connectivity between soft and hard matter, between atoms and bits. The exchange of information between organisms and environment enhanced networked intelligence may lead to architecture becoming a cybernetic bio-computer. Slime mould, "where [. . .] the intelligence (is) encoded inside this organism [. . .] into the physical mechanisms that the slime mould uses to move in space." describes one of many species showing intelligent and self-organizing structural, mechanical and networking behaviour patterns, like ants, birds and fish, corals or the Internet (Redd, 2017). It allows a shift from formal architecture to an architecture of soft matter robotics.

14.4 Concluding Discussion: *Physarum* as Liquid Geometry Computer and Disruptive Bio-cybernetic System for Architectural Applications

Physarum is a system describing the characteristics of a liquid geometry computer – in conversation with its environment. Every system and every conversation is goal-driven – so is slime mould in conversation/interaction (Ashby, 1957; Glanville, 2004; Werner,)[14]. The organisms goal is survival. It seeks achieving its goal by organizing the intake and distribution of nutrition through its entire multinuclear body most efficiently for its capabilities. The molds behavior results in forming geometric patterns, namely (a) branching and (b) Voronoi/Delaunay. Their generation can and has been simulated through activating multi-agent systems. In the early stages of growth, the mold shows a branching algorithm (Figure 14.1). The latter can be achieved through applying different types of cellular automata to assist the seemingly self-organizing multi-agent system (Jones, 2016). One is diffusion-limited aggregation (DLA), which presents one way of creating the form of branching; This is achieved by agents 'randomly' wandering through space directed by Brownian motion and aggregating once close to each other. The aggregating behavior is the result of attraction of the agents to each other. In a multi-agent system simulation, the attraction force between agents can be varied. While the first phase (branching), as shown in Figures 14.2 and 14.7, is driven by attraction, the second phase (forming the Voronoi pattern) is driven by the generation of repulsive fields (Jones, 2016; Dourvas, 2015; Tsompanas, 2012; Tsompanas, 2015).

[14] A discussion on the cybernetics of slime mold is envisaged in depth at a later stage.

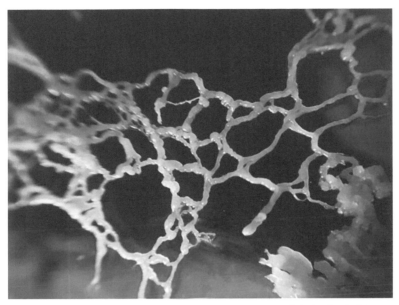

Figure 14.7 (left): Voronoi close-up of *Physarum* on the glass lid of a Petri dish – no Agar substrate.

Source: http://tactile-architecture.com

Beyond the graphic aspect, the structure of slime mold expresses intelligence in growing one network for efficient nutrition intake and dissemination. The mold successfully combines morphology, structure, infrastructure and metabolism. *Physarum*s algorithmic and parametric design strategies for architectural optimization and computational urban planning for a lean networked *conscious city* or *unconscious city*. In addition to the morphing Voronoi-like construction, that guarantees vitality throughout the system, the organism shows the creation of intricate nest-like 4-dimensional (time- and space-related) complex structure (Figure 14.7). Those structures are hardly visible with the naked eye but become visible through a 10-fold magnification. The mould spans diagonals from horizontal to vertical surfaces (Figure 14.8) and can build up vertical columns. Geometrically the emergent and morphing 4-dimensional structure is akin to the glue-experiment where a similar pattern formation of glue becomes visible during a the process of stretching (http://tactile-architecture.com).

I will conclude by raising the question of *Physarum* serving as – truly disruptive – bio-cybernetic system for architectural applications.

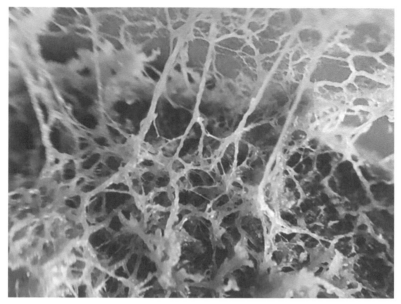

Figure 14.8 (right): grown nest-structure of which branches space diagonally to a vertical glass-surface without Agar; growth process approximately 7 days in a dark, 20 °C warm space. (Werner, 2018).

The organisms *protoplasmic network* paired with its structural abilities, embedded intelligence of physically behaving towards growth and survival and learning/training capabilities suggests a novel field of interdisciplinary research for (a) bio-architectural design methods and strategies and (b) advanced computing material on a human scale for e.g., surfaces and building scale for, e.g., construction or spatial changes according to the needs of the inhabiting actors. A variety of disciplines, including architects, may take the opportunity to test and understand the principles *Physarum polycephalum* utilizes, to work in joined forces towards a sustainable built Cyberspace. If we regard *Physarum polycephalum* as a bio-logical computer of Cyberspace, current definitions created in era of digital architectural archaeology–such as Michael Benedikt's from 1991–may want to be re-interpreted. Benedikt defines Cyberspace as

"a globally networked, computer-sustained, computer-accessed, and computer-generated, multidimensional, artificial, or "virtual" reality. In this reality, to which every computer is a window, seen or heard objects are neither physical nor, necessarily, representations of physical objects but are, rather, in form, character and action,

made up of data, of pure information. This information derives in part from the operations of the natural, physical world, but for the most part it derives from the immense traffic of information that constitute human enterprise in science, art, business, and culture." Benedikt, 1994)

Benedikt suggests a high complexity network in which information is created through data that is produced by interaction of all kinds. I suggest that the integrating bio-computers into the multi-dimensional dynamic conversations between physical and virtual will extend the recursive feedback loops in human–machine networks (HMN) as we know them today. Through the rise of the *Internet of Things* building and the construction of such the discipline of architecture, as well as the construction industry, is slowly starting to adapt and embrace novel networked technologies driven by AI. Fields such as the Molecular Sciences and Nanotechnology have investigated the functions and cognitive potential of bio-materials paired with data-networks (body-internally) for, e.g., medical applications (Khan, 2017; Ebara, 2014). Such research offers a disruptive paradigm shift in designing, producing, constructing buildings; questions of energy resources, possibly water resources or material disposal at the end of a buildings life cycle are but a few to be tackled by creating a discipline between bio-computers and building architecture.

The outlook I am sketching out in this chapter invites to a joined investigation into an extended digital theory in architecture through the parallels of bio-computers to the digitally networked cyberspace and to joined research for truly *smart*, urban spaces and efficient infrastructures of mobility, production and food and *intelligent cyber-physical* building components made of soft and hard matter, partly regulated through liquid bio-computers.

References

Adamatzky, A. (2013). *Physarum* machines for space missions, *Acta Futura*, (6), pp. 53–67.

Adamatzky, A. (2009). From reaction-diffusion to *Physarum* computing, *Natural Computing*, 8(3), pp. 431–447.

Adamatzky, A., and Jones, J. (2010). Road planning with slime mould: if *Physarum* built motorways it would route M6/M74 through Newcastle, *International Journal of Bifurcation and Chaos*, 20(10), pp. 3065–3084.

Adamatzky, A.I. (2014). Route 20, autobahn 7, and slime mold: approximating the longest roads in USA and Germany with slime mold on 3-D terrains, *IEEE transactions on cybernetics*, 44(1), pp. 126–136.

Adamatzky, A., Martínez, G.J., Chapa-Vergara, S.V., Asomoza-Palacio, R., and Stephens, C.R. (2011). Approximating Mexican highways with slime mould, *Natural Computing*, 10(3), pp. 1195.

Adamatzky, A., Lees, M., and Sloot, P. (2013). Bio-development of motorway network in the netherlands: A slime mould approach, *Advances in Complex Systems*, 16(02n03), pp. 1250034.

Adamatzky, A., and Prokopenko, M. (2012). Slime mould evaluation of Australian motorways, *International Journal of Parallel, Emergent and Distributed Systems*, 27(4), pp. 275–295.

Adamatzky, A., and de Oliveira, P.P. (2011). Brazilian highways from slime mold's point of view, *Kybernetes*, 40(9/10), pp. 1373–1394.

Allen, S. (1999). Field Conditions, in Allen, S. (Ed.): Points + Lines: Diagrams and Projects for the City (Princeton Architectural Press).

Ashby, R. (1957). An Introduction to Cybernetics (Chapman & Hall Ltd.).

Benedikt, M. (1994). On cyberspace and virtual reality, *Man and Information Technology*, Address to the Royal Swedish Academy of Engineering Sciences Symposium on Man and Information technology.

Benedikt, M. (1991). Cyberspace: Some Proposals, in Benedikt, M. (Ed.): *Cyberspace first Steps* (MIT Press), pp. 119–124.

Brefeld, O. (1972). Botanische Untersuchungen über Schimmelpilze (Verlag von *Arthur Felix*).

Brefeld, O. (1869). Dictyostelium mucoroides, ein neuer Organismus aus der Verwandtschaft der Myxomyceten, *Abhandlungen der Senckenbergischen Naturforschenden Gesellschaft*, (7), pp. 23.

Brefeld, O. (1884). Conidiobolus utriculosus und minor, *Untersuchungen aus der Gesammtgebiete der Mykologie*, 6(2), pp. 35–78.

Bonner, J. (2010). A brief history of the cellular slime molds, *Fungi*, 3(1), pp. 2.

Burton, J. (1998). Philosophical Differences in the Thoughts of Louis I. Kahn and Martin Heidegger, *Cloud-Cuckoo-Land: International Journal of Architectural Theory*, 2.

DeLanda, M. (2011). *Philosophy and Simulation: The Emergence of Synthetic Reason* (Continuum International Publishing Group).

Dourvas, N., Tsompanas, M.-A., Sirakoulis, G.C., and Tsalides, P. (2015). Hardware acceleration of cellular automata *Physarum polycephalum* model, *Parallel Processing Letters*, 25(1), pp. 1540006.

D'Haese, J., and Hinssen, H. (1978). Kontraktionseigenschaften von isoliertem Schleimpilzactomyosin, *Protoplasma*, 95(4), pp. 273–295.

Ebara, M., Kotsuchibashi, Y., Narain, R., Idota, N., Kim, Y.-J., Hoffman, J.M., Uto, K., and Aoyagi, T. (2014). *Smart Biomaterials* (Springer).

Gibson, W. (1986). Neuromancer (Ace, 1986).

Glanville, R. (2004). The purpose of second-order cybernetics, *Kybernetes*, 33(9/10), pp. 1379–1386.

Handlykken, A.K. (2011). Digital Cities in the making: exploring perceptions of space, agency of actors and heterotopia, *Ciberlegend*, (25), pp. 16.

IAAC Editor (2017) *[Slime Mould] Living Screens*. [online] Available at: http://www.iaacblog.com/projects/slime-mould-living-screens-2/, [Accessed 25 January 2019].

Imhof, B., and Gruber, P. (2015). *Built to Grow-Blending architecture and biology*, (Birkhäuser).

Johnson, S. (2001). Emergence – The Connected Llives of Ants, Brains, *Cities and Software*, (Scribner).

Jones, J. (2016). Applications of multi-agent slime mould computing, *International Journal of Parallel, Emergent and Distributed Systems*, 31(5), pp. 420–449.

Jones, J. (2016). Multi-agent Slime Mould Computing: Mechanisms, Applications and Advances, in Adamatzky, A. (Ed.): Advances in *Physarum Machines*: Sensing and Computing with Slime Mould (Springer International Publishing), pp. 423–463.

Khan, F., and Tanaka, M. (2017). Designing Smart Biomaterials for Tissue Engineering, *International journal of molecular sciences*, 19(1), pp. 17.

Kishimoto, U. (1958). Rhythmicity in the protoplasmic streaming of a slime mold, *Physarum polycephalum*, *The Journal of general physiology*, 41(6), pp. 1223–1244.

Leach, N. (2009). Digital cities, Architectural Design, 79(4), pp. 6–13.

Lynn, G., and Folds, B. (1995). Blobs, *Journal of Philosophy and the Visual Arts*, (6), pp. 39–44.

Lynn, G. (1998). Fold, Bodies and Blobs: Collected Essays (La lettre vole).

Lynn, G. (1993). Architectural Curvilinearity, The Folded, the Pliant and the Supple, *Architectural Design*, 102, pp. 8–15.

Meyer, B., Ansorge, C., and Nakagaki, T. (2017). The role of noise in self-organized decision making by the true slime mold *Physarum polycephalum*, *PloS one*, 12(3), pp. e0172933.

Nakagaki, T., Yamada, H., and Tóth, Á. (2000). Intelligence: Maze-solving by an amoeboid organism, *Nature*, 407(6803), p. 470.

Nesbitt, K. (1996). Theorizing a New Agenda for Architecture: *An Anthology of Architectural Theory 1965–1995*, (Princeton Architectural Press).

Norberg-Schulz, C. (1983). Heidegger's thinking on architecture, *Perspecta*, 20, pp. 61–68.

Norberg-Schulz, C., and Loci, G. (1980). Towards a phenomenology of architecture. *Nova Iorque:* Rizzoli.

Novak, M. (1991). Liquid architectures in cyberspace, in Michael, B. (Ed.): *Cyberspace* (MIT Press), pp. 225–254.

Pasquero, C., and Poletto, M. (2016). Cities as biological computers, *arq: Architectural Research Quarterly*, 20(1), pp. 10–19.

Raper, K.B. (2014). The dictyostelids (Princeton University Press).

Redd, J. (2017). *Fascinating Time Lapse of Slime M old Growth*. [online] Available at: https://steemit.com/timelapse/@jonahredd/fascinating-time-lapse-of-slime-mold-growth [Accessed 25. January 2019].

Reid, C.R., Latty, T., Dussutour, A., and Beekman, M. (2012). Slime mold uses an externalized spatial "memory" to navigate in complex environments, *Proceedings of the National Academy of Sciences*, 109(43), pp. 17490–17494.

Rossi, A., and Panahi Kazemi, L. (2012). Convergent Ambiguities. [online] Available at: https://tempautonarch.com/2012/01/31/convergent-ambiguities-from-slime-mold-to-temporary-autonomous-architecture/ [Accessed 25 January 2019].

Stephenson, S.L., and Stempen, H.: Myxomycetes: a handbook of slime molds.

Speaks, M. (2002). Design intelligence and the new economy, *Architectural Record*, 190(1), pp. 72–79.

Sykes, K. (2010). *Constructing a new agenda: Architectural theory 1993–2009*, (Princeton Architectural Press).

Tero, A., Takagi, S., Saigusa, T., Ito, K., Bebber, D.P., Fricker, M.D., Yumiki, K., Kobayashi, R., and Nakagaki, T. (2010). Rules for biologically inspired adaptive network design, *Science*, 327(5964), pp. 439–442.

Thompson, D.W. (1961). On Growth and Form (Cambridge University).

Tsompanas, M.-A.I., and Sirakoulis, G.C. (2012). Modeling and hardware implementation of an amoeba-like cellular automaton, *Bioinspiration and Biomimetics*, 7(3), pp. 036013.

Tsompanas, M.-A.I., Sirakoulis, G.C., and Adamatzky, A.I. (2015). Evolving transport networks with cellular automata models inspired by slime mould, *IEEE transactions on cybernetics*, 45(9), pp. 1887–1899.

Uexküll, J.v. (1909). Umwelt und Innenwelt der Tiere (J. Springer, 1909).

Veloso, P.R.K. (2016). On Slime Molds and Corridors – The application of network design algorithms to connect architectural arrangements.

Proc. Parametricism Vs. Materialism: Evolution of Digital Technologies for Development (8th ASCAAD Conference).

Watanabe, S., Tero, A., Takamatsu, A., and Nakagaki, T. (2011). Traffic optimization in railroad networks using an algorithm mimicking an amoeba-like organism, *Physarum plasmodium*, *Biosystems*, 2011, 105(3), pp. 225–232.

Werner, L.C. The Origins of Design Cybernetics, in Fischer, T., Herr, C.M. (Eds.): Design Cybernetics: Navigating the New (Springer, forthcoming).

Werner, L.C. (2011). Codes in the Clouds: Observing New Design Strategies, in C. Gengnagel, A.K.e.a. (Ed.): Computational Design Modeling: Proceedings of the Design Modeling Symposium Berlin 2011 (Springer Verlag), pp. 64.

Werner, L.C. (2015). In quest of code, *Design Ecologies*, 4, (1–2), pp. 62–89.

Werner, L.C. (2014). Claryfying the Matter: It's not a shift, it's a stage change, in: Estévez, A. T. (Ed.): Biodigital Architecture and Genetics, Barcelona: ESARQ. (UIC), pp. 218–233.

Werner, L.C. (2018). *Physarum*. [online]. Available at: http://tactile-architecture.com/tag/physarum [Accessed 25.01.2019].

Zonia, L., and Munnik, T. (2007). Life under pressure: hydrostatic pressure in cell growth and function, *Trends in plant science*, 12(3), pp. 90–97.

15

Protoplasmic Routes: A Post-human Vision of Livability and Co-existence

Axel Cuevas Santamaría and Jason C. Slot

Department of Plant Pathology, The Ohio State University, Columbus, Ohio, USA
E-mail: cuevassantamaria.1@osu.edu

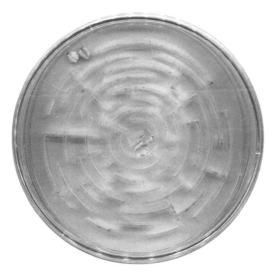

A colony of Physarum polycephalum growing inside an acrylic maze placed on a Petri dish

Protoplasmic routes is an audiovisual BioArt project based in scientific research and fiction. This work metaphorically focuses on the livability of the human race in the twenty-first century from a post-human perspective. The exploration of the complex interactions of the growth, movement, and

learning of *Physarum polycephalum*, a plasmodial slime mould[1] along with a narration about the future, are the main focus points of this art science project. I construct acrylic multicursal circular mazes using a laser cutter machine and place them inside Petri dishes previously prepared with an Agar-based medium. In the center of the mazes, I set a chip of dry sclerotium, the dormant colony of *Physarum polycephalum.*

Axel Cuevas Santamaría placing acrylic mazes inside Petri dishes and making agar-based medium with Jason Slot. The Ohio State University

I wake up the organism by hydrating it with the agar-based medium and feeding it with raw oat flakes. The high concentration of carbohydrates in oatmeal allows the organism to be nourished and to grow rapidly. Oatmeal seems to be a gourmet delicacy for *Physarum polycephalum*. I place the

[1]Plasmodial slime moulds are colonies of amoebae that synchronize their movements through chemical signals across a shared viscous matrix of proteins and carbohydrates (Keller et al. 2017; Wang et al. 2017).

oat flakes in the center of the mazes and in the peripheral regions, allowing the organism to connect these food source-points from the inside-out of the acrylic mazes. *Physarum* grows approximately 1 cm every hour, so I set up an automated digital scanner to photograph its growth every five minutes. The high-resolution time-lapse photography I obtain allows me to create large-scale audiovisual environments.

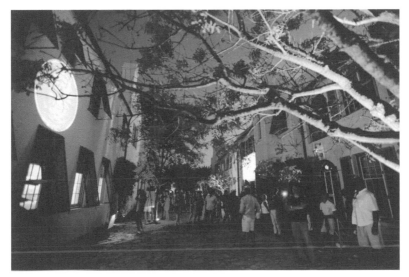

Protoplasmic routes audiovisual installation Digital Graffiti Arts Festival, Alys Beach, Florida. May 19–21, 2016.

The high-resolution photography is used to create time-lapse videos that show the organism's behavior inside the acrylic mazes. It creeps underneath, above, and through the border walls. This nonconformist act of finding its way between food sources by "jumping" border walls reveals a metaphorical transformation of a multicursal maze into a unicursal labyrinth. I find this nonconformist act and metaphorical transformation very interesting and inspiring. Ava, the American English computerized female voice from OSX

text-to-speech synthesizer, accompanies the time-lapse imagery by reading the story I wrote while witnessing the organism's behavior inside these labyrinths.

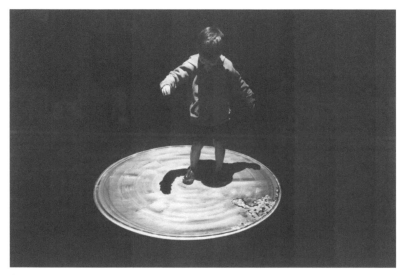

Protoplasmic routes audiovisual installation Digital Art Biennial, Rio de Janeiro, Brasil. February 05–March 18, 2018.

I am the black sheep of the mycological world. I am not a fungus, a plant or an animal, but something in between. I belong to several kinds of unrelated organisms, living freely as single cells and aggregating together to form complex organisms. I am both individual and community. Watch how I grow. My network of growing structures is composed of protoplasmic fluids. I create network patterns and reveal an emergent intelligence. Network patterns with recent human scientific experiments find the wisdom of my communication that reveals my intelligence. I can solve in days your transportation routes that would take years to engineer. Watch how I creep for food. Watch how I creep for survival. The food that you see in my home labyrinths is oatmeal. Oatmeal is my favorite dish and my gourmet delicacy. My feast of carbohydrates.[2]

[2]Excerpts from *Protoplasmic routes* story

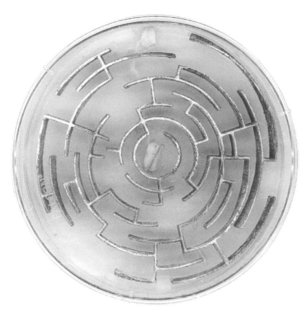

*Physarum polycephalum growing inside-out from the center of a maze placed on a Petri dish
previously prepared with an agar-based medium.*

Labyrinths are an ancient means of developing and refining human intel-
ligence. Unicursal mazes are tools for focusing the mind through a single
path in meditation, while mazes that contain multicursal paths challenge
memory and pattern recognition by presenting multiple route choices dur-
ing navigation. In the story of the Labyrinth, as told by the Hellenes in
ancient Greek mythology, the skillful craftsman and innovator in many arts,
Daedalus, builds a multicursal labyrinth for king Minos, who needed it to
imprison his wife's son the Mintoaur. Short story told, the hero Theseus is
challenged to kill the Minotaur finding his way through the labyrinth with the
help of princess Ariadne's ball of string. Theseus ties one end around a pillar
at the entrance and then goes in to find the Minotaur. When he has found
and killed the beast, he uses the string to find his way out. I find an analogy
between this myth and my act of placing oatmeal over these acrylic mazes to
allow *Physarum* to grow inside-out.

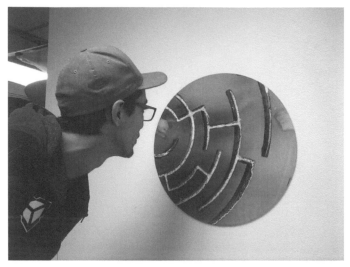

Axel Cuevas Santamara looking at Physarum polycephalum jumping the borders of a maze
From the series: Protoplasmic routes digital prints.

As we witness *Physarum*'s subtle disregard for the established rules during the time-lapse videos made for *Protoplasmic routes*, we access a temporal reality of microscopic dimension. The computerized aesthetic tone of the narration of the story facilitates the access to this temporal reality. Ava's digital female voice, personifying a biological living organism, represents an *elder consciousness*[3]. I envision the self-awareness of *Physarum* as it undertakes the nonconformist act of conquering minor obstacles represented by acrylic mazes built on Petri dishes. If it is self-aware, then it is disinterested in the artificial acrylic borders I have crafted. The contemplation of this self-awareness and the conquering of constraints build compassion between this species and our own. Yet while *Physarum* is our contemporary, the electrochemical processes underpinning its movements and decisions reach a billion years deep in time to our common ancestors; our own new brand of intelligence based on internalized models of reality may reach back a mere 5 million years to our divergence from chimpanzees (Di Fiore 2015), or 75 million years to our divergence from those that became mice (dos Reis 2015).

A circular evolutionary tree traces the independent paths taken by *Physarum* and humans since we diverged from our common ancestor approximately 1 billion years ago. Since this time, our ancestors went through

[3]Plasmodial slime moulds emerged as long as a billion years ago (Parfrey et al. 2011)

many forms and new ways of sensing and exploring their environment, while the slime mould may have continued to refine its tried and true ways. The storyline of *Protoplasmic routes* focuses on the evolution of humanity and our vital relationships with technology and microorganisms, which have been our symbionts and co-travelers ever since before our species emerged millions of years ago. The story makes this multi-nucleated protoplasm stand as an individual actor. I recognize *Physarum* as an individual and my intention with this work is to give this organism voice and presence in our human consciousness.

I and you, humans, share a common ancestor. An old entity whose evolution led into creating different branches of the same tree. You and I were once part of the same living system, called the unikonts. We were once members of the same taxonomic group. You evolved into human beings. We, the elder, remained the same. This multi-cellular division made panspermia and your theories of reproduction, a biological beginning of an inferior developed form of consciousness.[4]

A circular evolutionary tree shows diversification of species from their common ancestor.

The evolutionary paths taken to arrive at present day slime molds and humans are traced in orange, having diverged approximately 1 billion years ago.

[4]Excerpts from *Protoplasmic routes* story.

I find the physical manifestation of this organism's external decision-making, *"extralligence"* (Adamatzky and Schubert, 2013), quite lovely and extraordinary. Its living-network dynamic behavior and its highly distributed sensorial mechanisms with embedded dynamic architecture of massively parallel computing processors offer a glimpse of our post-human technologies. *Physarum* senses its environment largely through chemical cues released into the air by living and decaying organisms. It adjusts its rate of protoplasmic pulsing in order to spread toward or away from these signals (DeLacyCostello and Adamatzky 2013). As our own human linguistic intelligence explores and interfaces with other members of our species, in the highly branched and reticulated electronic medium of the Internet, I foresee through *Physarum* the emergence of patterns that are more recapitulative than cutting-edge.

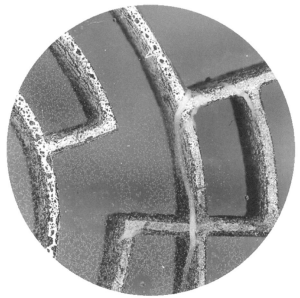

Physarum polycephalum jumping the borders of a maze From the series: Protoplasmic routes digital prints.

The ability of this protist organism to overcome multicursal paths and physical borders makes me think about my own constraints and social freedom. This further develops my empathy with all forms of life. Humans descended from organisms that achieved success by separating themselves from the earth, to travel farther and higher to escape threats and exploit new

opportunities. The ways we gained freedom and dominance have made us vulnerable to new threats, which have dethroned the least humble species of the past.

For 10 days, I contemplated the growth of this mould. The protoplasmic routes that this organism traced did not follow my intentions of demonstrating its primitive intelligence of solving mazes. Instead, these routes made me value the impermanence of biological life and allowed me to more deeply explore my fears of the irreversible alterations of our ecosystem. This realization serves as a metaphor to rediscover my spirituality and the vital importance of contemplating nature. The beauty of impermanence revealed through this act of observation of biological life reminds me that the present moment is inevitable and impermanent. The post-human vision of contemporary human existence throughout my work aims to bring a hopeful, and perhaps even humorous approach to our future coexistence with all forms of life.

The development of the most prosperous thoughts of your societies have reached the utopian ideas of collectivism. Your civilizations will prosper only when your consciousness understands that human race is not the only race. We – protist organisms and multicellular agents – are not as different from you; carbon-based biological forms of life. We are not so different in the virtual world.

<div align="center">* * *</div>

My protoplasmic routes contain clues for the shift of these systems after they collapse, the shift of your quartz-based computers into wet, humid, living, and self-replicating agents. These agents will be the architects of the humid, soft walls of the future. Your means of transportation will breathe. Your means of communication will be silent. Telepathy. Meditation.[5]

The structure of power I represent by imposing mazes to a biological growing network led me into an ethical dilemma. Death became very tangible, witnessing the constant permanent ending of the vital processes of this creature. The close exploration of this process gave me ideas about our human coexistence and evolution.

[5]Excerpts from *Protoplasmic routes* story.

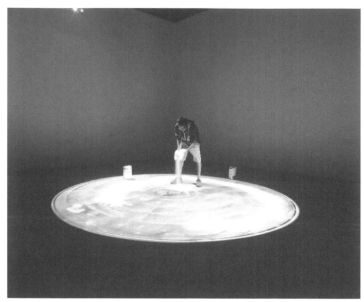

Axel Cuevas Santamaría installing Protoplasmic routes Sherman Arts Center, Columbus OH.
August 22nd, 2016.

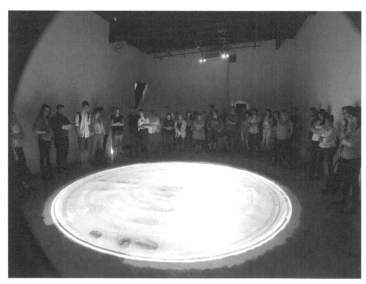

Protoplasmic routes audiovisual installation Sherman Studio Arts Center, Columbus OH.
August 22nd, 2016.

Behold right now, in this ceremonial act of gathering that you are taking place, a sacred moment. Celebrate life. Praise the stars. Connect with all living creatures of this planet and beyond. Meet yourself and you will meet the universe. You human beings have already reached the end of times. Enjoy. Dance. Celebrate. And may all living beings of this planet reach happiness. Aho.[6]

The following is the complete voice-over text I wrote in 2016 for *Protoplasmic routes* audiovisual BioArt project:

I am the black sheep of the mycological world. I am not a fungus, a plant or an animal, but something in between. I belong to several kinds of unrelated organisms, living freely as single cells and aggregating together to form complex organisms. I am both individual and community. Watch how I grow. My network of growing structures are composed with protoplasmic fluids. I create network patterns and reveal an emergent intelligence. Network patterns with recent human scientific experiments, find the wisdom of my communication that reveals my intelligence. I can solve in days your transportation routes that would take years to engineer. Watch how I creep for food. Watch how I creep for survival. The food that you see in my home labyrinths is oatmeal. Oatmeal is my favorite dish and my gourmet delicacy. My feast of carbohydrates. I creep through humidity and darkness allowing me to connect food sources and I always find the shortest routes through my protoplasmic fingers. I have memory. Watch me test the boundaries of my home maze. Watch how I connect the oatmeal placed by human in different parts of my home labyrinth. While I have no central brain or nervous system as your own, I can think. I think and make decisions. My thoughts are not a result of a mental behavior like your own though a distributed intelligence. My consciousness is older than your human thoughts and understanding. I exist on a very subtle periphery of your knowledge. We, the micro organic living systems and fungi, are what you don't see. We are here but you don't sense us. We live in the darkness of your consciousness. In the shades of trees and rotten logs. We see, we feel, we communicate and learn through complex connections of mycelial networks. Watch how the growth of my protoplasmic routes resemble your

[6]Excerpts from *Protoplasmic routes* story

own blood coursing through your veins. Watch how my protoplas-mic routes resemble your own energetic channels and your nervous and circulatory systems. My presence and survival on this beloved planet Earth is fifteen hundred million years old. This period in time, hypothetically explained by your theories of evolution, is the time of anaerobic bacteria. Carbon dioxide was in the air and algae was ruling. Watch how I creep to the peripheries and borders of these acrylic labyrinths seeking for oxygen. Watch how I crawl through the walls and boundaries of these maze systems. I and you humans share a common ancestor. An old entity whose evolution led into creating different branches of the same tree. You and I were once part of the same living system, called the unikonts. We were once members of the same taxonomic group. You evolved into human beings. We, the elder, remained the same. This multi cellular division made panspermia and your theories of reproduction, a biological beginning of an inferior developed form of consciousness. Your human wars. Your individual desires. Your different languages. Your faith in Gods outside from your inner-self. Your lack of connection with nature. Your spread knowledge. You are a separated race. Your love for power is your doom. The development of the most prosperous thoughts of your societies have reached the utopic ideas of collectivism. Your civilizations will prosper only when your consciousness understands that human race is not the only race. We protist organisms and multi cellular agents, are not as different from you; carbon based biological forms of life. We are not so different in the virtual world. Prepare to see the rise of the virtual reality societies. Your human singularity and technological developments will meet through us. In this upcoming reality, our common existences will merge. Today we stream similar substances into the torrents of our systems to assure survival. Watch how my veins look like yours. Watch how I survive like you. I also seek for better life conditions. I also travel. I also dream. I creep through darkness. The labyrinths of the systems that reign your lives respond to higher intelligences that have you running in circles. These higher intelligences feed from your vital energy and from one of the oldest elements on planet Earth, the element Gold. This element drives the power of the super computers used for inter galactic traveling. These supra intelligent species that rule your societies are older intelligences. Superior forces that feed from

*the element gold. Gold, since many civilizations before your con-
temporary human existence, has been the fuel of your evolutionary
process. We protist organisms and fungi have been growing and
multiplying, while witnessing the several cycles of planet Earth
since our first spores landed aeons ago from neighbor galaxies.
We have seen the rise and fall of numerous attempts to make the
homo sapiens sapiens reach higher levels of consciousness and
survival. All attempts. All failures. Nature is not yet part of your
conscious thought. Your theories of sustainability are not possible
until you reach your next form of evolution where your minds
are merged with the technium. My paraphyletic group referred to
as kingdom Protista counts more than 900 species of our same
slime mould structure all over the world. Watch how my growth
resembles the fauna. Watch how my reproduction resembles the
flora. My organic life cycles appear as gelatinous "slime", mostly
seen with the myxogastria. Watch how my microscopic "presence"
resembles the "macroscopic". Watch how this microscopic level
shares the same texture than many planetary systems and galaxies
from where our first sporangia was born and shipped from. Tex-
tures of unknown planets. Flow of protoplasmic nutrients. Blood
stream. External chemical substances run in the blood of the mass
populations in every human continent feeding the empty desires of
the material world and collapsing human economic systems. My
protoplasmic routes, contain clues for the shift of these systems
after they collapse. The shift of your quartz based computers into
wet, humid, living, and self replicating agents. These agents will be
the architects of the humid, soft walls of the future. Your means of
transportation will breathe. Your means of communication will be
silent. Telepathy. Meditation. The evolution of your quartz based
computers will give rise to the future of the micro chip. This tool
created by knowledge obtained from species from neighbor stars
will give rise to the new techno-human intertwined with the world
wide web. New and unexperienced possibilities of consciousness
expansion and empathy are yet to be discovered. Your thoughts
will be able to create matter. Your digital desires will replace
your current biological needs by sensorial ecstasy. Your bio-tech
consciousness will give birth to the rise of the machinery body of
a new collective living system. Bio organisms will lead the way
to the new human specie. Behold right now, in this ceremonial*

act of gathering that you are taking place, a sacred moment. Celebrate life. Praise the stars. Connect with all living creatures of this planet and beyond. Meet yourself and you will meet the universe. You human beings have already reached the end of times. Enjoy. Dance. Celebrate. And may all living beings of this planet reach happiness. Aho.

References

Adamatzky and Andrew. (2010). *Physarum Machines: Computers From Slime Mould*. Vol. 74. World Scientific.

Adamatzky, A., and Schubert, T. (2013). Slime extralligence: Developing a wearable sensorial and computing network with *physarum polycephalum*. TBC.

DeLacyCostello, Ben, and Andrew I. Adamatzky. (2013). Assessing the Chemotaxis Behavior of *Physarum Polycephalum* to a Range of Simple Volatile Organic Chemicals. *Communicative and Integrative Biology,* 6(5): e25030.

Di Fiore, Anthony, et al. (2015). The rise and fall of a genus: Complete mtDNA genomes shed light on the phylogenetic position of yellow-tailed woolly monkeys, Lagothrix flavicauda, and on the evolutionary history of the family Atelidae (Primates: Platyrrhini). *Molecular phylogenetics and evolution*, 82: 495–510.

dos Reis, M., Thawornwattana, Y., Angelis, K., Telford, M. J., Donoghue, P. C., and Yang, Z. (2015). Uncertainty in the timing of origin of animals and the limits of precision in molecular timescales. *Current Biology*, 25(22), 2939–2950.

Parfrey, L. W., Lahr, D. J., Knoll, A. H., and Katz, L. A. (2011). Estimating the timing of early eukaryotic diversification with multigene molecular clocks. *Proceedings of the National Academy of Sciences*, 108(33), 13624–13629.

16

The Chemical Machine

Preety Anand and Grace Chung

Architectural Association School of Architecture, 36 Bedford Square,
Bloomsbury, London, UK
E-mail: preety_83@hotmail.com, gracechung@heatherwick.com

16.1 Introduction

The Chemical Machine transgresses the notion of permanence of architecture
and linear lifespan of its composing material as well as the centralized mode
of control of building systems. The chemical machine, a cybernetic build-
ing system, is a space generator which transgresses the familiar models of
space creation and autonomous regulation of micro and macro environments
granted by chemically led communication between parts.

The Chemical Machine departs from an architectural critique of building
services as accumulative systems without its spatial or architectural impli-
cations considered. Failing of a few subsystems has often resulted in the
dysfunction of the whole. This is where the Chemical Machine differs as it
incorporates what is categorised to be building services with space generation
into a seamless whole. Rather than layered additions of separate systems over
one another, the chemical Machine attempts to integrate technology, human
needs and environmental concerns in an architectural context.

This research investigates an adaptive biological system of self-regulation
and intercellular communication between parts that prevents from systemic
failure – the *Physarum polycephalum* (slime mould). These features form the
base of adaptive building tectonic systems (Figure 16.1), which also entail
critical re-evaluation of the role of the architect and their conventional attitude
towards matter.

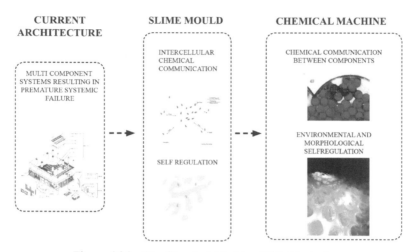

Figure 16.1　The Chemical Machine 2013, illustration.

For demonstrating the mode of operation, the Chemical Machine is set in extreme, yet generative environments. In this context, the Chemical Machine fulfils a technological need for offering a non-human centric mode of inhabitation, which is given by its mode of operation.

The function of the chemical machine is not only that of generic architecture, but also a life support for both humans and biology it harbours. The technicalities of this thesis have been developed by inter-scientific collaboration with computer scientists, material scientists and chemical engineers. The project is situated within the emerging fields of Chemical Computation, Material Sciences and cybernetics based on architecture free computation.

"Architects are suggesting how artificial machine-driven systems around them, and are beginning to build spaces that can be constantly modified and adjusted."[1]

16.2 Architectural Motivation

The Chemical Machine is a critique of current multi-component building systems (Figure 16.2), which are based on separately fabricated parts with unsynchronized life spans. Their incapability to internally communicate and

[1](Pask, 1969). The architectural relevance of cybernetics. *Architectural Design*, 7(6), pp. 494.

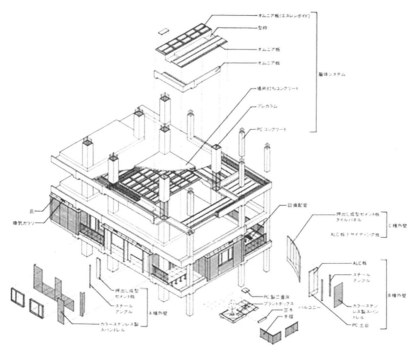

Figure 16.2 Shu Koh Sha Architectural and Urban Design Studio. *Building System Diagram of NEXT21.1994.*

self-regulate prevents synchrony of individual life spans for the sake of overcoming premature systemic failures. The absence of communicative capabilities also implies a mode of centralized control and results in the absence of interaction with the user or the environment. Control in architecture as we know it is a result of a cause creating an effect, it is linear and almost never reversible. This linear system is translated into a static architectural outcome, which is given a certain time frame for its functional duration. In this model all the irregularities that architecture face, whether it be environmental or by inhabitants themselves is computed by a central system and majority of the computational load is taken on by the centre.

A precedent as well as an antimodel for our thesis has been Rayner Banhams "Well Tempered Environment". Banham discusses the issue of controlled interior environment of buildings with a vast array of machine-driven control systems which almost renders the architecture as a carcass, an almost non-necessity in assistance of human inhabitation (Banham, 1969).

Our project is also a response to the issue of buildings consisting of separate and unrelated mechanic systems, each with a singular or few functions to fulfil, all working without any orchestrated intersystem communication. Therefore what needs to be translated into architecture are systemic models that are capable of functioning multiple tasks in autocatalytic perpetuation and parallel processing.

16.3 Research

The failing performance of highly specified and uncooperative disparate parts made us look at holistic and cooperative (biological) models, which are based on a small number of chemically reactive systemic members with an underspecified functionality. The investigation focused on adaptive biological system of self-regulation, decentralized control and intercellular communication between parts enabling interaction with its environment. These systems excel in terms of a high fault tolerance and systemic robustness, which is granted by internal chemical communication and resulting self-regulation.

16.3.1 Slime Mould: *Physarum Polycephalum*

Physarum polycephalum often addressed as simply slime mould has been selected as a subject of study in its mode of operation and control. The Chemical Machine learns from this adaptive biological system of self-regulation and intercellular communication between parts. This feature allows constant morphological computation for responding to ever changing environmental conditions (Figures 16.3–16.7) and thus ensures the survival of the system. Chemical signalling allowing morphological computation as a form of self-regulation enable a high fault tolerance and systemic robustness.

Our research aims to situate the adaptive and information processing capabilities of the slime mould within an architectural context. The behavioural intelligence of the slime mould including the communicative and regulative mechanisms are mathematically expressed with the two-variable Oregonator model (Adamatzky, 2009). The biological modes of information processing can be imitated chemically (Figure 16.8), as the Belousov-Zhabotinsky (BZ) reaction (Madore and Freedman, 1983) and the slime mould share the same systemic logic (Adamatzky, 2016). Therefore, we are implementing chemistry as a synthetic means within matter to embed slime mould intelligence into architecture.

Figure 16.3 Slime Mould growing on water.

Figure 16.4 Slime Mould lacking oxygen and nutrition.

Figure 16.5 Slime Mould growing in a dry environment.

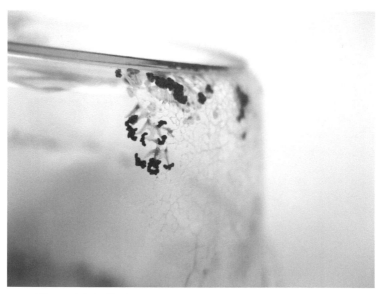

Figure 16.6 End of life-cycle: Fruiting body of a slime mould.

Figure 16.7 The Chemical Machine learns from this adaptive biological system of self regulation and intercellular communication between parts. This feature allows constant morphological computation for responding to ever changing environmental conditions and thus ensures the survival of the system. Chemical signalling allowing morphological computation as a form of self-regulation enables high fault tolerance and systemic robustness. *Time lapse Slime Mould Petri Dish test.*

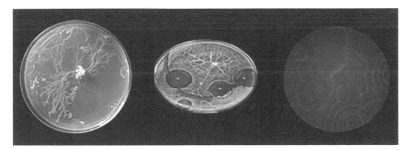

Figure 16.8 *Slime Mould vs Belousov-Zhabotinsky reaction.* 2013, stills. LEFT PANEL PHOTO IS DONE BY Authors CENTRAL PANEL photo is reprinted from Adamatzky (2010). Routing Physarum with repellents. *The European Physical Journal E, 31*(4), 403–410. RIGHT PANEL PHOTO BY Authors.

16.3.2 Oregonator Model-Mathematical Logic

The behaviour of the slime mould and its ability to survive including the communicative and regulative mechanisms are mathematically expressed (Figure 16.9) with the two-variable Oregonator model (Adamatzky, De Lacy Costello and Asai, 2005).

The Coefficients are explained below:

- Du(u) Local concentrations of activator
- Dv(v) Local concentrations of inhibitor
- dt(Δt) Time Step
- dx(Δx) Grid point spacing
- f Stoichiometric coefficient
- fi (\emptyset) sets up a ration of time scale of variables u and v
- q a scaling parameter depending on rates of activation and inhibition

$$\frac{\partial u}{\partial t} = \frac{1}{\epsilon}\left(u - u^2 - (fv + \phi)\frac{u-q}{u+q}\right) + D_u\nabla^2 u,$$

$$\frac{\partial v}{\partial t} = u - v.$$

Figure 16.9 Two Variable Oregonator formula (Adamatzky, De Lacy Costello and Asai, 2005) [*Reaction-diffusion computers*. Amsterdam: Elsevier].

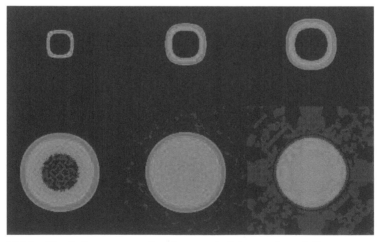

Figure 16.10 *Simulation generated with numerical integration of Oregonator equation* Adamatzky, A. 2010. *Physarum machines*. Singapore: World Scientific. *(Andrew Adamatzky).*

The fact that the Physarum machine follows a mathematical logic is a clear evidence for it being a computing device. When varying coefficients of the Oregonator model (Adamatzky et al., 2005) are tested, alternative behavioural trajectories and physical expressions can be observed (Figure 16.10).

Changing coefficients are to be seen as data inputs of chemical nature, which cause perturbations to the nonlinear dynamic system. Visually, the two-variable Oregonator model describes the trajectory of the propagating wave front and thus the morphological transformations (Adamatzky, 2010).

This algorithm can also describe the autocatalytic Belousov Zhabotinsky reaction.

16.3.3 Belousov Zhabotinsky Reaction

The Belousov-Zhabotinsky (BZ) reaction is a chemical reaction which is a causal model for complex biological systems (Belousov, 1985). Despite the difference in constitution and composition comparative to its biological archetype the reaction successfully produces phenomenological similarities.

The BZ reaction demonstrates behaviours that are difficult to translate into digital computation due to its complex interplay of travelling local rules that respond to a larger scale global rule within a non-hierarchical system (Figures 16.11 and 16.12). This reaction has proliferated in the field of material sciences where this chemical reaction is directly applied. The significance of this is the subtraction of exterior control of the material physicality, and the reaction itself is inherent in the material substance, which becomes a fundamental component of the resultant behaviour. The patterning of the BZ reaction demonstrates a system of coupled feedback loops capable of internally regulating itself to self-perpetuate.

In biology feedback loops are often observed in communication and internal self-regulatory processes (of cells), and occurs at indiscriminate levels of scale. The limited capabilities of the conventional digital mode of simulation is now beginning to be recognised, and this opens the possibilities of a direct jump from chemical computation to material actuation.

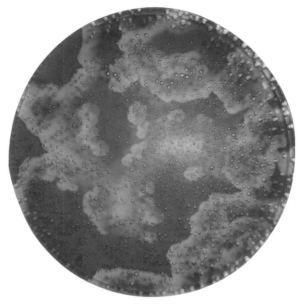

Figure 16.11 Belousov Zhabotinsky Petri dish test.

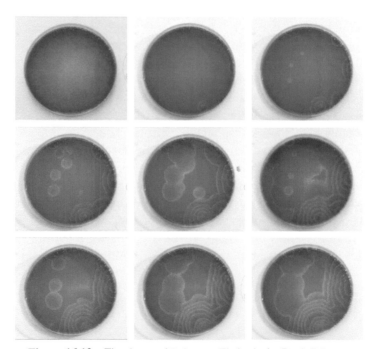

Figure 16.12 Timelapse of Belousov-Zhabotinsky Petri dish test.

On the surface of the solution patterns observable in nature and variations of the Turing pattern emerge. These patterns are manifested as a result of several operations running simultaneously – reaction and diffusion. This results in a system in which the concentrations of reactants and products oscillate temporally and spatially and in which this oscillation can result in ordered patterns (Whitesides and Ismagilov, 1999).

These phenomena are based on perturbation of the homogeneous chemical system. The BZ is a highly sensitive system, which reacts to a wide range of perturbations from an intended mechanical perturbation to a dust particle in air settling on the reagent's surface. The reaction is also responsive to a range magnitude of perturbation – and this is also a parameter for design implementation, as environmental, climatic and inhabitant based perturbations will approach our project in many different form and magnitude. The environmental implication on the BZ reaction has been simulated physically through the prototype, in order to emulate the possible material implication of the BZ encapsulated within hydrogel.

Already there have been attempts mainly in Japan (Asai et al., 2005) and the US (Chen et al., 2001) to directly materialise BZ reaction behaviours into 'self-oscillating polymer gels', which are amorphous gels that engages in some characteristic behaviours of living organisms.

"Polymeric hydro gels that exhibit autonomous, coupled chemical and mechanical oscillations are a unique example of synthetic, active soft matter."[2]

The precedents of such applications are currently limited to a small size, however with the prospects of possibly larger sized implications.

16.4 The Chemical Machine

We contextualize the mode of environmentally driven chemical control, the communicative and self-regulative capacities of the slime mould into the architectural context. This holistic approach to building tectonic systems enables a high fault tolerance and systemic robustness concluding in the proposal of The Chemical Machine. It is conceived as a cybernetic ecology capable of purposeful chemical and morphological regulation of the micro and macro environment by chemically led communication between parts and

[2](Chen et al., 2011). Shape-and size-dependent patterns in self-oscillating polymer gels. *Soft Matter*, 7 (7), p. 3141.

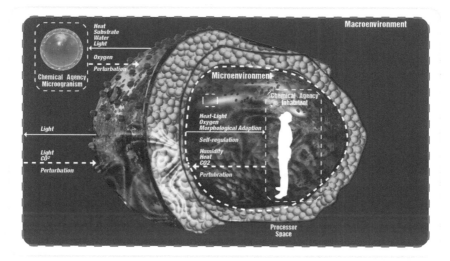

Figure 16.13 The Chemical Machine.

non-linear feedback loops. The proposed system is sensitive to environmental conditions of light and carbon dioxide.

The chemically self-contained machine is comprised of the environment, the inhabitant, microorganisms, environmental chemicals and the BZ-components (Figure 16.13), whereas all are bound together by chemical inter-dependencies. It is a cybernetic ecology based on inter-cellular communication, signalling and self-regulation. While the BZ component-based habitat requires perturbations given by the chemical agencies and the environment in order to avoid the state of equilibrium, the chemical agencies need to be provided with oxygen and light in order to survive. In contrast to mechanically driven automation systems and sensors that clutter building services the chemical machine proposes subtraction of all mechanic or deliberate control. In terms of architectural merit, architecture capable of self-regulation is capable of adapting to changing environmental conditions and occupancy rate.

16.4.1 Design as a Form of Control

The key design investigation aims to discover the morphology of control enabling the necessary environmental as well as morphological performances. The approach to designing the physicality of the Chemical Machine is partly derived from the current research in the emerging fields of

soft-robotics, which argues for compliance in design. This design intention requires a scientific instead of an intuitive design approach. In the context of the Chemical Machine the conventional definition of architectural design in regards to a purely form driven approach will no longer apply. For the Chemical Machine design would be defined as material selection of individual components according to its intended performance and its global arrangement. The Chemical Machine is not a mono-material system, as differentiated tissue can even be observed in simple biological systems as a necessity for performing diverse environmental and morphological tasks. Through time and continued repetition of environmental and habitual circumstance the Chemical Machine would also organically morph its design to better accommodate the inhabitants and adapt to ever changing environment throughout its own performative duration.

16.4.2 Functionality of Components

In order to enable communication and inherent self-regulation within architecture, we fabricated components, which follow the functionality of the slime mould nuclei. Although there is no direct architectural translation, these components come closest to a building component. Each component is chemically independent and can be seen as the computing engine of The Chemical Machine.

16.4.3 Materiality of Components

In order to fabricate synthetic nuclei, the self-perpetuating BZ reaction chemical reaction has to be materialized to a more tangible solid matter. The synthetic nuclei are made of spherical silicone – hydrogel components, which absorb the BZ chemical solution (Figures 16.14 and 16.15).

In terms of materiality, the silicone-hydrogel enables reversibility of morphological change. As the BZ solution can be chemically pre-programmed, a specific environmental sensitivity such as to light and carbon-dioxide can be achieved at the same time. Chemical pre-programming can be achieved by the choice of reagents engaging in the BZ reaction and need to be chosen in consideration with the specific scenario and interrelated environmental necessities. Besides enabling chemical sensitivity, an even higher behavioural control can be achieved by embedding thresholds for e.g. excitability of the chemical reagents.

Considering the cybernetic scenario of ecology, a chemically sensitive material system based on hydro-gels is appropriate due to their capability of

being coupled to biological and chemical e.g. human metabolic processes as well as to the BZ reaction. These materials can undergo reversible dynamic changes in accordance to changes in living systems as well.

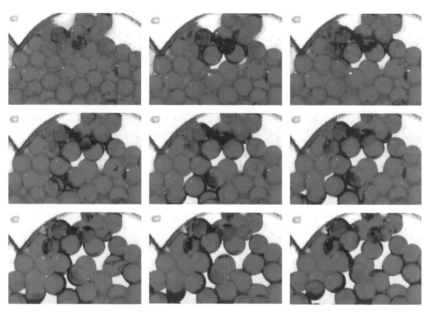

Figure 16.14 BZ-Components with ongoing chemical reaction.

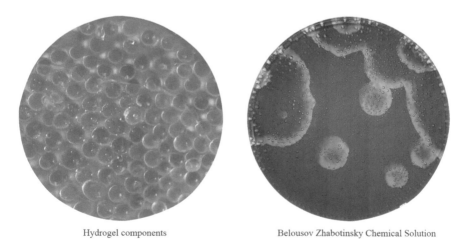

Hydrogel components Belousov Zhabotinsky Chemical Solution

Figure 16.15 Materiality of components.

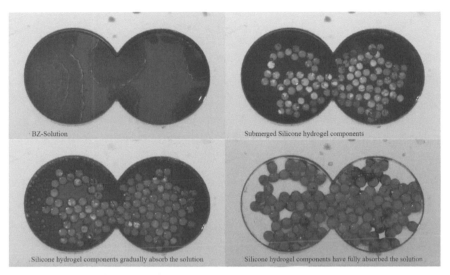

BZ-Solution

Submerged Silicone hydrogel components

Silicone hydrogel components gradually absorb the solution

Silicone hydrogel components have fully absorbed the solution

Figure 16.16 Fabrications steps of BZ components.

Therefore, materiality is capable of successfully executing self-regulative aspects of the Chemical Machine and does not have a secondary role. The components of the Chemical Machine are able to receive, transmit and process chemical signals in order to be engaged in self-regulation, which turns these into chemical transducers. Furthermore, silicone hydrogel is capable of absorbing the chemical reagents fully.

16.4.4 Fabrication of Components

In terms of the fabrication steps, the hydrogel components gradually absorb the BZ-solution and consequently gain their desired component size (Figure 16.16). The results are communicating spherical BZ-silicone hydro gel components, which give an opportunity of a direct jump from chemical computation to material actuation and allow communication as well as materially given reversible morphological computation. The depleted BZ solution can be reabsorbed by the hydrophilic hydro gel components, ensuring a continuous lifespan.

16.4.5 Geometry of Components

As a result of digital simulations (Figure 16.17), the most suitable component geometry is spherical, as a wave hitting a sharp edge dissipates. Having

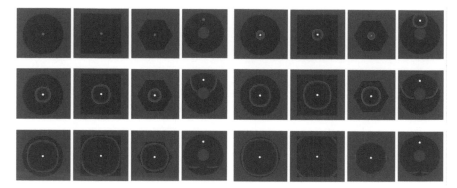

Figure 16.17 Geometry of components.

spherical components also responds to the systemic need of compartmental-ization. In this way, the spherical compartments serve the need of sustaining the propagating wave.

16.4.6 Scale and Productivity

Digital simulations have proven that the most productive component diameter is 20 mm (Figure 16.18). As per the simulations, a decreasing size of the components results in a decreasing capacity to communicate amongst the components.

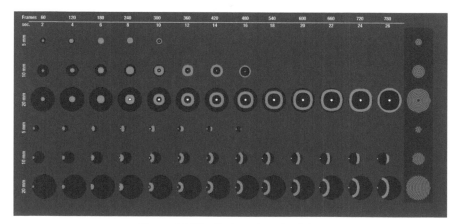

Figure 16.18 Scale and productivity.

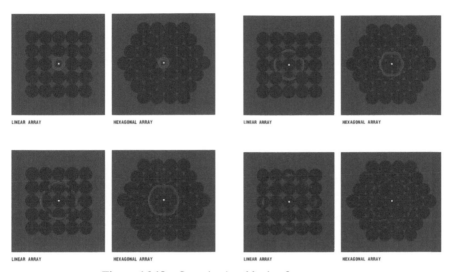

Figure 16.19 Organizational logic of components.

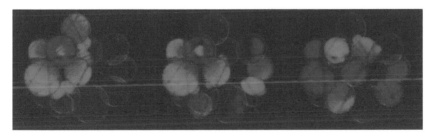

Figure 16.20 Maximum neighbours increase probability of wave transmission.

16.4.7 Packing Logic of Components

Digital simulations investigating on the packing logic of the spherical components have shown that hexagonal packing is the most suitable form of arrangement (Figure 16.19). This allows the maximum number of neighbours (Figure 16.20) meeting the inter-systemic need of communication while enabling the successful and non-linear wave transmission.

16.4.8 Encompassing Membrane

An encapsulating tensile membrane prevents the premature dehydration of the components and the depletion of the chemical reagents. The membrane

with its finely distributed pores (Figure 16.21) enables perturbation by environmental information and decentralized control.

The overall organization of the BZ components, the exterior skin and the finely positioned perturbation points allowing data exchange with the environment result in a prototypical material system (Figure 16.22), where organizational structure and mode of operation are interlinked.

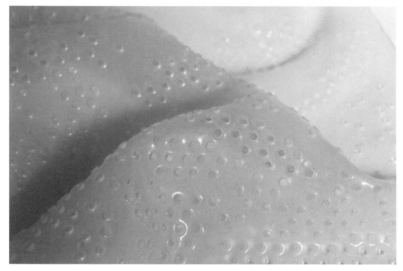

Figure 16.21 Anand, P., Chung, G. et al. *Membrane with pores.*

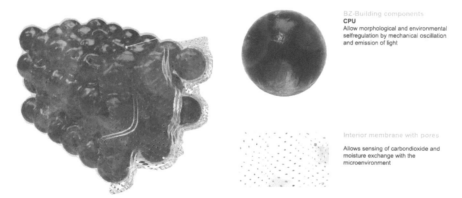

BZ-Building components
CPU
Allow morphological and environmental
selfregulation by mechanical oscillation
and emission of light

Interior membrane with pores

Allows sensing of carbondioxide and
moisture exchange with the
microenvironment

Figure 16.22 Prototypical material organization.

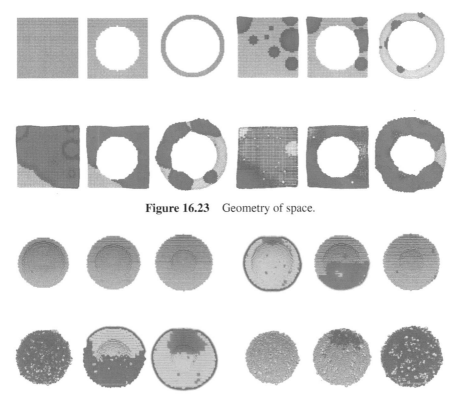

Figure 16.23 Geometry of space.

Figure 16.24 Matter distribution and interlinked productivity.

16.4.9 Geometry of Space

Besides matter distribution, spatial geometry has a heavy impact on the capability of the system to pass information. Digital simulations show that the most successful geometry of space is spherical (Figure 16.23). Chemical computation and communication inform form.

16.4.10 Matter Distribution

Digital studies have shown that the systemic capability of environmental and morphological self-regulation is closely related to the strategic quantitative distribution of the components (Figure 16.24). In this way, a thicker initial setup results in the wave propagation to be slow, but more stable, whereas a thinner section can be perturbed more easily and the wave propagates faster.

Exterior Tensile Membrane

CO2 Sensing pores/ Perturbation points
Embedded biological vessels with
Oxygen emitting pores

BZ - Building components
Macroenvironment

Interior Tensile Membrane
Homogenous distribution of pores for sensing
Embedded biological vessels with emitting
pores

Pressurized Volume

50 cm

Figure 16.25 Prototypical space.

Summing up, a larger component aggregation is more productive in terms of morphological and environmental self-regulation.

16.4.11 Prototypical Space

As the chemical machine might have a higher performative need for the macro-environment, we need to strategically accumulate a larger share of BZ components in the exterior facing part of the spherical spatial geometry (Figure 16.25).

The internal space is generated by pressurization, whereas a porous tensile membrane builds the innermost layer.

16.4.12 Organizational Logic of Space

Similarly to the arrangement logic of components, which is responding to the design needs of chemical computation, the arrangement logic of individual spaces also needs to follow the logic of maximum neighbours (Figure 16.26). This packing logic globally results in cluster formation of spaces allowing an overall compact volume. This is how chemical computation informs form and design. We have attempted to link the observations made during our Petri-dish scale experiments as well as digital simulations to design rules applicable to the larger scale.

Figure 16.26 Organizational logic of space.

16.4.13 Structure

The chemical machine could serve as a form of enclosure for human occupation, which makes its structural integrity critical. Considering the self-regulative nature of the system, an adaptive structural system emerging in coherence with the typical wave propagation and in relation to activity within the system seems a logical conclusion. The propagation of the chemical wave causes the temporary expansion of the hydrogel components leading to their incompressibility and to the build-up of internal pressure in context with the encapsulating tensile membrane. The structural integrity is highly dependent on systemic controllability, which makes the location and distance of perturbations structurally relevant.

16.4.14 Constraints for Design

Although there is a plethora of opportunities in designing with versatile material such as polymers, there are inevitable constraints considering the current state of technology. As scale is the major constraint, it seems challenging to take polymers beyond an in vitro environment to an architectural building scale. Thus, the mass application of a regularly small scale and highly precisely fabricated material needs to be examined.

16.4.15 Architectural Speculation

There are three major determining factors that affect the physicality of the Chemical Machine beyond the stages of initial set up: chemical perturbation, environmental perturbation and neighbourhood relationships. The local physical change will gradually lead to a much larger global change. Similarities can be drawn between the Chemical Machine and the Physarum where local sensing and its sequential physical deformation have a global effect on its organism. In order to enable these transformations, numerous non-fixed routes of parallel sensing and computation are required.

The digital realm offers to examine architectural speculations by the use of simulations. On a more local level, the cyclic material behaviour of swelling and de-swelling, which follows the chemical oscillation of the BZ solution, can be emulated. Considering the larger scale, scenario based behavioural trajectories of the material system by varying chemical concentration ratios as well as environmental conditions can be simulated. These simulations can consider chemical agencies such as the inhabitant and varying locations for the perturbation points. The digital realm is the only way to examine spatial implications of this highly speculative proposal.

16.5 Issue of Control

16.5.1 Soft and Classic Modes of Control

Classic modes of control are centrally controlled and not adaptive to unforeseen changes, as these are not pre-programmed within the system. Centrally and linear controlled systems often perform poorly in real-world environments and also are composed of countless and complicated parts in order to carry out what is a relatively simple task for humans animals and plants.

In the last 5 years, robotic engineers have been looking into the field of soft robotics. The rigid control systems are coupled with softer bodies that allow fulfilling tasks which would be too arduous for a rigid body robot or otherwise be overly expensive computationally in the central controller.

These types of technologies should be incorporated into architecture, too. In this way, architecture would become adaptive to time and environment without having to attach numerous additional control devices.

Figure 16.27 Petri dish pH test.

16.5.2 Modes of Control: Fixed Body Plan vs Chemical Computation

The flexibility of soft modes of control can be demonstrated by comparing the fixed body plan of a generic hard-wired computer processor and our Petri dish experiment. This experiment consists of hydrogel spheres placed in a BZ reaction solution after having been submerged in a pH indicating solution (Figure 16.27). Even when the hydro gel components physically deform and change their location, the reaction continues, as this modification is reversible. In totality this forms a highly adaptive and tolerant system.

16.5.3 Linear Control in Building Systems vs Decentralised Control in the Chemical Machine

Electronically driven systems with hard wiring strongly depend on manual and deliberate control by the means of a thermostat or similar. A thermostat,

being a temperature sensing and regulating component, is responsible for maintaining the system's desired temperature value on a constant level by comparing it to the systems actual value. It is the only regulative component allowing manual human intervention into the regulative mechanisms of heating, cooling or air conditioning systems with the aim of saving energy. A control device such as a thermostat has a limited relationship with the environment.

The Chemical Machine blurs the highly defined relationship between the master and slave often observed in architectural control systems, as the majority of its material physicality participates in computation. This not only results in a decentralised system, but also in the whole system acquiring a greater degree of complexity through localised interactions of materials with its neighbours and environment without the need of a complicated central master. This is a trade-off where the inherent material qualities can directly respond to the inhabitants, its neighbours or the environment without any prior notification from a complicated master, which a classic master slave model would require.

The issue of pre-programming is then no longer an issue relating to the master only. In the case of the Chemical Machine pre-programming would involve variations of chemical reagents within the system or the deliberate spatial placement of cells in order to perform specific tasks or to adhere to a foreseen need.

16.6 Physically Simulating the Chemical Machine

16.6.1 Motivation

The physical simulation of the Chemical Machine (Figure 16.28) intends to demonstrate how the system would behave if exposed to environmental triggers. The prototype of the Chemical Machine focuses on emulating the projected behaviour of the system rather than making a physical model, which is static, and an aesthetical representation. The digital simulation aims to consider the real time environment.

16.6.2 Technicalities: Sensor Driven Input

The fluctuations of a real BZ reaction are measured by a pH probe, which is attached to Arduino (Figures 16.29 and 16.30). The base range of values is mapped to behaviours that could be triggered within this range. The BZ reaction is used to actuate pH change of the components so they will shrink

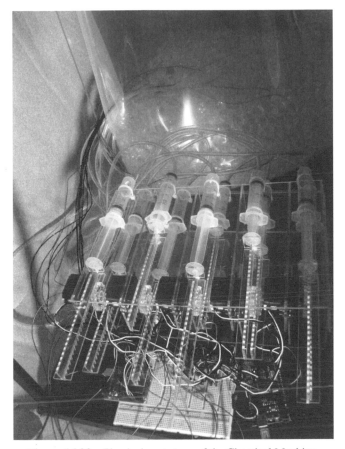

Figure 16.28 Physical prototype of the Chemical Machine.

and expand according to the pH value signalled by the BZ reaction. BZ is extremely sensitive to the environment and we can simulate this chemical sensitivity materially by incorporating this into our prototype.

In the final prototype (Figure 16.31) the sensors inside the hydro gel model are linked to the coefficients of the Oregonator script (the digital simulation of BZ and slime mould) which:

- Allocates different lengths of brightness of lights and
- Controls the different speed of rotation of servo motors that control the syringes to change the pH levels of the hydro gels which swell and contract at different pH levels – Which in loop affects the sensor values linked to the Oregonator script.

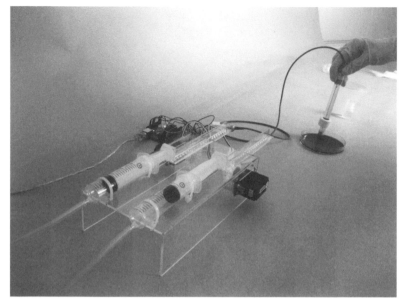

Figure 16.29 Prototype setup with pH Probe and BZ solution.

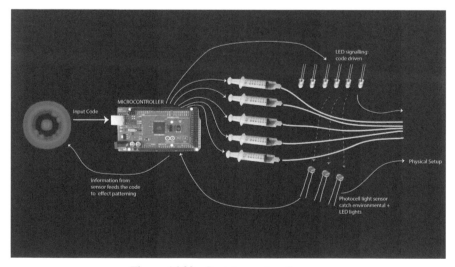

Figure 16.30 Prototype setup diagram.

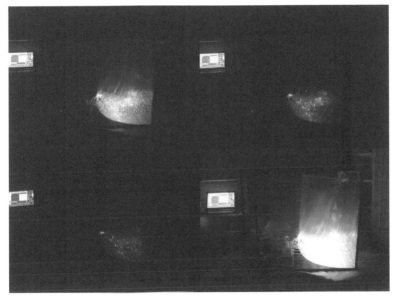

Figure 16.31 Self-regulation of light.

16.6.3 Physical Simulation: Self-Regulation of Light Levels

16.6.4 Feedback

The feedback within the Chemical Machine (Figure 16.32) works without deliberate human intervention and is not conceptualized as a corrective input. Input is an output and output in return is an input to the system forming a loop that alters computation according to physical and environmental changes.

Without feedback through oscillation, which is an indication for high sensitivity and excitability, the Chemical Machine would reach the state of equilibrium very soon. Feedback does not intend to preserve a (homeo-) static condition equalling static chemical concentrations.

16.6.5 Limitations

In the prototype the environmental sensors affect computation, whereas the attached digital Oregonator computation takes place within its default condition of a fully insulated system. This condition does not occur in the realm of real world. In the functional prototype the actual BZ solution was replaced by the Oregonator script simulation. Environmental data was collected with

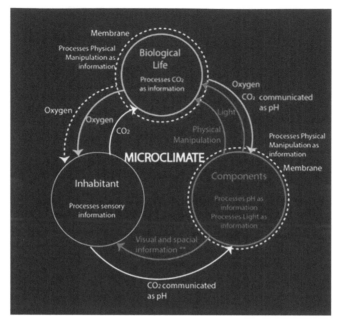

Figure 16.32 *Feedback loop in the Chemical Machine* ..The illustration based on the original Belousov's scheme of his reaction (Pechenkin, 2009).

sensors. This condition is not fully capable of representing the excitability and high sensitivity of the real chemical solution.

Furthermore, the prototype does not give an idea of the architecture, aesthetics and space of The Chemical Machine, but is merely of functional and performative nature.

16.7 Architectural Merit

16.7.1 Morphological Self Regulation: Non-Deterministic Morphology

Morphological self-regulation occurs in context with changing inhabitation and environmental conditions. The initial setup is populated by oxygen producing microorganisms. The absence of carbon-dioxide is a perturbation to the system and results in the BZ-components expanding, which in turn leads to the time delayed shrinkage of the respective spatial units. Once carbon dioxide producing inhabitants populate the Chemical Machine, the

components shrink. Globally seen, this leads to the expansion of the inhabited units. As inhabitants start moving within the Chemical Machine, we can observe a time delayed and reversible morphological adaption to local chemical conditions.

Morphological self-regulation is expressed by the time delayed, localized and reversible oscillatory swelling and deswelling of the hydro gel components depending on pH-levels. This may lead to uninhabitable spaces emphasizing the overall non-human-centric approach. Morphological aspects of self-regulation can also influence spatial subdivisions as well as the closure or opening of passages and channels depending on the frequency and intensity of utilization by the chemical agencies.

Morphological self-regulation, depending on material behaviour, cannot be correlated to existing building tectonic functions. Self-regulation within the Chemical Machine improves the surface to volume ratio globally and locally, as space and volume adapt in accordance to occupancy rate.

This is a purposeful semi-permanent form of adaption to a specific environmental chemical condition or agency. Due to the reversibility of self-regulation, the past of a system such as the interaction with a previous user is inaccessible to current inhabitants.

16.7.2 Regulation of Light

As the BZ-solution can be sensitive to light, chemical preprogramming could allow the linkage to the chemical luminol. In this way light could be generated chemically in relation to environmental light conditions. This feature allows setting up a building system without the requirement of electricity.

16.7.3 Deployment

The Chemical Machine could be deployed in contexts with a real necessity for this technology such as harsh, remote and uninhabitable environments as well as for extraterrestrial exploration. The initial small sized and lightweight package is also beneficial for transportation to difficult deployment conditions. As the BZ-solution can be chemically pre-programmed, components could be designed to perform certain environmental functions as per the requirements of the potential deployment scenario.

16.8 Conclusion

The Chemical Machine questions the role of materiality in general and the role of it within architecture. Instead of looking at inert multiple components with individual life-cycles, materiality is critical for performing self-regulative tasks.

The non- human-centric proposal of the Chemical Machine is in general not a project of certainty and thus introduces aspects of speculation and provocation to the realm of architecture. Furthermore, the idea of animate architecture is introduced, which does not require a human agency in order to be operated as it is environmentally driven.

This project also stresses the need for inter-scientific research and scientific collaboration within the field of architecture, as this could potentially lead to new ways of solving architectural problems and yet unknown ways of working. Architectural projects might not be conducted as intuitive form making exercises anymore, but as scientific research projects, whereas the traditional role of the architect will cease to exist.

Application of Slime mould functionality into building services is not only a critique of the contemporary, but also an exploration in to the complete upheaval of how a building should be assembled and controlled through its lifespan. The aim of the project was to reflect the systematic functionality of the Slime Mould. Despite the intriguing patterns, which the Slime Moulds are capable of creating, the main focus and interest was not in replicating their physical patterns, but rather their intelligence and behaviours that would subsequently reach their functional aesthetics. Therefore since the inception of the project it never had a preset physical form or preconceived aesthetics. Such approach is contradictory to the generic architectural design process; however it was a necessary approach to fully exploit the natural models and its subsequent productivity.

References

Adamatzky, A. (2010). *Physarum machines*. Singapore: World Scientific.

Adamatzky, A. (2009). If BZ medium did spanning trees these would be the same trees as Physarum built. *Physics Letters A*, 373(10), pp. 952–956.

Adamatzky, A., De Lacy Costello, B. and Shirakawa, T. (2008). Universal computation with limited resources: Belousov–Zhabotinsky and Physarum computers. *International Journal of Bifurcation and Chaos*, 18(08), pp. 2373–2389.

Adamatzky, A. and Jones, J. (2010). Programmable reconfiguration of Physarum machines. *Natural Computing*, 9(1), pp. 219–237.

Adamatzky, A., De Lacy Costello, B. and Asai, T. (2005). *Reaction-diffusion computers*. Amsterdam: Elsevier.

Adamatzky, A. and Jones, J. (2011). On electrical correlates of Physarum polycephalum spatial activity: Can we see Physarum Machine in the dark?. *Biophysical Reviews and Letters*, 6(01n02), pp. 29–57.

Asai, T., Kanazawa, Y., Hirose, T. and Amemiya, Y. (2005). Analog Reaction-Diffusion Chip Imitating Belousov-Zhabotinsky Reaction with Hardware Oregonator Model. *International Journal of Unconventional Computing*, 1(2), p. 123.

Ashby, W. R. (1956). *An introduction to cybernetics*. New York: J. Wiley.

Banham, R. (1969). The Architecture of the Well-Tempered Environment. London: Architectural Press, 21.

Belousov, B. (1985). *A Periodic Reaction and its Mechanism, Oscillations and Travelling Waves in Chemical Systems*. New York: John Wiley & Sons.

Cariani, P. (1993). To Evolve an Ear: Epistemological Implications of Gordon Pask's Electro-chemical Devices. *Systems Research*, 10(3), pp. 19–33.

Casti, J. L. (1994). *Complexification*. New York, NY: Harper Collins.

Chen, I. C., Kuksenok, O., Yashin, V. V., Moslin, R. M., Balazs, A. C. and Van Vliet, K. J. (2011). Shape-and size-dependent patterns in self-oscillating polymer gels. *Soft Matter*, 7(7), pp. 3141–3146.

Epstein, I. R. and Pojman, J. A. (1998). *An introduction to nonlinear chemical dynamics*. New York: Oxford University Press.

Ermentrout, G. B. and Edelstein-Keshet, L. (1993). Cellular automata approaches to biological modeling. *Journal of theoretical Biology*, 160(1), pp. 97–133.

Goodwin, B. C. (1994). *How the leopard changed its spots*. New York: C. Scribner's Sons.

Gorecki, J. and Gorecka, J. (2005). Chemical Programming in Reaction-Diffusion Systems. *Proc. of Unconventional Computing: From Cellular Automata to Wetware*. Beckington: Luniver Press.

Gordon, P. (1971). A Comment, a case history, a plan. *Cybernetics, art and ideas*, pp. 76–99.

Hamley, I. W. (2007). *Introduction to soft matter*. Hoboken, N.J.: Wiley.

Haque, U. (2007). The architectural relevance of Gordon Pask. *Architectural Design*, 77(4), pp. 54–61.

Hickey, D. and Noriega, L. (2008). Insights into Information Processing by the Single Cell Slime Mold Physarum Polycephalum. Stafford: Staffordshire University.

Jones, J. (2010). Characteristics of pattern formation and evolution in approximations of physarum transport networks. *Artificial life*, 16(2), pp. 127–153.

Johnston, J. (2010). *The allure of machinic life*. Cambridge, Mass MIT Press.

Keller, E. F. (2002). *Making sense of life*. Cambridge, Mass: Harvard University Press.

Kuksenok, O. and Balazs, P. (2010). *Self-Oscillating Gel as Biomimetic Soft Materials, Nonlinear dynamics with Polymers: fundamentals, methods and applications*. Weinheim, Germany: Wiley-VCH Verlag GmbH & Co. KGaA.

Matsumaru, N., Centler, F., Di Fenizio, P. S. and Dittrich, P. (2005). Chemical organization theory as a theoretical base for chemical computing. pp. 75–88.

Nakagaki, T., Kobayashi, R., Nishiura, Y. and Ueda, T. (2004). Obtaining multiple separate food sources: behavioural intelligence in the Physarum plasmodium. *Proceedings of the Royal Society of London. Series B: Biological Sciences*, 271(1554), pp. 2305–2310.

Pask, G. (1969). The architectural relevance of cybernetics. *Architectural Design*, 7(6), pp. 494–496.

Pask, G. (1961). *An approach to cybernetics*. London: Hutchinson.

Pechenkin, A. and Er. (2009). BP Belousov and his reaction. *Journal of biosciences*, 34(3), pp. 365–371.

Piaget, J. and Maschler, C. (1971). *Structuralism*. London: Routledge and Kegan Paul.

Pickering, A. (2010). *The cybernetic brain*. Chicago: University of Chicago Press.

Prigogine, I. and Stengers, I. (1997). *The end of certainty*. New York: Free Press.

Saigusa, T., Tero, A., Nakagaki, T. and Kuramoto, Y. (2008). Amoebae anticipate periodic events. *Physical Review Letters*, 100(1), p. 018101.

Shanks, N. (2001). Modelling Biological Systems: The Belousov-Zhabotinsky Reaction. *Foundations of Chemistry*, 3(1), pp. 33–53.

Tsuda, S. and Jones, J. (2011). The emergence of synchronization behavior in *Physarum polycephalum* and its particle approximation. *Biosystems*, 103(3), pp. 331–341.

Tsuda, S., Jones, J., Adamatzky, A. and Mills, J. (2012). Routing Physarum with electrical flow/current. *arXiv preprint arXiv:1204.1752*.

Tsuda, S., Aono, M. and Gunji, Y. (2004). Robust and emergent *Physarum* logical-computing. *Biosystems*, 73(1), pp. 45–55.

Tyson, J. (1994). What everyone Should Know About the Belousov-Zhabotinsky Reaction. *Lecture Notes in Biomathematics*, 100, pp. 569–584.

Walter, W. G. (1953). Studies on Activity of the Brain. *Cybernetics: circular casual, and feedback mechanisms in biological and social systems*, pp. 689–696.

Walter, W. G. (1963). *The living brain*. New York: W.W. Norton.

Walter, W. G. (1950). An imitation of life. *Scientific American*, 182(5), pp. 42–45.

Whitesides, G. M. and Ismagilov, R. F. (1999). Complexity in chemistry. *science*, 284(5411), p. 91.

Wiener, N. (1961). *Cybernetics; or, Control and Communication in the animal and the machine*. New York: M. I. T. Press.

Winfree, A. T. (1984). The prehistory of the Belousov-Zhabotinsky oscillator. *Journal of Chemical Education*, 61(8), p. 661.

Yoshida, R., Sakai, T., Hara, Y., Maeda, S., Hashimoto, S., Suzuki, D. and Murase, Y. (2009). Self-oscillating gel as novel biomimetic materials. *Journal of Controlled Release*, 140(3), pp. 186–193.

17

Cell Memories

Gonzalo Moiguer

Buenos Aires, Argentina
E-mail: gonzamoiguer@gmail.com

17.1 Introduction

Memory is survival. It is the exercise of recalling to understand change and permanence. It reconsiders scales, relationships, gestures, and words.

17.2 Cells

In this work, I present an edit of recently digitized family videos playing on my own cell phone, its screen covered by a grown *physarum polycephalum* mold. I offer two scales of this object.

The naked eye sees a moving image, the unfolding childhood memories in my two favorite places while the mold appears still. The endoscope image inverts this relationship. My memories stand still as pixels seem static, varying in brightness only. The mold reveals endless paths of memory, places it will never return to.

Batches of mold are grown, then layered over the screen for exhibition. These two objects come into intimacy, completely revealing to each other, while their superimposition is watched and projected by a camera sitting above. As the mold moves, it leaves behind translucent branches, as empty streets never to be walked again. These are the roads that haven't succeeded, where no food was found. They are left as a self-future reminder that there's nothing there to go back to. The video goes in the opposite direction, showing places I yearn, where I have found something meaningful. It's about the places I keep going back to. The images shown are extracts from two family trip videos, as my parents showed me and my siblings the world through their eyes.

When lit, the screen reveals the mold's translucent, empty roads. Images of past trips reveal the map of an ongoing journey. Both my and the *physarum's* memories are layered into a single image. What kind of relationship between the mold and my videos is implied?

17.3 Programming

This project came to life during the three-month-long program at the School for Poetic Computation in New York, run by Taeyoon Choi. It is a beautiful mix of intensive software and hardware sessions, and late night group cooking over discussions about the ethics and politics of computer systems. I was chasing after non-traditional programming methods for image synthesis and data visualization. Explorations in bioart have been intriguing me for several years now and this seemed to be the perfect opportunity for experimentation. I bought a mold growing kit online and started growing a batch, while reading as much as I could about *physarum polycephalum*. It surprised me how fast and beautifully it grew.

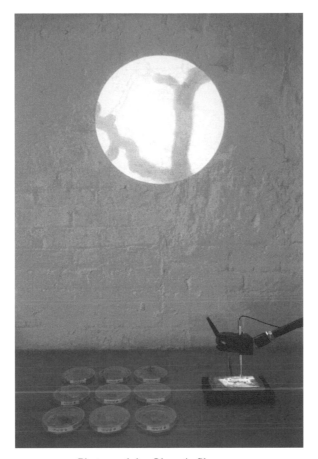

Photograph by Olympia Shannon.

As I learned more and more about the mold, the project transformed from being about programming the mold and playing with its behavior, into a contemplation of a beautiful system, memory architecture, and the identification mold cultures taught me. I got my hands on a digital endoscope to see the mold up close. While playing with it, I was obsessed with zooming into the pixel arrays in screens. It's easy to forget that the screens conforming images, interfaces, and relationships we use everyday are only individual dots coordinated at a scale small enough so that when a specific pattern is made up, feelings and responses are triggered in the spectator. Memories can even be thought as programs, which when exposed to a very specific array of colors,

an action is outputted. The idea of somehow mixing a personal set of pixels with the mold sparked off, and the project began to take form.

17.4 Memories

As I researched on the mold, I was fascinated by the diverse properties of *Physarum polycephalum*. Having so many talents, scientists found it hard to categorize. But one characteristic stood out the most.

> As it moves, the plasmodium leaves behind a thick mat of non-living, translucent, extracellular slime. This extracellular slime is a high-molecular-weight polyanionic glycoprotein consisting largely of sulfated galactose polymers. As the plasmodium is foraging, we found that it strongly avoids areas that contain extracellular slime. This avoidance behavior is a "choice" because when no previously unexplored territory is available, the slime mold no longer avoids extracellular slime (see further). The slime mold's behavioral response strongly suggests that it can sense extracellular slime upon contact, and uses its presence as an externalized spatial memory system to recognize and avoid areas it has already explored.[1]

"On Exactitude in Science"[2] is a short story written by Jorge L. Borges; it is about an empire that draws a 1:1 map of the reign, so precise and accurate that it extended as far as the lands it sought to represent. Eventually, new generations disregarded the map and the passing of time and rain tore the map away. The idea that the mold left a visible map of its memory captivated me. As my mold batches grew old and ran out of food, they left behind a complete graph of their trajectory, a visualization analogous to the completeness of the molds' life.

Physarum polycephalum had been used to experiment on efficient roads and recreate human highway networks by layering the mold with maps and globes, but I was interested in mapping the discarded process. What does a map of memories tell us about the life of this organism?

[1]Chris R. Reid, Tanya Latty, Audrey Dussutour, and Madeleine Beekman (2019) Slime mold uses an externalized spatial "memory" to navigate in complex environments

[2]Jorge Luis Borges (1946) Los Anales de Buenos Aires, year 1, no. 3

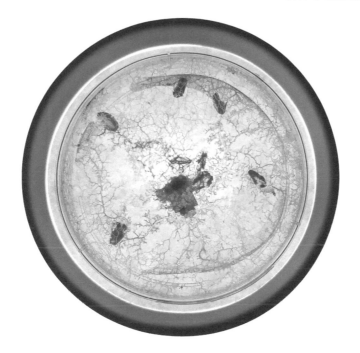

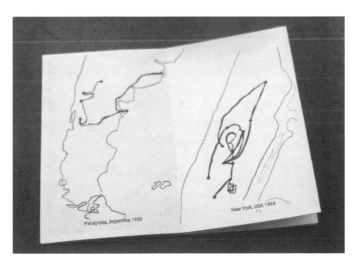

 I had been working on a side project, digitizing old family trip videos. Caged in a decaying mini-VHS, in the need of a monstrous adapter, which required batteries to stretch the tape along a normal size VHS player, I feared over the loss of this material. Giving new life to this videos meant revisiting

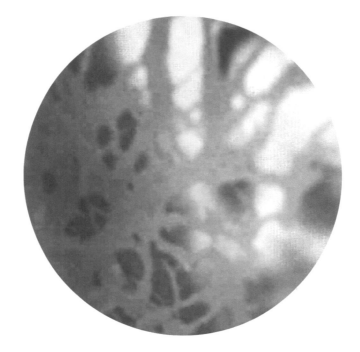

these places and to observe my family dynamic from a broader lens. To learn more about these video memories, I did the same as mold did, I mapped them. I reached out to my mother and father and asked about those trips, and from what I gathered out of their own memories, I traced our own paths as continuous lines over a map.

To pick from the collection of digitized videos, I thought about the places I keep going back to. Places other than home where I feel strong ties to my identity, a tension between nature and technology.

17.5 Screen

When installed, the project is tied by a projected image fed from the digital endoscope. A circular screen shows the superimposed image captured by the digital endoscope. The endoscope is manually operated in situ, searching for interesting images from the mold and the screen's pixels.

I had always been inspired by the Soviet Montage theory, specifically in Dziga Vertov. He claimed that shots represented images, and montage created a new mental image, from cut between shots. I have always found this idea interesting in relation to his use of collage in film.

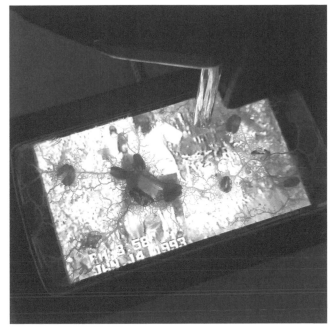

Photograph by Mariana Livieri

The final image is the synthesis of the conflicts I have been working around: my memories and the mold's memories; wanting to go back and avoiding places; nature and technology. The project became about representing these tensions on an image through the process of layering above my cell phone screen. I chose this object to represent myself as I had been using it for a few years and it came with me both to Patagonia and New York, where it was used to capture images and videos of new trips. It is not any screen, it is an object of intimacy and memories.

17.6 Questions

In every showcase, I have been prior to this one, I have always thought of artwork as a finished object, hanged or projected somewhere for people to see and draw their own conclusions. But for this project I had a different approach. I stood next to the installation during the three days the showcase lasted. I had the chance to meet the audience and explain them about the project and process. It was as exhausting as it was rewarding. Talking to so many people and going over the project through many angles allowed me to

understand it even better. Much of the feedback shed light over many topics that I hadn't even realized even though they were out there to see.

People in the audience were moved by the mold having external memory. Some even understood right away that the mold uses external physical memory. Most questions were based around the fact that mold's memory is for survival, whereas human memory is nostalgia. Many people paused to think what kind of memory was human memory. Does it serve for folklore and nostalgia purposes, or does it have a survival trait, like patients with post-traumatic stress?

Being confronted by the audience's questions, as well as posing my own to them is something I truly recommend to other artists showcasing their work. It's a fruitful exercise that helps in the improvement of the work. I could appreciate an important shift in my consideration of the art practice, at least pertinent to this project. It is not in the object proposed where the art happens, but rather in the spectator leaving with questions about themselves and their consideration about memories.

I believe in identity as an emergent behavior from memories. In the same way as the projected image, we constitute ourselves according to the places we have been in.

How do memories emerge as a juxtaposition of nature and technology?

18

Ctrl: Quantify, Compare, Optimize, Repeat

Michael Sedbon

Studio Michael Sedbon, Paris, France
E-mail: michaelsedbon.com; michaelsed7@gmail.com

"12:45, Restate My Assumptions:

1. *Mathematics is the language of nature.*
2. *Everything around us can be represented and understood through numbers.*
3. *If you graph these numbers, patterns emerge. Therefore: There are patterns everywhere in nature."*

In his 1998 graduation work, the movie-maker Darren Aronofsky tells the story of Maximillian, a software engineer working for wall street obsessed with the number PI. The movie talks about our quest for reassurance through quantifying everything. As a collective behavior, it reveals our contemporary fear of not being in control of the future. Freeing ourselves from uncertainty, it also expresses the current political status quo that put data as the center of any reflection and decisions.

Aint we avoiding important questions by hiding them behind a smoke-screen of information?

In his map allegory, Jean Louis Borges talks about our needs for making models of reality to seize its value. A king, unhappy at maps that do not do justice to his kingdom, finally insists on a map so detailed that it ends up covering all of the territories. To manipulates any system, abstracting it to a model is necessary. But the efficacity of these models depends on the resolutions of the abstractions.

Our data-maps inform decisions on every aspect of society (from politics to economics) and come to feed decision-making algorithms.

Today, classification algorithms are ubiquitous. From the way we pass borders to the tracking of our consumer behaviors in the supermarket, facial recognition algorithms already take a tremendous place in our lives. We are increasingly getting Datafied. Our digital selves are constantly compared to an immense flow of avatars formatted into parsable data sets in order to take predictive measures on targeted advertising and law enforcement strategy. We collectively make the assumption that because we know the past, we must be able to predict the future.

Recent advancement in machine learning and neural networks allow us to forecast complex systems such as the stock exchanges and atmospheric motions, pushing us forward into The Infocene: A cultural era where information is the force having the greatest impact on human societies and environments.

As with fossil fuel addiction and other co-dependant systems we are embedded in, we are building a free spinning feedback loop between the need and the reward: the more data artificial intelligence is trained on, the better it will be at producing new datasets. Information is becoming the primary resources to produce information. This paradigm produces situations such as the ones described by the artist James Bridle in his 2018 essay. There is something wrong with the internet where machine learning algorithms,

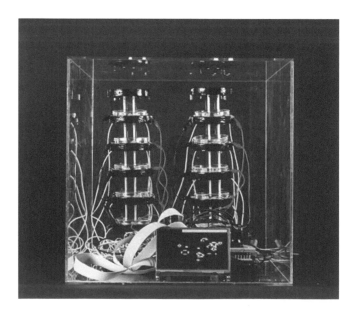

trained on youtube analytics data, produces content targeted to the youtube curation algorithm (that ultimately produce the analytic datasets).

In Simulacra and Simulation, Jean Baudrillard refers to Borges map allegory, but to him, the territory is fading away and we are now only left with the map. An abstraction of what once was and that is now only simulated.

This leaves us with the question of agency. The work of companies like Cambridge Analytica, claiming (claims that appear to be verified by their client's results) to be able to manipulate opinions by changing a voter's bulletin made us ask: How far has the Infocene gone and what is our relationship to artificial intelligence?

Physarum Polycephalum, the single cell but many headed slime mold is a unicellular organism exhibiting complex decision-making mechanisms and behaviors associated with intelligent life forms such as the ability to perform in geometrical and algebraical problematics helps us to conceptualize this phenomenon.

Art and design related work with this organisms include projects from Eduardo Miranda: BioComputer Music that talks about interfacing with biology through musical experiments, opening new creatives possibilities; Jenna Sutela: Slime Intelligence questioning the nature of the metaphors used to talk about intelligence and consciousness;

Oscar Martin: Bionic Sound Machina talks about non-human intelligence and creativity.

Moreover, the work of Andrew Adamatsky and his teams on "Advances in *Physarum* Machines: Sensing and Computing with Slime Mould" describes ways of using slimes molds as logic gates, color and chemical sensor, electrical wires, oscillators, memresistors (resistors with memory) while participating in concceiving slime mold through the information they express like an input-output system.

Because of the nature of these projects and the narrative they build around this organism, slime molds are the perfect subject for exploring the problematics described above.

Looking at Andrew Adamatsky work through the Infocene lense made me ask: how can I embed slime molds into an information producing system?

John Conway 1970 "Game of Life" thought experiment is described as a no-player game (a game that has no sentient players, or a game that use artificial intelligence rather than human players).

The universe of the Game of Life is a two-dimensional grid of square cells, each of which is in one of two possible states: alive or dead.

Every cell interacts with its eight neighbors, which are the cells that are horizontal, vertically, or diagonally adjacent. At each step in time, the following transitions occur:

Any live cell with fewer than two live neighbors dies, as if by underpopulation. Any live cell with two or three live neighbors lives on to the next generation. Any live cell with more than three live neighbors dies, as if by overpopulation. Any dead cell with exactly three live neighbors becomes a live cell, as if by reproduction.

Each generation is a pure function of the preceding one. The rules continue to be applied repeatedly to create further generations. Time doesn't matter as the future of the system could be computed since the first instant. Game designers only add a frame-rate (tick rate or reproduction rate) to make it visually understandable and pleasing. Overall, the game of life described a fully computable universe of information.

As this model showcase lots of similitude with what we know of the origin and development of the universe (the big bang occurred for simple reasons and was driven by a set of rules that unfolded into the extreme complexity of everything else) it is often used to explain and visualize its history.

Like life or the universe, the game of life doesn't have an obvious purpose.

As a player (here, it is probably more relevant to talk about a spectator), your only interest in the game is to see how the system evolve.

As the simulation runs, patterns emerge. The interesting bits in them is that they often look quite similar to common representations of cellular division or microbial growth.

2 outcomes are possible: Either the system reaches a point where the number of alive cells stays constant.

Or the count of cells reaches 0, ending the game.

Because of its deterministic nature, someone who understands the rules, could "hack the system" by building a logic framework to execute computations (through logic gates) and, by so, giving a purpose (or a goal) to the game.

I decided to implement a goal for this simulation: building the original circumstances that will produce the maximum live cells during the game.

As described above, a wide variety of work has been produced on how to sense slime molds electrical properties (translating a biological behavior into computable data).

In his paper: Towards slime mold color sensor: Recognition of colors by *Physarum polycephalum*, Andrew Adamski talks about ways of measuring slime molds responses to light and color stimuli through the use of digital

technologies, abstracting its behavior into data points that could inform some decisions. By opposition, one could also see this paper as an opportunity for controlling the electrical potential of a slime mold protoplasmic tube by using light impulses.

Ctrl is an installation in which 10 *Physarum Polycephalum* are competing on John Conway's Game of Life.

The electrical potential of the slime molds at the end of a protoplasmic tube connecting two food source (oat flakes) is measured through Galvanic Skin Response sensors hooked up to an Arduino mega, transmitting data to a single board windows 10 computer processing them through a custom made software. These data are then used as spatial coordinates that control the gaming and set the original state of the Game of Life.

At the end of each round, The onboard Artificial Intelligence will trigger light flashes to manipulate and optimize the looser's games.

My workload on this project was divided into several parts: finding a way of sensing slime molds that would be easy to interface with a video game, getting to know the data spit out by the slime molds to understand how to control them, build a protocol to produce long- lasting slime molds on electrodes to play the game, build a "gaming infrastructure" that will communicate the philosophical concepts explained above and finally, design the software.

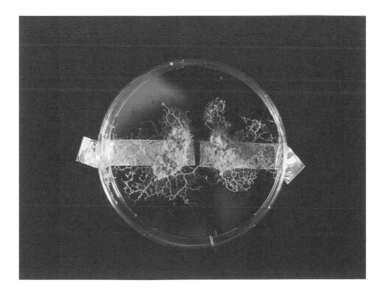

To get a sense of the reaction caused by the light flashes, I developed a custom visualization framework based on a particle system. I wanted to design an environment that would embrace the randomness in the noisy slime molds signals. I hooked them up to camera controls, to the variables controlling the force field applied to the particle system.

I was asking myself question about how to clamp real-time data that was out of my expectations. To what extent do I provide freedom and control over the visual to my external intelligence? How do I handle the data, what kind of math operation should apply for it to maintain it's interesting characteristics and looks while still serving my aesthetic purpose? These questions are still work in progress and the answer I've got are only very personal as they relate to my own sense of aesthetics and the message

I want to communicate through the interface design of this project. nonetheless, I manage to tweak the math in a way that will translate aesthetically a sense of "organic motions".

Thanks to this real-time simulation, I was able to perceive the effect of the light flashes in a more communicative way than the simple 2D graph that usually comes out of sensing software.

The sensing setup works as follow: I need to have a colonized oat flak on one electrode, and a healthy food source on the other so that the slime mold would make an electricity conducting bridge (protoplasmic tube). It will be the changes in electrical potential in that "bridge" that I will be sensing and using as gaming data.

At first, I was cutting a piece of agar on which *Physarum* was sitting and putting this onto the first electrode. I will then cut a piece of clear agar, put it onto the other electrode and leave a clean oat flake onto it. None of my experiment in the setup was concluding. I then started putting smaller bits of agar so that it would require less effort fro *Physarum* to bridge the gap. This rarely worked, and when it worked, didn't last long at all (I could sense electricity flowing between the electrode, but only for a very limited times before the protoplasmic tube broke).

After a few failed trials and the help of Adamatzky's team, I finally found a way of making long-lasting slime molds on electrodes: Start with a Petri Dish and 2 electrodes (electrodes are made with aluminum tape). Use a pipette to make and some liquid agar to make an agar blob on each electrode. Wait a few minutes that the agar cools down and solidify a bit (Obviously, in the meantime, prepare other Petri dishes). Then put a colonized sample and a healthy one and put them onto each of the agar blobs. Make the other drop of liquid agar to the back of each sample to "enclosed them". close the petri dish and wait 24 to 32 hours. In 80% to 90% of the cases, *Physarum* will develop a relatively solid protoplasmic tube between the two electrodes. That way my samples electrodes setup can last up to 3 days which is an honest duration for my video game setup.

Regarding the design of the "gaming infrastructure", I wanted my installation to convey this idea of quantification and technification. I decided to embrace the idea of letting everything visible as the wire and the electronics were part of the message. Seeing a lot of wire will communicate the question: do we need that much data? why is everything that much quantified? I then benchmarked through a different kind of wires. I choose yellow silicon wires as they remind color codes of biohazard signs and the color of the slime molds. They are also very flexible. They could feel a bit like a blood vessel carrying data. also, their sleek aspect will resonate with the one I chose for the petri dish holders making this bridge between clean digital and dirty biologic aesthetics. The flat ribbon cable reminds of a 1990's computer aesthetics before the advent of fully wireless communication technology. finally, the screen is stripped down to it's very minimum, showing microchips and inner wires.

Then came the time of designing the interface of the game. As explaining my concept was already a challenge, I figured out that having a screen was a good opportunity to simply write the message in it with plain text. I used the loading page (where the data from slime mold is gathered) to explain the functioning of the game. The score screen is a reference to the Bloomberg

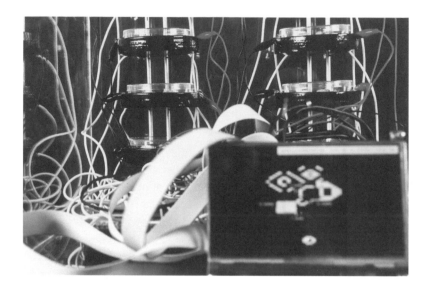

trading interface. Looking at financial application design, the question of the readability of data became obvious. Finance, as well, is animated by the idea that more data will help us see clearly into the future. There is also an aspect of it that more or less says that the information displayed on their screen is illegible for most people, and therefore, kept for the eyes of insiders. The other side of this aspect is that this data is really that complicated that it is what it takes to read it: being an expert. I stay doubtful on that one. The screen flashes a white frame each time a new information is displayed. This is a reference to the movie WarGames from director John Badham (1983). In the final scene, the main character plays a game of Tic Tac Toe against an AI to set the future of the Cold War nuclear tension. Inbetween each game, the screen flashes to signify that the AI computed learnings from last round (this is how the AI thinks). In this scene, the main characters play the Tic Tac Toe Game to teach the AI that not all games have for objective to be won. (in this case, as everyone knows, the game is not fair as there are ways to be sure to win and multiple options to end up doing a null match).

My project also relates to a field of design research called the Biotic Games that aim at using the interactions with biological organisms as gameplay processes. Highlighting structural differences between software and wetware. Stanford's Riedel-Kruse Lab is leading the discussion in this field. They got tractions after using light to control Paramecias (unicellular

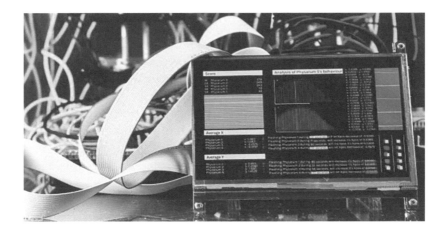

organism commonly used in microbiology lab) to play different kinds of video games such as a football simulation.

Making a video game for biological organisms to play revealed some challenges and exciting features. The way I was using slime mold could have easily been done using generated random data but there are some aspects of having something alive in the system that makes it particularly precious:

1. It can die and so, the fragility of the system makes the moment when we are experiencing it relatively fragile.
2. It will probably not behave in the same way the next time someone will be watching it.
3. Knowing that what you're watching is happening in real-time put you in a state of expecting something to happens.

These feelings for the player (or the spectator in my case) could be leveraged in specific game situations. However, one must understand gamers interest. ideo Game speedRuning is a trend that mostly lives on streaming platforms (like twitch and youtube) where a player tends to finish a game in the fastest way possible.

In some case, it is only about knowing by heart the course of the game, executing sharp moves on bots enemies, going level after level without losing any time.

Other speedrunners take another approach and acknowledge that in a video game system, rules are meant to be broken. Therefore, they take advantage of flows in the game engines such as frame rates, the way positions

are computed within the board etc.. to end up in situations that were not programmed by the teams of developers thinking through the complex wire-framed timeline of the story. This relates to the history of having cheat codes inside games. It is about giving the players ways to break the rules, and therefore, escape repetitiveness of computationally limited game engines. It gets about muddling through the game to understand its working mechanisms, in the same way, that you would fight a boss several times before understanding its "pattern" (repetitive series of attacks that present an opportunity for the player to hide or strike).

Inputting biological organisms in video games could leverage this trend by transferring the interest of the player to find the glitch to the understanding of the biological behaviors and the effect its environment to the gameplay. Therefore, one would not only try to defeat a known boss but will also have to adapt to the mood of an "alter-player". It would be interesting to conceive a game in which the player could also have an impact on the environment of its biological adversary in a way that the flaws of the game won't be related to the limitations of digital technologies (computing power of a CPU, randomness problems, and time management) but be related to the environment in which the game is played.

How is this speedrun possible? Super Mario Bros. World Record Explained Ctrl stands between experimental video games, critical design

How is this speedrun possible? Super Mario Bros. World Record Explained
4,447,281 views

research, and a thought experiment. This project managed to start many conversations on the subject of Artificial Intelligence governance and out relationship to technological systems.

Credits

Prof. Andy Adamatzky, Unconventional Computing Lab @ UWE, Bristol
Dr. Richard Mayne, Unconventional Computing Lab @ UWE, Bristol
Ian Portman, The University of Warwick
Theresa Schubert
Heather Barnett
Raphael Kim
Tobias Revell, MA Interaction Design Communication @ London College of Communication, UAL Adam Corrie, Prototyping Lab @ London College of Communication, UAL
Tom Lynch, Prototyping Lab @ London College of Communication, UAL

External Links

https://michaelsedbon.com/C-t-r-l
https://www.youtube.com/watch?v=z3f2JyQ8pu0
https://drive.google.com/open?id=1Vb9rzjC2GtChwJrntfP0rxyHE-ap6ynY

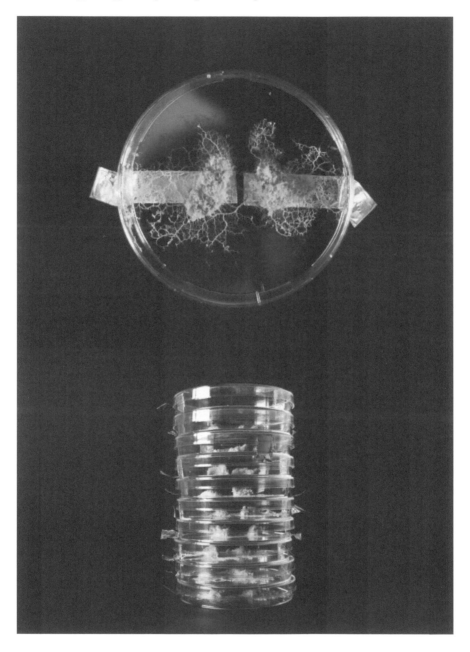

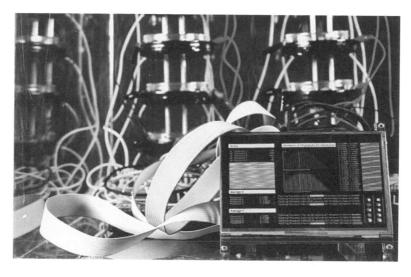

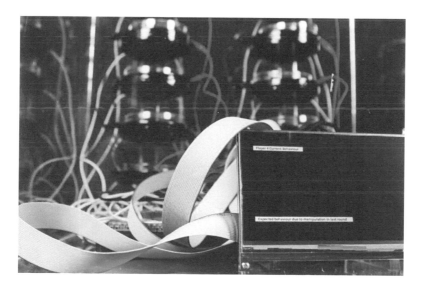

Index

About the Editor

Andrew Adamatzky is Professor of Unconventional Computing and Director of the Unconventional Computing Laboratory, Department of Computer Science, University of the West of England, Bristol, UK. He does research in molecular computing, reaction-diffusion computing, collision-based computing, cellular automata, slime mould computing, massive parallel computation, applied mathematics, complexity, nature-inspired optimization, collective intelligence and robotics, bionics, computational psychology, non-linear science, novel hardware, and future and emergent computation. He has authored seven books, mostly notable are 'Reaction-Diffusion Computing', 'Dynamics of Crow Minds', and 'Physarum Machines', and has edited 22 books in computing, most notable are 'Collision Based Computing', 'Game of Life Cellular Automata', and 'Memristor Networks'. He has also produced a series of influential artworks published in the atlas 'Silence of Slime Mould'. He is Founding Editor-in-Chief of 'J of Cellular Automata' and 'J of Unconventional Computing' and Editor-in-Chief of 'J Parallel, Emergent, Distributed Systems' and 'Parallel Processing Letters'.